PORTRAITS OF THE

New Negro Woman

PORTRAITS OF THE

New Negro Woman

*Visual and Literary Culture
in the Harlem Renaissance*

Cherene Sherrard-Johnson

RUTGERS UNIVERSITY PRESS
NEW BRUNSWICK, NEW JERSEY, AND LONDON

A British Cataloging-in-Publication record for this book is
available from the British Library

Library of Congress Cataloging-in-Publication Data

Sherrard-Johnson, Cherene, 1973–
Portraits of the new Negro woman : visual and literary culture in the
Harlem Renaissance / Cherene Sherrard-Johnson
p. cm.
Includes bibliographical references and index.
ISBN-13: 978-0-8135-3976-8 (hardcover : alk. paper)
ISBN-13: 978-0-8135-3977-5 (pbk. : alk. paper)
1. American fiction—African American authors—History and criticism.
2. African American women in literature. 3. Racially mixed people in literature.
4. Icons in literature. 5. Visual perception in literature. 6. Feminism in literature.
7. Race in literature. 8. African Americans—Race identity.
9. American fiction—20th century—History and criticism.
10. Harlem Renaissance. I. Title
PS153 .N5S49 2007
810.9´928708996073—dc22
2006011342

Manufactured in the United States of America

FOR

Amaud

Contents

List of Illustrations / ix

Acknowledgments / xi

Preface / xiii

Introduction: The Iconography of the Mulatta / 3

chapter 1
"A Plea for Color": Nella Larsen's Textual Tableaux / 21

chapter 2
Jessie Fauset's New Negro Woman Artist and the
Passing Market / 49

chapter 3
"Black Beauty Betrayed": The Modernist Mulatta in
Black and White / 77

chapter 4
The Geography of the Mulatta in Jean Toomer's *Cane* / 107

chapter 5
Redressing the New Negro Woman / 143

Notes / 169

Bibliography / 191

Index / 201

List of Illustrations

1. Archibald J. Motley, Jr., *A Mulattress*, 1924 / xiv

2. Thomas M. Easterly, *Unidentified Young African-American Woman*, 1860 / 8

3. Harry Shepherd, *Portrait of Mattie McGhee*, 1900 / 9

4. Archibald J. Motley, Jr., *The Octoroon Girl*, 1925 / 23

5. John Henry Adams, *The Octoroon*, November 1923 / 26

6. Archibald J. Motley, Jr., *Aline, An Octoroon*, April 1926 / 29

7. Eugène Delacroix, *Aline, the Mulatress*, 1824 / 30

8. Archibald J. Motley, Jr., *Octoroon (Portrait of an Octoroon)*, 1922 / 43

9. Carl Van Vechten, photograph of Blanche Dunn, 1934 / 46

10. *Plum Bun* advertisement, *Crisis*, April 1929 / 56

11. Laura Wheeler, story illustration, *Crisis*, August 1923 / 58–59

12. Reginald Marsh, *In Fourteenth Street*, 1934 / 62

13. Kenneth Hayes Miller, *The Shoppers* or *In Passing*, 1920 / 65

14. Sylvia Landry in *Within Our Gates*, 1920 / 82

15. Louise Howard in *Scar of Shame*, 1927 / 83

16. Robert S. Scurlock, photograph of Fredi Washington, 1930 / 95

17. William H. Johnson, *Self-Portrait*, ca. 1923–26 / 113

18. William H. Johnson, *Self-Portrait*, 1929 / 114

19. William H. Johnson, *Self-Portrait with Pipe*, 1937 / 115

20. William H. Johnson, *Nude*, 1939 / 124

21. William H. Johnson, *Girl in a Green Dress*, 1930 / 127

22. William H. Johnson, *Café*, 1939 / 138

23. Archibald J. Motley, Jr., *Brown Girl After the Bath*, 1931 / 149

24. Faith Ringgold, *French Collection #5: Matisse's Model*, 1991 / 150

25. Faith Ringgold, *French Collection #7: Picasso's Studio*, 1997 / 151

26. Faith Ringgold, *French Collection #3: Picnic at Giverny*, 1991 / 157

Acknowledgments

The love and generosity of family, friends, colleagues, and mentors made it possible for me to write this book. Many thanks to those who read this manuscript at various stages, including Biodun Jeyifo, Kenneth McClane, Hortense Spillers, Bethany Schneider, Eliza Rodriguez y Gibson, Jayna Brown, Grace Hong, Craig Werner, Susan Stanford Friedman, and the astute readers chosen by Rutgers University Press. *Portraits of the New Negro Woman* has been in the sure hands of my editor, Leslie Mitchner; I appreciate her support and expertise and that of the entire editorial and production staff.

I'd like to acknowledge the contributions of those who offered timely encouragement and wisdom at critical junctures, including Richard Yarborough, Frances Smith Foster, Thadious Davis, Deborah McDowell, Jennifer Wilks, Ivy Wilson, P. Gabrielle Foreman, Xiomara Santamarina, Shirley Samuels, Furaha Norton, Amy Quan Barry, and Ethelene Whitmire. Thanks to Duke University Press for permission to reprint Chapter 1, and a special thanks to Priscilla Wald and especially Houston Baker, Jr., editors of *American Literature*, the journal in which that chapter first appeared. I am grateful for the support of my colleagues in the department of English at the University of Wisconsin–Madison.

I owe an incalculable debt of gratitude to Nellie McKay, a fabulous colleague, reader, mentor, friend, and all-around inspiration. Her book on Jean Toomer was the very first that I read, and on her word alone I trusted that UW-Madison would be a safe and supportive place for my work.

Throughout the years funding from several sources has supported my research and writing, including the Graduate School at Cornell University, the Anna Julia Cooper Post-Doctoral Fellowship at UW-Madison, the UW-Institute for Race and Ethnicity, the Graduate School at UW-Madison, and the National Endowment for the Humanities. The expertise and generosity of

librarians, research, and technical staff at Yale's Beinecke Rare Book and Manuscript Library, the Schomburg Center for Research in Black Culture, the Moorland-Spingarn Center at Howard University, the Wisconsin Historical Society, the Chicago History Museum, La Bibliothèque National de France, the Smithsonian Institution's Archives of American Art, and Cornell's University Library were invaluable resources.

Finally, I thank my family: my parents, Fredric and Martha Sherrard, for their unbelievable support and love; my grandfather Johnnie L. Cochran, Sr., who continues to inspire with his insight and faith; the Bakers, the Chandlers, the Cochrans, and the entire Sherrard clan for their warmth and generosity. Most of all, I am grateful to my husband, Amaud, and our son, Hayden, for their love, patience, and steadfast confidence.

Preface

On February 25, 1928, the New Gallery unveiled "the first one-man show of a negro artist."[1] Though the gallery had invited Archibald J. Motley, Jr. before knowing his racial heritage, the curiosity of a solo exhibition by an African American artist fueled later sensationalist promotions of the show. Judging from the laudatory reviews in the *Crisis* and the *New Yorker,* it must have been an extraordinary evening. The period of artistic activism later known as the Harlem Renaissance was in full swing. Appealing to art aficionados with an appetite for the exotic and the avant-garde, Motley's work engaged the uplift aesthetics of the New Negro movement and the rage for the primitive sweeping the American and European art scene.

One painting, the provocatively titled *A Mulattress* (1924), surely lingered in the minds of those who attended the exhibition. After winning the Frank G. Logan Prize at the Art Institute of Chicago, *A Mulattress* was deemed arresting enough to grace the cover of the exhibition catalog (fig. 1). Sold to a private collector during the show (the only available image is in black and white), the portrait features a fiercely seductive woman. Motley paints her dress "fiery red," a shade, as he notes in "How I Solve My Painting Problems," that he chose purposely to signify her volatile personality. She sits in a well-defined chair on the lefthand side of the painting, with her shoulders slightly hunched. Her bobbed hair and sleeveless dress are the height of fashion; her pearl earrings and necklace, too long to be tasteful, are more appropriate for a late-night soiree than for a dignified sitting. Other markers of class, a vase filled with wildflowers and a barely decipherable Chinese incense burner, sit on a covered table, while a craggy, mountainous landscape, selected to "reflect the difficulty of her personality," balances the composition.[2]

What was so intriguing and new about this portrait? Not the title, which revisits an antiquated racial category and seems inapplicable to such a modern

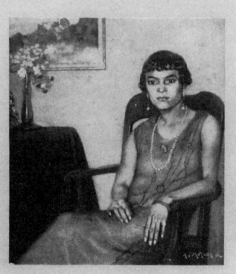

February 25th through March 10th, 1928

EXHIBITION OF PAINTINGS
BY
ARCHIBALD J. MOTLEY, JR.

The New Gallery

600 MADISON AVENUE · NEW YORK

NOTE: The first one-man exhibition in a New York art gallery of the work of a negro artist is, no doubt, an event of decided interest in the annals of the American school of painting. It seems, however, worth while to record the fact that the invitation to Mr. Motley to show his paintings at The New Gallery was extended prior to any personal knowledge concerning him or his lineage and solely because of his distinction as an artist.

1. Archibald J. Motley, Jr., *A Mulattress,* 1924.
CHICAGO HISTORY MUSEUM AND VALERIE GERRARD BROWNE.

composition. Why was *A Mulattress* singled out as representative not only of Motley's oeuvre but of a broader sense of New Negro identity? The terminology used to discuss *A Mulattress* and the exhibit as a whole is not the language of visual art. Contemporaneous critics did not draw attention to the quality of light, texture, or composition; instead, their commentary resembles nineteenth-century pseudo-scientific discourse, laden with spurious classifications based on phenotype and blood quantum. The *New Yorker* (1928), for instance, describes Motley's palette as "largely racial" and admires several portraits of octoroons but doubts that "real primitives, could hardly be executed by the young man who painted the sophisticated Octoroon" ("The Art Galleries," 79).[3] Apparently Motley, with his middle-class background and degrees from the Art Institute, did not fit the mold of the intuitive, self-taught Negro artist. As a result, those aforementioned "primitive" works, which I suspect were included as a concession to the viewing public's expectations, reveal merely nightmarish landscapes of a distant and distorted dark continent. Yet a footnote in the catalog privileges Motley's imaginative jungle scenes over his aristocratic studies: "whatever the excellence of Mr. Motley's portraits, presumably the public will find most fascinating those paintings which depict Voodism—the superstitions, the dreams, the charms of East Africa."[4]

Distinct among several paintings of mixed- and ambiguously raced women in the exhibit, *A Mulattress* mirrors the opposing impressions of refinement and primitivism that typified reactions to the collection. Even the artist tells us that he included the accessories not only to balance the geometry of the composition but to "reduce to a certain extent the fiery appearance of the figure." As important as the attenuation of the sitter's fingers (a trademark in Motley's portraiture) is the fact that she was the wife of doctor in Chicago in the heyday of the New Negro era. And consider Motley's description of her: "the subject was the possessor of an extremely fiery temper, a very temperamental person. I have tried to express her personality in the physiognomy of the face and the personality and relation of the hands to the face. I have also tried to express the true mulattress." But who or what was the *true* mulattress? A proper upper-middle-class club woman or a sultry temptress? In his notes, Motley writes that the foundation of *A Mulattress* is geometric: "it was built first on the triangular shape, the stem shape, the square or oblong shape, and finally the round or oval shape."[5] But I believe *A Mulattress* is instructive because it actually has a different blueprint, one that derives its lineage not from the architecture of portrait art but from literary, legal, and anthropological discussions of race. In short, in the imagination of the artist and the viewer, this composition typifies the iconography of the mulatta.[6]

Portraits of the New Negro Woman traces the variety of racialized, gendered,

and classed meanings that accrue around the figure of the mulatta in Harlem
Renaissance literature and visual culture. During that era, the mulatta was the
key figure for a variety of sometimes competing and paradoxical discourses.
Elitist and colorist rhetorics of uplift deployed the mulatta as a signifier of
African American propriety, domesticity, and civilization, all central aspects of
the New Negro movement, which attempted to claim a modern subjectivity
for African Americans. Yet the mulatta was also the object of sensationalist and
sexualized desire, the very embodiment of miscegenation as well as other trans-
gressive sexualities such as incest, sadism, and rape. These sensationalist images
responded both to the rise of consumerism and to the market considerations
that constrained writers and artists of the time, but their roots were mired in
the violent histories of chattel slavery. That the figure of the mulatta was re-
markably able to represent such a variety of contradictory meanings was tied
to her ability to "pass" and thus transgress racial, class, and gender boundaries.

This aspect of racialization in the Harlem Renaissance period leads me to my
methodology: *Portraits of the New Negro Woman* examines literature in relation
to the visual culture of the era precisely because the visual reproduced racial
knowledge and regimes. When cast as a passing figure, the mulatta's ability to
"fool" the eye both reinforced and undermined the notion of race as physiol-
ogy and phenotype. Therefore, I consider ways in which the mulatta recon-
firmed everyday beliefs about race but also ways in which her ambiguity and
complexity enabled Harlem Renaissance writers and visual artists to conceive
of the figure of the mulatta as an imaginative alternative to the dominant racial
discourses of the time. These writers and artists used the mulatta icon to artic-
ulate modes of agency and subjectivity that could not be entirely described
through discourses of uplift or the conventions of sensationalism.

To achieve a depth and dynamic fluidity lacking in critical studies of the
tragic mulatto/a in American literature, I focus on narrative and visual portraits
of the mulatta as a passing figure and icon of New Negro womanhood as a way
of foregrounding the artistic exchange among visual artists and writers as a cru-
cial aspect of the Harlem Renaissance (1917–35).[7] I begin by investigating the
influence of visual art—painting, photography, and sculpture—on the language,
themes, characters, and structure of several Harlem Renaissance novels. His-
torically, studies of the era have focused on the intersection between music (spe-
cifically, jazz and the blues) and poetry, avoiding the equally pertinent traffic
between fiction and visual art. Yet identifying the visual components of the
mulatta trope is vital to understanding the changing conditions of race in this
volatile period of American history and culture. The depiction of women as
mixed-race madonnas, teachers, or socialites in New Negro periodicals enforced
a sexist standard of behavior and vocation denoted by a colorist conception of

beauty and femininity. Unearthing the collaborative complexity of the mulatta icon requires a conversational inquiry ranging among novels as well as paintings, cover art, and illustrations from Eugène Delacroix to William H. Johnson, a strategy that reveals how primitivist and anti-industrialist streams within modernism intersect with Harlem Renaissance aesthetics.

In *A Chance Meeting: Intertwined Lives of American Writers and Artists, 1854–1967*, Rachel Cohen (2005) recounts how serendipitous encounters resulting in long-term correspondence enhanced and influenced the lives of artists and writers. Likewise, I place the work, rather than the individual interactions, of artists and writers from the Harlem Renaissance in conversation. Cohen's book deftly translates meticulously archived letters into an imaginative treatise on the nature of artistic collaboration and influence; similarly, I've compiled a visual and literary archive of the mulatta. What emerges is how the mulatta served a dialogic function that enabled interventions into American and European modernisms while simultaneously producing a related but distinct African American modernism during the same period that Cohen's book vividly re-creates.

On February 1, 1928, three weeks before Motley's New York debut, novelist Nella Larsen, the first black woman to win a Guggenheim fellowship, wrote this letter to Gertrude Stein:

> I have talked with our friend Carl Van Vechten about you. Particularly about you and Melanctha which I have read many times. And always I get from it some new thing. A truly great story. I never cease to wonder how you came to write it and just why you and not some one of us should so accurately have caught the spirit of this race of mine. Carl asked me to send you my poor first book and I am doing so. Please don't think me too presumptuous. I hope some day to have the great good fortune of seeing and talking with you. Very sincerely yours, Nella Larsen Imes.[8]

There is no historical evidence documenting what would have been a provocative meeting. As far as we know, Larsen never had the pleasure of conversing with Stein and her "charmed circle" on 27 Rue de Fleurus while she was in Paris, but the timbre of this letter expresses considerable awestruck praise. A burgeoning novelist very much influenced by modernist writers, Larsen expresses a wistful desire to meet Stein, despite the fact that *Melanctha* had been poorly received by fellow African American novelists Walter White and Jessie Fauset, who responded to what they saw as Stein's attempts at literary minstrelsy by penning their own more "authentic" stories. Larsen at least was ambivalent about who could authentically represent black life.[9]

In addition to tracing the ascendancy of the mulatta as an iconic figure, my book is necessarily about the writers who created her—writers like Larsen, those

uninvited guests who crashed the modernist party in their fiction and created safe spaces for visual artists and writers to discuss form, aesthetic philosophies, and politics. Just as Faith Ringgold's *French Collection* imaginatively incorporates black artists and writers into the salons and studios of white Europeans and Americans whose collaborative efforts have been well documented in studies of modernist art and fiction, this book illuminates the artistic collaborations, conversations, and influence of Harlem Renaissance visual art on the writers of the era. A selection of visually evocative novels demonstrates that particular writers—Jean Toomer, Jessie Fauset, and Nella Larsen, among others—found inspiration in both high art (painting and sculpture) and low art (film and magazine illustrations and photographs). There are some historical accounts of Harlem Renaissance era salons, such as those hosted by Jessie Redmon Fauset in Harlem, Georgia Douglas Johnson in Washington, D.C., and Paulette Nardal in Paris, where visual artists and writers presumably engaged in work-related conversations. A consideration of cross-genre interactions within the social and political spheres of the Harlem Renaissance is vital to our understanding of the era. And while we do have some documentation of creative exchanges between artists and writers, such as Jean Toomer's letter to Georgia O'Keeffe about his experimental novel *Cane*, there are more gaps than bridges in the archives. The depth of analysis applied to the relationship between Picasso and Stein has not been achieved in studies of the Harlem Renaissance. Not only does an examination of the visual reveal normative representations of black identity during the Harlem Renaissance, but it also provides an understanding of that period as Afro-modernist: a distinct, black, diasporic tradition that is nevertheless inseparable from European and American modernism.

From the 1890s through 1940, a period roughly spanning the end of Reconstruction to the end of the Harlem Renaissance, many black writers and visual artists fought a war of images in their effort to rewrite and re-envision black representation in high art and popular culture. In their attempts to counter stereotypes of black women as subhuman, immoral, and hypersexual, early African American fiction writers continued the project of reconstructing black womanhood begun by nineteenth-century authors of slave narratives and anti-slavery rhetoricians. Black artists and thinkers were deeply invested in presenting a new African American identity and culture at the dawn of the twentieth century. The spirit of self-invention and optimism for the future of blacks in the United States gave birth to the New Negro movement and the subsequent artistic explosion known as the Harlem Renaissance. Unfortunately, these concentrated narrative and visual efforts to christen the New Negro as a race leader cast the New Negro woman (frequently portrayed as ambiguously raced) in a supporting role. This was actually a regression from the more prominent political

visibility of activist-writers such as Ida B. Wells Barnett and Frances Harper, who worked side by side with male abolitionists and took on the perils and pitfalls of the Reconstruction era firsthand. What had changed? Why were black women being asked to take a backseat in the New Negro movement just as white American women were challenging their roles in the Gilded Age? Black women writers of the Harlem Renaissance responded to these questions by creating heroines who were struggling to find their place as artists amid the very real economic limitations of the thirties. The radical nature of their literary efforts, often submerged beneath the veil of the sentimental novel, was remarkable within a culture in which white patronage habitually benefited black male ingénues.

While there was no fully coherent image of the New Negro woman in visual art, popular culture, and literature, the most prevalent was that of an ambiguously raced woman who appeared to emulate Victorian femininity rather than the persona of a modern flapper or the independent new woman one might expect in the 1920s and 1930s. Why was the image of the mulatta so pervasive, particularly on the covers of presumably progressive black periodicals such as the *Crisis*, the *Messenger*, and *Opportunity*? Even periodicals with leftist sensibilities, such as the *Messenger*, which dedicated an entire issue to the New Negro woman in 1926, began to feature provocative, indeterminately raced women on its covers. The short-term gains of this representative strategy were obvious: then as now, pictures of attractive, mysterious women sold magazines. The long-term results were apparent in the black community's continued welding of uplift and economic mobility to skin color and its sustained concern about how black images of beauty, progress, and respectability functioned in American consumer culture.

The mulatta emerged as a dominant fictional character and a frequent subject for painters, photographers, and filmmakers not simply because she was, as Hazel Carby deems her, "a narrative device of mediation."[10] Far from resolving issues of race, class, and gender, the ambivalence of the mulatta figure fascinated writers and readers, artists and audiences. The mulatta as icon, then, became a representative of unspeakable subjugation and erotic desire, both inter- and intraracial. Styled as the ideal template for measuring black femininity, she was, by turns, a constrained symbol of Victorian womanhood, a seductive temptress, and a deceptive, independent, modern woman. Visual and fictional portraits of the mulatta attempted to balance and conjure these interpretations simultaneously, but only by tracing the dialogue between visual and fictional renderings can we comprehend the collaborative and experimental nature of these artistic endeavors.

Why is the *mulatta* but not the mulatto the focus of my study? Certainly, there are passing novels with central male protagonists, so why study the female

incarnation in isolation? First, as Chapter 1 will show, art and literature display many more stories and images of tragic mulattas and passing women. This is no coincidence; there is something flexible about the feminine that authors seem to find irresistible. The gender and the gendered discourse associated with the literary trope of the mulatta are crucial to understanding how she functions as an ambivalent icon of hybrid blackness in visual culture. After all, sexual exploitation of the African and Native American *female* body brought the mulatto/a and mestizo/a to the New World. The figurative and literal mark of illegitimacy, betrayal, and sexual violence connoted by the term *mulatta* repeatedly surfaces in twentieth-century literature. Antebellum patriarchal systems of oppression forced women into subservient yet acutely observant positions. In circumstances where survival is uncertain, gender, like race, is as much a performance as a result of cultural practice or phenotypical and biological classification. The mulatta becomes the ideal locus point through which to observe and interrogate not only the ways in which a study of race, class, and gender oppression illuminates specifically nuanced aspects of identity and human experience but also pseudo-scientific fantasies about blood, religious archetypes related to original sin, and the shifting definitions of citizenship and freedom before and after the Civil War that depended on the status (white or black, slave or free) of the mother. Although the masculine form is often universally applied to encompass both genders, I refer to mulatto/a when I wish to designate both genders and use the masculine form to designate male personifications of the trope.[11]

To recast the mulatta as an icon of visual and literary Afro-modernism, I study how she functioned as ambiguous symbol of racial uplift that ironically constrained African American womanhood in the early twentieth century. More broadly speaking, *Portraits of the New Negro Woman* is an exploration of the intangibility of racial performance and representation. In *Impossible Purities*, a study of feminized racial ambiguity in Victorian literature, Jennifer Brody uses the term *mulattaroon* to capture the figure's status as "an unreal, impossible, ideal," while feminist theorist Hortense Spillers, writing in *Black, White and in Color*, believes that "to reify 'mulatto/a' as an actual race being, whatever that might entail—as one fears is beginning to happen on the scene of the new pluralism—would amplify the 'race' question, reinforce it as an implement of political power, revivify the 'black'/'white' divide, and essentially reinstall a sometimes ambiguous color consciousness that the late twentieth century purports to have left behind."[12] Spillers may be right in the sense that, despite a century of discussion about the mulatto/a and the crossing of W.E.B. Du Bois's now infamous color line, there is still more to say about the mulatta figure. What has to change is the *way* we talk about her. While I agree with Spillers

that we must distinguish between actual mixed-race human beings and the construction of the mulatta in literature, I stress that only by analyzing the mulatta's iconic status can we resolve and explain the apparent contradictions inherent to fictional, visual, and even sociological considerations of her.

In 1924, the *Messenger* launched a photographic campaign entitled "Exalting Negro Womanhood" with the intent of showing, "in pictures as well as writing, Negro women who are unique, accomplished, beautiful, intelligent, industrious, [and] successful."[13] Despite the editors' best intentions, the preponderance of mixed- and ambiguously raced women featured in the pictorials and in articles such as "Glorifying the Colored Girl" illustrate that the mulatta icon had come to stand for the exaltation of a prescriptive femininity that was impossible for African American women to perform without considerable strain and often had destructive consequences. In my view, the ambivalence surrounding discussions of the mulatta in black culture has created opposition within popular culture and academic criticism that is difficult to conceptualize. In my journey to understand the mulatta's persistence in black literature and culture, I confront my own ambivalence regarding various artists' and critics' reification or demonization of her and my discomfort with popular culture's ahistorical fascination with contemporary multiracial icons. This same tension—a struggle between recognition and rejection—is present in the genesis, promotion, and criticism of the mulatta's iconic status in early twentieth-century African American literature and visual culture.

PORTRAITS OF THE

New Negro Woman

introduction

The Iconography of the Mulatta

She's no whiter than you see.

—WILLIAM WELLS BROWN, *Clotelle: or, the Colored Heroine* (1867)[1]

Mulatta iconography proliferated during the Harlem Renaissance as a result of visual and literary cross-fertilization. A by-product of counter-representational strategies to combat negative images of black womanhood, the mulatta was born from a complex melding of aesthetics and activism; and she remains a fraught, continually reinvented figure in black literary and visual culture. My framework for tracing the iconography of the mulatta can also be applied to other interartistic constructions that propose to represent identity, from the New Woman to the folkloric blues hero known as the bad-nigger. Conceived in broader terms, the framework pushes at the boundaries of narrative by identifying a protagonist who cannot be pinned down solely by pen, paintbrush, or lens. In this introduction, I clarify the scope and substance of my argument about the mulatta's status as a visual and literary icon, acquaint readers with the vocabulary of racial ambiguity, and provide a foundational lexicon of images that antedate the mulatta in Harlem Renaissance culture.

By establishing the mulatta as a literary trope, antebellum, Civil War, and Reconstruction literature laid the groundwork for the her iconic representation. Early African American writing provided a vocabulary that inscribed and codified what miscegenation meant and looked like, thus exposing what had once been invisible traces of blackness and, more important, making them evident to particular audiences. Two "portraits" from mid-nineteenth-century African American literature set the stage for my study and reveal the origins of the visual grammar of mulatta, a common language of perception and performance drawn from literary and visual culture.[2] The first appears in William Wells Brown's *Clotel, or, the President's Daughter* (1853).[3] Instead of beginning with a brief synopsis of his subject's childhood, as he does in his own autobiographical

3

slave narrative and as is common in most such narratives, Brown commences with a sensationalized portrayal of an auction. The diction in this scene relays the eroticism with which he infuses his descriptions of nearly white, enslaved women throughout the novel. When the title heroine first appears, she creates a "deep sensation amongst the crowd": "There she stood, with a skin as fair as most white women, her features as beautifully regular as any of her sex of pure Anglo-Saxon blood, her long black hair done up in the neatest manner, her form tall and graceful, and her whole appearance indicating one superior to her condition."[4]

Brown includes this early scene on the auction block, encoded with anti-slavery rhetoric, to evoke sympathy from free white women for the plight of enslaved black women; yet in so doing he creates a racialized discourse in which whiteness becomes violable through its collapse into blackness. The potential violence of this scene threatens any notion of racial stability and establishes a gold standard to which the majority of subsequent mulatta characters subscribe. Several characteristics attract attention: the reference to blood, skin color comparable to the whitest of white women, the woman's graceful and neat deportment, and the incongruity of her physical form with her enslaved status. The subsequent auction itemizes and attributes monetary value to her features. Her "chastity and virtue," along with the irresistible information that she has "never been from under her mother's care," results in her sale for "fifteen-hundred dollars." In *Clotel*, both the tragic central characters and other heroic figures are, as Brown was, mulatto/a with heavily emphasized Anglo features. Conferring external whiteness as a strategy for gaining sympathy also tends to reify hierarchies of the slave system, particularly when Brown juxtaposes Anglo-identified mulatto/a characters with figures such as Pompey, who is "no count-fit," but the "genewine artekil," with large features, wooly hair, and white teeth.[5] An obvious danger is that Brown's examples imply that slavery is somehow more befitting to darker slaves.

In a later version of Brown's novel, retitled *Clotelle: or, the Colored Heroine* (1867), Clotelle, the daughter of Isabelle and her white lover-master, finds herself on the auction block. This exchange ensues:

> "Indeed, sir, is not that young woman white?" inquired the parson.
> "Oh, no, sir; she is no whiter than you see!"
> "But is she a slave?" asked the preacher.
> "Yes," said the trader, "I bought her in Richmond, and she comes from an excellent family."[6]

Clotelle's African heritage is visually undetectable; however, her status as a purchasable commodity confirms that she must be black. The logic that one

inherits slavery from the mother contradicts the fact that she "comes from an excellent family." On the contrary, most antebellum mulattas do not come from excellent families: they are frequently the offspring of enslaved women sexually coerced by their white masters. The oxymoronic nature of the brief exchange between the trader and the parson exemplifies the obscured boundaries of racial instability. The bizarre syntax in their dialogue references a common understanding of the performance and manufacturing of race as well as their investment in the philosophy behind a racial superiority that defies its own logic: that whiteness is a visually identifiable and unassailable fact.

How was this vortex of sensationalized social, anthropological, and racial mythology visualized in antebellum and Civil War culture? Brown's readership had ready visual references for the almost-white slave women in *Clotel*; photographs, illustrations, and paintings of women and children involved in Louisiana's "fancy trade" reinforced the literary depictions. Affirming that "prints are powerful appeals," abolitionist Angelina Weld Grimké wrote in 1836 that "until the pictures of the slave's suffering were drawn and held up to public gaze, no Northerner had any idea of the cruelty of the system."[7] Brown's illustrated editions of *Clotel* were disseminated alongside a variety of widely circulated images such as the drawing "White Slaves" (1865) featured in *Youth's Companion* and the famously circulated visages of Ellen Craft, in and out of drag. I'm not suggesting that Brown's depictions reference a particular portrait, though sections of *Clotel* do paraphrase parts of the Crafts' *Running a Thousand Miles for Freedom*. But by asking the reader to imagine the slave woman as a beautiful and graceful lady who has been unfairly degraded, his work resonates with visual realizations of these subjects in newfound technologies.[8]

As nineteenth-century discourse of the body shifted from what Robyn Wiegman calls "the assurance of the visible to craft interior space" to "the possibilities of subterranean and invisible truths and meaning," authors continued to undermine presumptions of racial stability.[9] In 1900, Pauline Hopkins's *Contending Forces* added Sappho Clark, a second important icon in the catalog of memorable mulattas: "Tall and fair, with hair of a golden cast, aquiline nose, rosebud mouth, soft brown eyes veiled by long, dark lashes which swept her cheek, just now covered with a delicate rose flush, she burst upon them—a combination of a 'queen rose and lily in one.'" Like Brown's depiction of Isabelle, the portrait of Sappho emphasizes a particular brand of beauty and aristocracy. (The subtitle of one of the four versions of *Clotelle* is, after all, "The President's Daughter.") The sexual accessibility and commodification of these women complicate this sense of aristocracy and breeding, first through the act of being sold and then through their subjection to sexual violence in the guise of interracial romance. Despite Isabelle's grace, beauty, and superiority, her lover's betrayal

prompts her suicide: like a scorned Ophelia, she throws herself off a bridge. In Hopkins's novel, another Ophelia, Ophelia Davis, instantly recognizes Sappho Clark's heritage when she states: "thar ain't nothin' like thet growed outside o' Looysannie."[10] Louisiana, the place where slaves invariably surface when they are "sold down the river," represents the most severe manifestation of slavery's yoke. The response to Sappho within the bourgeois circles of black Boston reveals more than an otherwise submerged or invisible blackness: her body triggers a collective cultural memory of sexual exploitation as well as the mystery associated with the famed beauty of mixed-race women in New Orleans.

Hopkins's novels also expose incest as an important subtext in narratives featuring mulatta heroines, especially given the frequency of sexual abuse on isolated plantations. If the master viewed his progeny as property rather than offspring, incest, be it inadvertent or intentional, was not only possible but probable. In Hopkins's serial novel *Of One Blood, or The Hidden Self* (1902–3), the suggestively named mulatta Dianthe Lusk, a virtual twin of Sappho, her "fair face framed by golden hair, with soft brown eyes," and "rose-tinged baby lips," unknowingly becomes the paramour of both of her half-brothers, partly as a result of submerged family histories.[11] Clearly, Hopkins was not shy about portraying mixed-race women as both heroines and victims. Unlike Frances Harper's Iola Leroy, who was "tried, but not tempted," Hopkins's more sensational fiction subjects her characters to graphic sexual violence, though she never fails to highlight the complexity of her characters' position.[12] Dramatic, somewhat sadistic illustrations bolster the visual titillation of Hopkins's politically charged novels; for instance, the frontispiece to *Contending Forces* features the pale, naked back of Grace Montfort crisscrossed with scars from the lash in front of the two men who have whipped her. Despite moments of agency and affirmation, as when Hopkins has Dora insist, "I am not unhappy, and I am a mulatto," in response to a debate concerning how northern black women can best negotiate the stigma of sexual violence and deal with the growing numbers of "unhappy mulattoes of a despised race," the mulatta in Hopkins's novels usually functions as an irresistibly attractive and unsettlingly sexual ambiguous figure for black and white, male and female characters.[13]

In contrast to the eroticized portrayals of ambiguously raced women in Hopkins's and even Charles Chesnutt's fiction, the few photographs of free black women in the mid- to late nineteenth century are dignified images of club women. Photographs such as those taken by J. P. Ball & Son, Daniel Freeman, and Harry Shepherd feature impeccably dressed women, many of them light-skinned, holding books or diplomas strategically arranged as markers of education or decked in wedding regalia—another indication of virtue and middle-class respectability. Because daguerreotypes where cheaper than miniature

portraits, African Americans, especially in those in the north and midwest, took advantage of this new technology to memorialize and promote themselves as free and prosperous people of color.[14] An 1845 daguerreotype of an unidentified woman, taken by Glenalvin J. Goodridge, a pioneering black daguerreotypist, emphasizes a solemn grace. The composition features a rather austerely dressed and coiffed woman of ambiguous heritage resting her arm on a stack of books and carrying a beaded purse. An 1860 photograph by Thomas Easterly features the profile of a young, ornately attired woman of African and European descent (fig. 2). Though the photographer also took a frontal portrait, what's striking about the profile is how the composition emphasizes her stylish coiffure; the scallop of black-patterned lace overlaying her dress accents her hair's wavy texture. Furthermore, profiling harkens back to the eighteenth-century tradition of the silhouette, which was used by followers of phrenology and physiognomy to support the superiority of Anglo phenotypes. To trouble such practices, nineteenth-century black artists such as Moses Williams created self-portraits that reflected his biracial heritage but also parodied notions of phenotypical essentialism. Easterly drew on the silhouette tradition to compose a photograph that makes a statement about feminine gentility, education, and refinement as much as it reflects racial admixture. A 1900 print by Harry Shepherd similarly plays on the silhouette tradition, showing the wife of a St. Paul lawyer in three-quarter profile (fig. 3). Though her hairstyle and dress indicate her affluent social status, there is something wistful about this head shot, as if the photograph attempts to tell a story that will erase histories of disenfranchisement, enslavement, illiteracy, and sexual subordination, replacing them with a vision of a more hopeful present and future.

These images precede the proliferation of portraits of black women on the covers of New Negro periodicals, and what becomes apparent when we consider them alongside Brown's and Hopkins's heroines is that there are two interrelated but distinct discursive genealogies of mulatta representation: one sexualized and sensationalized; the other, as these photographs demonstrate, an exemplar of propriety and refinement. The sensationalist elements present in the literary portraits of mulatta would emerge in visual art and other media as blackness became all the rage in Harlem.

Exalting New Negro Womanhood

The mulatta emerges as an iconic figure at the cusp of the Harlem Renaissance, a period in which narratives of passing preoccupied black and white modernists, just as the legal designation of mulatto/a was disappearing.[15] Cultural practice, however, kept various incarnations of the ambiguous category alive.

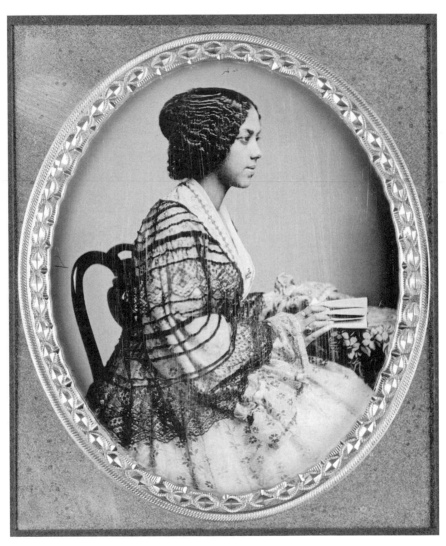

2. Thomas M. Easterly, *Unidentified Young African-American Woman,*
profile view, 1860.

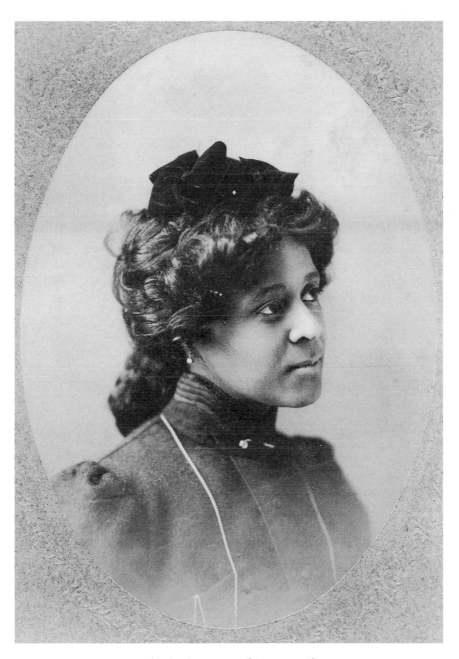

3. Harry Shepherd, *Portrait of Mattie McGhee*, 1900.
MINNESOTA HISTORICAL SOCIETY.

An *Opportunity* editorial titled "The Vanishing Mulatto" (October 1925) lists words denoting miscegenation, including *mulatto, mulatta, mulattresse, octoroon, quadroon, mustafinas, griffes, saltatras, coyotes, cabres,* and *albarassados,* to name just a few. According to the same editorial, 2,050,686 African Americans were classified as mulatto/a in 1910, while in 1920 that number had been reduced to 660,554.[16] According to the author of the editorial, the practice of passing—crossing the color line from one race to the other—was responsible for this reduction.[17]

The literary figure of the mulatto/a became a way of accounting for this supposedly vanishing group. Scholar Hazel Carby aptly describes the figure as a "literary displacement of the actual increasing separation of the races" who acts as an imaginary bridge between black and white spaces, in spite of Jim Crow laws.[18] During the Harlem Renaissance, the obsession with the mulatta flourished as the heroine of nineteenth-century fiction took on a new guise. Starring on visual, theatrical, and literary stages, the "new" mulatta was reborn as an icon of the age. Mulatta fiction from this period includes Walter White's *Flight* (1926); Fannie Hurst's *Imitation of Life* (1933); Nella Larsen's *Quicksand* (1928); and *Passing* (1929); and Jessie Fauset's *There Is Confusion* (1924), *Plum Bun* (1929), *The Chinaberry Tree* (1931), and *Comedy American Style* (1933). The mulatta was also a frequent subject in the poetry of Alice Dunbar-Nelson, Angelina Weld Grimké, and Georgia Douglas Johnson. Her male counterpart was the subject of T. S. Stribling's *Birthright* (1922), George Schuyler's *Black No More* (1931), James Weldon Johnson's *The Autobiography of an Ex-Colored Man* (1912), and Langston Hughes's full-length drama *Mulatto.* Hughes also penned two poems that dealt with what he called "the problem of mixed blood in America," including "Mulatto" and "Cross."[19] In addition, countless short stories and serial fiction in the *Crisis* and *Opportunity* featured tales of passing or mulatta heroines. If the northern, middle-class, white society of the twenties was fascinated with everything Negro, then black society during the Harlem Renaissance was preoccupied with everything mulatto/a.[20] This obsession with color reflects both white and black anxieties about identity in the midst of modernization. As a passing figure and a representative trope of the New Negro movement, the mulatta underlines how gender oppression and anxieties concerning sexuality and sexual difference constituted the New Negro movement's racial discourse.

Many illustrations, paintings, and photographs in New Negro periodicals chose identifiably mixed-race women to represent the positive and dignified face of the New Negro woman. These images are more sentimental than modern, more Victorian than New Negro. She is beautiful, educated, middle class, and usually engaged in a charitable, conscientious trade such as nursing, library

science, or teaching. It's significant to note that portrayals of the mulatta as a tempestuous Jezebel, flapper, or transgressor of the color line often counterbalanced her image as an exemplar of ladyhood and respectability. Although the aristocratic imagery of the mulatta featured in visual and literary culture appears to contradict images of the exotic transgressor, their coexistence demonstrates a connection between the commodification of the black female body and the aristocraticizing of the black race.[21] Ultimately, the idealization of black women as mulattas, madonnas, teachers, or socialites in Harlem Renaissance literature, visual art, periodicals, and aesthetic discourse established parameters that restricted artistic expression and agency for black women. Furthermore, it implied that a woman could not engage in antiracist work unless she fit the prevailing class and color standards of respectability—standards that would have eliminated the majority of black women.

Though the nineteenth-century roots of the tragic mulatta plot were still evident in often formulaic narrative conventions, Harlem Renaissance writers complicated earlier depictions by being more cognizant of the visual dimensions of her characterization and more sensitive to the modernist terrain she now traversed. Depicting the mulatta as an exotic, erotic beauty, for example, enhanced the popularity of passing narratives, which were already appealing because they flirted with the taboo of interracial romance. Although many passing narratives portray passing as a means to attain economic and social equality (albeit with heavy psychological and cultural consequences), several narratives by black women suggest that passing temporarily provides freedom from the enforced respectability and domesticity of the race woman. The typical passing narrative of the Harlem Renaissance features a protagonist whose beauty, light skin, and overwhelming desire for social and economic advancement make passing an acceptable alternative to a life of struggle and disappointment. The protagonist forsakes her cultural heritage and community and begins anew in a removed, frequently urban environment where she is protected by anonymity. Once the character achieves a modicum of success, she is generally stricken with guilt and experiences feelings of alienation. At this point, either the masquerade is discovered, or the passer confesses. If discovered, the result is frequently death. If the protagonist confesses and repents, she is invariably reintegrated into the African American community. Always the successful act of passing is predicated on whites' inability to detect blackness and the black community's reluctance to expose racial "fugitives." However critical they may be of passing, African Americans understand the passing figure's individualist scheme to obtain white privilege.

In selecting the most interesting and nuanced passing narratives, I explore the relationship between the visual representations of the mulatta and her narrative

partners. By crossing race, gender, and class boundaries, she deviates from accepted behavioral practices. The most ambitious passing narratives take the convention in a new direction, exploring the existential and sociological motivations behind the decision to pass and scrutinizing what the passing performance entails. While I sometimes make subtle distinctions between the mulatta and the passing figure, the literary and visual culture of the Harlem Renaissance often represented the two as one and the same. Each reflects a consolidation of behavioral and physical traits that both the New Negro movement and American culture at large recognized. This is not accidental. The tragic mulatta often passes, but the act doesn't divest her of her tragic plot trajectory; indeed, passing is often the precursor to the fated finality of her descent. The passing subject is not always of mixed (half black and half white) heritage but is occasionally just a very light-skinned black woman. The term *mulatta* is and has been shorthand for varying degrees of racial mixing, not always limited to black and white; and the legal history of the terminology reflects this somewhat illogical fluidity. As such, the word may refer to those who pass inadvertently or infrequently as well as those for whom passing is the defining act but who also exhibit the classic identity conflicts of the "tragic mulatta": a woman condemned by her mixed blood and unable to decide between two worlds. The passing performance tests visual and behavioral assumptions about race and, as such, is inextricably tied to the mulatta's function as an icon of visual modernity. Even when the mulatta *cannot* pass as white, she manifests the same symptoms of alienation, confusion, and unease that beleaguer the passing subject. In cases in which a mulatta who can pass will not, the mere possibility of passing creates conflict. Furthermore, because racial passing frequently accompanies change in class status, passing is sometimes thematized as the taking of a new, not necessarily racialized, identity in various locales, as Helga Crane does throughout the novel *Quicksand*. Ultimately, no clear, definitive lines can be drawn between the two; the narratives of both the passing subject and the tragic mulatto/a rely on shifting notions of what constitutes blackness and whiteness and the misrecognition of what the eyes see.

Chapter 10 of Ralph Ellison's *Invisible Man* allegorizes this dilemma in an episode that illustrates the complex relationship between the performance and the identification of whiteness. While the invisible man is working for Liberty Paints, whose motto is "keep America pure," he discovers that the secret to making their best-selling paint, "optic white," "the purest white that can be found," is to add ten drops of black paint to each batch. The black paint dissolves and creates a perfect, glossy, white paint that will cover anything. When the narrator mixes the paints, however, he sees "a brilliant white diffused with gray" that his boss fails to detect.[22] This scene indicates the mutual dependence

of whiteness on blackness: whiteness is achieved only in opposition to blackness, yet it is never pure. Liberty Paints demonstrates the logistics of the "one-drop" rule in a scene that neatly illustrates what is now common knowledge in critical race theory: that whiteness is dependent on, if not constituted by, blackness. The beauty of the mulatta figure depends on this same philosophy: there is always a barely perceptible flaw, usually in the eyes, that reveals blackness. The black subject understands that her own marginalization enables the concocted fantasy of white supremacy and privilege. Though the black community can detect the passing figure's nearly invisible drops of black blood, the white community, like the invisible man's foreman, is so invested in the purity of "optic," or visual, whiteness that it cannot perceive that the two may coexist in one body or all bodies.

The marketability and popularity of New Negro mulatto/a fiction depends on a certain voyeuristic appeal that can be attributed to how both tragic mulatto/a and passing narratives either appeal to or subvert the white male gaze. In fiction, the spectator's gaze is a lens that "others" the black female protagonists. These novels feature the near-white yet still flawed body of a black woman whose transgressions allow both black and white readers to participate in a voyeuristic fantasy of interracial interaction; white readers vicariously experience black American culture, while black readers identify with the mulatta's trespasses in mainstream society. By commodifying her tragic potential, phenotypical ambiguity, transgressive sexuality, and idealized femininity, Harlem Renaissance culture reinvented the mulatta as an Afro-modernist icon. While the image I trace is a limited one, I suggest that Harlem Renaissance literature popularized the mulatta to such an extent that almost every novel produced by black authors during the late nineteenth and early twentieth centuries deals in some way with a mulatta/o character.[23]

That said, however, I do not recast *every* novel of the Harlem Renaissance as a text complicit with or critical of mulatta iconography; this book does not, for instance, include a discussion of Zora Neale Hurston's *Their Eyes Were Watching God* (1937). Like the other heroines of Harlem Renaissance novels, Hurston's is faced with the boundaries of race, gender, and class; however, in circumventing these limitations, she actually transcends what I call her provisional mulatta status.[24] You might say that Janie is too successful a mediator, an icon of respectability and desire within the insular world of Eatonville, on the one hand, and a complicated figure of feminist self-discovery who overcomes tragedy, on the other. Passing does not emerge even as a subplot, and Janie summarily rejects the exclusionary class politics enabled by her skin.[25] That she neither desires white identity or white privilege further distinguishes her from other heroines who fit more firmly into the mulatta pantheon. Janie easily navigates

the excruciatingly difficult interracial terrain faced by characters such as Larsen's Helga Crane and Fauset's Angela Murray, both of whom express a profound ambivalence about race and class loyalties. Furthermore, the discursive castigation of the tragic mulatto/a trope—Sterling Brown termed it a dangerous and ultimately untenable concession to white tastes—simply did not hinder analyses of Hurston's work once her books had been reintroduced, as extensive literary and feminist readings of *Their Eyes Were Watching God* demonstrate.[26] Finally, Hurston's representation of Janie in the novel does not correspond as explicitly as the works of Larsen, Fauset, and Toomer do to the visual sensibility that mutually constructs mulatta iconography.[27]

Still, I would be remiss if I did not address at least one instance in which Janie's depiction works in concert with both earlier and contemporary mulatta icons. Given her upbringing in an insular black community, Hurston was conversant in the visual grammar of racial representation and the ways in which class and beauty, for better or worse, were fused to color. Like Hopkins's Sappho Clark, Janie's beauty derives from an ancestral history of sexual degradation: a slave master raped Janie's grandmother, producing a child with "gray eyes and yaller hair," Janie's mother, who herself is raped by a schoolteacher who subsequently abandons her. Throughout this book, I argue that there are particular characteristics that emerge repeatedly as visual markers of ambiguous or mixed heritage. In Hurston's novel it is Janie's hair that most strikingly invokes the iconography of the mulatta. Indeed, even more than her skin color, "the great rope of black hair swinging to her waist and unraveling in the wind like a plume" seems to represent her desirability.[28] In fact, the delight that others take in Janie's hair precipitates her husband, Joe Starks, to insist that she cover it, reaffirming her status as both his possession and the "bell cow" for the other women in the community:

> He never told her how often he had seen the other men figuratively wallowing in it as she went about things in the store. And one night he caught Walter standing behind Janie brushing the back of his hand back and forth across the loose end of her braid ever so lightly so as to enjoy the feel of it without Janie knowing what he was doing. . . . That night he ordered Janie to tie up her hair around the store.[29]

Only after Joe's death does she reclaim her hair from its inscribed racial and class-based value: "She tore off the kerchief from her head and let down her plentiful hair. The weight, the length, the glory was there." Her hair then takes on a more sensuous and intimate value for her lover, Tea Cake: "Ah been wishing' so bad tuh git mah hands in you' hair. It's so pretty. It feels jus' lak uh dove's wing next to mah face." Freed from its constraints, her hair becomes an

object of shared rather than private pleasure. One of the most memorable and sensual scenes involves Tea Cake "combing her hair and scratching the dandruff from her scalp."[30] Here Janie's hair exceeds its signification as a marker of miscegenation and middle-class respectability.

The multivalenced treatment of Janie's hair in *Their Eyes Were Watching God* underscores the cultural significance of hair in black culture; moreover, it echoes a rather germane anecdote from ideological discourse of Garveyism. Like other New Negro periodicals, the United Negro Improvement Association (UNIA) publication *Negro World* promoted its ideal of femininity with photographs of marching brigades of the Black Cross nurses, an auxiliary group of health care professionals and nutritionists modeled after the Red Cross. The Black Cross nurses were an international group, and the image of their white robes and green uniforms had a symbolic value. On the woman's page of *Negro World*, which Marcus Garvey's second wife, Amy Jacques, edited from 1924 to 1927, one can trace the Garveyite endorsement of "community feminism" that manifests the "interplay between helpmate and leadership roles" in columns such as "Our Women and What They Think."[31] Yet despite Garvey's pan-Africanist platform and his general disdain for and distrust of mulatto/as, his marriage to Amy Jacques seemed to contradict his condemnation of black men who married "the lightest colored woman for special privilege and honor." Interestingly, Amy remembered that "my hair, let down, thrilled him. It was long and naturally wavy; he asked me to never cut it," and "the first time he saw it down, curiously he felt some strands and said, 'why, it is so soft,' and 'so alive!'"[32] Despite Garveyism's ambivalent relationship to the New Negro movement and Hurston's complex connection to the group she coyly termed the "niggerati," the UNIA images of black womanhood and Hurston's writing still speak to the cultural preoccupations that promoted mulatta iconography in Harlem Renaissance culture. While this book takes up neither Garveyism nor Hurston's writing in detail, I'm intrigued by these two examples in which hair texture, functioning as a visual and tactile marker of racial miscegenation that black men can figuratively wallow in, appears to trump skin color.

Finally, despite light skin's association with Anglo culture, the Harlem Renaissance's preoccupation with the mulatta actually mirrored western fascination with the primitive "other." Western perceptions of so-called primitive people have little to do with their material reality. Instead, primitivism partakes of a fragmented knowledge of foreign cultures and romanticizes their "underdevelopment" in opposition to modernity. In the midst of the age of mechanical reproduction, the discourse of primitivism represented a nostalgic space for unfettered artistic expression within modernist art and literature. As the most obvious racial other in the United States, African Americans represented the

primitive for American modernists. Carl Van Vechten's *Nigger Heaven*, a novel replete with caricatures and exotic portraits of black culture, exemplifies white America's fascination with the Harlem Renaissance. Linking mulatta iconography with an analysis of primitivism in Harlem Renaissance art and literature allows me to analyze the patriarchal ideology of New Negro aesthetics within a discussion of how Harlem Renaissance artists critiqued or redefined American and European modernism and primitivism. My identification of the mulatta icon, presumably a bourgeois stereotype, as also a primitivist figure within Afro-modernist visual art and literature positions her as a locus point in the discourses of new modernisms, multiculturalism, and hybridity.

The Imaging of an Era

After Nella Larsen viewed Carl Van Vechten's photographs of her, she wrote: "Thank you for the pictures. . . . I think they are very unusual and extraordinarily interesting and they are so like me. The group pictures are charming. . . . But I am afraid that though they are more beautiful I don't like Dorothy's [Peterson] so much as I do my own."[33]

Larsen's comments demonstrate a certain degree of narcissism and investment in her own image that seem to characterize the Harlem Renaissance era's investment in and anxiety about visibility. The pictorial history of the era, immortalized in the photography of Van Vechten and James Van Der Zee, memorializes it as a glittering, black-and-tan age of talented artists, intellectuals, patrons, and entrepreneurs. Just as Winold Reiss's illustrations served as instructive sketches for Alain Locke's *The New Negro*, these portraits function as iconic memorabilia. Frequent reproduction of the photographs of the period's central figures and influential personae illustrate how visual images inform the way in which we picture its artistic activism and social climate. These images appear on mantelpieces and museums; in exhibits such as the Van Der Zee retrospective "Harlem On My Mind"; and as archival records in the pages of the *Crisis*, the *Messenger*, and *Opportunity*. They chronicle the New Negro movement's visual ideology.

Questions concerning authenticity and aesthetics are embedded within Harlem Renaissance visual culture: namely, who can represent the race and in what form? The artists and intellectuals of the era perceived the literary, musical, and visual art explosion of the twenties and thirties as artistic activism. They hoped that their achievements would result in political and social change. Alain Locke, who in *The New Negro* succinctly outlined the ideology of newness that would dominate the marketing and philosophy of the period, stressed the importance of creating transformative art. Others, such as Langston Hughes

in "The Negro Artist and the Racial Mountain" and George Schuyler in "Negro Art Hokum," debated which subjects should be appropriately claimed as black art. Unfortunately, the political imperative within the New Negro ideology of transformation did not always have the intended results. J. Martin Favor, for instance, argues that the writings of Jean Toomer and Nella Larsen actually demonstrate that concepts of authentic black identity were marked by incoherence rather than unity; ultimately, he characterizes their writing as texts that fail.[34] This discourse of failure also characterizes comprehensive studies such David Levering Lewis's *When Harlem Was in Vogue* and Nathan Huggins's *Harlem Renaissance,* both of which take the stance that the Harlem Renaissance failed in achieving its goals of liberation through art. This pessimism continues to beset new studies of the era.

Granted, the Harlem Renaissance may not have revolutionized the economic or social position of blacks in American society, nor were all of its writers and artists paragons of artistic genius. Nevertheless, the period was significant in that it welded artistic achievement to social, economic, and political change and thus set the stage for subsequent black arts movements. Black feminist studies of the Harlem Renaissance have already unearthed the artistic contributions and foundational work of women artists, poets, editors, and intellectuals who were marginalized in Lewis's and Huggins's comprehensive studies. Women's art, particularly poetry, was frequently misunderstood or degraded as sentimental and romantic, in spite of the ironic feminist spirit and lesbian subtext in the verses of writers such as Alice Dunbar-Nelson and Georgia Douglas Johnson. The foundational work of Gloria Hull's *Color, Sex, and Poetry,* Cheryl Wall's *Women and the Harlem Renaissance,* and Thadious Davis's *Nella Larsen* correctly situate Zora Neale Hurston, Jessie Fauset, and Nella Larsen as the literary foremothers of the modern African American literary tradition. Their studies deconstruct the male bias of Huggins and Lewis, whose studies either omitted or misread the contributions of women artists and intellectuals. In this book, I focus on concerns about the mulatta icon that scholars such as Hull, Wall, and Davis have discussed but do not address centrally. My specific treatment of the mulatta provides a flexible, critical vocabulary for discussing contemporary issues regarding hybridity, the multiracial movement, multiculturalism, and our society's continuing fascination with categorizing miscegenation and mixed-race icons, thus entering current debates about the changing nature of race, class, and gender roles in the United States and underlining the cultural value of both interdisciplinary feminist and ethnic studies.

Studying how the mulatta becomes not just a literary trope but an icon of mediation, desire, transcendence, tragedy, respectability, and transgression opens deeper questions concerning the Harlem Renaissance's role as a formative

moment in the African American literary tradition. For instance, what are the cultural ramifications of situating the mulatta icon as a counter-representational model of black femininity? On the one hand, the literature yields several complex and introspective female protagonists. On the other, these characters promote a standard of behavior and beauty impossible to emulate. Imagining the mulatta as an alternative to negative stereotypes of black womanhood and a challenge to the color line often resulted in contradictory representations of the mulatta that ultimately constrained African American womanhood. The Harlem Renaissance writers I study engaged in a complex conversation with visual artists to interrogate, deepen, and in some instances embrace prevailing notions of the mulatta.

Despite the pejorative history and etymology of the term, recent criticism has taken up what might be called the discourse of the mulatta. As I was completing this book, two other critical works addressing the mulatta as a literary trope appeared: Eva Allegra Raimon's *The Tragic Mulatta Revisited* and Teresa Zackodnik's *The Mulatta and the Politics of Race.* Building from Hazel Carby's view of the trope, Raimon considers the mulatta "as a narrative lens through which to explore antislavery writers' contested versions of race and nation at one of the most critical turning points in the drama of American self-definition."[35] Like Werner Sollors in *Neither Black Nor White Yet Both,* she revisits the tragic mulatta as product of interracial exchange and includes both white and black writers in her study. The scope of Zackodnik's study is broader. She begins as Raimon does with antebellum texts but expands her discussion to encompass the passing novels of the Harlem Renaissance with an interest in excising the tragic modifier from the trope. Looking specifically at African American women's imaginative explorations of the mulatta, she argues that in the hands of black women writers "the mulatta of tragic mulatta fame is restored rather than reinscribed."[36] Unlike Zackodnik, I consider male authors and artists because their representations of the mulatta are essential to a full consideration of the trope. And while I share both Raimon's and Zackodnik's interest in focusing on the female incarnation of the mulatto/a, what distinguishes my study is its focus of the mulatta as an iconographic coalescence of visual and literary maneuvers.

Although I do examine some interracial exchange between black and white modernists, my main concern is to deepen our understanding of the overrepresentation of the mulatta figure within *African* American literary discourse.[37] I caution those who would embrace the figure as an emblem of hybridity or who view the era as an ideal moment of multicultural exchange; it is vital that we understand the danger of arbitrarily eliding difference in favor of an amalgamated harmony that is not grounded in a specific cultural history. Certain

multicultural discourse fixes the mulatta as a utopic celebration of difference without complicating how such normalization reproduces a kind of pernicious colorism or acknowledging the history of exploitation and sexual violence from which such hybridity emerges. As terms such as *multi-ethnic* and *biracial* become familiar parts of our lexicon, it's important to understand them in the context of a long history of racial recasting in social, political, and artistic spectra. *Portraits of the New Negro Woman* provides a flexible yet deeply historicized context for discussing contemporary issues regarding hybridity, the multiracial movement, and American society's continued fascination with racial categorization and mixed-race icons.

Martha Nadell's recent book, *Enter the New Negroes,* examines what she calls interartistic works: texts that comprise and problematize the visual and the textual. By illustrating how the mulatta icon was developed as a visual and textual construction that became the representative image of New Negro womanhood, I expand her notion of the interartistic exchange beyond writings that include visual referents or direct evidence of artistic collaboration. Like Nadell, I focus on interartistic interactions, but my understanding of cross-genre exchange is more broadly defined. The mulatta icon is the locus point for a conversational model that places texts in dialogue with paintings, film, and illustrations. To facilitate this literary and visual exchange, each chapter examines the work of a central author in tandem with either a particular visual artist or a discussion of popular visual culture. The paired writers and artists all share a complex relationship to the visual; they allow me to uncover the intriguing layers that form the iconography of the mulatta. This conversational structure is not chronologically based, though all subjects fall within the rather fluid boundaries of the Harlem Renaissance. Rather, I argue that the commonalities between subjects are based on an accepted grammar of visual representation. As such, certain artists or writers may pre- or postdate each other, and figures central to one chapter may resurface as minor players in another. Another unique benefit of this conversational structure is that it allows me to extract critical stances from sources that most readers think of as primary: a line of poetry or an excerpt from a novel often expresses an essential theory of culture or art that I can't find anywhere else.

To this end, I consider a range of visual and literary interactions, including writing techniques imbued with elements of photography, as in Jean Toomer's *Cane*; a literary recapitulation of a modern-art icon; as in Nella Larsen's *Quicksand*; and characterizations of black female painters, as in Jessie Fauset's *Plum Bun.* Each analysis demonstrates the intrinsic nature of the visual in New Negro aesthetics and the international marketing of the Harlem Renaissance. These chapters are not discrete entities but connected, progressive conversations that

move us closer to an understanding of why promotion of the mulatta icon be-
came so ubiquitous and compelling for artists and writers as well as why they
complicated, criticized, and occasionally rejected it. For example, although
Chapter 1 focuses on Nella Larsen and Archibald J. Motley, Jr., other work by
Motley emerges significantly in later chapters. Chapter 2 reads Jessie Fauset's
use of the bohemian landscape of Greenwich Village as a way of locating *Plum
Bun* as *kunstlerroman*; while Chapter 3, which traces the origin and prolifera-
tion of the mulatta as an icon in race movies, centers on Fauset's execution of
the passing plot as a template for actress Fredi Washington's breakthrough pass-
ing performance in the blockbuster film *Imitation of Life.* Chapter 4 examines
the experimental writing of Jean Toomer, considering the photographic and
painterly elements of *Cane's* unique prose portraits of black women alongside
the abstract expressionist paintings of William H. Johnson. In Chapter 5, I con-
clude by looking at how contemporary art and fiction, from Toni Morrison's
novel *Jazz* to the story quilts in Faith Ringgold's *French Collection,* reconsider
the roles of New Negro woman and the mulatto/a in the Harlem Renaissance.
Because preoccupation with the mulatta is a truly vexed issue within African
American literary discourse, examining what a new generation of artists and
writers gleans from studying the mulatta as a visual and literary collaboration
leads to a broader meditation on the black female image in American culture.

chapter one

"A Plea for Color"

NELLA LARSEN'S TEXTUAL TABLEAUX

The Negro poet portrays our group in poems, the Negro musician portrays
our group in jazz, the Negro actor portrays our group generally with a touch of
hilarity. . . . So why should the Negro painter, the Negro sculptor mimic that which
the white man is doing, when he has such an enormous colossal field practically all
his own; portraying his people, historically, dramatically, hilariously, but honestly.

—ARCHIBALD J. MOTLEY, JR., "The Negro in Art"[1]

Today only specialized scholars instantly recognize the name of Archibald J.
Motley, Jr., yet two of his paintings are so well known that, for many people,
they have become visual embodiments of the Harlem Renaissance.[2] His *The
Octoroon Girl* (1925) and *Blues* (1929) have served as cover art for several edi-
tions of Harlem Renaissance literature, anthologies, and literary criticism.[3] With
a colorful, energetic composition incorporating the era's insignia—jazz, the
speakeasy, and interracialism—*Blues* bespeaks musical innovation and artistic
intellectualism. And the recurrent appearance of *The Octoroon Girl*, especially
on the cover of women's fiction, continues to make its subject, the mulatta, a
predominant referent in the visual culture, art, and literature of the Harlem
Renaissance.

The Octoroon Girl, which Motley considered to be his best painting, is the
second of a series in which he used color and composition to explore misce-
genation. He claimed to be "sincerely interested in pigmentation of the skin
in regard to the lightest type of colored person . . . consisting of one-eighth
Negro blood and seven-eighths caucasian blood."[4] In this painting, he depicts a
light-skinned, dark-haired, dark-eyed woman with high cheekbones, an aquiline
nose, and rose-colored, pursed lips (fig. 4). Sitting comfortably on a tapestry-
like couch, one arm resting on a small table with two books and a mustached
figurine, she is not perfectly centered in the portrait but situated slightly to the
right, her head counterbalanced by a gold-framed landscape hanging on the

wall. The dramatic contrast of dark and light forms a rich backdrop for this clearly modern woman and her penetrating gaze. Her stylish clothing, gloves, and finely drawn, tapered hands indicate her middle-class status, while her frontal position and serious expression lend a dignity that Motley consistently conveyed in his portraits. The only fracture in an otherwise graceful composition is the laughing figurine at her elbow. This mocking, clownish figure undermines the sitter's poise and subtly disturbs the dignity of the design. The figurine reminds the viewer that the portrait is an image projected by the artist and draws attention to the artificiality of modern realist painting. Placed precisely to illuminate some otherwise hidden aspect of the sitter's character, the laughing figure suggests there is more to the sitter than Motley's title, *The Octoroon Girl*, reveals. In its service as cover art for novels that thematize racial indeterminacy, the portrait gestures at a collective, visually inflected understanding of the aestheticized markers that created the mulatta, or passing, subject in African American literary and visual culture: physiognomy, exoticism, and the mysterious gaze.

Motley's painting provides a provocative lens through which to examine the iconographic aspects of Nella Larsen's novels *Quicksand* (1928) and *Passing* (1929). In their endeavors to portray both the psyche and the facade of their subjects, Larsen's and Motley's work complicate the figure of the mulatta, moving her beyond a nineteenth-century image of pathetic victim or tragic symbol. Larsen's precise handling of visual imagery and her incorporation of modern art forms and ways of seeing present the mulatta heroine as a psychologically complex, independent woman. Nevertheless, the personal, social, and vocational fulfillment that Larsen attempts to imagine for her volatile heroines—their self-creation—is constantly impeded by their function as an iconic fetish in both black and white elite circles. I argue, then, for a painterly rather than writerly reading of Larsen's work. Not only do her textual tableaux contain passages or frames so visually evocative that they demand a visually informed consideration, but the content of her fiction is anchored in a critique of the visual images of African American women that were circulating throughout the culture and limiting the mobility of the New Negro woman in the intellectual and artistic communities of the "talented tenth." In Larsen's search for a trangressive, transcendent heroine, her tableaux revise the black female subject in modernist works of art and popular visual culture—in effect, modernizing the mulatta figure.

By pairing Larsen and Motley, I do not suggest that they were directly familiar with each other's work or that their representations are literally referential. In fact, Motley's attempt to categorize and portray the mulatta figure often jars with Larsen's characterization of Helga Crane in *Quicksand* as a woman who does not fit many of the social identities open to her. Rather, I argue that mixed-race, black, female bodies have a common visual grammar of representation

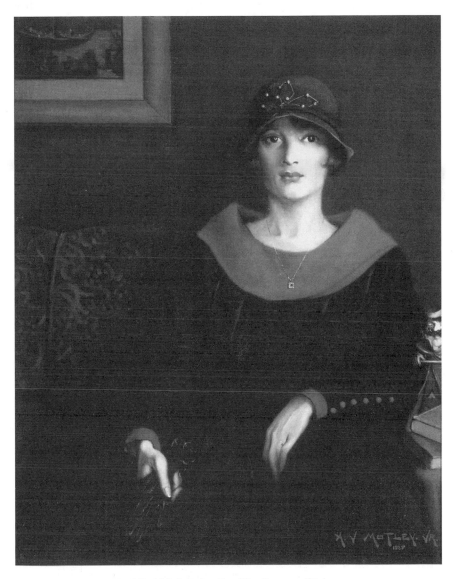

4. Archibald J. Motley, Jr., *The Octoroon Girl*, 1925.
CHICAGO HISTORY MUSEUM AND VALERIE GERRARD BROWNE.

that is intrinsically bound to textual as well as visual narratives and emerges when we study the artists in tandem.

Using Motley's work as a lens or, better yet, as a codex, we see how Larsen replicated the iconography of the mulatta through literary tableaux influenced by Orientalist accoutrements and modern-art referents in an effort to be more modernist and less New Negro.[5] If we situate their work in a cross-genre dialogue, we can consider the aesthetic and political ramifications of racially inflected improvisational maneuvers that artists and writers sometimes adopt when they feel compelled to create an authentic black art that fully represents black identity. Furthermore, attention to their iconography of the mulatta reveals the pitfalls of counter-representational strategies during the Harlem Renaissance. Although the aristocratic imagery of the mulatta in art and literary culture appears at times to contradict the popular notion of her exotic, sexual allure, both strains of the mulatta formation coexist in Motley's and Larsen's work, demonstrating a connection between the general commodification of the African American female body and attitudes prevalent among the "talented tenth." Although Larsen's conscious engagement with popular images of the mulatta had the potential to revise, and even counter, narrow genteel notions of the New Negro woman, she sometimes seems close to reifying the exotic, ambiguously raced heroine as the black feminine ideal. Like the question of whether Harlem Renaissance artists replicated or transformed primitivism, Larsen's treatment of the mulatta remains contested, even controversial. This chapter illustrates that the iconic stature of both the mulatta and the race-woman ideal arose from a visual-literary coalition that Larsen attempted to deconstruct. I focus on the acute visual sensibility of her fiction as seen in her translation of iconic ephemera into written text. This interrogation of the visual puts Larsen into the company of avant-garde authors such as Jean Toomer, whose prose is informed by the visual art of Alfred Stieglitz and Georgia O'Keeffe. To this end, Motley's notes and portraits provide an invaluable referent, illuminating the influence of visual culture and artistic convention on Larsen's fictional scenes.

Larsen's Orientalism:
"A Fantastic Motley of Ugliness and Beauty"

For several African American feminist critics, *Quicksand* is, in the words of Thadious Davis, a "portrait of the failed artist as a woman of color."[6] While the exact nature of her potential is never made plain, Helga Crane does possess a visual artist's perception and appreciation of decor, color, and style. Her contemplation of the idea that someone should write a treatise entitled "A Plea for Color?" suggests that writing might have been a productive outlet for her

acsthctic views, had that option been open to her.[7] But no matter which artistic medium she leans toward, Helga's creative and sexual desires are inseparable. Each time she suppresses a sexual desire, she suppresses a creative impulse. A sexualized encounter or quandary precipitates each of her decisions to leave a social or professional environment in what becomes her compulsive search for "a new life."[8]

Helga's struggle for agency and honest self-expression is imperiled by her reluctance to emulate the new race-woman ideal or its ostensible opposite, the Jezebel. Her oscillation between these two prescriptive identities recalls the trope of warring black and white blood responsible for the tragic conclusions of many nineteenth-century mulatta narratives.[9] During her first sojourn in Harlem, Helga is compelled to subscribe to the visual ideal of the New Negro woman depicted in the art and illustrations of periodicals such as the *Crisis* and *Opportunity*. A model of service, propriety, and moral character, this figure is, more often than not, light-skinned (fig. 5). Helga's benefactor, Mrs. Hayes-Rore, intensifies her discomfort with the stultifying propriety of the race woman by advising her to perform what she visually represents to others: a light-skinned, "colored" woman with, in Dr. Anderson's words, "dignity and breeding," not the child of an interracial union "born in a Chicago slum." It is Mrs. Hayes-Rore who introduces Helga to Anne Grey, a widow who takes Helga under her wing and introduces her to Harlem society. Anne "had the face of a golden Madonna, grave and calm and sweet, with shining black hair and eyes. She carried herself as queens are reputed to bear themselves, and probably do not."[10]

In establishing Anne as Helga's model for the ideal race woman, Larsen draws on popular cultural images, such as the fourteen color portraits of "racial leaders" included in the original edition of Alain Locke's *The New Negro* (1925).[11] The frontispiece of that book is Winold Reiss's *Brown Madonna* (1925), an idealized portrait of an African American mother and her infant child that emphasizes the race woman's social role. Like Motley, Reiss, who was originally a Bavarian landscape painter, aimed to "portray the soul and spirit of a people."[12] The language Larsen uses to describe the "brownly beautiful" Anne resonates with Reiss's portraits of leaders, which visually supplement Locke's occasionally contradictory characterizations of the "intelligent Negro of to-day" as "inevitably moving forward under the control largely of his own objectives," a figure who welcomes the "new scientific rather than the old sentimental interest."[13] In Reiss's portrait of educator and social organizer Elise McDougald, which accompanies McDougald's essay "The Task of Negro Womanhood," her golden-brown skin contrasts with her white clothing, which blends into a white background to give the portrait a celestial quality.[14] This quality is mirrored in the other portraits in Locke's book, making the figures seem to be

The CRISIS

NOVEMBER, 1923 FIFTEEN CENTS A COPY

5. John Henry Adams, *The Octoroon.*

REPRINTED FROM *CRISIS* 26 (NOVEMBER 1923), COVER.

models for emulation as well as guardians qualified to sift out those who do not fit the mold. By endorsing a womanliness that nurtures others, McDougald's essay draws on sentimental representations of African American women as teachers, homemakers, or nurses engaged in supporting the uplift endeavors of New Negro men—the race leaders. Reiss's portrait of McDougald, especially when considered beside his "Type Sketches of Negro Woman," provides a ready reference for better "visualiz[ing] the New Negro woman at her job."[15] A former teacher and librarian, Larsen was intimately aware of the challenges and constraints of such roles. Her depiction of Anne "as almost too good to be true" and "almost perfect" accentuates both the illusory nature of such models and the difficulty of living up to them.[16]

Despite Larsen's equivocating critique, which by turns admires and disdains the New Negro woman, Locke praised *Quicksand* as a "social document of importance, and as well, a loving, moving, picture of a type not often in the foreground of Negro fiction, and here treated for the first time with adequacy," demonstrating that he perceived the visual dimensions of her writing.[17] Through visual tableaux such as the textual "golden madonna" (Anne) and the "Orientalist mulatta" (Helga, whom I will discuss presently), Larsen challenges racist and sexist encoding in visual art and interrogates the iconic stature of the race-woman ideal and the mulatta as figures marked by both inter- and intraracial desire. The oppositional unity encapsulated by the phrase "a fantastic motley of ugliness and beauty," which Larsen uses to describe the varied hues of "this oppressed race of hers" on display in a Harlem nightclub, deftly captures the conflicting elements of black femininity that surface in *Quicksand*.[18] The New Negro woman, styled as the ideal template for measuring black femininity, is a constrained throwback to Victorian womanhood; but she can also be a seductive temptress or a deceptive, independent modern woman. Helga's quandary, overlaid by the fraught race and class dimensions of the mulatta figure, is analogous to contemporary African American women's struggles to reconcile the template of the race woman with their own self-definitions.

Several tableaux in *Quicksand* establish Helga as exotic and reveal the seemingly contradictory layers of her desire to escape the Jezebel–race woman dilemma and circumvent the objectifying gaze of both black and white spectators. Helga's experiences in Copenhagen and in several visually commodifying moments elsewhere illustrate Larsen's understanding of how racist and sexist projections can penetrate the psyches of both the subject and the observer, preventing Helga from reinventing herself and transcending race. In *Quicksand's* first tableau, Larsen depicts Helga as a traditional nineteenth-century mulatta figure with fair skin, dark hair, and Caucasian features but situates her within a modern setting saturated with Orientalist motifs. This establishes Helga as

a sensualized subject amid the repression and sterility of Naxos, a small, repressive African American college based on Larsen's experiences at Fisk and Tuskegee:

> An observer would have thought her well fitted to that framing of light and shade. A slight girl of twenty-two years, with narrow, sloping shoulders and delicate, but well-turned, arms and legs, she had, none the less, an air of radiant, careless health. In vivid green and gold negligee and glistening brocaded mules, deep sunk in the big high-backed chair, against whose dark tapestry her sharply cut face, with skin like yellow satin, was distinctly outlined, she was—to use a hackneyed word—attractive. Black, very broad brows over soft, yet penetrating, dark eyes, and a pretty mouth, whose sensitive and sensuous lips had a slight questioning petulance and a tiny dissatisfied droop, were the features on which the observer's attention would fasten; though her nose was good, her ears delicately chiseled, and her curly blue-black hair plentiful and always straying in a little wayward, delightful way.[19]

Like Larsen's description of Helga, Motley's discussion of his painting *Aline, An Octoroon* (1926) includes a list of similar attributes, which he associates with different types of mixed-race subjects. Helga's sharply cut face, good nose, and chiseled ears are commensurate with Motley's emphasis on symmetry in his portrayal of mulatta figures: "I have seen octoroons with skin as white as people from northern Europe such as the Baltic countries; with blond straight hair, blue eyes, sharp well-proportioned features and extremely thin lips. The head is normal and well constructed and symmetrically balanced. The construction of the body such as an elongation of the arms, a tendency toward a weak bone construction found in many of the dark purer Negroes and large fat heels are nonexistent."[20]

This visual typing is apparent in *Aline, An Octoroon* (fig. 6). Although Motley stresses that his work bears his own distinct voice, he cites Eugène Delacroix and Frans Hals as influences.[21] No doubt Delacroix's portrait studies of "La mulatrêsse" bolstered Motley's desire to portray the mixed-race black female body in an African American context. Delacroix was known for his Orientalist paintings and his use of black models, writing that "the mulatt[a] will do very well. I must get fullness. If it is less natural, it is more fecund and beautiful."[22] Indeed, Darcy Grimaldo Grigsby notes that the mulatto/a afforded Delacroix "unprescribed colouristic possibilities."[23] Although *Aline, An Octoroon* revisits Delacroix's *Aline, the Mulatress* (1824), Delacroix's and Motley's paintings reflect a century's worth of difference. Motley's *Aline* conforms to his aesthetics of the mulatta figure as nearly white, showing only a trace of her African heritage. While Motley visualizes an octoroon who could pass for white in an urban setting, Delacroix's mulatress maintains an identifiable African heritage (fig. 7).[24] The features of his *Aline* are, to quote the artist, "more fecund": full

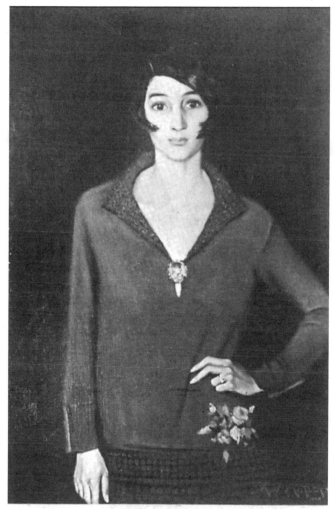

Aline, An Octoroon—Archibald J. Motley, Jr.
Courtesy of the New Gallery

6. Archibald J. Motley, Jr., *Aline, An Octoroon.*

REPRINTED FROM *OPPORTUNITY* 4 (APRIL 1926): 114.

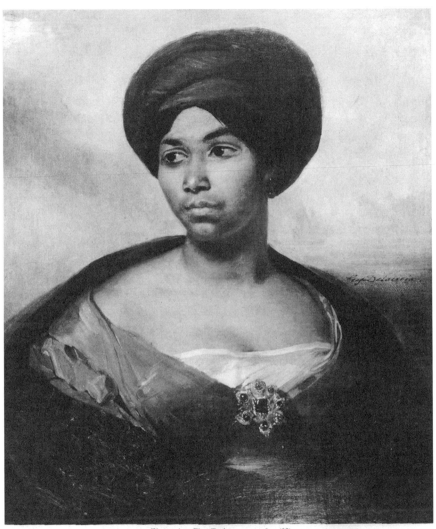

Woman in a Blue Turban. 59.1 × 48.3. (88)

7. Eugène Delacroix, *Aline, the Mulatress*, 1824.

REPRINTED FROM ALAIN LOCKE, *THE NEGRO IN ART*
(1940; REPRINT, NEW YORK: HACKER ART BOOKS, 1979), 157.

lips; large, expressive eyes; and rounded cheeks, head, and bosom. Her extravagant jeweled brooch indicates that she is either a woman of some status in the slave hierarchy or a free woman of color. Delacroix's *Aline* looks wistfully to the side, while Motley's *Aline* stares directly at the artist, an obstinate hand resting on her hip, just above her flowered corsage; her bobbed hair is impeccably coifed. Like Delacroix's *Aline* and the women in many of Motley's other paintings, the woman also wears a jeweled brooch at her breast. When viewed in the company of the artists' other, more obviously eroticized portraits of mixed-race women, both *Aline* paintings exude an air of exoticism that is reinforced by their titles, despite the models' relatively conservative dress. Motley's revision of *Aline, the Mulatress*, however, remains indicative of the manner in which modern African American writers and artists revisited classic, traditional images, even those that, like Delacroix's, were not overtly stereotypical.[25]

While Motley modernizes Delacroix's portrait by updating the subject's coiffure and attire, Larsen relies on Orientalist representations of African American women to distinguish Helga from the race women at Naxos and in Harlem. Fusing Orientalist imagery with mulatta iconography, Larsen contrasts Helga's personal space with her physical form in a concise passage depicting a decor evocative of Delacroix's exoticism: "Only a single reading lamp, dimmed by a great black and red shade, made a pool of light on the blue Chinese carpet, on the bright covers of the books which she had taken down from their long shelves, on the white pages of the opened one selected, on the shining brass bowl crowded with many-colored nasturtiums beside her on the low table, and on the Oriental silk which covered the stool at her slim feet."[26] The "blue Chinese carpet," the "black and red shade," and the "Oriental silk" label the unique, exotic nature of Helga's beauty as Oriental; her clothing, accessories, and furniture are frequently described as "Chinese."

Although Helga's locale changes over the course of the narrative, the Oriental iconography follows her. Larsen employs this imagery, which relies heavily on stereotypical misconceptions of Asian women as sexually submissive, to situate Helga as an exoticized and eroticized figure within the black as well as the white communities. At Naxos and in Harlem, Helga's beauty and light skin indicate breeding, but in Denmark, her brown skin has an exotic appeal: "she had enjoyed the interest and admiration which her unfamiliar color and dark curly hair, strange to those pink, white and gold people had evoked."[27] The inclusion in Helga's library of Marmaduke Picktall's *Said the Fisherman*, an English Orientalist novel, indicates Larsen's familiarity with Orientalism as a genre.[28] While Larsen's use of Orientalist imagery to describe Helga is not anti-Orientalist, it does illustrate, whether contentiously or not, the permeation of western discourse about the other into modern conceptions of the mulatta.

Larsen's iconic representation of black femininity, particularly the exotic construction of Helga's body, raises questions about the place of primitivism in Harlem Renaissance visual art and literature. Larsen's visual tableaux demonstrate her awareness that the intersecting discourses of primitivism, capitalism, sexism, and racism constitute the othering gaze. Primitivist discourse—specifically, in the primitive-as-high-art stage successively popularized by European modern artists such as Gauguin and Picasso—governs the other characters' treatment of Helga in Denmark, which is further complicated by Helga's complicity in her own commodification. She admits that she "loved color with a passion that perhaps only Negroes and Gypsies know" and, amid the delight of receiving so many new clothes, she "gave herself up wholly to the fascinating business of being seen, gaped at, desired."[29] The tactile pleasure she takes in her own objectification delays her acknowledgment of the consequences that accompany her favored position among the Danes. In Denmark, Helga realizes that whether she is in Europe or the United States, her mixed-raced body renders her an exoticized other. In each setting, her desire to invent herself differently is interrupted as the spectatorial gaze transforms her into a commodity, confirming that internal reinvention, without societal change, leads to alienation. Helga's experiences in Denmark explicitly mark her as subject to rather than an agent of her desire, interrupting the "rapture" and "blissful sensation" of "visualizing herself in different, strange places."[30]

The painting of Helga that the Danish painter Axel Olsen assures her is the "true Helga Crane," as well as the costumes he and her aunt select for her, reveal that they see her as an object to be adorned and displayed. Their ideas about primitivism, which they project onto her body, are so entrenched that they emerge in apparently complimentary statements. For instance, her aunt remarks, "You must have bright things to set off the color of your lovely brown skin. Striking things, exotic things," while Olsen observes that Helga has the "warm impulsive nature of the women of Africa" but "the soul of a prostitute."[31] Warmth and spontaneity, then, are seen as pure primitive traits; and Olsen intimates that Helga's "soul" has been tainted by western notions of commodity exchange. His painting, with its gesture toward Oscar Wilde's *The Picture of Dorian Gray*, portrays a soulless being who can be owned and displayed; it is a purchasable version of Helga as a sexualized, primitive objet d'art. While Olsen's romanticized notions of the primitive woman imply that Helga's sexuality should be free (accessible to him) and natural (she should be willing), the idea that she might control her sexuality offends his sensibilities. Walter Benjamin's theorization of the modern prostitute as "commodity and seller in one" doubly applies to Helga, who is defined by her race, sex, and beauty as a commodity shadowed by the history of slavery and illegitimacy.[32] She realizes

too late that, like her favorite tea sandwiches, the *smørrebrød,* which are displayed in an "endless and tempting array" at every social event in Denmark, she is being consumed.[33]

Not until Helga attends the minstrel show in Copenhagen does she truly understand the European consumption of black people as spectacle, in spite of assurances she receives that "this foolishness about race" means nothing "here in Denmark." When she attends an American theatrical review, she observes the black performers enacting a masquerade of minstrelsy and American ragtime, playing into Danish perceptions of race and providing the show that Helga is reluctant to perform: "She felt shamed, betrayed, as if these pale pink and white people among whom she lived had suddenly been invited to look upon something in her which she had hidden away and wanted to forget. And she was shocked at the avidity at which Olsen beside her drank it in."[34]

The shock of recognition Helga experiences while watching the performers reminds her that she, too, has been performing by allowing her aunt and uncle to bedeck her in batik dresses, leopard skins, and eastern perfume. She feels "like nothing so much as some new and strange species of pet dog being proudly exhibited." At one of their parties she recognizes that "no other woman in the stately pale-blue room was so greatly exposed." During this party, she is "effectively posed on a red satin sofa, the center of an admiring group, replying to questions about America and her trip over, in halting, inadequate Danish."[35] This reclining image suggests Larsen's familiarity with Paul Colin's feathered drawings of Josephine Baker, who was at the height of her fame as the star of *La Revue Nègre* and the *Folies-Bergère* at the time Larsen was writing.

A dangerous collusion occurs when subjects participate, either inadvertently or willingly, in their exploitation as spectacle. Though Helga is not a singer or a dancer, like Baker, she performs her sexuality; and she restricts herself to speaking in broken Danish, just as the newly arrived Baker spoke only in broken French to create, according to Adah "Bricktop" Smith, a "charming" impression and to disguise her working-class St. Louis roots.[36] Although Helga imagines herself as unique, the pervasiveness of the figure of the primitive in European art and imagination indicates that there is nothing new, or flattering, about situating a black woman as an objet d'art. Her displayed body evokes Saartje Baartman, the Venus Hottentot, who was brought from South Africa to Europe by a Danish entrepreneur and exhibited naked as a specimen and a spectacle.

Visually, Helga's pose on the red satin couch in "practically nothing but a skirt" invokes the reclining nude.[37] This scene, framed by Olsen's painting of Helga, replaces the white female nude with a light-skinned black subject. Because Helga's beauty and appropriateness as an artistic subject are based on her blackness in the Danish setting rather than her fairness in the Harlem locale, Larsen's

replacement of a white with a black subject is not a reinscription but an artic-
ulation of the danger of challenging Eurocentric standards of beauty by installing
the black female on the objectified pedestal that has been the province of white
women.[38] The female nude is not in an enviable position; she is an object of
display.[39] This scene in *Quicksand* revises Edouard Manet's *Olympia*, a nude
painting of a prostitute and her black maid that caused a scandal in 1863. Manet's
painting is the prime representative of the tradition of the reclining nude in
which a black woman is used as a marginal figure to intensify the sexual con-
tent of the portrait. By situating Helga on Olympia's couch, Larsen engages a
modernist tradition of fascination with the contradictory status of the prosti-
tute as Benjamin's "commodity and seller." Though Helga is not a prostitute,
her subject position as a black female renders her an accessible commodity, even
though she sees herself as being in control of her image and at times enjoys the
attention.

By placing Helga on the couch—and black female beauty at the center of
the scene—Larsen reverses the black woman's role as the foil for white femi-
ninity. Unfortunately, the reversal is undercut by Larsen's replication of Euro-
centric standards in Helga's eroticized light-skinned body. However exotic this
body may be in Denmark, it is not that different from the body of Manet's
Olympia. But in a later scene in *Quicksand*, Larsen rephrases the relationship
between Olympia and her maid by positioning them as viewers rather than
subjects of the portrait. In Manet's painting, Olympia gazes directly at the spec-
tator, while her black maid's gaze is on Olympia. In *Quicksand*, Larsen's maid,
Marie, in turn, invalidates Olsen's portrait when Helga, searching for recog-
nition, asks her, "Is this a good picture of me?" Marie replies, "I know Herr
Olsen is a great artist, but no, I don't like that picture. It looks bad, wicked."[40]
By condemning this painting and refusing Olsen's offer, the women interrupt
the gaze and insert themselves as spectators viewing Olsen's art, just as Olympia's
gaze and the gaze of her maid disconcert viewers by preventing easy identifi-
cation and erotic pleasure.

Olsen refers to his painting of Helga as the "true Helga Crane" and pro-
nounces it a "tragedy."[41] The tragedy, of course, is that Olsen has projected into
his painting the very gaze that thwarts Helga's ability to express herself creatively
and sexually. Modern portrait painters, unlike the realists who preceded them,
sought to capture more than the superficial facade of a subject; they wanted
to paint the inner workings of the psyche and the soul. (Motley alludes to this
goal in expressing his desire to capture the "Negro Soul" of his subjects.)[42]
Olsen believes he has captured Helga's sensual nature, which he presumes she
is suppressing by refusing his marriage proposal. Helga attempts to disassoci-
ate herself from the painting as she always does from situations that disturb her:

"It wasn't, she contended, herself at all, but some disgusting sensual creature with her features." Like Helga, however, the portrait is praised by critics enamored with the primitive; and it "attracted much flattering attention and many tempting offers."[43]

When Helga returns to Harlem, the middle-class African American community also sees her eroticized, mulatta body as primitive. Anne Grey, now the newly married Mrs. Anderson, avoids Helga, apprehensive at the thought that her husband might encounter her. Lurking beneath the surface of intellectual interests and polite behavior, Anne fears, is "a vagrant primitive groping toward something shocking." In an impulsive act that appears to justify Anne's perception of Helga's appeal, Dr. Anderson kisses Helga shortly after her chilly reception from Anne. The kiss encourages Helga to allow herself to finally act on the "ecstasy which had flooded" her during their encounter. But Dr. Anderson ultimately dismisses the kiss with a "trivial apology" and "direct refusal," thus preventing Helga from fulfilling the "desire" that "burned in her flesh with uncontrollable violence." In response to this rejection, she slaps him "savagely." Ironically, the "primitive" diction that describes both the encounter and Helga's response to it suggests that the "true Helga Crane" featured in Olsen's painting may not have been that far off the mark.[44] Together, the kiss and Dr. Anderson's rejection precipitate Helga's religious epiphany and her subsequent repressive marriage to a southern preacher. Unable to reconcile two seemingly oppositional aspects of mulatta identity, the Jezebel and the madonna, Larsen's musings on the tragic mulatta as a black female artist end as Helga's domestic responsibilities stifle her creativity. Her potential for artistic or intellectual production is subsumed beneath the reproductive duties of a wife.

"That Craving for Some Place Strange and Different"

Quicksand's tableaux turn the tragic aspect of the mulatta trope into the frustration of black female artists and intellectuals. In *Passing*, however, Larsen advances a radical conception of racial transcendence. What she merely suggests in *Quicksand* with her brief sketch of Audrey Denney, a "cool girl" with the ability to "placidly ignore racial barriers," is developed in *Passing* through the juxtaposition of Irene Redfield and Clare Kendry. Irene is a chic, modern race woman whose well-ordered life is interrupted by a chance meeting with a childhood friend, Clare, who has been passing for white. Lonely and anxious to once again be part of the African American community, Clare enlists Irene's help in gaining access to Harlem society. Larsen's depictions of Clare as acquisitive, "catlike," and "tempting" underscore the African American community's erotic fascination with the mixed-race, black female body. Successive encounters with Clare

heighten Irene's "inexplicable" attraction to her and threaten both her marriage and her allegiance to her race.[45] Through Irene's turmoil, Larsen reveals the consequences of subscribing to the race-woman ideal. The visual imagery in *Passing* represents her cross-genre effort to refute the reification of the race woman in New Negro culture. Read against Motley's gallery of haunting, eroticized, bourgeois mulatta figures, *Passing* illuminates the insidiousness of colorism and class stratification within African American communities. It also dramatizes one of Helga's possible futures. Had she married Dr. Anderson, she might have become an Irene Redfield: self-righteous, hypocritical, and obsessed with security.

While the visual tableaux in *Quicksand* illustrate the destructive effects of the white male gaze on the eroticized black female subject, *Passing* directs our attention to the spectatorial gaze among African Americans. In the novel's three parts, Irene's perceptions of Clare propel the narrative movement. Although Clare's gaze disconcerts Irene, it is Irene who views Clare as an object. With the gaze now in blackface, so to speak, it becomes a function of the classist, colorist, self-exoticizing obsessions of the black bourgeoisie. In her role as spectator, Irene projects onto Clare her own desire for more money, mesmerizing beauty, and freedom from race, gender, and class restrictions.[46] Irene's persistent examination and derogation of Clare's physical appearance and character, and the irrational emotions she experiences at the mere mention of her rival, convey the extent of her anxiety about conforming to New Negro standards for financial security and moral character. Irene's gaze is analogous to what Sigmund Freud identifies as "scopophilia." When we look into the mirror, Freud writes, we see a reflection of ourselves, filtered through the prism of our experiences, socialization processes, and psychological formations.[47] Irene's gaze so dominates the narrative perspective that Clare remains an iconic reflection of Irene's projections. Clare's own self-perception never materializes.

Various readings of the erotic attraction between Clare and Irene seek a language to reveal the nature of desire in *Passing*.[48] While queer readings provide a nuanced vocabulary with which to discuss Clare and Irene's mutual attraction, they do not adequately explain Irene's desire not so much for Clare as for the idea of inhabiting Clare's alluring "white" body and devil-may-care attitude. Conveyed through eroticized language, the desire between Clare and Irene masks a desire for a community in which economic and social parity does not require an erasure of culture—a space, that is, where women's creative or artistic work is not subsumed by or restricted to reproduction, as it is in *Quicksand*. Irene's turmoil, conveyed by her progressively unhinged observations, demonstrates the slipperiness of these overlapping desires. In an article in the *Crisis*, W.E.B. Du Bois labeled Clare a "lonesome hedonist" and Irene a "race-conscious puritan"; yet these reductive categorizations miss the complexity of Larsen's critique.[49]

Larsen derives her portrait of the race woman partially from the heroines of nineteenth-century African American novels such as Frances Harper's *Iola Leroy* (1892). A voracious reader by all accounts, Larsen was no doubt familiar with American writers of that period who dealt with themes of miscegenation and popularized the mulatta heroine, including Harper, William Wells Brown, Harriet Beecher Stowe, and Pauline Hopkins. In these novels, the mulatta's physical whiteness as well as her virtue heighten her value as a commodity on the auction block; ironically, her black blood ensures that her virtue will be quickly dispensed with upon her sale. In a recent introduction to Brown's *Clotel* (1853), a novel that provides the pre-text for mulatta iconography and a blueprint for early African American fiction, Hilton Als declares that American miscegenation is essentially a "pornographic story," citing Brown's "autoerotic writing," particularly his voyeuristic portrayal of the quadroon heroine in *Clotel*, as evidence.[50] During the Harlem Renaissance, authors and editors continued to fetishize the mulatta as the ideal race woman through similarly spectatorial representations.

By questioning the madonna-like figure of the race woman in her modernist adaptation of the passing narrative, Larsen criticizes the patriarchal tendencies and elitism of the Harlem Renaissance vanguard, a risky proposition given that her critique is leveled at figures like Du Bois, who heralded *Quicksand* as "fine, thoughtful and courageous. . . . on the whole, the best piece of fiction that Negro America has produced since the heyday of [Charles] Chesnutt." Du Bois considered Helga Crane typical of the "new, honest, young fighting Negro woman" who "never will surrender to hypocrisy and convention."[51] Far more than a "race-conscious puritan," Irene embodies both visual and social-class prerequisites of the idealized new race woman. From this deified position, which Irene's husband ridicules by observing that "uplifting the brother's no easy job," she is expected to supply the moral rationale for her behavior and the choices she makes for her family. Her anxiety regarding her husband's restlessness—"that craving for some place strange and different"—which she has "had to make such strenuous efforts to repress," reflects her own inner struggles to reconcile herself to her role as wife, mother, socialite, and race woman. Unfortunately, the choices Irene makes often conflict with her desires (for Clare or Clare's lifestyle, more money, control over her family, and a world without racism). The answer to Clare's question of "why more coloured girls" like Irene never pass is that Irene ultimately prefers the perceived safety of her position as a race woman. The fissures in this supposedly secure world, however, are illustrated by a succession of parodic tea parties and soirees that align the "dark-white" mask of the New Negro woman with Clare's "ivory mask."[52] Clare acts as a mirror that illuminates the cracks in Irene's manufactured marriage and

social position by reflecting her suppressed desires. Clare appeals to Irene in the same way she appeals to the reader: as a modern flaneur who can move unimpeded in the white world of wealth and privilege and among the elite of Harlem Renaissance society.

Along with exposing the constraints on the persona of the race woman, *Passing* presents moments of racial recognition and misrecognition that create the sustained motif of a muddled color line and dispel the notion that whiteness is physiologically impossible to penetrate. Larsen strikes at the core of what constitutes whiteness to reveal it as a performance—the blueprints of the construct, as it were. Recognition of the passer as either white or black is reliable only to the extent that the observer has a trained eye sensitive to the visual encoding of race. Yet those visual codes are difficult to concretize. Confident in her ability to detect passers, Irene dismisses common visual clues: "fingernails, palms of hands, shapes of ears, teeth and other equally silly rot." Instead, she maintains that something more exists that only African Americans perceive: "[a] thing that [can't] be registered."[53]

Larsen's reference to the 1924 Rhinelander case indicates that she was cognizant of the era's fascination with the ambiguously raced black female body. In one of the more sensational moments of this case, the defendant, a woman accused of misleading her husband about her true race, was ordered to disrobe so that the jury could more accurately ascertain her racial identity.[54] By revealing Irene's initial misperception of Clare as white, Larsen undermines the premise that only African Americans can authenticate the performance of blackness or whiteness. In fact, it is Clare in whiteface who first recognizes Irene and leads the reader toward recognition of Irene's race: "They always took her for an Italian, a Spaniard, a Mexican, or a gipsy. Never, when she was alone, had they even remotely seemed to suspect she was a Negro."[55] While Irene attributes her ability to detect passers to a spiritual or racial kinship that allows her to perceive what white people cannot, such detection is purely a survival instinct for Clare: she knows another passer when she sees one. Irene's failure to recognize her pleases Clare immensely, proving she has perfected her disguise. Irene cannot detect anything beyond her own fear of exposure until Clare laughs, triggering Irene's memory and lifting the curtain. This scene is crucial because it establishes the iconography of the passing subject only to undermine those visual codes with an aural signifier. Armed with the knowledge of her race, Irene provides the reader's first vision of Clare:

> Just as she'd always had that pale gold hair, which, unsheared still, was drawn loosely back from a broad brow, partly hidden by the small close hat. Her lips, painted a brilliant geranium-red, were sweet and sensitive and a little obstinate. A tempting

mouth. The face across the forehead and cheeks was a trifle too wide, but the ivory skin had a peculiar soft lustre. And the eyes were magnificent! dark, sometimes absolutely black, always luminous, and set in long, black lashes. Arresting eyes, slow and mesmeric, and with, for all their warmth, something drawn and secret about them.

Ah! Surely! They were Negro eyes! mysterious and concealing. And set in that ivory face under that bright hair, there was about them something exotic.[56]

Clare's dazzling white skin is emphasized whenever she appears in the text. Her blond hair reiterates her alabaster whiteness—a color pattern that Richard Dyer asserts is "uniquely white, to the degree that a non-white person with such features is considered, usually literally, to be remarkable."[57] Although Irene's first description establishes Clare as beautiful according to Eurocentric standards, she concludes that "Negro eyes" ultimately determine Clare's beauty and render her passing performance "absolute, beyond challenge."[58] After this decision, Irene repeatedly locates both Clare's blackness and her ability to dissemble, racially or otherwise, in her eyes.

In several passages, Irene is suspicious of, or finds flaws with, Clare's whiteness, though not with her beauty. Those flaws, like the laughing male figure in Motley's painting *The Octoroon Girl* (which appears on the novel's cover), address the contradictions in mulatta iconography. It is important to understand that both Clare's visibility as well as the flaws in her character and physical form make her an intolerable figure to everyone else. She is a woman without regard for the boundaries of either white or black society whose presence reflects the hypocrisy and desires of both groups. For nineteenth-century African American writers, the perceptible flaws in the mulatto/a's whiteness were often tell-tale signs that revealed light-skinned protagonists to be dedicated race men and women. As a result, the visual imagery of the mulatta figure sparked a consumable iconic tradition in African American culture akin to the widespread use of the Cuban mulatta figure on cigar and tobacco labels as a symbol for Cuban nationalism.[59] Unlike the nineteenth-century mulatta figure, whose "white" skin enabled white writers to critique patriarchy and African American writers to garner sympathy for the antislavery cause, Clare's visual presence necessitates her spectacular, public execution.[60] And when Clare dies by falling from a window, both the black bourgeoisie and white law-enforcement officials determine that her death is a result of her own "misadventure"—the logical outcome of her forays back and forth across the color line.[61]

Larsen's precise attention to color encodes Clare as a mulatta icon perceived through Irene's gaze, a perspective that highlights the spectacular nature of passing. Like the exoticized descriptions of Helga Crane, the mulatta iconography

associated with Clare is revealed through a series of tableaux that always under-
line her brilliant whiteness and dazzling clothing. These accoutrements of the
passing performance are juxtaposed against the costume of the ideal New Negro
woman. Filtered through Irene's gaze, Clare's appearance sets a standard that
Irene sees herself as lacking: "Clare, exquisite, golden, fragrant, flaunting, in a
stately gown of shining black taffeta, whose long, full skirt lay in graceful folds
about her slim golden feet; . . . her eyes sparkling like dark jewels. Irene, with
her new rose-coloured chiffon frock ending at the knees, and her cropped curls,
felt dowdy and commonplace." (203). Whenever Irene describes Clare's appear-
ance, she compares it with her own. Clare is a mirror reflecting Irene's mate-
rialistic desires, indicated by the excessiveness of Clare's accessories: "Irene
couldn't remember ever having seen her look better. She was wearing a super-
latively simple cinnamon-brown frock which brought out all her vivid beauty,
and a little golden bowl of a hat. Around her neck hung a string of amber beads
that would easily have made six or eight like the one Irene owned. Yes, she was
stunning." (220). In spite of her admiration for Clare, Irene often finds her-
self torn and confused by envy and fear. She is critical of what she perceives as
Clare's extravagance in dress, emotion, and behavior. Larsen's detailed descrip-
tions of Clare's clothes read like a catalog of conspicuous consumption, and the
adjectives associated with Clare's appearance connote excess: she is "superlative,"
"stunning," "flaunting," and "exquisite."[62] Clare embodies the extremes of the
iconography associated with passing and mulatta figures, an excess that also
references the proliferation of narratives that feature such figures as highly mar-
ketable entities. The spectacle and allure of her physiognomy and her ability
to transgress both white and black communities contributes to the voyeuristic
appeal of passing narratives.

 To construct the color-sensitive world of *Passing*, which Larsen with her
peculiar sense of humor originally titled *Nig*, the author provides luxurious and
visually evocative images that afford a unique glimpse into the Afro-modernist
world of the Harlem Renaissance as mirrored in Motley's paintings.[63] The lush-
ness of Motley's compositions evoke the carefree life-style that Larsen's heroines
chased yet found ever elusive. Because Larsen was skeptical about the possibil-
ity of authentic representation, her images possess an ambiguity that derails
attempts to codify the passing subject; Motley, however, was preoccupied with
organizing his subjects into types in an attempt to portray the diverse nature
of the African American subject. In an interview with Dennis Barrie, he said,
"All my paintings where you see a group of people you'll notice that they're all a
little different color. They're not all the same, they're not all black, they're not,
as they used to say years ago, high yellow, they're not all brown. I try to give
each of them character as individuals."[64] A striking difference, then, between

Motley's and Larsen's explorations of miscegenation is that Motley attempts to capture and categorize identities that for Larsen remain fundamentally elusive. Quadroon and octoroon types, Motley explained, are "what I specialize on."[65] For Motley, color seems to be the most clarifying signifier of racial mixture, from the dark-eyed, dark-haired, golden-hued mulatta, which *The Octoroon Girl* and Irene in *Passing* apparently represent, to the Nordic type, with white skin, blonde hair, and blue eyes. He ascribes these identifiers, which recall pseudoscientific anthropological studies of racial categorizations, to his studies of racially mixed subjects as he explores "various colored people and what the true relationship is to the blood."[66] Motley's desire to picture the biology of race truthfully is a dangerous endeavor that sometimes reinforces the mulatta as an exotic figure in the African American community.

It is not surprising that African American artists such as Motley helped perpetuate mulatta iconography during the Harlem Renaissance, given American culture's general fascination with the mulatto/a and the proliferation of mixed-race and light-skinned African American women in periodicals and race movies made by African American filmmakers such as Oscar Micheaux. Motley's journals and notes provide a bizarre methodology for visually representing miscegenation and the mulatta that risk glorifying miscegenation and reifying the New Negro woman as a mulatta. It is not just skin color that denotes miscegenation in Motley's paintings; he often conflates personality and behavior with color composition. In *Portrait of My Grandmother*, he uses gray, white, and black shades in the background and in the figure's dress to designate her racial heritage. Elaine Woodall notes that "the transparency of the white blouse allows its mingling with her brown skin to suggest the mingling of her Caucasian and Negroid blood."[67] In his focus on mulatta "types," as he calls them, Motley identifies a range of characters: the fiery *Mulattress*; the demure, mysterious *Octoroon*; and the modern, disdainful *Aline*.

Among the paintings in Motley's octoroon series, *Octoroon (Portrait of an Octoroon)* (1922) best articulates the dramatic resonance and "having nature," to borrow Larsen's term, of the mulatta figure in Harlem Renaissance visual culture (fig. 8).[68] The subject's regal bearing is strikingly conveyed by her upswept hair, pearl earrings, and necklace; she is clearly a woman with money as well as leisure to pose for such a portrait. Unlike *The Octoroon Girl*, which gives the viewer the impression that the modern figure has paused for a moment at the artist's behest, this woman wears a fixed, expectant half-smile. As with other paintings of mixed-race women, Motley uses color to denote biological and cultural biraciality. Mimicking the technique used in *Portrait of My Grandmother*, he chooses grays and blacks to visualize the subject's biracial background and emphasize her white skin and black eyes, both of which are heightened by the

lush maroon drape, black dress, and the placing of her orchid corsage, the colors of which favor the background. In this painting, Motley sought to "show that delicate one-eighth strain of Negro blood"; he considered *Portrait of an Octoroon* not just "an artistic venture but a scientific problem."[69] His early obsession with painting light-skinned, bourgeois, black women and identifying them in his notes and painting titles as mulattas and octoroons favors white blood but with a peculiar, misleading logic.[70] Even if his purpose was, as Sharon Patton argues, to provide a "visual rebuttal" to Mammy and Jezebel images by presenting dignified, affluent women, his valorization of the mulatta replaces one kind of iconography with another.[71] The elongation of the octoroon's fingers, which are placed as if she is about to raise her hand in greeting, is consistent with the elegant attention Motley pays to hands in his other portraits. The erotic allure of the subject's plunging neckline and secretive smile distinguish this painting from *Aline, An Octoroon* and *The Octoroon Girl.* This smile haunts the viewer as Clare's smile haunts Irene throughout *Passing.* "The seduction of Clare's smile," described alternately as "caressing," "odd," and "provocative," both disarms and entices: "She sat motionless, her bright lips slightly parted, her whole face lit by the radiance of her happy eyes." In the moments before Clare's fall from the window at the Freelands' party, Irene, who has become increasingly desperate to be "rid of [Clare] forever," observes: "She seemed unaware of any danger or uncaring. There was even a faint smile on her full, red lips and in her shining eyes; It was that smile that maddened Irene."[72]

This last glimpse of Clare's face, frozen in a death mask, bears a marked resemblance to Motley's *The Octoroon* as well as *Quicksand*'s Audrey Denney:

> [Audrey] was pale, with a peculiar, almost deathlike pallor. The brilliantly red, softly curving mouth was somehow sorrowful. Her pitch-black eyes, a little aslant, were veiled by long, drooping lashes and surmounted by broad brows, which seemed like black smears. The short dark hair was brushed severely back from the wide forehead. The extreme *décolleté* of her simple apricot dress showed a skin of unusual color, a delicate, creamy hue, with golden tones. "Almost like an alabaster," thought Helga.[73]

Alluding to gothic representations of the covetous female vampire, the palette of "brilliant red," "pitch," and "alabaster" applied to Denney in this passage emphasizes the whiteness of her skin. Like the mulatta, the vampire is a hybrid creature, existing in the borderlands between day and night, amid the living and the dead. Erotic, alluring, and ultimately deadly, Denney and Clare are a 1920s versions of J. Sheridan Le Fanu's "Carmilla" (1872). As an icon of the Victorian gothic, the female vampire encompassed society's terror of the beast masquerading beneath

8. Archibald J. Motley, Jr., *Octoroon (Portrait of an Octoroon),* 1922.
CHICAGO HISTORY MUSEUM AND VALERIE GERRARD BROWNE.

feminine propriety, recalling Anne Grey's fear of the "vagrant primitive grop-ing" she perceives in Helga.[74] While other similarities between *Passing* and "Car-milla" indicate Larsen's familiarity with the gothic genre, if not necessarily with Le Fanu's work (mutual childhood recognition, an undead being passing for human, feline references), most relevant here is that the mulatta and the female vampire share iconography: they both possess a flawed beauty concen-trated in an ultra-whiteness that raises suspicion. Just as Larsen adds Oriental-ist imagery to her depictions of Helga, the subtle gothic eroticism in *Passing* further indicates that Larsen saw literary eclecticism as a way of adding an avant-garde edge to the traditional mulatta character while keeping her work modernist. The vampiric quality evident in Larsen's depiction of Clare's visage is a portent of her imminent demise; like Carmilla, she is gruesomely destroyed after her true identity is revealed.

Although Clare is a fuller embodiment of *Quicksand*'s Audrey, a woman the black elite disapproves of but Helga admires, there is one striking distinction between the two women: Audrey does not have to pass. She elects to live out-side the secure nest of the Harlem elite: "Downtown. West Twenty-second Street. Hasn't much use for Harlem any more." And she hosts parties where black and white guests commingle. Again, unlike Clare, who has to hide, Den-ney is considered "outrageous, treacherous" not because she passes (she does not) but "because she goes about with white people. . . . and they know she's colored." Helga's contradictory perceptions of Audrey as both admirable and dangerous foreshadow Irene's conflicting emotions about Clare. Helga "felt that it would be useless to tell them that what she felt for the beautiful, calm, cool girl who had the assurance, the courage, so placidly to ignore racial barriers and give her attention to people, was not contempt, but envious admiration. So she remained silent, watching the girl."[75]

Possibly modeled after the Caribbean-born Harlem socialite Blanche Dunn, Audrey appears for a brief, glittering moment in *Quicksand* before vanishing from Helga's life. She is the one character in Larsen's fiction who successfully transcends race. European noblemen adored Dunn, as did commoners such as Harold Jackman and Carl Van Vechten, and the nobles sponsored her impec-cable style; she lived as one "totally untouched by race prejudice and free of all racial concerns" (fig. 9).[76] Like Dunn, Audrey exudes a devil-may-care attitude that her later incarnation, Clare Kendry, also manifests. At the close of one chapter, Helga observes Audrey dancing: "She danced with grace and aban-don, gravely, yet with obvious pleasure, her legs, her hips, her back, all swaying gently, swung by that wild music from the heart of the jungle." Neither Helga nor Irene achieves Audrey's free self-expression. As Helga gawks at Audrey, a "more primitive emotion" replaces her envy. She feels her heart throbbing and

is forced to escape from the party before she is overcome. Similarly, Hugh Wentworth inquires about Clare while she is dancing: "What I'm trying to find out is the name, status, and race of the blonde beauty out of the fairy-tale." Unfortunately, unlike Dunn, whose fate was a "fairy-tale" marriage to a nobleman and expatriation to Capri, Clare's "misadventure" results in a spectacularly public death. Unable to conceptualize a utopic, race-blind world in the United States, Larsen leaves us without a fairy-tale ending, instead providing an ambiguous resolution for Clare's "torturing loveliness." Clare does not have the power to reinvent the world around her; and despite her promise, Audrey quickly disappears from *Quicksand*. Perhaps she thrives in a world that Helga imagined, one where she could belong "to herself alone and not to a race."[77] But it was a world that Larsen could not write into being.

After reading *Quicksand* and *Passing* in concert and in the company of Motley's images, I found that two images of the mulatta icon remained vivid. The first is Helga just after her labor: "Helga, who was lying on her back with one, frail, pale hand under her small head, her curly black hair scattered loose on the pillow. She regarded him from behind dropped lids. The day was hot, her breasts were covered only by a nightgown of filmy *crêpe*, a relic of prematrimonial days, which had slipped from one carved shoulder. He flinched. Helga's petulant lip curled, for she well knew that this fresh reminder of her desirability was like the lick of a whip." This scene of a woman incapacitated by labor provokes not only a kind of bizarre maternity but also fresh desirability. The antebellum implications of the whip heighten the tension between husband and wife, and her reclining image stands in contradistinction to the tableaux of her body in Denmark and her first depiction in her room at Naxos. Unlike previous iconic displays, which reveal some potential for agency, Helga here appears to be trisected by the limits of her race, gender, and class subjectivity, too paralyzed to control or retract her own allure. Significantly, the passage comes a mere seven pages before the final, ominous line of the book: "And hardly had she left her bed and become able to walk again without pain, hardly had the children returned from the home of the neighbors when she began to have her fifth child."[78] While her desirability is a "whip" that causes her husband to "flinch," she bears the reproductive cost of that appeal, which she cannot convert into a vehicle for her own benefit or even escape.

This lingering, disturbing image of Helga can be paired productively with the final scene in *Passing*, in which our last vision of Clare is not actually painted for us in the text but is in every way present in our imagination. On reading "one moment Clare had been there, a vital glowing thing, like a flame of red and gold" and "the next she was gone," the reader immediately conjures a spectacular picture of Clare's death throes, reinforced not only by the copious

9. Carl Van Vechten, photograph of Blanche Dunn, 1934.

chronicling of her physique and dress throughout the novel but by three fore-shadowings of her fall and its presumably gruesome aftermath:

> Irene finished her cigarette and threw it out, watching the tiny sparks drop slowly down to the white ground below.

> On the floor at her feet lay the shattered cup. Dark stains dotted the bright rug. Spread . . . before her, Zulena gathered up the white fragments.

> [Irene] tore the offending letter into tiny ragged squares that fluttered down and made a small heap in her black *crêpe de Chine* lap. The destruction completed . . . she dropped them over the [train's] railing and watched them scatter, on tracks, on cinders, on forlorn grass, in rills of dirty water.[79]

In each of these scenes Irene rehearses an active role in Clare's symbolic destruction, yet the actual impetus of her fall is absent. So, too, is any detailed description of the literal impact of such a plunge.[80] To implicate the reader in the ambiguity of the ending, Larsen omits a description of Clare's exit, but the apparition haunts Irene and the reader.

In a letter to her close friend Dorothy Peterson, Larsen wrote, "Right now when I look out into the Harlem Streets I feel just like Helga Crane in m[y] novel. Furious at being connected with all these niggers."[81] Larsen's jibe can be read as sarcastic or classist. Even if she does not really feel this way, Larsen imagines that Helga experiences self-denigrating feelings of alienation within the African American community. Though it is dangerous to ascribe too much value to a brief remark made to a friend in a personal letter, if taken with some of Larsen's comments to Van Vechten and other confidants, the remark does suggest concern about the social status that others might assign her. But her ideal, modern, black heroine, epitomized by characters such as Audrey Denney and Clare Kendry, remains for us what she was for Larsen: a woman unable to find a community that accepts her for who she is, not what she represents. Larsen's explorations of the iconography and the plot trajectory of the mulatta as a tragic, alienated figure in *Quicksand* and a mischievous vamp in *Passing* leave the reader with no hopeful alternative. Still, it must have cheered her to read reviews like Du Bois's, who wrote that if more writers produced works like *Passing*, "we can soon with equanimity drop the word 'Negro,'" and W. B. Seabrook's, who suggested that the book "rises above race categories and becomes that rare object, a good novel."[82] And even if her heroines cannot transcend race, class, and gender restrictions, Larsen's influence has extended beyond her fiction's contemporaneous reception.

The concerted, interartistic efforts of some Harlem Renaissance writers and artists to expose objectifying representations of mulatta iconography was made even more difficult by the colorism and classism that such iconography carried. Larsen's novels warn us against dismissing the mulatta as an obvious aping of Eurocentric beauty and womanhood, yet is it appropriate to unequivocally herald Charles Chesnutt's "new people" as the future of the race?[83] Motley's intent to make the African American subject an appropriate model for high art resulted in a preoccupation with the mixed-race female body that reinforced the objectifying gaze. While Larsen confronts the consuming gaze, she cannot completely dismantle its intraracial force. Though many artists and writers of the Harlem Renaissance attempted to humanize and complicate the black subject and create an art of the authentic New Negro that could surpass racial boundaries, their efforts nonetheless produced a new take on an old stereotype. Bound by the transience of self-consciousness—namely, what we think we know of ourselves and presume to know of others—authentic racial representation becomes as elusive as its transcendence.

chapter two

Jessie Fauset's New Negro Woman Artist and the Passing Market

[Jessie] Fauset has written many novels about the people in her circle.
Some white and some black critics consider these people not interesting enough
to write about. I think all people are interesting to write about. It depends on the
writer's ability to bring them out alive. Could there be a more commendable prescription
for the souls of colored Americans than the bitter black imitation of white life?
Not a Fannie Hurst syrup-and-pancake hash, but the real meat.

—CLAUDE MCKAY, *A Long Way from Home*

I didn't want to be a woman artist, I just wanted to be an artist.

—ISABEL BISHOP, December 16, 1982[1]

If Nella Larsen's portrayals of the tragic mulatta and the passing subject are ultimately ambivalent because they do not successfully transcend racial boundaries, Jessie Fauset's writing acknowledges the complications of inhabiting the passer's guise without eschewing those aspects of the mulatta icon that endorse a particular and feminized New Negro identity: the New Negro woman artist. In *Reconstructing Womanhood*, Hazel Carby dismisses Fauset as an ideologue who presents moralistic portraits of the black middle class but praises Larsen's representation of "the full complexity of the modern alienated individual."[2] Yet Fauset's second novel, *Plum Bun,* directly articulates the challenges facing the New Negro woman artist and the proliferation of mulatta iconography as it relates to passing and racial authenticity.

In *Plum Bun,* the mulatta icon as artist is the locus point for Fauset's oscillation between advocating an avant-garde new womanhood and endorsing a more conventional New Negro womanhood. Her genius resides in her referential engagement of the aesthetics and subjects of the Fourteenth Street School (the urban vein of American scene painting) and her development of her protagonist's psyche within that locale. By contrasting the cosmopolitanism of

Greenwich Village with Harlem's "striver's row," Fauset advances two compet-
ing life-styles: one definitively modernist, the other essentially New Negro.
Though it appears that never the twain shall meet, her use of the passing trope
allows these two worlds to intersect and her heroine to negotiate the pitfalls
of each. Though Fauset ultimately rejects Fourteenth Street's urban bohemia
as a viable alternative for her heroine, the Village enables her protagonist to
inhabit the artist's life and negotiate the contradictory roles of the new woman
in the twenties and thirties. As such, her novel foregrounds the obstacles faced
by the modern black female artist during the Harlem Renaissance in a passing
narrative that explores ever-shifting categories of race, culture, and identity.

The plot tells the story of Angela Murray, a young black woman who for-
sakes family and cultural heritage to pursue a career as an artist in Greenwich
Village. Immersing her heroine in an artistic community best known for its
representations of women as shoppers and workers allows Fauset to articulate
the economic and political implications of the bohemian aesthetics of free love
within the passing trope. Angela's first introduction to passing occurs while
shopping with her mother, and this early nurturing of her desire for "the finer
things" later impedes her artistic goals as her craving for luxury becomes inex-
tricably linked with white privilege. At first the myopic protagonist appears
oblivious to the cultural and spiritual sacrifice her passing persona entails.
Instead of using her ability to pass to achieve independence and the sexual and
social emancipation of the new woman, she places herself on the market, thereby
ceding her authority as a consumer artist to that of a submissive romantic hero-
ine. When she fails in her attempts to emulate her sophisticated white friends,
who exemplify flapperdom and modern womanhood, Angela regains her faith
in traditional matrimony, preferring it to a free-love relationship. After a disas-
trous romance with a wealthy white man she returns "home" to her racial and
cultural roots, finds a renewed commitment to her art, and is rewarded with
an appropriate partner of her own race. *Plum Bun* concludes as Angela is pre-
sumably about to be married to her soul mate. United with another passing
artist whose aesthetic philosophy is aligned with her own and living in Paris,
an idealized space where her race does not have to be defended, announced,
or hidden, Angela is able to function as an artist, a wife, and a socially con-
scious, if not overtly politically committed, New Negro woman. In this way,
Fauset negotiates a space for the African American female artist that does not
eschew the important aspects of the nineteenth-century African American
women's literary tradition but that is also completely engaged in negotiating
the competing modernisms of the 1920s and 1930s.

Once dismissed as a literary midwife, whose main contribution was discov-
ering Langston Hughes, Fauset has lately gained a more central role in Harlem

Renaissance studies, thanks to a flowering of Fauset criticism. Insider critiques portray her as an often-maligned artist, a much-heralded editor, and an unfairly satirized hostess. The epigraph by Claude McKay, which opened this chapter, suggests that searching for consensus on Fauset's subject matter and writing style may recall the title of her first novel: *There Is Confusion* (1924).[3] Though often contradictory in his praise and criticism of Fauset, McKay's comments are emblematic of the peculiarly incongruent critical considerations of her place in the Harlem Renaissance canon. As an artist and literary editor of the *Crisis* whose work in both realms expanded the internationalist scope of the Harlem Renaissance, Fauset did more than midwife poets Jean Toomer and Langston Hughes. None of the characterizations of her (notably, those of Claude McKay, Alain Locke, and Langston Hughes) capture the complexity of the position that she found herself in. Langston Hughes's stereotype, in "The Negro Artist and the Racial Mountain," of the "Philadelphia club woman" who doesn't "care for the Winold Reiss portraits of Negroes because they are 'too Negro'" appears to be aimed at Fauset.[4] Yet while Hughes condemned the elitist nature of Fauset's literary teas, he was also careful to note her wariness of white Negrophilia and the fascination that certain blacks held for white patrons. In a letter to Hughes, she cautioned him against conditional, and often aesthetically restrictive, patronage: "I was interested in your diagnosis of V.V. [Carl Van Vechten]. I don't know what his motives may be for attending and making possible these mixed parties. But I know that the motives of some of the other pale-faces will not bear inspection."[5] And though McKay once referred to Fauset as "prim and dainty as a primrose," he respected her as a woman well liked by "radicals" yet who lived "proudly like the better class of conventional whites" on "much less money."[6]

In their studies of modernist interracial exchanges, Ann Douglas and Michael North indicate that both black and white artists of the era imitated each other; but as Douglas and others have illustrated, there was much more at stake when black authors elected to use "white material." Later critiques of Fauset appear to bear out Douglas's assertion that "whites may borrow from blacks with impunity, but Negro use of white materials is always suspect" by both the black and white community.[7] Racial recasting is more costly to black men than to white men, and the dismissive critiques of Fauset's writing indicate that the cost doubles when applied to black women. Nevertheless, she did not silently accept characterizations of her writing as old-fashioned, assimilationist, and sentimental. After Alain Locke labeled her work "mid-Victorian," she castigated him in a 1934 letter: "your malice, your lack of true discrimination and above all your tendency to play it safe with the grand white folks renders you anything but a reliable critic. . . . At least I can tell a story convincingly."[8]

Fauset's contemporaneous critics also misunderstood her use of irony, masking, and parody, which were trademarks of late nineteenth-century black women's fiction and early African American modernism. Scathing and patronizing reviews, such as this one from the *Amsterdam News*, demonstrate the narrow, rigid aesthetic concerns of some of her critics:

> It seems to this reviewer that a fictionist of any group so situated as the American Negro has a special duty to perform. It is to indicate some means of meeting the problems of the race. There are currently any number of suggested solutions: acceptance and promotion of the principles of Marxism; the building of racial economy; back to Africa; social and cultural integration in American life; amalgamation. Miss Fauset indicates not one of these, nor does she suggest any new outlet. And this is the tragedy of Jessie Fauset.[9]

Such reviews forestall a sincere engagement with Fauset's novels, which explicitly deal with the repression of female sexuality and refuse to separate or hierarchize issues of race, class, and gender. The reviewer just quoted dismisses Fauset's placement of introspective black female heroines at the center of her novels and overlooks the complexity of characters, delivering instead a prescriptive approach to New Negro aesthetics and thus revealing his or her limited perception of how art should serve the race.[10] This flawed reading simplifies Fauset's examination of how intersectional oppression restricts black economic participation and her dramatization of the psychological effects of racial self-hatred and the structures that promote such an ideology. Her use of nineteenth-century literary strategies and plot structures are not merely, as Houston Baker, Jr., argues, examples of "bright Victorian morality in whiteface" that use the mulatta to cater to white audiences; instead, her novels respond to essentialist critiques of women's fiction that identify sentimental aspects as clearly non-modernist. Just as Baker traces the southern roots of the black modernist tradition to Booker T. Washington, Fauset's work extends the issues that nineteenth-century black female artists and activists confronted in their social, political, and romantic lives: namely, how to balance political commitment with sexual and creative desire.[11]

A Shop Girl's Guide to Harlem, or
Two Faces of the New Negro Woman

A laughing actor's mask attached to the lower side of a black woman's face illustrates the 1933 cover of Jessie Fauset's *Comedy American Style*. Unlike the traditional Janus face symbolizing the dramatic arts, which is half-black, half-white,

half-comic, and half tragic, the mask on Fauset's cover is entirely white and smiling; the woman's dark, stern visage stands in for the tragic component of the image. Although the cover introduces Fauset's last passing novel, the Janus face is also an appropriate allegory for the way in which her earlier novel, *Plum Bun*, portrays the New Negro woman. The bifurcated cover image underscores Fauset's interest in the stylized performance of gender, class, and race and those aspects of identity that are determined by how the body, especially the racially ambiguous body, is read. Fauset uses the iconography and the tragic plot trajectory of the mulatta to construct her passing heroine and illustrate the struggles of the New Negro woman. Angela/Angèle Mory embodies the frustrations of having to choose between marriage and an artistic career, between familial and cultural ties and individual desire. Questions mark every inch of Angela's journey: Which community? Which man? Which career? Which *race* offers her the best chance for personal and material fulfillment? Each appears to have disadvantages.

This brief allusion to the cover art hints at the extent to which Fauset consciously integrates visual elements into her writing; combining the *künstlerroman* (a becoming-an-artist novel) with the passing plot, she creates a unique modernist text anchored in references to the specific visual culture of the Fourteenth Street School of painting and the visual images of the New Negro woman in black periodicals. Her direct references to Fourteenth Street display an affinity with modernism, yet her investment in the passing narrative and New Negro ideology place her work squarely within the purview of Harlem Renaissance discourse. *Plum Bun*'s nuanced exploration of class boundaries, gender roles, and female sexuality in two distinct locales—the bohemian culture of Greenwich Village and the Harlem of the New Negro—distinguish it from contemporaneous passing narratives such as Walter White's *Flight* (1926).[12]

By situating Angela as a modern *flâneuse* in the Village, Fauset enables her protagonist to inhabit the role of a consumer artist who views her subjects as types based on Fourteenth Street paintings that portrayed women as shoppers and working girls. David Levering Lewis refers to Angela as the "Gibson Girl of the Renaissance"; however, she resists the lure of becoming a turn-of-the-century American icon, opting instead for a flapper's bohemian life-style.[13] As Ellen Wiley Todd writes, "because she assumed an independent air without radically challenging patriarchal assumptions, the Gibson Girl became the most visible and acceptable symbol of new womanhood at the turn the century."[14] The visual and literary discourse of the New Negro woman replicates the contradictions present in the Gibson girl, illustrating that these gendered positions are always in flux. To succeed as a new woman and a modern artist, Angela first must eschew New Negro womanhood as represented by her sister Virginia,

a role that Angela believes is burdened by sacrifice and conventionality. In lieu of the Gibson Girl, Angela adopts the more bohemian guise of the flapper. In Angela's "visual minded" view, "flapperdom" is synonymous with the "torrent of [F]ourteenth" Street, a modernist Mecca where the surrounding community of intellectuals and artists experiments with free love and the relatively apolitical and romantic aspects of scene painting.[15] What emerges from the intersection of the sentimental tradition, New Negro aesthetics, and the contrast between social realism (as a reaction to modernism's formal features) and American scene painting is a fully developed depiction of the New Negro woman artist.[16] Fauset's juxtaposition of two types—Angela, the new woman artist in Greenwich Village; Virginia, the New Negro teacher Harlem—resists advocating either position as ideal.

Throughout *Plum Bun*, Fauset juxtaposes Angela's discontent with the race pride of her sister Virginia, from whom she is estranged. Though both sisters share the same African American parentage (a very light-skinned mother and a dark-skinned father), Angela identifies entirely with her mother's visible whiteness and thus exhibits the discontent frequently associated with the tragic mulatta trope. In contrast, Fauset portrays the darker sister, Virginia, as an innocent, idealized race woman of the sort portrayed in the New Negro periodicals such the *Crisis, Opportunity,* and the *Messenger* and enshrined in the uplift ideology of the New Negro movement. She fashions Virginia as a colorful, modern, African American woman without the melancholic, tragic flush of Angela's beauty: "Angela thought she had never seen any one so pretty and so colourful. Jinny had always shown a preference for high colours; to-day she was reveling in them; her slippers were high heeled small red mules; a deep green dressing-gown hung gracefully from her slim shoulders and from its open collar flamed the rose and gold of her smooth skin. Her eyes were bright and dancing. Her hair, black, alive and curling, ended in a thick velvety straightness like cut plush." If Virginia's beauty depends on color, a lack of color defines Angela's allure. Although Angela inherits her mother's "creamy complexion" and "cloudy, chestnut" hair, Virginia is a "living manifestation" of Angela's black blood. She is Angela's moral mirror; her morality and virtue is neither a parody, nor a performance. While Fauset perceives the oppressive circumscription of the black female artist, she still idealizes the talented tenth community as the best approximation of happiness. In opposition to Angela, the never-satisfied, alienated, racially conflicted artist, Virginia puts her talents to appropriate, charitable use as a music teacher. That Virginia lives and teaches in Harlem is a constant reminder to Angela that she has sacrificed a supportive, nurturing community and her own self-respect. Despite Virginia's evident self-sufficiency, her sister, Angela and her beau, Anthony, both refer to her as simultaneously

"maternal" and infantile, a "wise baby" or a "little girl" who must be constantly sheltered yet possesses depths of strength Angela cannot imagine.[17]

Fauset's contradictory characterizations of Virginia as childlike, angelic, and maternal reflect the dissonance evidenced in images of the New Negro woman, who was represented in New Negro discourse, periodicals, and popular art as either a madonna and mother figure or a mulatta. Like Charles Johnson, editor of the *Opportunity*, Fauset believed that integrating visual images with written text was an effective way of creating positive images of African Americans, which were perceived to be more authentic and realistic than depictions of blacks in mainstream society. Along with her multiple roles as an editor, hostess, mentor, intellectual, scholar, literary critic, and writer, Fauset was a progenitor of the Harlem Renaissance's interartistic culture because she fostered space for intellectual exchange among its writers and visual artists. As literary editor of the *Crisis* from 1919 to 1926, she shaped the images of women represented in the periodical.[18]

Clearly, mulatta iconography was a persistent element in Harlem Renaissance culture, and periodicals of the era promoted mixed and ambiguously raced black women as emblems, stereotypes, and models. Thus, it makes sense to consider how visual culture strategically advertised New Negro womanhood. The April 1929 issue of the *Crisis* actually featured a promotion for *Plum Bun* (fig. 10). The advertisement depicts a young, dark-haired, white-skinned woman along with a question mark and a blurb by George Schuyler that declares the book to be "the last word on race relations."[19] While, on the surface, it might seem bizarre to use an image of a white woman to market a book to a black audience, the advertisement anticipates *Plum Bun*'s manifestation of the unreconciled tensions surrounding New Negro womanhood in black popular culture. Could a white-skinned, racially indistinguishable woman represent black womanhood? Certainly, a select cadre of black fiction writers from the 1890s—Pauline Hopkins and Frances Harper, for example—seemed to think so. But like her literary foremothers', Fauset's modernist mulatta did not stand uncontested. Despite the question mark in the advertisement, the iconic referent also points to how Angela/Angèle functions as a passing figure who faces the same difficulties that the tragic mulatta does. As a result, she becomes an excellent example of how the iconography of the mulatta encompasses even those who do not meet rigid legal or biological definitions of the mulatta as exactly half-black and half-white.

The following excerpt from Fauset's short story "Double Trouble" (1923) illustrates the odd flexibility of the term *mulatto/a* and typifies the author's use of skin color to identify class status and accentuate femininity within the African American communities she portrays: "Angélique's mother whom she rarely saw, was a mulatto, too, but a very light one, quite yellow, and though she could

10. *Plum Bun* advertisement.
REPRINTED FROM *CRISIS* 36 (APRIL 1929): 139.

not remember her father, she had in her mind's eye a concept of him which made him only the least shade darker than her mother. He had to be darker, for Angélique always associated masculinity with a dark complexion."[20] Published in two parts in the *Crisis*, "Double Trouble" features characters and plot lines (incest, thwarted romances, interracial sex) that Fauset would later develop and expand in her novel *The Chinaberry Tree* (1931). In addition to articulating an aesthetic of representation that "associate[s] masculinity" with darker skin and desirable femininity with light skin, this passage also demonstrates the imprecision with which characters are identified colloquially as mulatto/a. At one point, with unveiled irony, Angélique asserts that her "unblemished parentage" entitles her to a "right to race pride" that her cousin Laurentine, the daughter of a brown-skinned former slave and her white master, cannot claim. Significantly, the story includes two black-and-white illustrations by Laura Wheeler (Waring), a classically trained African American artist associated with the Harmon Foundation (fig. 11). In the first, Waring depicts Laurentine, described in the text as "dark-emerald" eyed with skin like "the flesh of a mango," and her mother confronting her white half-sisters while cousin Angélique peers in on the reunion from the window. The text states that Laurentine is a "replica of the Courtney sisters [her half-sisters] startlingly vivified." In the illustration, Laurentine, whose sharp-nosed face is drawn in profile, appears to be a shaded version of the sister seated directly opposite; however, because a fashionable hat (no doubt made by Laurentine, who is a modiste) shades the other sister's features, the exact resemblance identified by the narrator is only suggested in the visual image. More striking is the contrast between the slim, straight figure of Laurentine and the rotund Aunt Sal: despite that fact that, in *The Chinaberry Tree,* Fauset later describes young Sal as "a slip of a brown girl, slim and swaying like a birch," she here resembles a traditional southern mammy, with apron and headwrap.[21] Not only do Waring's contrasting figures illustrate the racial typologies which mark Fauset's fiction, they also illuminate the doubling motif that is so prominent in *Plum Bun*.[22]

The racially instability of the mulatta icon only complicates Fauset's vacillation between promoting the progressive sexuality of new womanhood and her continued indebtedness to Victorian standards of conduct. On the one hand, her work seems to criticize elitist, black middle-class communities that isolate themselves from the black underclass or align with the white patriarchal power structure; on the other hand, her exploration of class, race, and gender in *Plum Bun* betrays her uneasy investment in ladyhood.[23] This concept is central to the figure of the New Negro woman, who must maintain her status as a lady to be worthy of esteem, protection and emulation.

Fauset's artistically inclined heroines continually seek safe communities in

THE TWO YOUNG WHITE LADIES

11. Laura Wheeler, story illustration.

REPRINTED FROM *CRISIS* 26 (AUGUST 1923), 156–57.

WHO CAME TO SEE AUNT SAL AND LAURENTINE

which to produce their art; their ensuing conflicts reflect the text's insistence that subscribing to the moralistic restraints of the middle class is the only way of countering hypersexual stereotypes of black women. Unlike white women, who were, as Elizabeth Ammons observes, "busily casting off a constricting ideal of Victorian femininity" at the turn of the century, black women were struggling with a history of subjectivity that negated their very humanity.[24] Mainstream American culture perceived black women as the antithesis of the "true woman." In her Memphis diary, journalist-activist Ida B. Wells, who was also a teacher, was preoccupied by the appropriate behavior for a black woman of her station, even as she continually violated standards of propriety. Wells wrote that, contrary to a colleague's "obedient disposition," "extreme tractableness and . . . evident ladylike refinement," her own "tempestuous, rebellious, hard headed willfulness" caused M. Hooper (her teacher) to "cut short her scholastic career."[25] If ladies are protected, cared for, and looked after, they are also confined, subordinate, and ornamental. Unfortunately, it was difficult for black women to partake of the protection and esteem of ladyhood without having to submit to male authority. Though Fauset had been educated in the Ivy League, held a master's degree in French, had attended the Sorbonne, and came from a middle-class Philadelphia family, she shared the financially and socially precarious position of black middle-class women like Wells, who despite the constraints of the "cult of true *black* womanhood," ultimately pursued a brilliant career as a radical journalist-activist. What complicated the middle-class status of Jessie Fauset, Nella Larsen, and other female "talented-tenth" artists, such as Alice Dunbar-Nelson, was that, while they had "the breeding, education, culture, looks and manners of their 'higher classes,' . . . [they had] none of the money to back it up."[26] These writers struggled to reconcile their artistic desires and ambitions with the difficulty of being both ladies and writers, two professions that offered leisure but no money. For Fauset the tension was constant. After she left the *Crisis,* she was unable to find work in her area of expertise, despite her excellent credentials; and in 1926, she wrote a heartbreakingly proud letter to Arthur Spingarn:

> I am on the lookout for a new position. . . . I should like 1. To be a publisher's reader (if remunerative enough). 2. To be a social secretary in a private family. . . . 3. To be connected with one of the foundations here in New York. . . . I prefer not to teach. . . . In the case of a publisher's reader, if the question of color should come up, I could, of course work at home.[27]

Because she could not find work in her field, Fauset ultimately took a job teaching French at a New York high school, where she worked until 1944. The choice was disastrous to her writing career; she produced no more novels.

A Visual-Minded Heroine

Unlike *Quicksand*'s visually attentive Helga Crane, whose artistic nature bears no fruit, *Plum Bun*'s Angela is a talented painter characterized throughout the novel as "visual-minded." Her categorization of people into specific, visually identifiable types, imbued with ideological assumptions of race, class, and gender, indicate her judgmental nature and deluded self-perception. Through Angela's visual mind, Fauset also gives voice to an imaginative sensuality triggered by her aesthetic sensibilities. For instance, she chooses to wear a "flame-coloured dress" while out with Roger. The color suggests the danger and intensity of fire; it exceeds the passion and love connoted by mere red. In this dress Angela feels transformed, "lighted up from within." Her body and mind have become "new." She experiences "the effect of a flame herself: intense and opaque at the heart where her dress gleamed and shone, transparent and fragile where her white warm neck and face rose into the tenuous shadow of her hair. Her appearance excited herself."[28] The sensuality of the flame imagery betrays her narcissism and reveals that her preoccupation with whiteness is the root of her self-deception. The "tenuous shadow" of her hair signals that her pleasure in her physical form is flimsy and insubstantial. She falsely believes that she can alter her circumstances through sheer will, that it is possible to erase her family history, culture, and social position.

Angela's vision of Fourteenth Street's potential to provide artistic content contrasts sharply with her impressions of Harlem. A description of Fourteenth Street commences the "market" section of the novel:

> Fourteenth Street is a river, impersonally flowing, broad-bosomed, with strange and devious craft covering its expanse. To Angela the famous avenue seemed but one manifestation of living, but Fourteenth Street was the rendezvous of life itself. Here for those few weeks after her arrival in New York she wandered, almost prowled, intent upon the jostling shops, the hurrying, pushing people, above all intent upon the faces of those people with their showings of grief, pride, gaiety, greed, joy, ambition, content.[29]

This description of Fourteenth Street strongly resembles Reginald Marsh's aptly named 1934 painting *In Fourteenth Street* (fig. 12). In the painting, the pressing crowds exhibit the mélange of races, ethnicities, social classes, and genders that filled Fauset's descriptions of Fourteenth Street culture. Marsh's careful use of color and contrast distinguishes individual figures, especially the women, in the painting: in one corner a bright blue skirt, in another a red dress, in the center a young African American woman with a stylish bob and

a yellow dress. She carries something under her arm, possibly schoolwork or a package. Singled out by the brightness of her dress and a certain resilient focus, she is not swallowed or overtaken by the crowd.

Where might *Plum Bun*'s Angela appear in the painting? If the African American girl catches the eye of a viewer sensitive to public racial interactions, so does the ethereal whiteness of the woman in the blue dress. This woman is a recurring figure in Marsh's work, a tribute to the Hollywood siren. Marsh was acutely aware of cinematic devices, especially the camera's voyeuristic eye. *In Fourteenth Street* is based on a photograph of his neighborhood, and in it a gritty urban realism meets the make-believe glamour of the movies. The siren's inaccessibility, her proximity to and elevation above the crowds make her a likely foil for a black counterpart.

12. Reginald Marsh, *In Fourteenth Street*, 1934.

If we concede that Fauset's novel references the images as well as the culture of Fourteenth Street, what might these figures represent to Angela? For one, they suggest modes of identity that she as a newcomer to the Village might be able to inhabit or perform; however, the brown skin of the woman in the yellow dress and the platinum blonde of the siren make them racially and sexually conspicuous in a way that a passing figure reliant on her ability to blend in would find impossible to emulate.[30] Given the risk of discovery, the painting's grey, indistinguishable throng might provide more safety, as *Plum Bun*'s "impersonally flowing" river does.[31]

The next scene in the book contrasts Angela's somewhat conflicted impressions of Fourteenth Street with her first visit to Harlem, where she encounters a man whom she immediately classifies as a type: "a man's sharp, high-bred face etched itself on her memory—the face of a professional man perhaps, it—might be an artist. She doubted that; he might of course be a musician, but it was unlikely that he would be her kind of an artist, how could he exist?"[32] Angela's gaze is that of an artist seeking paintable subjects, yet her own perceptions of others contradict her desire to be seen in all her multiple, and oppositional, identities as a black female artist. Her characterization of certain paintable subjects as types connotes a Victorian vocabulary in which, as Jennie Kassanoff argues, "*type* indicated a distinct racial ontology of permanent (if often peculiar) genetic characteristics—a way of determining the general by extrapolating the specific."[33] Angela cannot conceptualize him as black *visual* artist but only as a musician; her visual grammar defines him as a nonexistent type. Although she was "amazed and impressed at [Harlem's] bustling, frolicking, busy, laughing great city within the greater one" and had never seen "coloured life, so thick, so varied, so complete," she rejects the brand of art produced there. After considering the face of a Harlem man, she makes this generalization: "Ah, there lay the great difference. In all material, even in all practical things these two worlds were alike, but in the production, the fostering of those ultimate manifestations, this world was lacking, for its people were without the means or the leisure to support them and enjoy." Angela leaves Harlem relieved that she has "cast in her lot with the dwellers outside its dark and serried tents" and settles in a Village apartment on Bank Street, a stone's throw from her art classes at Cooper Union, where "men and women were living at a sharper pitch of intensity." There she produces her own "Fourteenth Street types," paintings that echo the themes popularized by the Fourteenth Street school and its locale, including "a purse-proud but lonely man," "society girl[s]," and "the smiling despair of a harlot," possibly modeled on Marsh's siren.[34]

A comparative analysis of two paintings from the Fourteenth Street school read in conjunction with Fauset's depiction of Angela illustrates how the

trajectory of the novel shifts from one of promise and opportunity to a caution-
ary tale plagued by isolation and disappointment. The first painting, Kenneth
Hayes Miller's aptly titled *In Passing* or *The Shoppers* (circa 1920, fig. 13) res-
onates with Angela's romantic vision of passing at the beginning of her "Free,
white and twenty one" soliloquy.[35] The painting has a dreamy quality, a result
of the artist's soft brushstrokes, and features two affluent women who are pre-
sumably window shopping. The central shopper clutches a handbag and wears
a stylish fur and hat. Though neither woman appears to have a male chaperon,
a shadowy masculine figure lingers in the background. While it's intriguing to
contemplate the suggestiveness of the secondary title, *In Passing*, there is no
reason to think that the painter portrayed racially ambiguous women. In fact,
Ellen Wiley Todd compares the style of the painting, which portrays the sub-
jects "with rose-tinted, creamy complexions and chiseled features recalling the
profiles of Greek goddesses," to Renoir's, writing that "Miller transformed the
shopper into a goddess of commerce, a Venus of 14th street."[36] In short, Miller
put a new face on an old type as a way of preserving the femininity of the New
Woman as consumer. In lines that could serve as a caption to Miller's painting,
Fauset depicts Angela and her mother as a "modish pair" of passing shoppers:
"They had browsed among the contents of the small exclusive shops in Wal-
nut Street; they had had soda at Adams' on Broad Street and they were stand-
ing finally in the portico of the Walton Hotel deciding with fashionable and
idle elegance what they should do next." Unbeknownst to the doormen, shop
girls, and waiters who serve them, they are trespassing in white spaces of com-
merce. Tellingly, these black women can inhabit the guise of the female shop-
per *only* because of their resemblance to the subjects of Miller's painting: "Angela
had received not only her mother's creamy complexion and her soft cloudy hair"
but her father's "aquiline nose." Fauset's depiction of these "Saturday excur-
sions" draws into relief a missing facet in Miller's portrait, making visible the
links between race, capitalism, and the desire to consume.[37]

The second painting, Raphael Soyer's *Shop Girls* (1936), reveals the flip side
of consumption and marks a shift from the woman as consumer to the woman
worker within the capitalist machine. With its assembly line of gaunt-faced
young women, *Shop Girls* mirrors the change from the roaring twenties to the
depression ridden thirties. The girls in this painting are younger and more
starkly conceived than Miller's shoppers are. Few are distinguished among the
crowd of girls: they are not relaxed as they consider some delectable item but
are crowded together with little elbow room; their arms are laden not with pur-
chases but with serviceable coats, handbags, and hats. All but two are portrayed
in profile, and the most striking figure, who faces forward, wears a forlorn
expression. Her gaze is not the inviting look of the reclining nude; instead, it

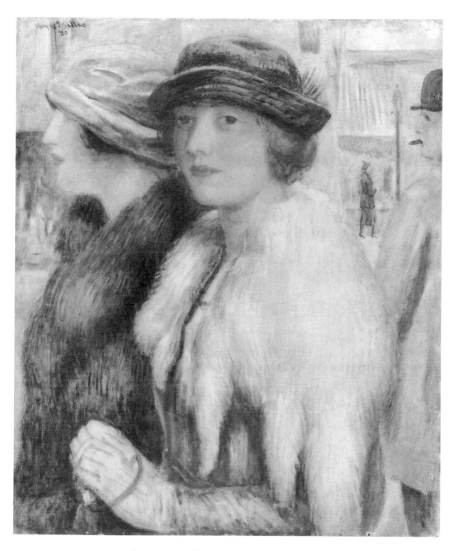

13. Kenneth Hayes Miller, *The Shoppers* or *In Passing*, 1920.
THE PHILLIPS COLLECTION, WASHINGTON, D.C.

challenges and disconcerts the viewer. Rather than being caught "in passing," this shop girl and her sister appear to be emerging from a Fourteenth Street shop at the end of the work day.

As the reality of being a starving artist sets in, the narrative no longer presents Angela in the guise of one of Miller's privileged shoppers. Haunted by her failed love affair and financial anxiety, she now resembles Soyer's weary workers: "This condition of her mind affected her appearance; she began to husband her clothes, sadly conscious that she could not tell where others would come from. Her face lost its roundness, the white warmness of her skin remained but there were violet shadows under her eyes; her forehead showed faint lines; she was slightly shabby. Gradually the triumphant vividness so characteristic of Angèle Mory left her, she was like any one of a thousand other pitiful, frightened girls thronging New York." Angela has lost her individuality, her sense of being "lighted from within"; she has become one of the masses of struggling, working-class white women. Her lost purpose is a direct result of her decision to forego her pursuit of "REAL ART," instead choosing to achieve power through marriage to a white man: "And she was ashamed, for she knew that for the vanities and gewgaws of a leisurely and irresponsible existence she would sacrifice her own talent, the integrity of her ability to interpret, to write down a history with her brush." Her materialist desire to consume compromises her artistic vision; and as a result, the bohemian Village loses its luster and becomes merely its bare reality: "a network of badly laid off streets with, for the most part, uncomfortable, not to say inconvenient dwellings inhabited by a handful of artists in the midst of a thousand *poseurs*."[38] Through Angela, Fauset questions how a black woman claims ownership of her body and talent and whether or not she can perform or commodify herself in order to achieve equal status and opportunity. Angela's admission of shame also echoes the internal conflicts expressed by the narrator in James Weldon Johnson's *Autobiography of an Ex-Colored Man,* when he makes his climactic decision to pass, thus exchanging his birthright for a "mess of pottage."[39] The idea that the passer can either choose to be an exceptional member of the colored race by working as an artist or an intellectual engaged in social uplift or choose to live a comfortable, unremarkable life as an ordinary white person is a recurring theme in late nineteenth- and early twentieth-century literature. Johnson's biblical allusion to Esau's mess of pottage refers to the spiritual vacuity that exile from one's kin and culture entails and the tragic consequences that such a separation has for the subject's family. Because passing necessitates severing familial ties, the subject is left with no verifiable bloodline or class background and, if female, no way to secure higher status except through marriage.

As a passing painter, Angela tries to see beauty beyond race; yet her pragmatic assessments of people as types prevents her from appreciating physical features that society might view as disadvantages. When she first sees Miss Powell, she describes her with blunt disdain: "Her squarish head capped with a mass of unnaturally straight and unnaturally burnished hair possessed a kind of ugly beauty. Angela could not tell whether her features were good but blurred and blunted by the soft night of her skin or really ugly with an ugliness lost and plunged in that skin's deep concealment." This early observation of Miss Powell demonstrates the extent to which Angela has internalized Anglo ideals of beauty; she appears to take established racial norms for granted but is confused about how to apply them. She considers Miss Powell's attempts to conform (by straightening or coloring her hair) unnatural and seeks to determine whether or not her features are "good." But it is unclear what Angela identifies as "good." Are Miss Powell's features asymmetrical or patrician, like Angela's nose? Whatever the case, it is Angela's preconceived and destructive notions of beauty, and not her friend's dark skin, that "blunt" and "blur" her ability to "objectively" evaluate Miss Powell's bone structure. The evolution of Angela's impressions of Miss Powell actually marks her transformation from a myopic materialist to a sincere artist. Later in the novel, after she has matured through her failures to entrap Roger into marriage and the loss of Anthony to her sister, she perceives Miss Powell with new eyes:

> Angela thought she had never seen the girl one half so attractive and *exotic*. She was wearing a thin silk dress, plainly made but of a *flaming red* from which the satin blackness of her neck rose, a straight column topped by her squarish, somewhat massive head. Her thin rather flat dark lips brought into sharp contrast the dazzling perfection of her teeth; her high cheek bones showed a touch of red. To anyone whose ideals of beauty were not already set and sharply limited she must have made a breathtaking appeal.[40]

Now it is Miss Powell who has become the flame, lit from within with the confidence and determination that Angela once possessed. Instead of functioning solely as an indicator of what penalties Angela might endure if she reveals her race, Miss Powell becomes a model whose still somewhat oppositional features give her "breathtaking appeal." That Angela is now able to reconcile the incongruity of racial visibility into something powerful and positive shows the progress she has made from an existence "sharply limited" by her own blinders to a more self-aware state.

The Passing "Market" and Fauset's "'Home' of Mirth'"

The often contradictory language of consumerism and commodification shapes Fauset's competing portraits of the black female subject: one articulated through the bohemian modernist aesthetic, the other through the black bourgeois discourse of New Negro womanhood. Fourteenth Street school aesthetics shape Angela's artistic philosophy, but the life-style of the new woman encourages her misguided embrace of free love as a strategy through which to obtain a wealthy husband and enjoy the "great rewards of life—riches, glamour, pleasures"—accessible only to the "white-skinned."[41] Many historians of consumerism argue that the early twentieth century was a time of shift in notions of the modern citizen subject, who moved from labor-producer to consumer. As a result of this shift, which was by no mean fluid or consistent, certain strains of modernism are marked by their rejection or appropriation of consumerism.[42] Nowhere is this more pronounced than in the sections of *Plum Bun* titled "Market."

In thinking about the metaphor of the market in *Plum Bun*, I find Wai Chee Dimock's analysis of the marketplace in Edith Wharton's 1905 novel *The House of Mirth* particularly relevant. According to Dimock, "the power of the marketplace . . . resides not in its presence, which is only marginal in *The House of Mirth*, but in its ability to reproduce itself, to assimilate everything else into its domain. As a controlling logic, a mode of human conduct and human association, the marketplace is everywhere and nowhere, ubiquitous and invisible."[43] Like *The House of Mirth*'s heroine, Lily Bart, Angela is a speculator on the marriage market. Just as Lily deploys her uncanny talent as a socialite to maneuver and maintain herself among the upper echelons, Angela as Angèle intends to use passing to catapult herself from being a mere spectator to a major player. She conceives of Angèle, her passing self, in ways similar to F. Scott Fitzgerald's description of the modern flapper: "lovely, and expensive, and about nineteen."[44] In this passing manifesto, she pragmatically assesses the limitations of her life options and identities as an African American, a woman, and an artist. Her desire to achieve white privilege, the "plum bun," sets her on the path of self-delusion. Determined to obtain a leisurely, free, and pleasure-filled life-style, she concocts what she believes is a sure-fire marketing scheme:

> She remembered an expression "free, white and twenty-one,"—this was what it meant then, this sense of owning the world, this realization that other things being equal, all things were possible. "If I were a man," she said. "I could be president," and laughed at herself for the "if" itself proclaimed a limitation. But that inconsistency bothered her a little; she did not want to be a man. Power, greatness,

authority, these were fitting and proper for men; but there were sweeter, more beautiful gifts for women, and power of a certain kind too. Such a power she would like to exert in this glittering new world. . . . To accomplish this she must have money and influence; indeed since she was so young she would need even protection; perhaps it would be better to marry . . . a white man. The thought came to her suddenly out of the void; she had never thought of this possibility before. If she were to do this, do it suitably, then all that richness, all that fullness of life which she so ardently craved would be doubly hers. She knew that men had a better time of it than women, colored men than colored women, white men than white women. Not that she envied them. Only it would be fun, great fun to capture power and protection in addition to the freedom and independence which she had so long coveted and which now lay in her hand.[45]

Essentially, Angela's narrative of self-commodification indicates her desire to obtain power through marriage. Her decision to pass for white in order to marry a white man requires a carefully rehearsed performance of race and gender. She sees herself as the "plum bun," as on the market. The sexual suggestiveness of the plum bun image alludes to images from popular blues songs, such as those that describe sex as a "jelly roll."[46] The plum bun also functions as a prize; it symbolizes Angela's desire to acquire the freedom and independence of a white man along with the pleasures she associates with white womanhood. Angela chooses to market herself as a commodity instead of pursuing the intangible, quixotic goal of becoming an artist, which was her original intent.

In her search for a wealthy husband, "Angèle" is as calculating as Wharton's Lily Bart; furthermore, both women function as racial icons within their respective communities. Jennie Kassanoff accurately describes Lily as an "iconic preservation of a perfect museum piece," a finely made model of inherited genetic advantages, intellect, and artifice.[47] Lily's status as a racial icon is based on more than her white skin; she's a fusion of natural, inherited aristocratic manners and grace combined with artificially perfected values: "Everything about her was at once vigorous and exquisite, at once strong and fine. He had a confused sense that she must have cost a great deal to make, that a great many dull and ugly people must, in some mysterious way, have been sacrificed to produce her."[48] Kassanoff argues that Lily's aloofness, her status as a museum piece, a taxidermied memento dedicated to a dying race, make her an unmarriageable but appealing spectacle. In contrast, abstract forces like "Fate," which "bestowed on [Angela] the heritage of her mother's fair skin," a "colour" that was "clearly one of those fortuitous endowments of the gods," confirm her status as a desirable mulatta icon.[49]

Like to Lily Bart, who inherited her mother's abhorrence of "dinginess,"

Angela's mother's "ecstatic" cravings spark her thirst for luxury: "Mrs. Murray loved pretty clothes, she liked shops devoted to the service of women; she enjoyed being even on the fringe of a fashionable gathering. A satisfaction that was almost ecstatic seized her when she drank tea in the midst of modishly gowned women in a stylish tea-room. It pleased her to stand in the foyer of a great hotel or of the Academy of Music and to be part of the whirling, humming, palpitating gaiety. She had no desire to be of these people, but she like to look on; it amused and thrilled."[50] Unlike her mother, however, Angela is not content to be a spectator on the "fringes"; she wishes to be at the center of such society. Yet despite the similarity of Lily's and Angela's desires, Angela's consumerist yearnings more accurately reflect the complex relationship of African Americans to mass culture. As Lizabeth Cohen explains, "unlike ethnic workers, blacks did not reject chain stores and standard brands, nor try to harness radio to traditional goals. . . . For ironically, by participating in a mainstream commercial life—which black Chicagoans did more than their ethnic co-workers—blacks came to feel more independent and influential as a race, not more integrated into white middle class society." Furthermore, as a result of strict regulation of where blacks could live and work, "consumption—both through race business and more mainline chains—became a major avenue through which blacks could assert their independence." Because blacks tended to patronize large stores with standard merchandise, their boycotts, such as the "Don't buy where you can't work" campaign, were more effective in large stores like Woolworth's and Blumstein's than in small, family-run businesses. In response to the "Don't buy" campaign, Blumstein's hired "fifteen black women immediately and Woolworth's agreed to hire thirty five." Yet organizers continued to criticize the stores' preference for light-skinned clerks; Arthur Kemp and Ira Reid, black nationalists from the Garvey movement, protested that "light and mulatto women received employment, 'while black ones did all the [picket] work.'"[51] If the ability to shop is synonymous with freedom and independence, then Angela's status as one of those working "light and mulatto women" is simply not enough. Her keen interest in luxury and material pleasure prompts her to adopt the passing guise. Wearing the "badge of that power that was whiteness" "like the colours on the escutcheon of a powerful house" enables her to become a more effective consumer.[52]

The economic influence of modern capitalism is evident in the passing market that Angela traverses in *Plum Bun*. In the guise of the flâneuse—a feminization of a masculine perspective position she can only inhabit by passing—Angela is a desiring consumer unwilling to let color restrain her. Early in their affair, she pays Roger a compliment: "You look just like the men in the advertising pages of the Saturday Evening Post."[53] This blunt observation indicates

that her attraction is fueled by her admiration of what Roger represents not as an individual but as a key player in the consumption-driven capitalist marketplace. In Dimock's assessment of the social marketplace, she observes that the "actual wielders of power in the [*House of Mirth*] are often not men but women."[54] Likewise, in *Plum Bun*, Angela acknowledges that women wield "power of a certain kind too. Such a power she would like to exert in this glittering new world. . . . To accomplish this she must have money and influence." For Angela, passing enables her to enter the social marketplace, where it "would be fun, great fun to capture power and protection in addition to the freedom and independence which she had so long coveted and which now lay in her hand." In this context, she can not separate her feelings for Roger from her materialist desires. In fact, the closest she gets to declaring love is when she admits that she "loves [his] car" and the "comfort, beauty and dainty surroundings" he provides for her.[55] Influenced by her bohemian friends, Angela treats the marriage market as a business. Those who refuse to participate, like Paulette, engage in free love; others, like Angela, wage a calculated siege with one objective in mind: matrimony.

Angela's sophisticated friends, Martha and Paulette, instruct her to manipulate Roger; they are her examples of flapperdom and modern womanhood, epitomizing the life of the twenties artist in the Village with their theories of free love and men's razors on their bathrooms shelves. Paulette advises Angela, "I've learned that a woman is a fool who lets her femininity stand in the way of what she wants. I've made a philosophy of it. I see what I want; I use my wiles as a woman to get it, and I employ the qualities of men, tenacity and ruthlessness, to keep it. And when I'm through with it, I throw it away just as they do. Consequently I have no regrets and no encumbrances."[56] Fully ensconced in her passing persona, Angela does not consider the risks that race poses to such a course of action. A white woman who succeeds in marrying above her social station lives a "Cinderella story"; a black woman, as in the case of Alice Rhinelander, becomes the center of a legal maelstrom of duplicity and accusation.[57] Angela's failure to acknowledge the vulnerability of her race and class position ultimately undermines her ability to succeed at the courtship game using the advice of her modern white female friends.

Predictably, she plays her hand badly: falsely assuming that Roger's infatuation will eventually prompt him to propose, she sweeps her principles aside and sleeps with him after he appears at her door on a stormy night and entreats her not to turn him away. Despite her passionate yielding, Angela's sexual performance fails to win her the "plum bun" because she does not anticipate that her class position will inhibit a wealthy marriage or a happy ending. She believes that, once she eliminates the racial barrier to her happiness by passing, nothing

will impede her success. She sees Roger as "a golden way out of her material difficulties; he was becoming more than a means through which she should be admitted to the elect of the world for whom all things are made." If Angela is the prize, the elusive fair maiden, then Roger, "the blond, glorious god," is the knight in hot pursuit of her. When Roger asks Angela to share a "love nest" with him, she considers it a "milestone" in her life: the moment when she begins to perceive the jagged tears in her imagined secure future. The prince has not offered to promote the peasant girl to princess; instead, he contrives to destroy what he finds most attractive: her innocence. Rather than proposing marriage, which for Angela is synonymous with financial security and therefore freedom and happiness, her beau offers to "keep" her as a mistress, knowing his father will never countenance marriage to a woman without family connections, even if she is beautiful and talented. But Angela's innocence is already somewhat negotiable. After all, she has set out to entrap Roger. She has believed that the only impediment to realizing the fairy tale is her color but has missed the important lesson that "life is more important than colour" and that the fairy-tale of romantic love is a myth for everyone." She has also failed to realize that, while her color enables her to cross the color line, her class position prevents her from achieving her marriage goals. While at first Angela appears to want nothing more from life than a free, leisurely experience, her materialist desires and selfishness prompt her descent in a "curious mixture of materialism and hedonism."[58] Until she uses her skin color and artistic talent for the collective good of the black community, her individualist motivations for passing will not fulfill her emotional or financial needs.

If Angela is also a racial icon, albeit of the hybrid variety—one that embodies the sexual abuses of slavery and mongrel modernism—where is her organic environment? The new market economy that Angela traverses is not the old world of strict social mores but the perilous bohemian terrain of the new woman and the prescriptive activism of the New Negro. Again like Lily Bart, Angela fails to capture her wealthy husband. At first Fauset seems to cast Angela down the same the tragic path, but in the end Angela's impetuous act of moral rectitude—declaring her true race and refusing Roger's tardy proposal of marriage—pays off and rewards her with true love. This is where the novel abandons its critique of the market and the possibility of black female agency within it; instead, Fauset settles on a conclusion inspired by Jane Austen rather than Edith Wharton.

Freedom in Paris?

"Should there be a club—a comfortable small hotel in Paris to which the American Negroes can go and be more welcome?" wrote author Sinclair Lewis to

Jessie Fauset in response to inquiries that led to a series of letter-articles published in the *Crisis* titled "The Negro in Art: How Shall He Be Portrayed? A Symposium" between February and November 1926.[59] Unfortunately, there is no evidence that Fauset ever visited Paulette and Jane Nardal's "Salon Clamart," an interracial circle that featured readings by writers such as Gilbert Gratiant as well as gospel singing. At the Nardals, women rather than men dominated the rites of the afternoon. Editor and founder of *Revue du Monde Noir* (1931–32), a journal that illustrated the influence of African American literature and culture on race consciousness around the world, Paulette Nardal was Fauset's French counterpart. As at Fauset's literary teas, "ni vin, ni bière, ni cidre de France, ni whisky, ni café exotique, ni même ti-punch creole ne refraichissait les gosiers" [neither wine, nor beer, nor French cider, nor coffee, nor rum punch refreshed the attendants].[60] Only English tea was served, and no one stayed past dinner. Fauset's essays on world issues from colonialism to famine demonstrated a cosmopolitan outlook on black diasporic culture. Although she declined to translate René Maran's *Batoaula* into English, she wrote an insightful review and, while in Paris, joined a transatlantic dialogue with pre-Négritude writers and intellectuals.

Focusing on Fauset's use of France as a locale in *There Is Confusion* and *Comedy American Style*, Michel Fabre writes that "Fauset made hardly any use of her French experience in *Plum Bun*"; but in fact the novel does offer the possibility of France as a place for social and artistic freedom.[61] Before and after the Harlem Renaissance, Paris represented an idealized space for social and artistic freedom, attracting African Americans and artists from around the world. Only in France, where Angela has decided never to pass again and to work to become a "significant painter of portraits," can she reunite with Anthony. Her French pseudonym, Angèle Mory, foreshadows her eventual Atlantic crossing. France is where Angela can "immerse herself in the atmosphere of the Louvre" and remember her ambition to become a painter.[62] But given Fauset's negative portrayals of permanent black expatriates, it is likely that Angela will return with her new husband to the United States. Although in her travel accounts Paris is a place where Fauset can have tea "*at the first tea room which takes my fancy*," the inclusion of Paris as the final locale in *Plum Bun* is more than an idealized space: it is yet another gesture to mainstream modernist art culture. Even more important, Angela's French sojourn symbolically situates her in a genealogy of black painters and sculptors (from Meta Vaux Warwick Fuller to Hale Woodruff) who studied in France.[63]

Through Fauset's dramatization of the trials of the African American sculptor Augusta Savage, *Plum Bun's* meta-commentary on New Negro discourse and issues of representation extends the Harlem Renaissance across the Atlantic.

To finance her passage abroad, Angela submits the painting entitled "Fourteenth Street Types" to a contest. The painting's name and subject matter suggest the confluence of folk art and high art common in early twentieth-century African American portrait painting. It also indicates Fauset's consensus with Langston Hughes's argument in "The Negro Artist and the Racial Mountain": among the black working class—the "folk"—"there is sufficient material to furnish a black artist with a lifetime of creative work."[64] It is no coincidence that Fauset's protagonist, Angela/Angèle, is a painter; for through her, Fauset dramatizes the precarious and limited sphere of the black female artist. Together, Angela and her black classmate Miss Powell neatly juxtapose the benefits of passing with the constant discouragement faced by black artists. Both women are gifted African American painters who win scholarships to Fontainebleau. At the last moment, however, as they prepare to sail, Miss Powell's passage money is returned because she would have to travel across the Atlantic on the same ship, perhaps even in the same stateroom, as some white southern girls, which would ostensibly cause her "embarrassment." The unfairness of Miss Powell's treatment prompts Angela, in an act of valiant solidarity, to reveal that she too is "colored" and therefore should also be disqualified.

A widely publicized incident involving sculptor Augusta Savage inspired Fauset's dramatization of Miss Powell's dilemma. In 1923 Savage also sought admission to the prestigious Fontainebleau school. An American committee of artists and architects was responsible for selecting one hundred female artists to attend but, with regret, rejected Savage before she could send in her letters of recommendation and returned her application fee, just as Miss Powell's fee was returned. Significantly, unlike the reticent Miss Powell, Savage fought the rejection. Her mentor, Ethical Culture Society leader Alfred Martin discovered that "the committee felt that [Savage's exclusion] avoided a difficult situation for the accepted 'southern' girls. They would all have to travel on the same ship, eat together, work in the same classes, and this would have been 'embarrassing' to Savage."[65] In the _New York World_, Savage wrote, "How am I to compete with other American artists if I am not to be given the same opportunity?"[66] Her heartfelt words received an inescapable answer: her exceptional talent notwithstanding, she was not to compete with other American artists. Savage's courageous effort drew the attention and support of the New Negro community. Unfortunately, although these supporters included Harlem ministers, intellectuals, and scholars such as Frank Boas, she was severely penalized for being one of the first African American artists to challenge the American art establishment. The incident haunted her career, and eventually she retreated from the art scene too early for an artist of her caliber; she was labeled a troublemaker and

blacklisted by several exhibits, galleries, and museums as a result of her stance toward racial prejudice.

As an editor, writer, and integral figure of the New Negro movement, Jessie Fauset would have known the details of the Savage incident and might also have recalled the experiences of May Howard Jackson, a sculptor of both Anglo and African descent whose work was unfairly criticized by her black and white peers. Jackson's most famous work, *Mulatto Mother and Child*, drew on encounters she had in both black and white spaces as an African American who could pass but did not. Indeed W.E.B. Du Bois's belief that "in the case of May Howard Jackson the contradictions and idiotic ramifications of the Color Line tore her soul asunder" resonates with Angela's identity conflicts.[67] The parallels with Savage, however, are undeniable; Savage actually took courses at Cooper Union, where Angela and Miss Powell both study. Furthermore, their respective treatment by Fountainbleau echoes one of Savage's responses to the denial of her application: "they seemed to get the notion that I must be a mulatto or octoroon, for that seems to me the only way which I could possibly force myself into the white race. Now I happen to be unmistakable [unmistakably black], and that is obviously out of the question."[68] Miss Powell, who represents Savage in the novel, is also "unmistakably black." The crucial difference in Fauset's dramatization is that Miss Powell does not challenge the decision made by the council.[69] White philanthropist Martha Starr, who intends to organize a protest on her behalf, misunderstands her reticence. Only Angela/Angèle understands her decision: "Miss Powell hadn't a thought in her mind about social equality. All she wanted was to get to France and get there as cheaply as possible." A resigned Miss Powell acknowledges: "You don't know the prizes within my grasp that have been snatched away from me again because of colour." Like a modern Tantalus, Miss Powell has to sustain herself as the fruited branches rise and the life-sustaining waters recede. Through this proud yet sympathetic woman, Fauset conveys the double tragedy of the struggling black artist, who must attempt to create without the financial support or encouragement of an artistic community. Yet Miss Powell's fierce pride moves Angela, who has passed in order to avoid the pitfalls Miss Powell has negotiated, to confess her own "colouredness." The explanation is that "she was perfectly justified in letting go so she could avoid still greater bitterness and disappointment and so she could have something left in her to devote to her art. You can't fight and create at the same time."[70] This last sentence contradicts Fauset's own artistic career and the aesthetic philosophy of the Harlem Renaissance, which waged the war for social and economic equality through artistic production. Like Angela, Jessie Fauset was an artist who struggled to represent black beauty without

completely espousing either white ideals or black caricatures. As Fauset attributed her failure to produce more novels to her political and domestic responsibilities, Angela's frustration is a telling commentary on the efficacy of artistic resistance and activism.

As a progenitor of artistic and intellectual exchange in the United States and across the Atlantic, Fauset responded to white American and European representations of the black female subject with her own imaging of the New Negro woman, exemplified by the trials of Angela and Virginia Murray. Angela's visual-minded gaze and the references to the art of the Fourteenth Street school and New Negro periodicals adds another layer to the interartistic representations of the mulatta icon. Fauset imagines the mulatta struggling not just with constraints of race and marriage but with vocation. After Angela's disclosure, instead of returning to the bosom of her family and the black community, she relocates to France to wholeheartedly pursue her art. She has learned the moral that the subtitle of the novel disclaims: passing leads to disappointment and alienation; it allows access to interracial free love or a successful career as a white female artist, but not both. Only after Angela's declaration that, "from now on, so far as sides are concerned, I am on the coloured side," is the love rectangle between Angela, her sister, Anthony, and Matthew Henson resolved in both her and Virginia's favor.[71] Yet the tension between political and personal commitment, tidily resolved in an idealized Paris away from U.S. minefields of interracial strife and sex, lingers even as Angela embraces her "true love." Whether that love is Anthony or her art remains to be seen.

chapter three

"Black Beauty Betrayed"

THE MODERNIST MULATTA IN BLACK AND WHITE

Films made for the lower classes are even more bourgeois than those aimed at the finer audiences, precisely because they hint at subversive points of view without exploring them. In a word, they smuggle in "a respectable way of thinking."

—SIEGFRIED KRACAUER, "Little Shop Girls Go to the Movies"

[In Hollywood] the most tragic situation, the greatest conflicts, the most dramatic phases of racial life: those concerning the mulatto, were ignored and overlooked altogether.

—FAY JACKSON, "Fredi Washington Strikes a New Note"

(Hollywood
laughs at me,
black—
so I laugh
back.)

—LANGSTON HUGHES, "Movies"[1]

When Claude McKay asks, "Could there be a more commendable prescription for the souls of colored Americans than the bitter black imitation of white life?" he criticizes white representations of black life as "syrup-and-pancake hash." Yet he refers to Jessie Fauset's writing as the "real meat" because she situates her heroines in an urban black community. For McKay, Fauset's writing illustrates the dangers of passing, of engaging in the "bitter black imitation of white life." His insertion of racially qualified adjectives into the title of Fannie Hurst's novel, *Imitation of Life,* forces an analogy between Hurst's and Fauset's novels that identifies the tension that besets discussions of authenticity and representation. Fauset's "imitation" demonstrates an African American–centered investigation of race and gender performance: her heroine possesses a depth and complexity that Peola never attains in either Hurst's novel or John Stahl's film adaptation.

Some critics might see Fauset's brand of black art as conservative, bourgeois sentimentality, mostly because the authenticity she valued was frequently synonymous with presenting blacks as attractive, well-educated, industrious, and invariably light-skinned. Fauset steered of sensationalism, refusing to imitate the "lowlife" and inauthentic novels of Carl Van Vechten and T. S. Stribling or the popular local-color fiction of her approving yet patronizing admirer McKay.[2] Instead, she employed a strategy of counter-representation similar to the war of cinematic images that characterized the relationship between the early race films of Oscar Micheaux and *Birth of a Nation*.

If, as I argue in Chapter 2, Jessie Fauset's literary execution of "the pass" in *Plum Bun* relies on a visual grammar informed by the marketing of the New Negro woman as mulatta in popular culture, then considering her passing novel as a primer for charting the screen image of the mulatta in cinematic passing narratives opens a discursive realm in which film translates the convergence of the literary and the visual. This chapter demonstrates that the intense saturation of visual culture referents and stylized acts of passing in Fauset's work, when understood in the context of popular cinematic images of mulattas in films, developed into a new, rich, and influential medium that added its own peculiar logic to the performative aspects of the mulatta in black modernist culture.

I focus on cinematic representations of the mulatta and the passing subject in independent race films and Hollywood productions such as *Imitation of Life*, a film that explicitly links black female stereotypes with American consumer culture and opens a space for cross-genre exchange traceable through reviews, fictive depictions of audiences, and fictional revisions of cinematic portrayals. Ambivalence is the common denominator of the mulatta in literature and on the silver screen; in one scene, she is a New Negro woman committed to uplift and support of black manhood—a moral guide and a calming influence; in another, she is a seductive temptress who threatens class, gender, and race boundaries. Rather than fixing the mulatta icon as a stable figure in varying genres of artistic production, this chapter looks at how a specific medium—the cinema of the twenties and thirties—responds to the themes of transgression and assimilation present in literary passing narratives.

Does the image of the mulatta in early film resonate with her iconographical representation in literature? The major hindrance to this kind of inquiry is the dearth of empirical information on black audience reception. We can, however, examine fiction, reviews, and editorials to unearth the often complex responses of black audiences who were watching race movies and classic Hollywood cinema just before and during the Harlem Renaissance era.[3] Early black film criticism and audience responses to Micheaux's race movies and *Imitation of Life* demonstrate that public scrutiny of the mulatta was often varied and

contradictory: she was by turns denounced as an accommodationist aping of white ideals of beauty and heralded as a radical subversion of Hollywood's depictions of blacks. Once we understand that mulatta iconography and passing narratives were part of a highly marketable genre of fiction and illustration commissions in popular periodicals of the Harlem Renaissance, then we expect those images in cinema as well. The appearance of the literary and cultural mulatta icon in both American cinema (low culture) and the literature of the Harlem elite indicates a certain fetishism of the ambiguously raced black female image. But did these ostensibly divergent black audiences—moviegoers and readers, two supposedly distinct social and economic groups—similarly recognize the narrative codes of mulatta iconography?

I borrowed this chapter title from bell hooks's response to Fredi Washington's portrayal of Peola in *Imitation of Life* to suggest the uneasiness at play when the mulatta appeared as a modernist racial icon in the new but influential and far-reaching medium of film.[4] As with the prolific recycling of the mulatta in Harlem Renaissance fiction, counter-representational strategies often result in reifying a new stereotype when they attempt to undo the old. I cautiously label the specific plot trajectories, characterizations, or portrayals that form these strategies as *transgressive,* but attempts to subvert racial boundaries often reinforce the very structures they challenge by giving them legitimacy through recognition. Such boundaries also know how to police themselves. Hence, what is new has to be consistently redefined. Yes, lightness was valued and idealized as a bourgeois ideal of black femininity, but that did not always mean that the medium advocated the assimilation of Eurocentric definitions of ideal womanhood or that the actresses themselves were mixed-raced or fair-skinned. Because of film lighting, amateurish cinematography, and the degradation of silver nitrate in early films, it's impossible to determine the actual skin color of the actors. As such, race films underline artifice, the calculated performance of color, class, and caste. What I call the aesthetics of ambiguity can be achieved through a stylized routine that combines lighting, speech, and costume along with a familiar narrative involving desire, temptation, deception, and tragedy. Understanding the status of the mulatta icon as a position that can be inhabited, performed, and accentuated by artifice—whether the tool is Motley's painter's brush, Van Der Zee's camera lens, or Micheaux's big screen—should shape how we interpret the relationship between the subject and the gaze and between the product and the consumer.

"But if her skin is white, yet eyes betray her origins"

Before illustrating how a reading of Fauset's *Plum Bun* illuminates the fractures (moments of recognition and misrecognition) in *Imitation of Life,* I want to

consider how Oscar Micheaux's prolific use of the mulatta icon in his race films primed black viewing audiences' reaction to Fredi Washington's performance as Peola.[5] Current film criticism of black spectatorship acknowledges that there are degrees of spectatorship, including accommodationist, resistant, and subversive responses. The degrees reflect the myriad subject positions of individual audiences. Black spectatorship is a diverse and multilayered experience based on a shared understanding of visual grammar. In his introduction to *Black American Cinema*, Manthia Diawara argues that "*Birth of a Nation* constitutes the grammar book for Hollywood's representations of Black manhood and womanhood, its obsession with miscegenation, and its fixing of Black people within certain spaces, such as kitchens, and into certain supporting roles, such as criminals, on the screen."[6] To comprehend the visual grammar associated with passing figures in Harlem Renaissance literature, we must also understand how American cinema has fixed particular images in our collective psyche. This framework is useful to my reading of Fauset's integration of visual elements in her writing; she is always attentive to the value of the image that her female characters project, either through their passing performances or by exemplifying New Negro womanhood. Harlem Renaissance literature draws from the literary bibliography of the nineteenth-century tragic mulatta; film, however, places the old literary tropes in new technology. If *Birth of a Nation* is, as Diawara says, "the master text" suppressing "real" black American culture and history, then race movies provide an alternative grammar that at times subverts Griffith's articulation and at other moments reifies it.[7] That grammar, with its tense balance of sensationalism, voyeurism, and uplift, is drawn from a coalition of visual and literary sources, including the turn-of-the-century fiction of Pauline Hopkins and Charles Chesnutt, whose novels anticipated the mulatta iconography of the Harlem Renaissance.

During Reconstruction, as legal and social systems reconstituted under Jim Crow policed the borders between black and white identities, several common elements of mulatta iconography emerged in both literary and cinematic narratives. Though there may be numerous moments of convergence between film and literary passing treatments, three points emerge significantly. First are eyes, which are primary identifiers of blackness; a viewer can recognize the true race of a passer by looking into them. Remember that in Larsen's *Passing*, Irene locates Clare's blackness in her "negro eyes." Similarly, a fellow passer identifies Eve Mason in Micheaux's *Symbol of the Unconquered* as "one of the many mulattoes who concealed their origins" through her betraying eyes.

Second is skin, represented as either excessively white or "creamy."[8] In race films, the marked female body often signals the historical ambivalence of the mulatta: she is usually marred with some kind of scar or blemish.[9] In the case

of Hollywood films such as *Imitation of Life,* this ambivalence is not always represented onscreen but manifests itself in the audience's response. Black-and-white cinematography further complicates this process of translation because, although camera shots, lighting, editing, and other cinematic apparatuses work together to render the director's vision, they do not always predetermine how the screen image plays to viewing audiences.

Third is the most elusive and intangible element: the soul, the "thing that can't be registered," what Stephen Henderson refers to as "saturation." It's something only the in-group can sense.[10] Synonyms such as loyalty, affinity, and kinship only marginally represent this elusive quality; yet in many narratives, this bond draws the passer back to the black community. Through a continuous recycling of the mulatta icon and these three elements of the passing plot, the visual and literary culture of the Harlem Renaissance produced racially literate, though by no means homogenous, black reading and viewing audiences.

Before the eyes of its captive audience, the orthochromatic screen translates literary myth into pathology; first, with the power- and sex-crazed image of the mulatta in *Birth of a Nation*; then with the slew of victimized and idealized (sometimes at the same time) mulatta heroines in black silent film. Comparatively, Peola, who demands an equal share of white opportunities, seems more transgressive than Micheaux's heroines do, despite the fact that she is a product of mainstream Hollywood. His race-film characters appear to be haunted by the mixed heritage manifested by their pale skin or other mulatta markers. The most dramatic examples of such markers include Sylvia Landry's birthmark in *Within Our Gates* and the scar hidden by Louise Howard's scarf in *Scar of Shame* (figs.14, 15). Furthermore, the practice of casting by color often presents conflicting images that replicate literary vacillations between the image of the mulatta as the model for New Negro womanhood and the seductive, morally questionable vamp. While we can only speculate as to how these images may have affected the spectators who viewed them, their persistence is evident in literature and visual culture during and after the Harlem Renaissance.

Despite film critics' claims that filmmaker and novelist Oscar Micheaux was an outcast of the Harlem Renaissance and the fact that contemporaneous black newspapers denounced him as a "colored Judas," his films made important contributions to the public visual representation of the mulatta icon.[11] According to Jane Gaines, attaching "race movies to the Harlem Renaissance" is a "historical error since the Harlem elite virtually ignored these popular films and wrote them off as having nothing to do with art."[12] Her assumptions are based on rigid definitions of literature as highbrow and cinema as lowbrow and her presumption that inflexible boundaries existed between the black working class and the so-called Harlem elite. Yet class boundaries in the black community

in the late nineteenth and early twentieth centuries were not so definitively or easily drawn. Fauset refers to movie going in both *Plum Bun* and *Comedy American Style*, contradicting critics who maintain that film audiences did not intersect with the artistic and ideological productions of the Harlem Renaissance.[13] Though Gaines is correct in that Fauset does not specifically mention *Micheaux's* films, her understanding of visibility in this case is too limited. By arguing that "race movies were the 'face of the race'" because they "celebrated visibility, relishing the face and bodies of the actors representing the black community," but that the "printed page gives us *nothing to see* really," she ignores how these writers imagined the performance of race through and in conjunction with visual referents of both high and low culture.[14] Those who consider the Harlem Renaissance to be firmly limited to the theoretical domain of Du Bois and Alain Locke might also exclude Micheaux because of his affinity for Booker T. Washington.

14. Sylvia Landry in *Within Our Gates*, directed by Oscar Micheaux, 1920.
PHOTOGRAPH BY THE AUTHOR.

Micheaux did describe himself as so "imbued with the spirit" of Washington that he "injected his ideals into my pictures."[15] Yet to exclude the midwestern-born Micheaux from the Harlem Renaissance is to reaffirm the fixity of the geographic, chronological, ideological boundaries of black artistic expression in the early part of the twentieth century, thus reaffirming genre- and class-bound policing of form.

Like the New Negro periodicals, Micheaux's films yield an iconography that includes portraits of racially ambiguous women as mischievous vamps, angelic madonnas, and innocent schoolgirls. We cannot deduce exactly how audiences perceived the light-skinned female characters portrayed by his "star system of fair skinned actors," but we do know that there are varied opinions about his representations of color and caste.[16] Lorenzo Tucker, one of Micheaux's leading men, maintains that the director featured actors and characters spanning a variety of African American types and hues with the intent of illustrating the diversity of the black image, not unlike Archibald J. Motley, Jr.'s, insistence on presenting "the numerous shades and colors which exist in such great variety among Negroes."[17] Yet Motley had an early predilection for portraits of mulattas, and for the most part Micheaux's films showcase the mulatta as an ideal of

15. Louise Howard in *Scar of Shame*, directed by Frank Perugini, 1927.
PHOTOGRAPH BY THE AUTHOR.

black womanhood whose mixed-race heritage is a often a plot-determining aspect of her narrative that does not prevent her from fully committing herself to the black race. As a result, the heroines from Micheaux's most productive decade (1918–29) do not pass for subversive or individualist reasons.

In this regard, Micheaux's films, especially those that adapt passing novels, reverberate with anti-passing ideology. Central to society's castigation of the passing subject is the notion of a betrayal (of white people, of one's race) that threatens the audience's or reader's sympathy with passing heroines and makes the motivations for passing an important consideration. A case in point: *Plum Bun's* Angela might be forgiven for passing to achieve her artistic goals, but readers will be less inclined to support her shunning of her sister to protect her relationship with her wealthy white suitor. Similarly, in several Micheaux's films, the heroine is often redeemed because she is either ignorant of her mixed heritage or is coerced to pass.

In order to undermine passing as a legitimate strategy, one that is irrecoverably incompatible with uplift, Micheaux dramatically rewrote the heroine of Charles Chesnutt's *The House Behind the Cedars,* retitled for the film as *Veiled Aristocrats.* He altered Rena Walden's motives for passing, making her sojourn in the white world entirely her brother's work. The film's Rena frequently voices her preference for the black community and her upstanding African American lover over the privileges of the white world, as embodied by the suitor her brother advocates. Furthermore, Micheaux rewrote Chesnutt's ending so that Rena repudiates her white fiancé, declares herself proud to be "a negress" and "tired of being a liar and a cheat," and elopes with her black lover Frank Fowler.[18] As in his interpretation of Rena, most of Micheaux's heroines pass either under duress or out of an ignorance of their racial heritage. Once they become aware of the ubiquitous one drop in their veins, Micheaux mulattas are absorbed readily into the black world, their white blood serving to move the black race forward as (to quote both *Veiled Aristocrats* and *The House Behind the Cedars)* "new people."[19] (57). In contrast, those who do not fit the visual or behavioral constraints of New Negro womanhood, such as the promiscuous, "lower-class" Liza Hatfield in Micheaux's *The Girl from Chicago* (1932) or the passing Naomi in Micheaux's *God's Step Children* (1938), either die or remain ostracized.

As evidenced in his film adaptations of his own novels as well as Chesnutt's *The House Behind the Cedars, Marrow of Tradition,* and *The Conjure Woman* and T. S. Stribling's *Birthright,* Micheaux pinpoints a productive oscillation between the written text and the cinematic rendering of that text.[20] His penchant for adaptation indicates his familiarity with turn-of-the-century black fiction. Though several critics have drawn attention to his obvious borrowing from Chesnutt's *The House Behind the Cedars* and his somewhat more discrete reliance

upon *The Marrow of Tradition*, *Within Our Gates*, arguably Micheaux's most radical film, also borrows from an overlooked source: Pauline Hopkins. The plot of the film reveals a fairly standard uplift agenda: the heroine Sylvia Landry is seeking funds to educate black children in the south. In doing so she must overcome her tainted past in order to marry an optometrist, Dr. Vivian, and thus live out a happy black-middle-class existence. The scene where Sylvia Landry (played by Evelyn Preer) is raped (or not) by her father has much in common with the story of Hopkins's heroine in *Contending Forces* (1900). In the novel Hopkins cites "lynching and concubinage" as the major factors threatening blacks at the turn of the century. With a flair for sensation, she then relays the story of her heroine, Mabelle Beaubean/Sappho Clark, at a political rally. Politics and melodrama go hand in hand as the character Luke Sawyer relays how the young Mabelle's uncle rapes and then discards her, offering her father (his half-brother) a thousand dollars to "call it square." The tale provokes a visceral response from the listeners: "Sobs shook the women, while the men drank in the words of the speaker with darkening brows and hands which involuntarily clinched themselves in sympathy with his words."[21] Despite the fact that she was Chesnutt's contemporary, Hopkins has not surfaced as a referent in Micheaux's cinema; yet the parallels are too similar to ignore. Her tendency to insert scenes of explicit racial and sexual violence within her sentimental uplift fiction is structurally similar to Micheaux's flashback to the lynching and "rape" of Sylvia Landry in *Within Our Gates*: the cross-cutting in the film's infamous lynching scene links these two forces. Like the Hopkins's novel, the film relies on melodrama as its preferred method for spotlighting these social issues.

What does it mean for women to emblematically reflect an ideal of black womanhood as racially ambiguous, exotic, or mixed? Such portrayals appear to reinforce Eurocentric standards of beauty, yet they also attempt to expiate the shame, or "mark," of sexual oppression commonly imposed on enslaved women. The desire to recuperate black womanhood from its history of sexual trauma is one that Micheaux shares with Hopkins. The mulatta, whose body is figuratively and literally marked by its heritage of sexual oppression, has to be revealed and then reincorporated into black society. Hopkins's novel advocates a new blueprint for black female virtue in which choice is the primary determinant: "We are virtuous or non-virtuous only when we have a choice under temptation," asserts Mrs. Willis, an influential club woman in *Contending Forces*. Often engaged in uplift endeavors, Micheaux's heroines, including Sylvia Landry, serve to rectify the injustices of people like Sappho Clark's uncle, who, when he explains the his niece's rape to her father, asks, "What does a woman of mixed blood, or any Negress, for that matter, know of virtue?"[22] Ultimately, most of Micheaux's mulattas derive from nineteenth-century portrayals that sought to

restore rather than castigate the mulatta and, by association, all black women, redefining them as true women according to new cultural standards of morality.

Yet one disturbing aspect of Micheaux's treatment of the mulatta subject is swept under the rug in critical discussions: his suggestive staging of incest. Three of his films—*God's Step Children* (1938), *Within Our Gates* (1920), and *Veiled Aristocrats* (1932)—link the passing motif with this often unexplored theme in early African American literature. Micheaux's subtle treatment of incest invokes nineteenth-century pseudo-scientific discussions of hybridity, such as nineteenth-century theorist Henry Hughes's claim that "the same law which forbids consanguineous amalgamation forbids ethnical amalgamation. Both are incestuous. Amalgamation is incest."[23] Because the famous lynching scene in the film *Within Our Gates* has been discussed in detail elsewhere, I will briefly touch instead on the "rape" that takes place between Sylvia and her father. The cutting and intertitles suggest two possible scenarios. In one, Sylvia's father "recognizes" her by a birthmark *before* he rapes her, hence avoiding the incest: "A scar on her chest saved her because, once it was revealed, Gridlestone knew that Sylvia was his daughter—his legitimate daughter from marriage to a woman of her race—who was later adopted by the Landrys." But the cross-cutting invites a second interpretation: the shock on Gridlestone's reveals that he has already assaulted his own child. As Gaines argues, Micheaux presents an instance in which interracial rape is "enacted as well as averted."[24] This sequence, in which Gridlestone's hand appears menacingly on his daughter's breast, significantly reveals the open secret of miscegenation. It underlines the dangerous results of white male desire for the black female body. Unchecked, such desire not only produces mixed-race children but can lead to the misrecognition of one's progeny, hence precipitating interracial incest.[25]

In *Veiled Aristocrats*, Micheaux infuses the reunion scene between John and Rena (they share a not-so-fraternal kiss) with the same the tensions conveyed in Chesnutt's novel. In the first chapter, John Walden follows and "find[s] his glance fixed upon [Rena]." This languid scene, which precedes the reunion of John and the woman he suspects is his sister Rena, describes her in more than brotherly terms. With much focus on Rena's "admirably proportioned figure," the narrative illustrates that her brother assesses her with the same "measured distance" he keeps as he walks behind her. He observes her "promising curves" on the cusp of womanhood, her "abundant hair," and her neck's "ivory column" and pronounces her "strikingly handsome." "A woman with such a figure," he determines, "ought to be able to face the world with the confidence of Phyrne confronting her judges." Or, as John plans, she should be able to pass for white and serve as a substitute wife-hostess for himself and mother-aunt for his son.[26] Though Micheaux's *Veiled Aristocrats* draws precious little from Chesnutt's novel,

the director did film this opening scene, with the camera standing in for John's obsessive voyeurism. In the novel, John's gaze is a precursor to the judging gaze that will follow Rena throughout the novel and ultimately to her grave. In the film, which has a different ending, the gaze heightens her desirability.

In a later passing film, *God's Step Children* (1938), Micheaux was less subtle about incest. Several scenes suggest an improper relationship between Jimmie and Naomi, the prodigal daughter. When Naomi arrives home from the convent, where she has been incarcerated for about twelve years, she repeatedly asks her foster mother, Mrs. Saunders, about her brother Jimmie and his financial success. In an earlier scene entitled "Girlhood," Jimmie defends the child Naomi from the community's rage when it discovers she has instigated a salacious rumor about a teacher. Now he views the beautiful adult Naomi with caution. Bizarrely, their mother encourages Jimmie to kiss his sister: "You know what she needs," she says, inviting him to greet her with a more-than-brotherly kiss. She then observes rather obtusely that their hesitation makes them look more like long-lost lovers than brother and sister.

In a later scene, Jimmie takes both his sister and Eva (his fiancée) to a club where they watch a black woman performing what can only be an imitation of Josephine Baker's *Danse Sauvage* or Aida Overton Walker's *Black Salome* to the tune of Duke Ellington's "Mood Indigo." The image of Black Salome is an important one. Western interpretations of Salome portray her, to quote Bram Dijsktra, as "virgin and devouress," an ambivalent characterization similar to the fraught role inhabited by the mulatta.[27] Following a sensuous performance by a chorus line, Jimmie dances with a scantily clad Naomi at the behest of Eva, causing Eva's disapproving aunt to comment that they do not appear to be brother and sister and to remind Eva that they are actually foster siblings. In this scene, the look on Naomi's face is both serene and calculating. The other patrons of the club admire her beauty, which is accentuated by the deep V-back of her shimmering white gown. Though Eva is also attractive, in contrast she appears much more modest than her rival. On screen, Naomi's white skin is her most distinguishing feature. The intoxicating appeal of exotic blackness contained in a visibly white form—whiteface, so to speak—is mirrored and amplified by Micheaux's insertion of provocatively attired chorus girls.[28] The girls underscore Naomi's desires for both incestuous love and money; they embody the primitive and the modern at the same time, tapping into a romantic sensuality that, like Salome's performance, exacts a high price.

On and off screen, chorus girls, black or white, both appealed to and threatened the wealthy and powerful. African American audiences may have been familiar with the whirlwind romance between then assistant pastor and heir-apparent to the famed Abyssinian Baptist Church, Adam Clayton Powell, Jr.,

and chorus girl Isabel Washington, sister of actress Fredi Washington. In her unpublished memoir *Adam's Belle*, Isabel W. Powell wrote, "Somehow it wasn't proper for the pastor of the greatest black church in the country to marry a showgirl."[29] Described by Powell as "the most beautiful woman I have ever seen," their 1933 wedding was a social spectacle that attracted a crowd of thousands.[30] No doubt Oscar Micheaux also noted the popularity of *Gold Diggers of 1933*, a mainstream film about a songwriter whose family threatens to disinherit him if he marries a chorus girl. In *God's Step Children*, in the scene just before the strategically choreographed chorus girls perform, we discover that Jimmie has saved a small fortune ($6,700) by working as a Pullman porter, a very respectable and desirable position for black men during in the thirties. The love- triangle scene follows this disclosure, emphasizing that Naomi's romantic interest in her brother is also function of his material success.

Not surprisingly, after the dance scene, Jimmie and his mother confer and conclude that, unless they marry Naomi off quickly, she'll cause trouble. They decide to marry her to a neighboring farmer named Clyde. The dark-skinned, dialect-speaking Clyde worships Naomi for her beauty and color. But Clyde horrifies Naomi, who is already in love with her brother. She describes him as ugly and asks, "What's wrong with his face?" Her prejudice against dark-skinned blacks has clearly persisted into adulthood. Naomi tells her brother that marriage to Clyde would be a "sublime sacrifice" but that she will do it, on the condition that he kisses her passionately one last time. A year later, Naomi abandons Clyde and leaves her son with her mother before going over to "the other side," a euphemism for passing as white. Of course, she can't take her brown baby boy with her. In a conversation that eerily anticipates an exchange between Peola and her mother in *Imitation of Life,* when Peola tells her mother, "Even if you pass me on the street you'll have to pass me by," Naomi says to Mrs. Saunders, "If you pass me on the street, we're strangers." Tellingly, the existing print does not show the scenes in which Naomi actually passes as white or has a white husband. Were they filmed and then censored afterward? Unless another print surfaces, we will never know.[31]

At one point Jimmie says that "Naomi hasn't changed but she's learned restraint." What has gone wrong with Naomi? Has she been punished, confined, married, and ultimately condemned because she has the wrong desires, including incestuous love and a hatred of dark-skinned blacks? This is what's suggested. Like Larsen's Clare Kendry, she must be contained and cannot be allowed to fulfill her very improper desires. The child Naomi is a bad seed, naughty, colorstruck, but still possessing the potential for reform. Once she is an adult, Naomi's surrogate family prevents her from expressing her love and her sexuality. To prove she's "learned restraint," to temper and conceal her true nature, which is

evidently unchangeable, she consents to marry Clyde. Because of her inability to reform completely, the film ultimately portrays Naomi as a Jezebel in contrast to Eva. The final scene constructs Eva as a brown madonna: she sits, holding Naomi's deserted son in her lap, encircled by her own children. A repentant Naomi gazes longingly at her son through a window before running away again—this time, presumably, to her death. Thus, the passing woman is castigated for her denial of her foster mother, her abandonment of her son, and her refusal to be an ideal New Negro woman. Desire for an alternative identity renders her a race traitor, a wayward wife, and a bad mother with inappropriate desires for whiteness, same-sex attraction, and incest. When the little boy asks his grandmother, Mrs. Saunders, about the woman in the window, he is told "no one else saw her. So let's forget all about it and just pretend she wasn't there."

If we concede that the mulatta figure is a fictive construction reliant on the mythology of pseudo-scientific genetic determinism and social perceptions of racial mixing, and if we allow that artists and writers incorporate history to reinforce the authenticity of their representations, we can see that Micheaux is no exception. The sensationalism of the famous 1924 Rhinelander case, for instance, found its way into the promotional material of Micheaux's 1924 version of *The House Behind the Cedars*, "an amazing parallel to the famous Rhinelander case," which tells the "the story of an aristocratic young white millionaire's passionate love for a beautiful mulatto girl being passed off as white."[32] Of course, Micheaux, who often screened films in defiance of the census boards and used inflammatory material to garner audiences, knew the value of sensationalism and controversy.[33]

One of the more sordid trials of the twentieth century, the Rhinelander case marks an interesting point of convergence between Harlem Renaissance novels and Micheaux's race movies. Nella Larsen obliquely refers to the case; and though Fauset makes no direct gesture to it, the case haunts the love affair between Angela and Roger in *Plum Bun*. The class and color issues that drive a wedge between the lovers echo many of the issues at stake in the Rhinelander case. In an early conversation about Roger, Paulette warns Angela that he "mustn't make a misalliance"; and when Angela replies, "He's not royalty," Paulette rejoins, "Spoken like a good American. No, he's not. But he mustn't marry outside certain limits. No chorus girl romances for his father. The old man wouldn't care a rap about money but he would insist on blue blood and the Mayflower." Angela half-listens to Paulette's warning, hearing only "Roger, a multi-millionaire."[34]

Interestingly, early press coverage of the Rhinelander case characterized Alice and "Kip's" relationship as a classic rags-to-riches tale—until, of course, Alice was found to have black blood. As in *Plum Bun*, the case featured a family

with two sisters; one married black, the other white. And like Angela, Alice Jones Rhinelander was depicted as a gold-digging social climber, who, as the court proceedings revealed, had engaged in premarital sex. In the novel, though Roger does treat Angela cruelly toward the end of their relationship, she is never subjected to the kind of exposure that Alice Jones Rhinelander experienced: "By offering her body as evidence, . . . Alice's lawyers placed her within this iconography, which pictured black women as highly sexualized bodies available for the entertainment of white men."[35] At stake in the Rhinelander case was the answer to this question: how can blackness, something supposedly evident and legally fixed, be disputable? The conflicting elements of mulatta iconography as aristocratic, exotic, virginal, and sexually accessible collided, in this case, to transform a real woman into a public courtroom spectacle. To save herself, Alice had to prove that her race was legible to her husband. Her lawyers had her undress to prove this "fact," submitting her body as evidence that she was not engaged in deceptive passing. Alice's disrobing was, in effect, a spectacle of legally sanctioned pornography engineered by her defense lawyers to prove that her husband was not a dupe but a racially literate white man. Although the press was barred from the courtroom on the day of Alice's exposure, several newspapers imagined the scene for their readers through sketches or other manufactured illustrations of her naked body. The *Evening Graphic* actually created a composite photograph, inserting a light-skinned, dark-haired hired model to pose as Alice *en dishabillé*.[36] W.E.B. Du Bois castigated the press for its treatment of Alice, indeed laying the blame for her marriage's dissolution at its feet: "Why could the press persecute, ridicule and strip naked, soul and body, this defenseless girl?"[37] Whether or not the black public sympathized with Alice, authors and filmmakers saw the potential in referring to this case.

Few African American–authored passing narratives published in the 1920s and 1930s were made into films, yet writers such as Jessie Fauset were eager to see their work up on the big screen. In a 1950 letter to Langston Hughes, nearly twenty years after her last novel was published, she wrote, "I think I shall die if I don't succeed in getting THE CHINABERRY TREE and COMEDY: AMERICAN STYLE accepted in Hollywood." Her letter indicates that she had spoken with three agents, one of whom explained that several films appearing in 1949 had already treated passing: *Lost Boundaries, Pinky,* and *Intruder in the Dust.* In the same letter, she explained the differences between her work and those films: "*Comedy American Style* is a strong limning of the psychological and pathological effect of color prejudice on colored people themselves. Not too much of that has been done, I think, in films, plays or novels. If we get some director to recognize the poignancy of that effect there really would be something new under the sun and we'd be getting places."[38]

What makes Fauset's novels sharply different from white-authored passing narratives is that she places the passer in juxtaposition with a vibrant black middle-class community that could not be replicated in mainstream Hollywood cinema. In Hollywood films of the period, even those dealing with social issues, black characters seem to be stranded on a white island or are limited to starring in all black musical fantasies like *Cabin in the Sky*. Micheaux produced several films that dealt with passing and miscegenation during the time that Fauset was writing; but though his films do portray black communities, his race melodramas lack Fauset's perceptive critique of intersectional politics. Her protagonists face proto-feminist dilemmas substantially more complex than those of the heroines in either Micheaux's race films or Hollywood melodramas, which probably explains why they never made it to the silver screen. Moments of intersection between fictive melodramas like Micheaux's films and real-life tragedies like the Rhinelander case contextualize the controversy surrounding the Hollywood production of *Imitation of Life*. Hollywood did not fail to exploit the potential intrigue of race melodrama, and that film was just the beginning of a slew of profitable movies that hoped to capitalize on its success.

Fauset's "Imitation" and the "Peola Discourse"

The 1934 *Imitation of Life*'s representation of Peola, as played by black actress Fredi Washington, can be productively discussed with Jessie Fauset's visually inflected narratives of passing.[39] Rather than a straightforward comparative analysis between mainstream cinema and race movies, I focus on Fredi Washington's performance to demonstrate how the discourse surrounding the mulatta starlet of race movies and the iconic passing subject disturbed the logic of Hollywood representations of blackness, especially black femininity. Placing audience responses to Washington within the framework of Fauset's narrative template reveals a disjuncture between black and white representations of passing. This strategy allows us to unpack the contradictions embedded in the passing plot's dependence on a common understanding of mulatta iconography as portrayed in early black cinema and recycled with a difference in John Stahl's film. The visual grammar of racial recognition circulating in African American literature and popular culture during the Harlem Renaissance was endemic to the language of passing, a language comprehensible only to the in-group. This language is at once specific, authentic, and mythic. Similar to what Amy Robinson calls the "triangular theater of the pass," the poetics of passing rely on a set of intangible rules that enable recognition by the in-group and misrecognition by the dupe.[40] African American authors addressing a white audience propose to introduce readers to the "freemasonry of the race," to expose

and quantify what Larsen's character Irene in *Passing* describes as "a thing that couldn't be registered."[41] Although all of Fauset's novels thematize performative and spectacular aspects of racial identity, *Plum Bun,* with its highly detailed tracing of the passing performance, best articulates this aspect of racial identity. In her racially divided world, mothers model the passing performance for their children, who in turn rehearse it within the safety of the family before it is finally enacted in the outside world. That performance and all it entails is the focal point of this section.

Fannie Hurst's 1933 novel *Imitation of Life* tells the story of two single mothers, one black and one white, who build a commercial empire on packaged pancake batter yet suffer in their private lives because they cannot ensure or control their daughters' happiness.[42] Submerged beneath the melodrama of this rags-to-riches tale is the equally sentimental struggle of the black daughter to reconcile her desire to be white with her love for her mother. In the dual climax of John Stahl's film, the black daughter, Peola, rejects her mother, who then promptly dies of heartbreak, while the white daughter, Jessie, falls in love with her mother's fiancé, effectively preventing their marriage. The private, parallel, mother-daughter conflict is juxtaposed against the public material success of the white mother, Bea Pullman, which is gained by exploitation of the black mother's pancake recipe and the commodification of her image as "Aunt Delilah" (a play on "Aunt Jemima") to sell the product.[43]

As in Fauset's *Plum Bun,* the marketplace is a powerful entity in *Imitation of Life;* the film consistently exposes audiences to images and objects of consumption, and its heroine, Bea, is motivated and manipulated by the demands of the market. Advertisements that used women's faces and physiques to sell products bombarded a wide variety of American consumers in the thirties. At the same time, the proliferation of consumer organizations, many focused on women, such as the League of Women Shoppers, indicated that certain groups had to negotiate the freedoms that accompanied membership in American consumer society.[44] In *Imitation of Life,* the suggestion of customer Ned Sparks, who later becomes Bea's manager, to package the pancake flour (or, in his words, "Box it") refers to the million-dollar advice given to Coca-Cola mogul Asa Chandler: "Bottle it." Not surprisingly, Coca-Cola marketed their product in a patented, distinct, hourglass-shaped bottle. Their advertisements consistently featured scantily dressed actresses and models gleefully grasping Coke bottles. The unstated assumption was that the elation one feels while drinking Coca-Cola—the "pause that refreshes"—was akin to sexual gratification.[45]

We know that sex sells, certainly, but does race? Figures that evoke plantation nostalgia in the American psyche have long been used to promote and sell products.[46] But what specifically does the mulatta icon advertise? On the one

hand, she presents a refined version of black femininity; on the other, she exudes an alluring subversive modernity. In Micheaux's films, the chorus girls exemplify this bifurcation; they advertise an illicit, dangerous, and immoral life-style available only to a privileged few who can view them in a cabaret setting, thus reflecting the class status of the hero, who can afford to patronize such clubs. Their provocative attire and energetic physicality balances an exotic primitivism with an urban industrialism, which they convey through their repetitive movements and synchronism. Their performance reminds us that, although mulatta icons can communicate respectability as aristocratic helpmates who foster masculine achievement, we cannot underestimate their sex appeal. The mulatta slave was a valuable commodity inaccessible to black men who had neither the capital with which to purchase her nor the right of ownership over their wives and daughters. It is this complex mix of legitimacy and eroticism that makes the mulatta so difficult to codify.

On the surface, Peola and Delilah fit the cinematic and literary stereotypes of the tragic mulatta and the black mammy; however, there are fissures in their performances, dialogue, and stage directions that question the constructed nature of these roles and what they are supposed to be representing. For instance, responses to Peola vary from a complete understanding of her desire for a better life to condemnation of her refusal to acknowledge her mother. Peola's frustration with her appearance and her desire to be white, particularly when read against the artificiality of her smiling, pancake flipping, yet heartbroken mother, illustrate how American cinema distorts the black female body and attempts to mask the provocative questions about race and entitlement that Peola's anxiety and visual presence demand. In one of the most crucial scenes of the movie, when Peola explains her decision to pass to her mother, the camera twice interrupts the tearful exchange between them to focus on Bea Pullman's sympathetic white face. Instead of doing a shot reverse shot during the dialogue between mother and daughter, the camera keeps Peola and Delilah at a distance in a medium long-shot frame and then reverses to a close-up of Bea's face while we hear Peola say, "You don't know what it is to look white and be black."[47] The technique maintains Bea's centrality, even though this is Peola's climactic scene. In the sequence, the camera also avoids placing Bea, Jessie, and Peola, all dressed alike in dark dresses and hats, side by side facing the camera in a frame. This draws attention away from the fact that the three women obviously look more like a family than Peola and Delilah do. Only at the end are they shown together, again in black, but this time for a funeral.

Most film and cultural studies criticism focuses on the 1959 Douglas Sirk remake, which lends itself to psychoanalytic interpretations because of its preoccupation with artificiality and repetition; however, despite Sirk's stylistic

sophistication, John Stahl's 1934 version is more suited to an analysis of visual culture's impact on Harlem Renaissance literature.[48] Not only is Stahl's film a closer adaptation of Fannie Hurst's novel, but it stars African American actress Fredi Washington as Peola, the passing daughter.[49] More important, his *Imitation of Life* was produced at a time when viewers still confused reality with on-screen portrayals, often mistaking those images for real life (fig. 16). Donald Bogle reports that Fredi Washington's portrayal of Peola was so convincing that some black audiences conflated the personality and politics of the fair-skinned, green-eyed African American actress with that of her character:

> On one occasion, as Fredi Washington sat in a beauty parlor, she overheard another woman telling a beautician that she knew Fredi Washington and that that high yellar so and so was, in real life, just the way she had been on screen. Of course, the woman did not know Washington at all, and when Fredi introduced herself, the lady promptly shut up. On another occasion, as Washington was leaving a Chicago theatre that had shown the picture she was grateful not to be recognized because all the conversation centered on the ingrate daughter. "I bet that Fredi Washington is just like that too" was comment the actress heard too often.[50]

Black audiences' discomfort with Washington and her convincing performance as Peola laid bare a buried, shameful desire—the desire to be white—which, according to cinematic and mainstream American ideologies of beauty, was the same as the desire to be beautiful.[51] Identification with Fredi Washington's portrayal of Peola sprang from the black female spectator's honest desire for to identify with beauty. Only a complex and multilayered understanding of both the discourse of passing (as an act of betrayal on the part of the dupe, as an act of subversion on the part of the passer) and the spectator's response to visual black images can account for these contradictory readings of Peola. On one hand, the audience is sympathetic to her critique of the social circumstances that prevent her from sharing the advantages entitled to the white daughter Jessie; however, they simultaneously condemn her ingratitude toward her mother, even if she is a mammy figure—or precisely because she is a mammy. As bell hooks admits, "There was something scary in this image of young sexual sensual black beauty betrayed—that daughter who did not want to be confined by blackness, that 'tragic mulatto' who did not want to be negated. 'Just let me escape this image forever she could have said.'" (*Reel to Real* 204).[52]

The irony is that neither Peola nor Washington nor any black or white spectator could escape the mulatta icon, who, in both literature and film, drew attention to the limited socioeconomic position of African American citizens in the United States. Black press coverage of actresses such as Nina Mae McKinney

16. Robert S. Scurlock, photograph of Fredi Washington, 1930.

and Lucia Lynn Moses illustrates how black periodicals used photographs of actresses and other performers as models of ideal womanhood whose images advertised a specific type of black beauty. For instance, the *Pittsburgh Courier* had a special interest in covering Nina's rise to stardom at the tender age of sixteen through her bit role as a low-class hussy in the fifties passing film *Pinky.* An article on McKinney, where she is cleverly quoted as an ambitious promoter of integration, is accompanied by an ad for hair straightening.[53] In *The Scar of Shame*, an uplift film by the Colored Players Production Company, Lucia Moses plays Louise Hillyard, a young beauty abused by her father, abandoned by her husband, and forced to wear a scarf around her neck to cover her "scar of shame." Newspapers called Moses the "most glamorous of black actresses on the silent screen."[54] Ironically, the character she plays in the film has to die in order to allow her husband, a heroic race man who marries her only out of a duty to protect and redeem black womanhood, to marry a woman of his own "caste." The film bears out the two most common incarnations of the mulatta icon: the seductive vamp and the ideal wife.

Though few of these race movies ever crossed into the mainstream, they set the stage for Fredi Washington's portrayal of Peola in the Hollywood hit *Imitation of Life.* Some audiences had already seen Washington perform as the ill-fated dancer in Duke Ellington's 1929 short "Black and Tan Fantasy."[55] The film features Washington, scantily clad in a sequined dress, dancing an energetic number reminiscent of Josephine Baker's *Danse Sauvage* atop a mirrored stage. Despite a heart condition that forces her into retirement, she agrees to dance one last time in order to pay off Ellington's debt. After she falls to the ground as a result of her exertions, the club manager has her unceremoniously carted offstage as Ellington continues to perform. The next time we see her, she is on her deathbed in a frame eerily similar to Delilah's death scene in *Imitation of Life.* Gospel music croons in the background as Washington turns a despondent face toward the Duke and says, "Play me the Black and Tan Fantasy" one last time. The visual impression of the self-sacrificing dancer fixed Washington as a tragic mulatta icon in the eyes of the viewing public even before she starred as Peola. In a strange slippage between the actress and her onscreen persona, the film credits her as an unnamed "dancer," but just before her fateful performance, the club manager introduces her as "Fredi Washington." The fact that she essentially stars as herself further elides the boundaries between the "high yella" dancing girl on screen and the black actress-activist in the Harlem community.

Empirical understanding of how African Americans experienced and responded to black cinematic and literary representations concretizes the difficult nature of black spectatorship. With regard to literature, I use the term

spectatorship along with *reader* and *audience* because it accentuates the voyeuristic gaze present in *Quicksand* and *Passing, Cane* and *Plum Bun,* the central novels of this study. Both bell hooks and Valerie Smith contend that black women develop an oppositional spectatorship that prevents them from uncritically absorbing the stereotypical images portrayed by mainstream Hollywood cinema.[56] This idea of an oppositional spectatorship suggests a disjunction between what is being represented and what is real or authentic. Jacqueline Stewart's compelling concept of "reconstructive spectatorship" provides a nuanced "formulation that seeks to account for the range of ways in which black viewers attempted to reconstitute and assert themselves in relation to the classical cinema's racist social and textual operations." The idea of reconstructive spectatorship destabilizes the "presumed pleasure of classical absorption and distraction."[57] Several reviews and responses to *Imitation of Life* in the 1935 issues of the *Crisis* and *Opportunity* reveal how black spectators may have responded to the film; however, I mainly focus on those that illustrate how the visual currency of the mulatta icon and the passing subject disturbs notions of authenticity in African American visual culture. Yet it is impossible to discuss Peola's authenticity without mentioning Delilah's because, in the pantheon of American racial stereotypes, the mammy and the mulatta are, in many ways, foils of one another. The responses from black audiences illustrate that, while many did have an oppositional reaction to the film, the nature of their opposition circulated around the discussion of representing a real black experience rather than the inauthentic Negro caricature of white mainstream imagination. In addition, *all* the responses demonstrate difficulty in dealing with Peola.

It is significant that the first review I discuss reveals that the bizarre grammar of American race relations is literally untranslatable and unrecognizable in a foreign context. In Mercer Cook's review, "Imitation of Life in Paris," he relays a laudatory review of actress Louise Beavers in *Le Populaire,* which asserts, "She is not merely an interpreter of a role, she is Delilah herself."[58] It is difficult to reconcile American and French receptions of the film. On one hand white spectators from both countries saw Beavers's portrayal of Delilah as authentic: she looked like their image of a mammy figure. Cook, however, acknowledges that there is no French translation for the line "I ain't no white mother, I'se your mammy." This line syntactically makes a racial distinction between white and black motherhood. Nevertheless, the context (Peola asks her mother to pretend not to notice her if they pass each other on the street) suggests that a black mother could never disown her child, while a white mother might. The incongruity between the scripted dialogue and Beavers's performance often presents contradictory messages that usurp the authority of the film and expose the flaws in its imagined representations. When this happens in the French

context, the visual images do not denote a corresponding grammar. Evidently, there is no language to represent what is seen onscreen, and that supposed lack of language shields the real evidence of France's discriminatory policies and prejudices toward its colonial subjects.[59] Along with *mammy, passing* evidently also cannot be translated into French; and the translators had difficulty reproducing black dialect for a French audience. A perplexing compromise results in the inclusion of lowercase letters in the subtitles to reflect the mispronunciation of specific words. For instance, instead of "Pour," the French word for *for,* the subtitles read "POUr." The challenge of rendering the film comprehensible to a foreign audience reveals the inherent absurdity of America's racist caricatures. Furthermore, Cook explains that the French screening included a statement from critic Odette Pannetier explaining how discrimination, segregation, and prejudice make the Negro's life in the United States unbearable. This preface would never have appeared in the United States because it explicitly critiques America's treatment of its African American citizens and focuses the audience on the movie's racial theme rather than its formulaic white mistress–black maid pairing. In the U.S. context, the iconography of the mammy and the mulatta overwrite any flaws perceived by the audience. From the vantage point of white American spectators, Beavers's character can be read as authentic, despite her dissembling.

The difficulty of accurately translating America's racial idioms overseas reveals a disjuncture in the film that black audiences immediately identified. In a letter to the editor published in the *Crisis*, Pauline Flora Byrd contradicts Cook's notion that Beavers is "Delilah herself" by arguing that Delilah and Peola are not "real negroes." but represent "what white people want us to be."[60] Byrd's response to these onscreen portrayals as inauthentic echoed ongoing debates about race in the late nineteenth and early twentieth centuries, which coalesced in Alain Locke's *The New Negro*, published just nine years earlier in 1925. In his treatise, Locke insists that the New Negro is in the process of "shaking off the psychology of imitation and implied inferiority" and that the days of stock figures, "aunties," "uncles," and "mammies" are gone.[61] But as *Imitation of Life* and many other films demonstrate, intellectual intervention without the political power to enforce it cannot completely dismantle the myth of the ignorant, sentimental, dehumanized "Negro" in mainstream imagination, although that is the task that Locke, Fauset, and many other Harlem Renaissance writers and artists set for themselves.

Because most of the U.S. reviews focus on Beavers and her inconceivable, though pardonably sympathetic, figure, they share a general, discursive avoidance of Peola—with one exception: Fay Jackson's "Fredi Washington Strikes a New Note" in the *Pittsburgh Courier*. With the authority and style of an established

early black film critic, Jackson writes, "Actress though she be, Fredi Washington expresses the desire for freedom and equal justice in this picture that is more convincing that any mere performer could have voiced. True to her own life, the injustices of color and race retarded and prohibited a fuller life and freedom of expression." Washington's portrait of Peola spoke volumes to the black spectator, despite the fact that her role was primarily "confined" to a "carefully handled subplot" and that audiences disapproved of Peola's condemnation of Delilah. According to Jackson, when Peola utters, "I want the same things other people enjoy," that desire echoes "in the hearts of 12 million smoldering Negroes throughout the United States."[62] The significance of Washington's performance cannot be underestimated, but its effect was not always transparent, as these conflicting responses demonstrate.

Although these viewer responses provide a rich context for inferring how audiences might have responded to the mulatta figure in *Imitation of Life*, such perceptions are left out of Lauren Berlant's otherwise illuminating "National Brands/National Bodies," which analyzes all three versions of *Imitation of Life*: Fannie Hurst's novel (1931), John Stahl's film (1934), and Douglas Sirk's remake (1959). She does use Larsen's *Passing* as an introductory text to the history of passing narratives in American literary and cultural memory, but she focuses mainly on the relationship between Delilah and Bea, between the mutually constitutive bodies of ultra whiteness and blackface blackness promulgated by classic Hollywood cinema, in lieu of a thorough analysis of Peola's complex liminal status.

As disparate viewing experiences indicate, Peola strikes an odd chord in Stahl's film by occupying an in-between space both visually and racially. Onscreen, she is trapped between Delilah's neon, trademark mammy image and Bea's duplicitous persona as a loving but unobservant mother who focuses more on business than her own child.[63] Significantly, Peola represents an instance in which the mulatta stands in as a signifier of both male and female black identity. Indeed, the only politicized statements in the film that draw the audience's attention to the system of racial hierarchy in the United States are those concerning Peola's awkward position. Described by Donald Bogle as "the New Negro demanding a New Deal," Peola represents black desire for white privilege and a kind of repression of sensual expression; despite her beauty, there is no love match for her.[64] As the reviews demonstrate, Fredi Washington's stunning image gave black spectators a space for partial identification and a limited expression of their deeper, unconscious desires. What's striking is that Peola voices racial dissatisfaction for black men and women in a film where black men are conspicuously absent (with the exception of Delilah's pastor and Bea's chauffeur). The film intends audiences to interpret Peola's problem as a combination of

ingratitude and her own inability to accept her rightful place in the racial hierarchy, despite Delilah's comment that she is "puzzled" by racial inequities. For black audiences, according to Jackson, Peola represented "the true symbol of the American Negro struggling."[65] Tellingly, even at the end, once Peola has been punished for her renunciation of her mother by Delilah's death, there is still no place for her. At one point, Bea suggests she go away to a black college where she would not be confronted with "the problem of white all the time." At the funeral, the black spectators and undertakers view her with apathy and mild curiosity. (Incidentally, this is also the only scene that shows the prodigal Peola and Delilah interacting with a black community.) After the funeral, Peola is placed in the front of the hearse with the driver, while the white family reconstitutes itself in the backseat of the car.

The White Woman in the Mirror

According to Laura Mulvey, "women are constantly confronted with their own image in one form or another, but what they see bears little relation or relevance to their own unconscious fantasies, their own fears and desires."[66] This assertion explains the primacy of the patriarchal spectator in classic Hollywood cinema, yet it does not account for Peola's experience of her own image when she gazes into the mirror with her back to her mother, passionately exclaiming, "Isn't that a white girl there?" Hollywood frequently used uncredited black women to amplify the sex appeal and beauty of white starlets, fixing their screen goddess status in the public eye. For an actress such as Fredi Washington, it took more than a "white skin" to get that white woman in the mirror to come to life; she had to draw on an already familiar discourse of passing and mulatta iconography in her performance.

Passing narratives thematize the conundrum of the "white woman in the mirror": the incongruity of looking white but being black. Fauset's *Plum Bun* is no exception; her novel repeatedly mocks the predictability of the responses to racial disclosure. Whenever Angela's race is discovered, the injured white party responds with dismay: "But, Miss Murray, you never told me that you were coloured," to which Angela replies, "as though she were rehearsing a well-known part in a play. 'Colored! Of course I never told you that I was coloured. Why should I?"[67] Angela justifies her actions, rationalizing that if people cannot tell she is black, why should she tell them? It is difficult to distinguish inadvertent passing from supposedly deceptive passing, which is performed with cunning, adeptness, and determination. The moral of the novel, and the film, locates itself around Angela's and Peola's question: why should I tell? If you fall for the performance the illusion is real; the mask becomes the face.

To understand *Imitation of Life* as a cinematic passing narrative that employs sentimental melodrama in the service of social commentary, we must comprehend the moral, social, philosophical, and cultural baggage that the passing subject carries in literature. In *Plum Bun*, Angela's character development as an artist occurs within the novel's exploration of the morality of passing, indicated by its deliberate subtitle, "A Novel without a Moral," which addresses, among other issues, the supposed deceit inherent in passing. Whenever Angela discloses her race, her employers discharge her on the pretense that they cannot condone such "quixotic" and "deceitful" behavior; they ignore the reality that if she had been identifiably black she would never have obtained the position in the first place. Both *Passing* and *Plum Bun* establish that there is "harmless" passing; for instance, Irene taking tea at the Drayton hotel or Angela and her mother's Saturday department-store outings. But as in Micheaux's race movies, there is no harmless passing in *Imitation of Life*. Even when Peola is a child passing in her all-white classroom, she is admonished and perceived as naughty for not announcing her blackness to the other children. In *God's Step Children*, during an early scene of Naomi's childhood that similar to an incident involving Peola and her mother in *Imitation of Life*, the disobedient Naomi "ditches" on her first day of school, telling her mother she refuses to attend a school in Coloredtown and presumably passes at a white school.[68] The white dupes in literary passing narratives are deceived because they are victims of misrecognition and, as a result, have allowed a viper into their bosom. Such deceit challenges the fundamental core of racial hierarchy when these dupes discover that a woman they have called *sister* is, in fact, a member of the despised race. In *Imitation of Life*, the white characters, who after all understand why one would not want to be black, pity and gently chide the passing Peola. Micheaux's film more accurately attributes African Americans' disapproval of passing to the passing subject's disavowal of her or his family and community. Aspiring to a better life is admirable, but uncritical embracing of whiteness is not. In *Plum Bun*, passing is understandable if it is used as a tool through which to achieve social and economic equality; sometimes it is even enabled by the co-conspiracy of the black community. When Angela reveals her race and loses her place at the art school at Fontainebleau, Miss Powell's mother does not see her sacrifice as grand but declares, "She was a fool."[69]

Passing can be either deliberate or inadvertent; the responsibility of recognition is the viewer's, while the burden of performance belongs to the passing subject. It is one thing for Angela not to protest when Roger, her white boyfriend, insists that a black family be turned out of a restaurant, thereby exposing herself to similar insult or expulsion. But it is a clear lapse in Angela's morality for her to cut her sister to her face, as she does in the train station. To abate

the anxiety of racial misrecognition, a mythology of telltale signs, such as blue half-moons on the fingernails, surfaced in literature, art, and popular culture as a way to detect transgressors. This mythology composes the visual and conceptual grammar of the mulatta. In *Imitation of Life*, Peola examines herself in the mirror, saying, "Am I not white? Isn't that a white girl there?" Her action of self-misrecognition reveals an oxymoronic quandary in racially binary America. To rectify the elusiveness of color, which does not always denote race, U.S. legal discourse of the time attributed race to blood quantum, something even more elusive. Therefore, something people could not see determined racial status and supported deterministic science of atavism and the old cliché "blood will show itself." This sense of misrecognition, a literal dismissal of what the eyes see, demonstrates the constructed nature of race as a category for identifying a commodity rather than a denotation of a shared culture, heritage, or experience. While the visually misrecognized subject lacks color, she is ultimately drawn back into the African American community in most modern passing narratives precisely because she misses her family and culture.

In the modernist passing narrative, performance, mis/recognition, and disclosure become the three main movements that signify drama, trauma, and realization. The spectator searches the physical form for telltale signs of race; but no matter how manufactured the performance, the eyes of the passing subject seem to hold the key to racial identification. In *Plum Bun,* whose structure at times mirrors a play's, the performance of race becomes particularly stylized. More than superficially recognizable racial features, the performance requires a spiritual, cultural, and familial disassociation that carries with it dire consequences. The ability and desire to pass are inherited traits, but *how* they are inherited differs. In Peola's case, she genetically inherits her desire to be white from her father, who according to her mother also suffered alienation as a result of his light complexion. Similarly, Angela inherits her light coloring from her mother; and by emulating her mother's mischievous passing, she first becomes exposed to the white world of privilege and, in her estimation, beauty. For her mother, passing is simply an "old game of play-acting," but for Angela it becomes the principal role in the theater of life.[70]

Imitation of Life provides a detailed demonstration of the passing performance in the scene in which Peola refuses to acknowledge her mother when she is working at the cigar counter. This is a crucial scene because the passing subject depends on the black community's complicity to succeed in his or her masquerade. Ostensibly, whites usually cannot disclose passers because their preconceived notions about how a black person looks and behaves preclude them from "recognizing" the diversity of the black community. These perceptions are difficult to change, even when whites are confronted with an image

that is directly opposed to them. That is why Peola can pretend that her mother is crazy, exclaiming, "Do I look like I could be her daughter?" and then denying her in front of her employer without fear of recognition. As soon as Bea steps into the store, however, Peola gives up and walks out. While it takes Delilah to reveal Peola as black, Bea has to confirm it.

Contemporary viewers, well versed in the effects of socialization, might logically deduce that that Peola's passing results from her upbringing in a household where her mother's labor serves to enrich the lives of her white employers, thus provoking the daughter's desire to "want the things other people want." Instead, the film implies, through Delilah's dialogue, that Peola's behavior is inherited from her mysterious, never seen, absentee father. The only times that Delilah refers to Peola's father are when she says that he, like Peola, was "light-complected" and that he "beat his head against life." Instead of attributing the discontent of her daughter and her deceased husband to racism, Delilah considers it to be an internal, pathological condition. The one instance in which Delilah questions this assumption is when she offers this explanation (to the camera) of her daughter's predicament: "I don't know rightly whose fault it is. It can't be our Lord's. Got me puzzled."

In contrast, *Plum Bun* stresses that, while one might inherit the physical prerequisites, passing is a *learned* rather than a genetically imprinted behavior. For instance, when faced with the choice to either rebuke her sister or expose herself, Angela chooses to shun her sister. Her behavior is an imitation of her mother's refusal to recognize her father and sister in the portico of the Walton Hotel. Angela's disavowal is contemptible because, unlike her mother, who subsequently apologizes, she never admits her misstep but instead justifies her behavior. Her excursions with her mother give her a glimpse into the world of conspicuous consumption, and she is mistakenly led to believe that the "great rewards of life—riches, glamour, and pleasure—are for white-skinned people only."[71] For Angela, freedom is synonymous with experiencing pleasure. It is significant that she refers to the privileged group as white-skinned and not white; her emphasis on color as a determinant of race allows her to envision herself as a white woman. Color is what matters, not race. She is racially black, but her skin color is white. Angela's justifications lead to further confusion; is it possible to separate skin color (a biological factor) from culture (a sociological factor)? Yet this is the frail distinction through which she justifies what others see as deceptive behavior.

Jayna Brown's study of the relationship between white performers and their black maids, on- and offscreen, illuminates another way in which *Plum Bun* reinforces both the inherited and performed aspects of racial passing. Hollywood's familiar pairing of white starlets and black maids emphasizes whiteness

and punctuates the actresses' sexuality; yet slippage occurs between the support-
ing role the "maids" play on screen and the instructive role they play offscreen
and backstage. In her study of the relationship between white performers and
their black referents, Brown quotes Ida Forsyne, Sophie Tucker's maid: "I got
$50 dollars a week and did the maid part on and off stage."[72] According to
Brown, it was common practice for vaudevillian performers to "borrow" vocal
and dance techniques from black performers; the material taken and taught was
rarely credited. In *Plum Bun*, it is telling that Angela's mother Mattie's desire
for passing was first sparked by her actress employer: "the situation with the
actress had really been the best in many, in almost all, respects." Despite Mat-
tie's white skin, the actress indicates that "she would not have taken the girl
on had she not been coloured," as she "felt dimly that all coloured people are
thickly streaked with immorality." Though the position with the actress had
its dangers, often putting her in the way of her mistress's lecherous associates,
Mattie "glimpsed, thanks to her mistress's careless kindness, something of the
life of comparative of ease and beauty and refinement which one could easily
taste if he possessed just a modicum of extra money and the prerequisite of a
white skin."[73]

Numerous references to play acting in *Plum Bun* foreshadow Angela's deci-
sion to pass and emphasize the slippery distinctions between inadvertent and
manufactured passing performances. The passing game that Virginia and Angela
play as children functions as a dress rehearsal for Angela's denial of her sister
at the train station. In the game Virginia asks, "Pardon me, isn't this Mrs. Hen-
rietta Jones?" to which Angela responds, "Really you have the advantage of
me." Later, when Virginia cheerfully greets Angela with their childhood hello
at the train station, Angela's response is cold and invested with a frantic plea:
Virginia must allow her to leave with Roger without a fuss. In *Imitation of Life*,
Peola's declaration "I want to be white like I look" echoes Angela's explanation
to Virginia that her light skin dooms her to inadvertent passing, placing her
in the ludicrous position of having to announce, "I know I look white but I'm
coloured and expect to be treated accordingly."[74]

Peola's screen presence, characterization, and treatment in film criticism ex-
pose the visual and psychological difficulties of race performance and the inabil-
ity of early American film to contextualize the dilemmas of the mulatta. We
are left with the haunting, onscreen presence of the light-skinned Fredi Wash-
ington as a kind of tragic spectacle. There is at least one moment in *Imitation
of Life* when the film reflects on its artificiality: the only time Louise Beavers
pokes fun at her portrayal of the mammy figure is the scene when Bea coaxes
her into a wide, inane smile. At first she misunderstands; but then, upon sub-
mitting, she freezes with the smile on her face long after it is necessary, drawing

attention to its illusory nature. The trailers quote that she gives a "corking" performance, possibly a reference to the burnt cork used to "black up" in minstrel shows. Like the mammy, the mulatta is burdened by overdetermined nineteenth-century tropes of sentimentality and tragedy that provide the melodrama for Stahl's film and are later resuscitated in Sirk's 1949 remake. Yet is Fredi Washington's body, with its visible whiteness and questionable blackness, that draws attention to the complications of racial longing and belonging for viewing audiences.

Through their use of mulatta iconography, Fauset's novels and Micheaux's films primed audiences to read and critique the mixed-race black female body in their respective media. Though yet to be realized on the big screen, Fauset's novels feature complex racial performances that use the iconography of the mulatta to articulate her particular modernist and feminist perspective. Moving her heroine back and forth across the urban geography of Harlem and Fourteenth Street puts a new spin on an old tale, but ultimately the story is limited by the overwhelming sentiment that passing is always a moral transgression. Since her characters' happiness requires self-disclosure—a refutation of their passing behavior—their attempt to cross ultimately means that boundaries remain intact. This acknowledgment allows the return of the prodigal passer from the fate of the tragic mulatta back into the fold of African American society. Significantly, the anti-passing "moral" of *Plum Bun* resonates with Micheaux's anti-passing stance: a perspective that prompts him not only to present passers as either deranged or race traitors, but also to revise Chesnutt's *The House Behind the Cedars*. Whereas Chesnutt's Rena is ultimately a victim of both of her inner turmoil and society's inability to accept her in-between status, Micheaux's Rena rejects whiteness for a black middle-class existence. Although Fauset's views on passing and American race relations became increasingly dire by the time she completed her last novel, all of her fiction demonstrates a sincere dedication to exploring the intersecting discourses of race, class, and gender within an overarching debate of artistic philosophies and uplift aesthetics.

chapter four

The Geography of the Mulatta in Jean Toomer's *Cane*

The aim is twofold. First, to arrive at a sound and just criticism of the
actual place and condition of the mixed-blood group in this country, and, second,
to formulate an ideal that will be both workable and inclusive.

—JEAN TOOMER, letter to Alain Locke

For Toomer, the southland is not a problem to be solved: it is a field
of loveliness to be sung. The Georgia Negro is not a downtrodden soul to be
uplifted: *he is material for a gorgeous painting.* The segregated self-conscious brown
belt of Washington is not a topic to be discussed and exposed: it is subject
of beauty and of drama worth of creation in literary form.

—WALDO FRANK, foreword to *Cane*[1]

Thus far, I have placed female authors' representations of the mulatta icon
as both the ideal New Negro woman and the transgressive passing subject in
conversation with primarily male painters, illustrators, and filmmakers to con-
textualize and examine the genesis, promotion, conflicts, and contestations of
mulatta iconography. In this chapter, I considers two male artists, Jean Toomer
and William H. Johnson, whose similarly vexed relationship to the Harlem
Renaissance informs their literary and visual portraits of black women. Each
artist consistently equates the feminine with the primitive; and each reinvents
his notions of the modern primitive using the black female body, especially the
mixed-race black female body, as a locus point from which to create an artistic
vision that privileges a hybrid America.

Examining Toomer's *Cane* alongside Johnson's paintings not only provides
a new understanding of how primitivism functioned in Harlem Renaissance
literature and aesthetics but also places the mulatta icon in a radically differ-
ent geography. As he literally and figuratively resituates the south in the mulatto/
a-dominated fiction popularized during the Harlem Renaissance, Toomer asks

us to reconsider the location of Harlem as the center of black modernism and the New Negro. Fauset's and Larsen's novels portray southern culture as rural and desolate, depicting the region as place of the past at best, as death and decay at worst. Although early twentieth-century African American literature tends to situate the mulatta icon in an urban setting, she remains a hereditary southern figure. The southern soil of the American slave system fertilized miscegenation; the mixed-race body of the mulatta is a canvas painted with a brutal history of rape that visually embodies the negation of black paternity. Toomer's portrayal of the mulatta in *Cane* engages issues of miscegenation in rural southern and urban northern spheres, creating a mediating space that I refer to as the "dreamscape." In this space, often denoted by reference to *dusk* (as time of day, image, or color), the shifting nature of black and white identities coincide, collide, and sometimes reverse. Within the dreamscape, the primitive physicality of his female prose portraits confronts the surreal ambiguity of racial indeterminacy. It might seem strange to consider the mulatta icon as a primitivist subject given her promotion as an ideal of New Negro womanhood, yet this aspect of mulatta iconography is often clear to those characters who encounter her in the literature and those artists who imagine her on the canvas. Focusing on the visually dynamic imagery and iconography of Toomer's female portraits exposes the tensions between his prophetic conceptualization of American identity as essentially mulatto/a and the cataclysmic effects of the geography of urban capitalism on what he perceived as the primitive nature of black folk culture.

Although there is no evidence that Toomer and Johnson ever met or collaborated (Johnson's spent much of his early career in Denmark and Europe), my combined analysis of *Cane* and Johnson's art illuminates a joint search for an emerging Afro-modernism that occasionally contests but is always inextricable from European and American modernism and its primitivist elements. Comparing Johnson's paintings with Toomer's writing demonstrates how each sought to redefine primitivism in his own terms, a difficult enterprise given that the discourse is burdened with the racist iconology and presuppositions of western culture. For Johnson, what he called the "modern primitive" was a mode of expressing black folk culture; to this end he incorporated folk and African elements into his later paintings.[2] Similarly, Toomer's *Cane* reshapes the primitive to capture an "authentic" Negro folk culture while simultaneously recapitulating the south into the Afro-modernist project.

Soon after the publication of *Cane*, Toomer separated himself from the contingent of artists associated with the New Negro movement. Despite this retreat as well as his sparse publication history, he remains one of the most studied authors of the Harlem Renaissance. Although Johnson's career spanned two decades (1926–46) and several continents, his work went undiscovered and

unnoticed for many years. Yet he was an impressive and distinctive American painter, known for both his early abstract expressionist work and later interpretative paintings of the folk. Similarities in Toomer's and Johnson's artistic development, ethnic heritage, and public personae sparked my desire to place them in dialogue. Moreover, my analysis of Johnson's paintings draws out the visual techniques present in *Cane* and has deepened my understanding of artistic circles in the Harlem Renaissance. Given that scholars have dedicated entire books to exploring *Cane*, I focus this comparative chapter on points of thematic intersection between Johnson's paintings and Toomer's poetic portraits.

Before discussing how *Cane* and Johnson's paintings complicate the iconography of the mulatta through their Afro-modernist interpretations of primitivism, I want to touch on the discord surrounding their public life and their relationship to the New Negro movement. Both Toomer and Johnson left behind extensive archives of their musings on art, aesthetics, and racial identities. Though some believe that, after the publication of *Cane* and the writer's encounter with German philosopher and mystic George Gurdjieff, Toomer became unrecognizable as a black author and unconcerned with race, his criticism, journal writings, and extensive unpublished manuscripts demonstrate that his philosophical stance against the materialist sensibilities of the modern era and his interest in race dynamics had laid the groundwork for *Cane*'s formal and narrative innovations and continued even after he embraced Gurdjieff's teachings.[3] In "The Negro Emergent" (1924), Toomer attempts to focus discussion of the race problem on individual rather than mass identity. He isolates the prevailing condition from which the Negro, who is presently in a state of discovery, must emerge. According to Toomer, this state of transformation involves "detaching the essential Negro from the social crust"; the crust is the superimposed persona enforced by slavery and maintained through a continuing American ideology of superiority that has stifled the Negro socially, psychologically, and economically. Highly critical of racial discourse that lumped African Americans into an undifferentiated group, Toomer's views toward race and nationality were highly idealistic and frequently contradictory. In "Race Problems and Modern Society" (1929), he writes, "No serious student of race claims to know what race really is; nor do we know."[4] Despite his skeptical stance about the possibility of capturing an authentic portrait of the African American, he still sought to distill the collective essence of the Negro in his work.

Toomer began his career at the predominantly white University of Wisconsin and had this to say about his racial identity:

> In my body were many bloods, some dark blood, all blended in the fire of six or more generations. I was, then, either a new type of man or the very oldest. In any

case I was inescapably myself. . . . If I achieved greatness of human stature, then just to the degree that I did I would justify *all* the blood in me. If I proved worthless, then I would betray all. In my own mind I could not see the dark blood as something quite different and apart. But if people wanted to say this dark blood was Negro blood and if they wanted to call me a Negro—this was up to them.[5]

He did not want to be pigeon-holed as a Negro writer solely on account of his "dark blood." Despite his attempts to regulate his racial identity, he would later become frustrated by attempts to categorize his writing. He complained that he had missed out on a lucrative artistic opportunity because a review of *Cane* had "called [him] a black poet, grouping [him] with [Eric] Walrond and [Claude] McKay." But in fact, not until his return to the south of his ancestors did he truly begin to identify with his African American heritage.[6] In *Jean Toomer, Artist,* Nellie McKay cites his trip to Sparta, Georgia, in 1921 as "the single most important fact that led to the emergence of Jean Toomer the artist." Of the trip, he wrote, "When one is on the soil of his ancestors, most anything can come to one"; and what came to Toomer was *Cane.*[7] Toomer's representation of folk culture and the primitive in *Cane*, which predated Walrond's fiction but followed Claude McKay's poetry, determined the standard of consideration in experimental prose of the Harlem Renaissance.

Although similar questions about his racial heritage had plagued William Johnson since his childhood, he was more comfortable than Toomer was with the appellation "New Negro artist" as long as critics recognized him "as a painter of value." Indeed, Johnson believed himself to be "no ordinary American Negro Painter [nor am I an] ordinary American painter."[8] He was born in March 1901 in Florence, South Carolina, to Alice and Henry Johnson. From his birth, his paternity was questioned: unlike his brothers or sisters, he had fair skin and wavy hair. Dispute and gossip about his possible white blood led to his reclusiveness. Typical of African American artists since Henry Ossawa Tanner, Johnson eventually crossed the Atlantic to Paris, where his work was deeply influenced by Chaim Soutine and other abstract painters. While studying in Paris, Johnson entered and won the 1929 Harmon Foundation gold medal.[9] He competed against artists such as Lois Mailou Jones, Augusta Savage, and Sargent Johnson. With this award and his successful exhibition at the Harmon's annual art show in 1930, Johnson solidly emerged as a "New Negro" artist, despite critics' claims that his work imitated the style of French modernist painters.[10]

If Toomer's immersion in rural black culture sparked his desire to write, then Johnson's trip to northern Africa likewise prompted him to distinguish his work from European primitivism and abstract modernism

I will go to Africa in order to crystallize all of these impressions. In reality, colored folk are so different from the white race. Europe is so very superficial. Modern European art strives to be primitive, but it is too complicated. Now Modigliani believed he was "in Africa," but just look at his pictures; Raphael permeates them! All of the darker races are far more primitive—these are the people who are closer to the sun. . . . [The sun] is closer to us dark people.[11]

Johnson's critique of European art as "too complicated" indicates his desire to out-primitive the primitivist vein in modern art. Missing from this passage is any serious interest in studying *African* art forms, which he avoided until his later works and even then studied in only a limited way.[12] When Johnson returned to New York City from Europe in 1938, he did so because he was moved by a desire to "paint his own people" and to portray the "modern primitive," which is how Johnson perceived African Americans in the city.[13] One might say that he sought to transform black folk culture into modern abstract art. Primitivism constructs an imaginary other whose savage innocence and natural purity can be donned like a blackface refuge within the isolation of the modern world. Unfortunately, in seeking to capture the essential Africanness (which too often gets translated as *otherness*) of black folk culture, Johnson and Toomer tended to rely on the primitivist gaze of their European American modernist influences. For Toomer, these were Sherwood Anderson, Alfred Stieglitz, and Georgia O'Keeffe; for Johnson, they were Chaim Soutine and Charles Hawthorne. Both men were partially conscious of their mediated introduction to African culture via primitivism, and their respective journeys (Toomer to Sparta, Johnson to Tunisia) helped them redefine the primitive through the lens of lived experience with cultural and ancestral heritage. Unlike the primitivist modernism that fetishized African and other "third-world" cultures as an avant-garde aesthetic within modernist art, Toomer's and Johnson's depiction of the modern primitive was somewhat different. After his trip to North Africa, Johnson separated himself from European primitivism and abstract modernism and stressed his own innate ability to capture the primitive. Toomer's and Johnson's insistence on racial self-identification and their particular proprietary relationship to primitivism reveal an aesthetic kinship that is manifest in their respective artistic media. Johnson's art is an apt correlative to Toomer's writing because of the discordant notes both play in New Negro discourse. Harder to reconcile is the idea that their unique vision of Afro-modernism results in an idealized expression of the primitive that depends on exotic depictions of the black female body.

Johnson's many self-portraits reveal his search for a form through which he could "express in a natural way what I feel, what is in me, both rhythmically

and spiritually, all that which in time has been saved up in my family of prim-
itiveness and tradition, and which is now concentrated in me."[14] Moreover,
they illustrate his progression from American realism to European abstraction
to a unified, cohesive, abstract expressionist vision of black culture. His first
self-portrait is a realist piece titled *Self-Portrait, 1923–1926,* which he painted
while he was a student of Charles Hawthorne (fig. 17). Hawthorne's influence
on both this piece and Johnson's later work is evident in the primacy of color
and a de-emphasis on the importance of drawing the human form.[15] His tech-
nique diverged from the academic tradition that stressed proficient drawing of
the human body, with the goal of creating an image that is both realist and
ideal. Though he presents himself in the typical self-portrait format (quarter
profile, half-figure), the image that emerges dramatically from the dark-brown
background is reminiscent of the highly circulated and magnetic illustration
of Jean Toomer by Winold Reiss (1925). The deep garnet of Johnson's partially
opened shirt contrasts with the illumination of the rich golden tones of his skin
and his chest, adding a muted sensuality complemented by the reddish tint of
his lips. The play of light and shadow on his face heightens the hard angles of
his bone structure, a technique also present in his later face studies of South
Carolina residents, paintings that explore the multi-ethnic heritage of his home-
town. If we compare this early painting, in which Johnson adheres to conven-
tional aesthetics of portraiture, with his 1929 *Self-Portrait* (fig.18), painted in
France, we see that, while color is still prioritized, it defies the realism of his
earlier work. The curving arcs formed by the temple, eyebrows, and moustache,
as well as the splotches of color in the obscured background, demonstrate
Johnson's new interest in abstract expression. This *Self-Portrait* was exhibited
in the Harmon show and was thought to be one of the most experimental
pieces in the exhibition. Finally, Johnson's 1937 *Self-Portrait with Pipe* (fig. 19)
illustrates his perception of himself as a modernist artist. While the previous
two portraits do not indicate his profession, this painting portrays him with the
accoutrements of his craft and the romantic paraphernalia of an artist: smok-
ing jacket, pipe, and paintbrush. By 1937, Johnson believed his work deserved
international recognition; and this portrait presents a playful and confident
image. In his later work, Johnson conceived of the modern primitive as synon-
ymous with the alienation he experienced early in his career from the Harlem
Renaissance community. By claiming himself and his later art, which manifests
the aspects of primitivism that celebrate primordial motif (basic foundations
rather than elaborate forms) as primitive and choosing to represent urban and
southern black culture, he solidified his position as an African American artist.[16]
Reading *Cane* in conjunction with Johnson's art gives us a unique and com-
plex understanding of how some black artists and writers struggled to recoup

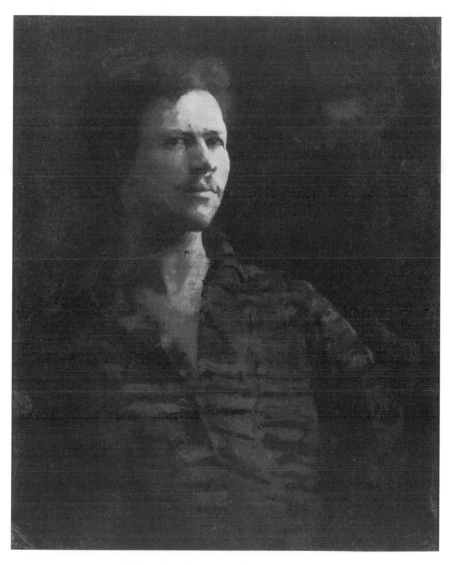

17. William H. Johnson, *Self-Portrait*, ca. 1923–26.
SMITHSONIAN AMERICAN ART MUSEUM, GIFT OF THE HARMON FOUNDATION.

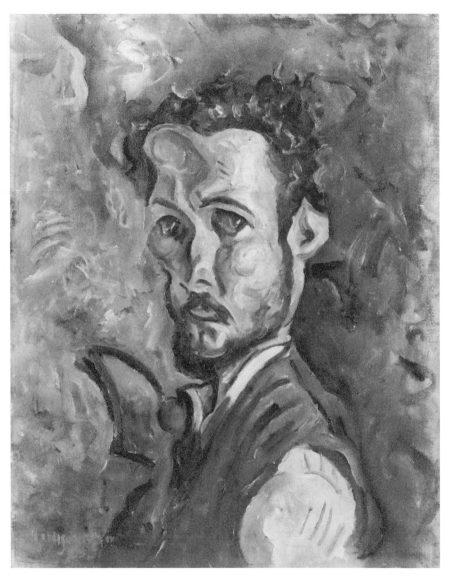

18. William H. Johnson, *Self-Portrait*, 1929.

SMITHSONIAN AMERICAN ART MUSEUM, GIFT OF THE HARMON FOUNDATION.

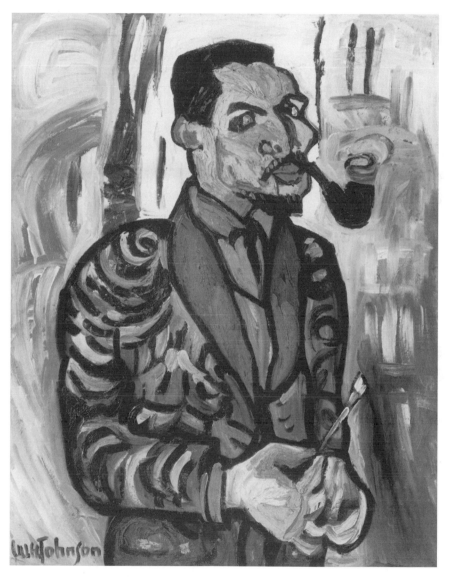

19. William H. Johnson, *Self-Portrait with Pipe*, 1937.
SMITHSONIAN AMERICAN ART MUSEUM, GIFT OF THE HARMON FOUNDATION.

primitivism as more than a remedy for modern melancholia: they saw it as a medium through which to access both ancestral heritage and innovative forms.

Seeing *Cane*

A schematic study of *Cane*'s structure reveals how Toomer incorporated photographic and painterly elements into his female portraits in the opening, middle, and concluding sections. Visual techniques borrowed from painting and photography inform the poetry, prose, and organizational structure of *Cane,* making it the most modernist and experimental literary endeavor of the Harlem Renaissance. Although Toomer did not conceive of *Cane* as a novel (he wanted to publish "Kabnis" with the short stories and poems from the first section), his publisher believed it was too short and prompted him to add the second section. As a result, *Cane* is a collection of short stories, prose, poetry, and drama that share a thematic unity and dialogic relationship. The narrative structure can roughly be divided into three sections. The first consists of poems and prose sketches of black women in the south. Nature imagery that consistently identifies women with the earth and its fruit dominates this section. The male poet-narrator begins with detached, spectatorial observations; however, as the narrative progresses, he becomes immersed in his observations until at last he is an active participant. The second section deals with urban migration and binary conflicts between male and female, north and south, spiritual and material values, fresh opportunities and the suffocating industrialism of the urban setting. In the last section, which is part prose narrative and part dramatic exposition, Toomer dramatizes the return of the northern-born Kabnis to the south. In the south, Kabnis personifies both the future and the past; he is the prodigal "Son" in the "Song of the Son" who must face the south's brutal history and accept his heritage in order to move forward.

Toomer's interest in the transformation of the African American psyche and collective spirituality led him to search for appropriate forms to express the collective through the individual. The dialogic relationship between his poetry and prose and his use of several artistic genres, including the blues idiom, photography, and painting, together create a new form that is difficult to classify. On the basis of its thematic and organizational unity, I read *Cane* as an experimental, Afro-modernist novel, a precursor to the popular form of linked stories in contemporary fiction.[17] Straddling modernism and pragmatism, *Cane* manifests the tensions in modernist writing between avant-garde aesthetics and primitivism.[18] If the modernist impetus was to challenge conventional narrative forms and critique innovations of technology, industrialization, and the resulting bourgeois consumerist culture, *Cane* sits on the intersection between

modernism and the African American novel tradition. As Mark Sanders asserts, "*Cane*'s sense of fragmentation, highly impressionistic economy, and multi-genre eclecticism clearly reference the visual and verbal cubism of Picasso and Stein, invoke Eliot's montage, the imagist insistence of fresh vision and on the perfect clean economic line,' and anticipate Hemingway's lyric compression in *In Our Time*."[19] In contemporaneous and more recent reviews, critics repeatedly characterize the short stories and poetry in *Cane* as "impressionistic," underscoring the visual elements that Toomer himself believed were key to understanding the novel.[20] In a letter to Stieglitz, Toomer tells him that he is sending him a copy of *Cane* and writes, "Nor Can I Reduce This Experience to a Medium," referring to both his contemplation of the luminosity of the sun and Alfred Stieglitz's ability to capture pure black in his photography.[21] This phrase encapsulates Toomer's desire capture the multiple dimensions of humanity through various artistic forms; furthermore, the word *medium* has spiritual connotations that evoke the dreamscape, that mystical indeterminate space that the women in *Cane* simultaneously conjure and occupy. To capture the "essence," the psychology of the female subjects in his vignettes, Toomer imbues his writing with a visual artist's sensibility.

The first clues indicating *Cane*'s visual structure are the set of arcs or semicircles on the pages before each section.[22] The arcs symbolize a fractured unity—two halves reaching toward each other. This image functions on many levels: it is the fragmented black and white culture that does not understand its unifying nationality; it is the spiritual mind and physical body that do not perceive their perfect wholeness; it is the man and woman who can only achieve self-knowledge through mutual dependence; it is the individual and the collective, the modern and the premodern, the mechanical and the pastoral.

If the arcs symbolize Toomer's philosophy and *Cane*'s interwoven themes, several letters provide further clues to the book's narrative assemblage. In a letter to Frank, Toomer expands on *Cane*'s visually inspired construction:

From three angles, CANE'S design is a circle. Aesthetically, from simple forms to complex ones, and back to simple forms. Regionally, from the South up into the North, and back into the South again. Or, From the North down into the South, and then a return North. From the point of view of the spiritual entity behind the work, the curve really starts with "Bona and Paul" (awakening), plunges into Kabnis, emerges in Karintha etc. swings upward into Theatre and Box Seat and ends (pauses) in Harvest Song.[23]

According to Toomer, the best readers of *Cane* need a highly developed sense of visual perception to "catch its essential design": a comprehension of the

interior as it is embedded within the outer layer of an image or character along with the particular emotion or philosophy that the image or character personifies.[24] To create unifying strands among individual psychoanalytic portrayals, he often chooses abstract, visually charged images that refer to modern photography. "Most people cannot see [Bona and Paul,]" he wrote to O'Keeffe, because of their "inhibitory baggage."[25] In these letters, he cautions against superficial readings of his prose portraits, drawing attention to his unconventional use of color and attentiveness to the geographical location of the subject and the natural landscape. Toomer's encounters with O'Keeffe and Stieglitz were not so much inspirational as they were inevitable; his search for a form that would capture the essence of the New Negro had already led him to employ the visual art writing techniques that Eugene Holmes astutely characterizes as "word-painting."[26]

To emphasize the visual dimension of poems such as "Face" and "Her Lips Are Copper Wire," Toomer employed both imagistic and painterly diction to create abstract literary landscapes.[27] More important, his strategic placement of "Face" directly after "Becky" and "Karintha" but preceding "Fern" and "Esther" allows its metaphors to collectively address the prose pieces. In "Face," images of "canoes," "grapes," "worms," and "streams" all evoke a tension between vitality and decay; they signal the connection of the body to the land and its inevitable return. The rotting "cluster grapes of sorrow" refer to the exploitation of Karintha's budding sexuality, while the sense of motion conveyed by the stream and its "recurved canoes quivered by ripples" foreshadow the emergence of Fern's face and eyes from Georgia's topography. One of the many unique aspects of Toomer's imagism in "Face" is that it lacks the conventional descriptiveness prevalent in Harlem Renaissance poetry about black women. For instance, it omits any direct reference to skin color or feature type. This is because Toomer felt that the visual could do more than simply describe the surface; it could also reveal the internal psyche of his subjects.[28] His eclectic treatment of poetic form and narrative structure reveals a formal virtuosity unique among Harlem Renaissance writers.

Just as "Face" refers to surrounding prose pieces, the poem "Portrait in Georgia" amplifies "Blood-Burning Moon." "Portrait" recalls the most common provocation for lynching in the post-Reconstruction era: a white woman's false allegation of rape. "Blood-Burning Moon" dramatizes a lynching for an actual rather than a fabricated crime. The metaphors and images in "Portrait" are less lyric and more visually stark than those in "Face." They recall the severe photographs of lynched bodies published in black and national newspapers as warning, documentation, and protest:

Hair—braided chestnut, coiled like a lyncher's rope
Eyes—fagots
Lips—old scars, or the first red blisters
Breath—the last sweet scent of cane.[29]

This corporal itemization evokes the lynched black male and the participation
of the white female in death; it is a portrait of interracial desire painted upon
the body of the white female subject. The poem also suggests that the idealized,
forbidden beauty of white women is a white male construct designed to main-
tain men's hegemony. The last line of the poem, "white ash of black flesh,"
irrevocably links the forbidden allure of the white woman with the black man's
demise.

The themes compressed in "Portrait" foreshadow the interracial romance in
"Bona and Paul" and the fatal consequences of the "crime" of miscegenation
in "Becky"; the theme of lynching also returns, this time as a punishment for
Tom Burwell's retributive murder of Bob Stone, whom he thinks has violated
his Louisa. Burwell's judgment is obscured by jealousy, desire, and a cultural
memory of the white master's rape of the black female slave. Imagining the
purgatorial light of "deep dusk" and a scarlet halo around the moon, Toomer
confuses racial identifiers, drawing attention to how visual perception influ-
ences and interacts with the psyche. As Bob Stone heads purposefully toward
his trysting place with Louisa, Tom Burwell's gal, he undergoes a transforma-
tion: "The clear white of his skin paled, and the flush of his cheeks turned pur-
ple. As if to balance this outer change, his mind became consciously a white
man's." The passage illustrates that white identity can be asserted only in the
presence of blackness; the two identities are, like the co-dependent images in
"Portrait," inseparable. Bob Stone's conscious whiteness empowers him: he
"went in as a master should and took her."[30] His white consciousness trans-
forms him from man to master and reduces Louisa's position from a free woman
to a slave. In Stone's mind, thought becomes act. Like a slave, Louisa is com-
pletely disempowered; her own desire and will become irrelevant, overridden by
Stone's intent. Though her white lover-master brings her gifts of silk stock-
ings, she is his property and thus does not have the agency to refuse him.

Neither "dusk" nor gray are ideal midpoints between black and white; rather,
they mark the shift into the dreamscape (*Cane*'s netherworld of subversion and
misrecognition) and evoke a "shadowy tableau" similar to the scene that intro-
duces the *San Dominick* mutiny at the beginning of Herman Melville's "Benito
Cereno."[31] Comparisons with Melville are no stretch: Toomer refers to Mel-
ville's writing in his journal, noting in particular the way in which he contrasts

natural elements with the human psyche. Toomer saw Melville as "a true brother in the search of the source and essence of all clouds."[32] This rather oblique reference to clouds reminds me that gray is the predominant image when the slave ship first appears in "Benito Cereno": "The sky seemed a grey mantle. Flights of troubled grey fowl, kith and kin with flights of troubled grey vapours among which they were mixed."[33] In Melville's story the gray imagery plunges the reader into an ambiguous realm in which identity and action are not what they seem. Similarly, Toomer begins and ends "Blood-Burning Moon" with an image of the factory's "skeleton stone walls." The factory's oak beams also calls to mind the biblical allegory that Melville uses to compare *San Dominick* to an ark of bones launched from "Ezekiel's Valley of Dry Bones."[34]

In addition to obscuring violence, the shadow imagery foreshadows the inversion of black and white that occurs when Bob Stone moves with determination to claim Louisa and the subsequent struggle for balance that permeates the dreamscape of the text. The final confrontation is acted out as "shadows of figures fought each other on the gray dust of the road" and in Louisa's indecisive fancies: "His [Tom Burwell's] black balanced, and pulled against, the white of Stone, when she thought of them." Louisa is simply an object of desire in the interracial love triangle of power, whose beauty is synonymous with the terrain upon which the men fight. Her skin is "the color of oak leaves on young trees in the fall," her breasts are "firm and up-pointed like ripe acorns," and her singing reminds the narrator of "the low murmur of winds in fig trees." Though Louisa senses the upheaval heralded by the blood-on-the-moon (an evil omen in folk culture), her inseparability from the landscape renders her powerless to stop it. The image of Babo (the leader of the slave revolt in "Benito Cereno") and his decapitated head reappears in Tom Burwell's lynching spectacle in "Blood Burning Moon": "Now Tom could be seen within the flames. Only his head, erect, lean like a blackened stone. Stench of burning flesh soaked the air. Tom's eyes popped." The horrific image of Tom's burning body continues to haunt the community: "it fluttered like a dying thing down the single street of the factory town." The lynching is the inevitable climax to the performance of racial hierarchies and patriarchal power. Just as the exhibition of Babo's severed head remains a haunting apparition for whites because he so graphically embodies the necessary reification of their hegemony, the spectacle of Tom Burwell's burned flesh reaffirms the constant violence necessary to preserve the white power structure.[35]

Although "Blood-Burning Moon" exposes the sexual exploitation perpetrated against black women by black and white men, the women in *Cane* remain sexually expendable unless they are transformed into religious icons. Tracing the iconography of the mulatta through *Cane*'s juxtaposition (and occasional

conflation) of urban and rural geography provides a distinctly Afro-modernist take on the idealization and sexualization of New Negro womanhood. Lush descriptions of rural women and colorful depictions of urban women are both betrayed by their emptiness: a gray dullness exists where introspective consciousness should be. Only when likened to the Virgin Mary and transformed into a brown madonna, an image popularized in New Negro art and photography, does the mulatta icon in *Cane* transcends her suffering through spiritual epiphany.[36] In "Kabnis," *Cane*'s final section, Toomer imagines the mulatta as a madonna giving birth to a new race. From her womb, the New Negro becomes the new mulatto/a; as Toomer pontificates in *Essentials*, he or she becomes a person of "no particular class" and "no particular race" but one "preparing a new class" and "a new race."[37] What's exactly new about this race is somewhat elusive. But *Cane* does respond to the nineteenth-century trope of the tragic mulatta, a figure characterized by an overwhelming desire to be white and unresolved turmoil caused by her dueling identities. Significantly, *Cane*'s mulatta figures are not isolated or markedly distinguished from other women; rather, they are seamlessly constructed from the book's natural and artificial landscapes.

The Body's Canvas: Toomer's and Johnson's Female Portraits

The female characters in *Cane* provide the canvas upon which Toomer first attempts to redefine the primitive and then constructs as vessels from which a new American identity will emerge. The narrator's descriptions are incredibly precise; he paints a meticulous landscape that reveals both the hybridity of the mulatta icon and the prophetic consequences of miscegenation. Du Bois characterizes the women in *Cane* in this way:

> Jean Toomer is the first of our writers to hurl his pen across the very face of our sex conventionality. In "Cane" one has only to take his women characters seriatim to realize this: Here is Karintha, an innocent prostitute; Becky, a fallen white woman; Carma, a tender Amazon of unbridled desire; Fern, an unconscious wanton; Esther, a woman who looks age and bastardy in the face and flees in despair; Louise, with a white and a black lover; Avey, unfeeling and unmoral; and Dorris, the cheap chorus girl. These are his women, *painted* with a frankness that is going to make his black readers shrink and criticize; and yet they are done with a certain splendid, careless truth.
>
> Toomer does not impress me as one who knows his Georgia but he does know human beings; and, from the background which he has seen slightly and heard of all his life through the lips of others, he *paints* things that are true, not with Dutch exactness, but rather with an impressionist's sweep of color.[38]

While Du Bois praises Toomer's technique and knowledge of humanity, he questions his ability to authentically represent the black experience after what was really only an extended field trip. Ironically, the same critique could be leveled against Du Bois's own *The Souls of Black Folk*, particularly the chapter "Of the Black Belt" in which he establishes himself as a detached observer who, like Toomer, slips in and out of intimacy with his subjects, sometimes adopting a scientific distance, other times passionately aligning himself with the folk.[39] Du Bois's favorable reading of Toomer's female portraits seems unusual. Given the idealized portraits of African American women in the *Crisis*, one would expect him to prefer portrayals similar to those of Winold Reiss's *Brown Madonna* or the schoolteachers who illustrate Elise McDougald's essay in Alain Locke's *The New Negro*. Other reviewers, such as *Periscope's* Roger Didier, were more critical of *Cane's* sexual language: "Negro women are likely to protest the insinuation in Mr. Toomer's fine picture of a Negro girl. One reads: Fern's eyes said to them (the men) that she was easy. When she was young, a few men took her, but got no joy from it." Critic Robert Bone dismissively defines Toomer six female portraits as "all primitives."[40] While Toomer's portraits of the women critique the sexual oppression of black women by white and black men, a revolutionary argument for the time, his use of mulatta iconography and primitivist imagery undermines that critique by maintaining the male artist as the spectator and the female subjects as victims without any control over their destiny. The logic of *Cane* argues that women's oppression can be relieved only if men become more spiritually aware. Indeed, the women's stories of betrayal, abuse, and the misunderstandings of white and black society constitute a microcosm of oppression. Du Bois's easy categorization of these women as fallen merely scratches the surface.[41]

An analysis of William H. Johnson's face studies and portraits of black women helps us to understand Toomer's prose portraits as narrative studies of the inner consciousness and outer shell of black women amid the modernist and primitivist discourses of the Harlem Renaissance. According to Du Bois, Toomer's portraits reveal an "impressionist's sweep of color" rather than a "Dutch exactness"; they evoke emotion, color, and beauty but not realism. Indeed, the natural, sometimes transcendent, images with which Toomer imbues his dusky maidens transforms the town of Sparta into a rural, southern dreamscape. He imagines this dreamscape in writing inspired by and often imitative of visual art. A comparison with Johnson's paintings highlights ways in which the imagistic and impressionistic aspects of Toomer's writing revise the image of the black woman. For both Toomer and Johnson, women embody the primitive aspects of black folk culture, the distilled essence of what it means to be Negro; their construction of the black woman as a primitive figure is part of a complicated,

not to mention somewhat misguided, strategy through which they attempt to establish black as beautiful. Associating the primitive with beauty contradicted the image of the New Negro woman as featured in the *Crisis*, the *Messenger*, and *Opportunity*—all magazines that actively countered negative stereotypes of black women with portraits of fair-skinned teachers, socialites, and madonnas. Given the New Negro's interest in reforming the black female image, Toomer's and Johnson's portraits seem at odds with New Negro uplift ideology that endorsed restrained representations of black women as icons of respectability and domesticity.

Despite the fact that Johnson's and Toomer's conceptualizations of the primitive appear to be misguided, they occasionally yield something extraordinary. This is the case with Johnson's recapitulation of black beauty as modern primitive art in *Nude*, a painting that neither bestializes nor aristocratizes the black female body (fig. 20). *Nude* is an explicit reformation of paintings in which the black woman is a marginal figure, as in Edouard Manet's *Olympia* (1863) or Jean Auguste Dominique Ingres's *Odalisque with a Slave* (1842). Painted in the reclining nude tradition, Johnson's *Nude* is a radical departure from his stark psychological portraits of women in *Girl in a Green Dress, Portrait Study, No. 16*, his abstract landscapes, and his realist self-portraits.[42] Representative of Johnson's folk-art phase, *Nude* demonstrates his new espousal of color and the influence of African sculpture on his technique. Instead of the subdued pastels of *Olympia*, the subject is lying on a colorful print of red, black, and yellow. The framing palette of primary colors, set against an ultra-white background, heightens her rich brown color. The painting is oil on burlap rather than canvas, which adds texture to the brushstrokes. The subject's reclining posture pokes fun at the aloof reclining nude tradition, but her face remains composed and regal. This portrait pays meticulous attention to placement of the bottle, the wine glass, and the fruit, which centralizes the genitalia. As Richard Powell observes, "the undulated colors, simplification of form, and direct, yet constrained imagery in *Nude* create a visual metaphor for female allurement and male desire that, despite the potential of sensationalism, remains level-headed and clear."[43] To achieve this harmony of form and substance, Johnson paints clean, symmetrical lines. While the figure is nude, she is not naked; the portrait is not pornographic.

Johnson's expressionist portrayal of the black nude is distinct from parallel images produced by artists and photographers such as James Van Der Zee in the 1920s and John Mosley in the 1940s.[44] At one point, Van Der Zee even created a calendar of nude studies; the most well known of that group is *Nude Girl on Oriental Carpet* (1923), which features a light-skinned model with long wavy hair facing a painted fireplace. In his discussion of Johnson's *Nude*, Powell observes

that a more conventional subject choice would have been "a blond pin up type or a Caucasian-featured black like the then popular Lena Horne." He calls "Johnson's choice of a large, dark skinned woman of unquestionable African ancestry to embody the sensuous and the beautiful" "a radical step in 1939."[45] While *Nude* is a beautiful and celebratory portrait of black beauty, it is also a more explicit replacement of the idealized white female body than the literary-visual reversal Larsen achieves in *Quicksand* when she places Helga as the object of desire and her maid as the spectator. In Johnson's painting, there is no maid: the black female nude is the only subject, and the audience focuses solely on her. Johnson signed this painting twice: as W. H. Johnson and as "Mahlinda," a pseudonym that appears infrequently in his work.[46] Possibly he conceived of the name as a play on Paul Laurence Dunbar's famous dialect poem "When Malindy Sings" and used it to emphasize the influence of folk culture on specific paintings.

Though "Karintha," the opening sketch in *Cane,* predates *Nude,* Toomer's vision of black beauty partakes of Johnson's revisionist sensibility. Toomer

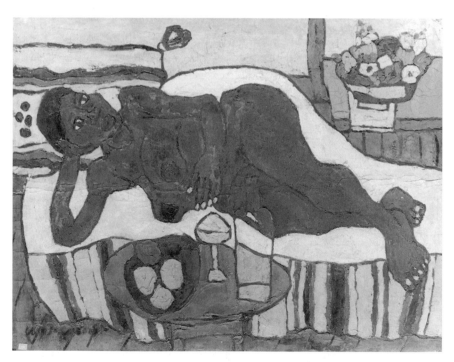

20. William H. Johnson, *Nude,* 1939.
SMITHSONIAN AMERICAN ART MUSEUM, GIFT OF THE HARMON FOUNDATION.

explicitly marks "dusky" beauty as beautiful, suggesting that only the women whose features reflect the earthy darkness of the soil are beautiful. As Nellie McKay writes, "in this yoking of color, beauty, the perfection of nature, and Karintha, Toomer breaks with the usual tradition of female beauty—even much of Afro-American literature—and establishes the dusk-skinned woman as naturally beautiful." McKay describes Karintha as "much like a photograph in words"; and indeed, Toomer cleverly uses photographic elements to create a stunning, opening portrait that foregrounds the importance of the visual in the succeeding sections of *Cane*.[47] As a case in point, he describes Karintha's running as "a whir" with the "sound of the red dust that sometimes makes a spiral in the road," and her "sudden darting past you was a bit of vivid color, like a black bird that flashes in light." These first images of Karintha capture the definition of *photography*, which literally means "light-writing."[48] The confusion of the sensual imagery in Karintha's portrait reflects the imbalance between her natural beauty and her spiritual and emotional development. If Robert Bone is correct in characterizing all six female portraits as "primitives," Karintha's is the most primitive. Men use her sexually before she is a woman; they do not make love to her but "mate" with her. When she is impregnated by one of the many "matings," she gives birth with the ease of an animal: "a child fell out of her womb into a bed of pine needles in a forest."[49]

The compact structural unity of "Karintha" (which was also published separately in *Broom*, accompanied by an illustration of an African-style mask to denote the story's exotic content) models the density of the short pieces. Described as a poignant, oxymoronic, "November cotton flower," Karintha is sketched so as to enact the turn in the last two lines of a sonnet that appears a few pages later and is also titled "November Cotton Flower": "brown eyes that loved without a trace of fear / Beauty so sudden for that time of year." The blues refrain interwoven through her portrait demonstrates Toomer's expertise at interweaving poetic styles and techniques. The lines "Her skin is like dusk on the eastern horizon, / O cant you see it, O cant you see it, / Her skin is like dusk on the eastern horizon / . . . When the sun goes down" are repeated three times in the brief sketch. The stanza names her beauty as "dusky" and demands that we visualize her with the line "O can you see it."[50] These early poetic stanzas within the prose direct a dialogic reading of *Cane* that stresses how each piece communicates with the others and acknowledges the various artistic media referred to throughout.

An analysis of Johnson's *Girl in a Green Dress* (1930) illustrates the techniques that both he and Toomer use in their respective media to construct an emotional and physical profile from the amalgamated southern landscape (fig. 21). In "Fern," Toomer depicts Fernie May Rosen's face as a multi-ethnic

landscape where color and nature flow together as in a watercolor painting: "Face flowed into her eyes. Flowed in soft cream foam and plaintive ripples." "If you have ever heard a Jewish cantor sing, if he has touched you and made your own sorrow seem trivial when compared with his, you will know my feeling when I follow the curves of her profile, like mobile rivers, to their common delta."[51] Johnson's symmetrical portrait places a dusky, copper-skinned young woman against a deep-brown background speckled with glints of light. While the rich jade of her dress suggests a fertile sensuality, the portrait is highly psychological. Similar to Motley dignified portraiture, Johnson's *Girl in a Green Dress* illustrates a refusal to portray blacks as comical or servile figures. The subject's exaggerated eyes, small mouth, and elongated neck evoke discomfort, anxiety, and fear. The stark expression and deep-set lines of her face invoke American realist representation. But harsh angles give the portrait an abstracted look that situates it with the psychological face studies of Johnson's French modernist influences, Soutine and Modigliani. The model was a young black resident of Johnson's hometown of Florence, South Carolina (which had a multiracial community of interwoven black and white families similar to Toomer's Sparta). Just as Toomer's photographic and painterly diction adds depth and opacity to his female subjects, Johnson sought to capture an "abstract something of" African American girls and boys.[52] Both artists strove to reveal the essence of their subjects; they wanted the outer shell to reflect psychological depth. The features and bronzed coloring of this young black woman are intended to reflect a mixed heritage. *Girl* is a painting that invites readers to discern African, European, and Native American ancestry.

Like *Girl in a Green Dress*, Fern is a multi-ethnic portrait whose seamless lines exist harmoniously in the past, frozen in the frame of the train window where the narrator captures his last picture of her: "Saw her on her porch, head tilted a little forward where the nail was, eyes vaguely focused on the sunset. Saw her face flow into them, the countryside and something that I call God, flowing into them. . . . Nothing ever really happened." Fern's spirituality, which the men in the town sense but do not understand, regenerates her purity. Even though she does not deny them her sexual favors, "she became a virgin." In the canebrake, at dusk, the time of possibility and otherworldly interaction, the narrator captures a glimpse of what makes Fern sacred. Just as the countryside flows in and out of her face, he sees that her eyes "held God. He flowed in as I've seen the countryside flow in." Possessed with something otherworldly, Fern convulses, sings alternately with "a child's voice" or "an old man's," and faints. The epiphany in the canebrake leaves her as frozen in time and space as she was before. She is in harmony with God and nature but with a spiritual confluence that could not happen in the north. The narrator's picture of Fern remains

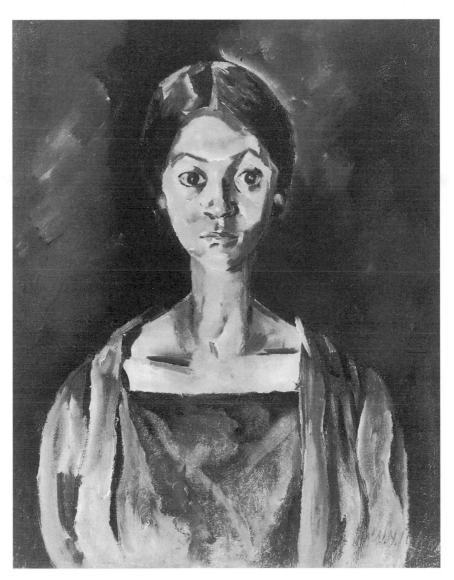

21. William H. Johnson, *Girl in a Green Dress (Portrait Study No. 22)*, 1930.
SMITHSONIAN AMERICAN ART MUSEUM, GIFT OF THE HARMON FOUNDATION.

in the present even after he moves on. Although he knows she is still living, "nothing ever came to Fern, not even I."[53]

Despite her intense spirituality, Fern remains oddly flat. Though the narrator participates in her "possession" and reveres her as the other townsfolk do, she remains immobile, a fixture in the narrator's scope that could not exist in the urban setting to which he is returning: "Picture if you can [Fern], this cream-colored solitary girl sitting at a tenement window looking down on the indifferent throngs of Harlem. Better that she listen to folk songs at dusk in Georgia, you would say, and so would I."[54] The narrator leaves the south with only her photograph, whereas the townsfolk are left with an imprint of her transformation: the black madonna traced in charcoal on the courthouse wall. Through this tracing, Fern's image becomes part of the iconography of the Virgin Mary; and the fact that it is emblazoned on a courthouse wall reveals a mocking irony: the courthouse symbolizes law and justice, both theoretical values disregarded by the practice of lynching, as "Blood-Burning Moon" later attests.

The spectatorial narrator's limited observations of the women in *Cane* suggest uncharted depths. Like the wide-open eyes of *Girl in a Green Dress*, Fern's eyes suggest vulnerability and spiritual potential. While the narrator criticizes the black men of the town for failing to see Fern as anything other than a sexual object that they cannot fully possess, his depiction of her aloofness does not indicate an introspective personality but a vague dullness. The narrator perceives Fern as a landscape, a canvas upon which to paint his dreams. Indeed, all the women in *Cane* are vessels into which he can pour meaning. Yet Toomer's gendered gaze, particularly in "Fern," is self-conscious. Nellie McKay compares Fern's relationship to the narrator to Toomer's relationship to the folk; she suggests Toomer and the poet-narrator share difficulties in interpreting and observing black culture. The narrator's perspective is inhibited by his masculinity and his northern-outsider status, which empowers him to criticize the men's exploitation of Fern and Karintha. Yet despite his acumen and good intentions, he replicates their behavior. A sense of inevitability in the narrator's depiction of the women in *Cane* suggests that freedom is inseparable from violence and conformity. Though Toomer allows some of his female characters to break their silence, they are for the most part unknowable. In the case of Karintha, the detached narrative voice cannot seem to decide whether to blame her or the men of the town for her "primitive" abandonment of her child and her promiscuity. Either way, Karintha, "a growing thing" "ripen[ed]" "too soon," remains a victim of her own subjectivity and circumstances as a southern-born black woman.[55] Despite the fact that Toomer was revolutionary in his dramatization of patriarchal oppression, the silent unknowability of his subjects' psyche, which his spectatorial narrator cannot comprehend, does

not allow the women to be anything more than victims of male oppression, white or black.

The narrator in "Fern" pontificates that "men are apt to idolize or fear that which they cannot understand, especially if it be a woman"; and Toomer's complex interpretation of mulatta iconography supports this oppositional observation. While Fern's mulatta status (her Jewish-African mixture unites two historically persecuted and spiritual people) is idolized, the subsequent portrait of Esther demonstrates that too much whiteness is dangerous, even frightening. Esther, the only character other than Avey whom we observe from childhood through middle age, embodies the dangers of complete mental and physical assimilation into the materialism and covetousness of American society. Her portrait parodies the supposed beauty of the tragic mulatta with equally tragic results, and her name connotes the difficult choice that the biblical Esther faced: to stand by and be silent while her people were slaughtered or to reveal her Jewish ancestry and appeal to her husband, the king of Persia. Toomer's Esther neither emulates her namesake's courage nor shares her beauty. Significantly, unlike the unearthly loveliness of Larsen's mulattas, Clare Kendry and Audrey Denny, Esther's whiteness holds little appeal: "[Her] hair falls in soft curls about her high-cheek-boned chalk-white face. Esther's hair would be beautiful if there were more gloss to it. And if her face were not prematurely serious one would call it pretty. Her cheeks are too flat and dead for a girl of nine. Esther looks like a little white child, starched, frilled, as she walks slowly from her home towards her father's grocery store."[56] Unlike Karintha and Carma, who draw their allure from their dusky skin and the southern soil, Esther lacks both color and connection to nature. Instead, she is a product of the new commercialism transforming the south—a shopkeeper who is daughter of a shopkeeper. She is disconnected from the folk culture of Sparta; furthermore, the narrator suggests that her participation in commerce, along with her class position, severs her from the land.

Esther perceives her inner lack and seeks to rectify it through a sexual union with Barlo. Barlo is as black as Esther is white; he is: "a clean-muscled, magnificent, black-skinned Negro."[57] Like Fern, he has a spiritual epiphany; yet unlike her, he speaks. He becomes a figure of legend, a hero, and, most important, a preacher. Esther's inexplicable attraction to him is similar to the passion sparked by Helga Crane's religious epiphany, which leads her to marry a simple country preacher and move to Alabama.[58] Like Helga, Esther (the "near white" daughter of the "richest colored man in town") must conform to a social position that represses her creativity and sexuality. Contrary to most of the women in *Cane*, who are outwardly motivated by their passionate natures, Esther consciously "decides she loves [Barlo]." He becomes for her a thing of legend and dreams; he is a "vagrant preacher" and the best man at lovemaking, dice, fighting, and

cotton picking. Her inexpressible desire for Barlo becomes a festering interior wound that corrupts her appearance: "Her hair thins. It looks like the dull silk on puny corn ears. Her face pales until it is the color of the gray dust that dances with dead cotton leaves."[59] Instead of the fertile and spiritual imagery of dusk that personifies Fern's religious iconicity and spiritual transformation, Esther is synonymous with dust, an equally natural and biblical allusion that denotes the body's inevitable decay and return to the earth.

When Esther's dream of attaining blackness and sexual fulfillment through her romanticization of King Barlo proves absurdly unattainable, she goes mad. Her complexion is likened to that of a dead woman; her mind becomes a "pink mesh-bag of baby toes"—a jumbled, grotesque image too horrifying to imagine. Yet Esther's mental illness gives her clarity of vision; and once the daydream collapses, she perceives Barlo as "ugly and repulsive"—a hideous drunk. After Esther offers herself to Barlo, one of his women laughs, "So thats how th dictie niggers does it"; her desire for him is a joke.[60] Esther transfers her self-hatred to Barlo, but it is too late. She has already wasted her youth on a dream.

Miscegenation in the dreamscape of *Cane* is a wraith that haunts the cane-brakes precisely because it denotes an unspeakable history. Only through acceptance and the unifying glue of multiple racial and cultural heritages can Toomer imagine a future for American identity. His response to the tragic ending of the mulatto/a trope suggests that the outcome stems from an intense inner and psychic turmoil brought on by an internalization of capitalist consumption and assimilation rather than the traditional explanation that madness is caused by an infusion of white blood. Consider Esther's story alongside that of the others in *Cane* cursed by whiteness and miscegenation: Becky gives birth to not one but two black sons. In so doing, she becomes the scapegoat for the white and black inhabitants of the town. The reader is not privy to Becky's thoughts; but like Esther, she is either dead or might as well be. The similarity between Toomer's gothic tale of Becky and the 1701 "Declaration and Confession of Esther Rodgers"—a sensational testimonial of interracial sex and murder—reveals that there is more to the history of miscegenation in this country than we are allowed to discuss. Taken by a preacher before her death, Esther's confession details two separate incidents of interracial sex that resulted in mixed-race offspring, whom she killed at birth. According to her testimony, at seventeen she "suffered [herself] to be defiled by a Negro lad living in the same house." When the child was born, she suffocated the baby and buried it in the garden. A few years later, she "fell into the horrible Pit (as before) of carnal pollution with the Negro man belonging to that house." She delivered the child of that union in a field and dropped "[her] by the side of a little pond."[61] Unlike Karintha, who carelessly abandons her child, she buries it under dirt and

snow. When she returns, her neighbors are suspicious. Upon inspection, they discover the child and have Esther arrested. It is not clear if she was sentenced to death for infanticide or for engaging in interracial sex. Either way, the act of miscegenation necessitated murder.

Significantly, unlike the other women in *Cane*, the narrator never *sees* Becky. Similar to Esther Rodgers, Becky "suffers herself" to commit interracial intercourse with two different men.[62] Yet Becky chooses to raise her two sons amid the contempt and disdain of both the black and the white communities. While her offspring are seen, she is not. It is striking that, in a text so preoccupied with color and the visual, we are left to imagine Becky ourselves. Like Esther in *Cane*, Becky is a ghost: no one knows for sure if she is still living. Together, *Cane*'s Becky and Esther Rodgers's *Confession* ask a unspoken question in our country's history of miscegenation: what happened when white women kept their mixed-race children? Their communities condemn both Becky and Rodgers to death. Though Becky's death is never verified, the walls of her shack cave in upon her like a small-scale House of Usher. Only a telltale groan, from which Barlo and the narrator run in horror, proves that she may have been inside.

Ultimately, the problem with Toomer's valorization of dusky beauty is that, like the grayness and shadows that come with dusk in "Blood-Burning Moon," the "dusk" motif in the sections on Fern, Esther, and Becky represents an in-between period. It does not have the whole purity of day or night but the elusiveness of the glowing dreamscape in which surreal qualities are imposed upon the geography. Toomer does this to distance himself from the idea of purity or singular representation; there is little division between the natural and the psychological. In previous chapters, I have argued that the mulatta functions as an exotic figure within black culture and that the many incarnations of her—as a passing figure, as a proper race woman, as a tempting vixen—embody the tensions surrounding assimilation and resistance in both uplift endeavors and aesthetic ventures. Rather than the dark beauty privileged by Johnson's *Nude*, the repetition of the dusk motif in *Cane* signifies Toomer's investment in the mulatta as the mother of his new American.

Toomer's Urban "Theater"

If the women in *Cane*'s first section are a metaphor for black folk culture and African American spiritual salvation, when transplanted to the north, they either become alienated in the spiritual void of the city or personify capitalist accumulation. The women in the urban section may be displaced, like Avey, or wear masks of assimilation, like Muriel. While Toomer acknowledges the appeal of the urban center, class stratification and colorism among the black

bourgeoisie hamper opportunity for advancement. A lack of spirituality and disconnection from nature permeate the characters.

As they imagine the geography of Afro-modernism in the city, Toomer's and Johnson's urban scenes recapitulate the themes of their rural portraits of women. Even in these pictures of city life, southern black folk culture leaves an indelible mark. One might say that the southern pulse continues to animate their art. Jean Toomer's structurally diverse *Cane* centers the history and geography of the south as an integral part of African American modern life. He dramatizes the surge northward while prophesying the inevitable return south. In *Modernism and the Harlem Renaissance*, Houston Baker, Jr., considers the position of the south in the urban north, arguing that what he calls the "mind of the South" is integral to any discussion of black modernity. For Baker, the black south constitutes an "expressive cultural reservoir" that has influenced national and international modernist movements.[63] Though Baker's rethinking of modernism focuses on Booker T. Washington's performative rhetoric, Toomer's and Johnson's work also mines the cultural reservoir of the black south as a way of rethinking primitivism and its role within the modernist landscape of urban black culture.

In the section that explores the "south in the city" (Toomer actually identifies this second section, starting with "Bona and Paul," as the actual beginning of *Cane*), the writer situates the themes of miscegenation, love, male-female relationships, and assimilation, which dominated his southern sketches, in an urban setting.[64] He marks the start of this section with a drawing of a half-curve; the missing half symbolizes the severance of African Americans from their southern heritage and folk culture. Yet instead of rendering the south as a space of decay and the past, Toomer shows how its culture survives in the north. He refuses to idealize the ramifications of the Great Migration and urban life; he delineates what the New Negro has abandoned and what he can never leave behind. The visually dynamic imagery in *Cane*'s urban section illustrates the tension between Toomer's prophetic conceptualization of American identity as essentially mulatto/a and the cataclysmic effects of the geography of urban capitalism on what he perceives as the ideal primitive nature of black folk culture.

While Toomer may have been an interloper in the south, in the urban section of *Cane* he is on familiar territory: urban scenes of bourgeois desire and transgressions of the color line were part and parcel of his childhood among Washington, D.C.'s, black elite. There he attended poet Georgia Johnson's "Saturday Nighters," intellectual and artistic gatherings similar to Jessie Fauset's literary teas in Harlem. Toomer's aesthetics were influenced as much by Washington's black artistic community as by the contingent of white New York modernists with whom he regularly published in the *Dial* and *Broom*.[65] By situating

"Avey," "Seventh Street," and "Theater" in Washington, D.C., not in Harlem, he positions that city as an important, alternative site of black modernism.

Like the women from the southern dreamscape, Avey, the first female prose portrait in the urban section, struggles against the overdetermination of the spectatorial narrator's gaze. In a way, Avey is Fern transplanted to the north. This time, the narrator summons the courage to speak, to tell Avey what he wanted to tell Fern in the canebrake. Although Avey is not overcome by the spiritual ecstasy that seizes Fern, she also passes out in his arms. By falling asleep during his passionate prediction, however, she resists the role he imagines for her, uninterested in his somewhat insulting plea to develop an inner life. Her name suggests "avatar," one who is on a quest for enlightenment, yet she does not achieve it. Unlike Fern, she does not even leave a lasting impression: "she did not have the gray-crimson splashed beauty of the dawn."[66] Toomer felt that the message of *Cane*, as the closing chapter of an unspeakable history, fell upon deaf ears. So, too, did his prediction of women's artistic agency.

Toomer's use of photographic imagery in "Avey" evokes the fraught power dynamic between the viewer and the viewed, the artist-narrator and the subject. The image of the Capitol covers her, and she is unable to hear her would-be lover prophesying a new day: "I talked, beautifully I thought, about an art that would be born, an art that would open the way for women the likes of her. I asked her to hope, and to build up an inner life against the coming of that day."[67] In "Avey," Toomer seeks to emulate Stieglitz's objective to "capture the subject itself, in its own substance and personality"; yet the character's lack of self-awareness, viewed from the perspective of the narrator renders her enigmatic, unknowable, and ultimately comatose.[68] The gendered gaze of his narrator seems to preclude feminine assertion. The narrator's "promise-song" and "passion die" as his muse is revealed to be as "indolent as ever."[69]

According to Charles Scruggs, in "Avey" Toomer reconfigures Stieglitz's famous photograph of New York City's Flatiron Building into a "new symbolic landscape."[70] For Stieglitz, the building (completed in 1933) was a symbol of American progress; he described it as "a picture of new America still in the making."[71] In "Avey," the Capitol stands in for the Flatiron. But Toomer's image does not herald a new America for African Americans. Instead, it presents a shadowed snapshot made grainy by a past filled with false promises to former slaves: "The Capitol dome looked like a gray ghost ship drifting in from sea."[72] In this linking of images, the Capitol moves from the symbolic heart of the nation to a slave ship, an apt metaphor, considering that Stieglitz compares the Flatiron to a "monster ocean steamer," unimpeded as it swiftly ushers in a new modern America and again invoking the ghostly, gray image of the drifting ship that opens Melville's "Benito Cereno."[73]

Although "soft" "mist," and grays dominate "Avey," Toomer's next urban scenes answer the "plea for color" that Helga Crane makes in *Quicksand*; in fact, color is the predominant motif in this swiftly paced section.[74] Unlike the languid, dusky sensuality of the southern dreamscape, the colors in the urban section are vibrant and electric; they capture the momentum and vitality of the city. Toomer also uses color to mark class divisions and colorist discrimination in the urban black community. According to him, "the consciousness of primitive folk, of great artists and philosophies are temporal dimensions. The middle class, the bourgeoisie, on the other hand are overburdened with time."[75] The colorful introductory piece, "Seventh Street," indicates how Toomer accelerates time in the middle section. The following passage, framed by parallel *aabb* quatrains, augments *Cane*'s improvisational quality and immerses the reader in the commerce and materialism of the city:

> Seventh Street is a bastard of Prohibition and the war. A crude-boned, soft-skinned wedge of nigger life breathing its loafer air, jazz songs and love, thrusting unconscious rhythms, black reddish blood into the white and whitewashed wood of Washington. Stale soggy wood of Washington. Wedges rust in soggy wood. . . . Split it! In two! Again! Shred it! Wedges are brilliant in the sun; ribbons of wet wood dry and blow away. Black reddish blood. Pouring for crude-boned soft-skinned life, who set you flowing?[76]

If Avey's drowsiness represents arrested progress, then the short syncopation of this passage presents the exact opposite. The rhythm, adjective clauses, punctuation, and alliteration suggest not only swift movement but jazz riffs, evident in the repetition of "soggy wood" and "black red-dish blood." The punctuation evokes urgency and excitement, reflecting the elusiveness of time. The color imagery is stark and dramatic. Black people are flowing north; their blood is flowing; black people are flowing into white neighborhoods. Like the blood imagery in "Blood-Burning Moon," the image of "black red-dish blood" suggests both internal and external violence.

The expressive performance Toomer depicts in "Theater" through lines such as "Blackskinned, they dance and shout above tick and trill of white-walled buildings" echo the lines "white and whitewashed wood of Washington" in "Seventh Street"; but in "Theater," Dorris's dancing mulatta body conjures the audience's active call and response. Dorris is a dancer in the city's famous Howard Theater. John, a mulatto and a member of Washington's talented tenth, adores her and regularly attends her performances. With "crisp-curled," "black" hair, a "lemon-colored face," and lips that "are curiously full, and very red," Dorris is a study in the contradictory features of mulatta iconography.[77] While

she possesses the skin color and beauty of an aloof, upper-class woman, she is actually a member of the underclass, an entertainer whose physicality and expressiveness render her an unsuitable mate. Though also a mulatto, John is a member of Washington's elite, an aristocratic group that Toomer believed occupied a transient position in American society: "these people whose racial strains were mixed and for the most part unknown, happened to find themselves in the colored group."[78] Despite her light skin, Dorris cannot surmount the intraracial class divide; John's spectatorial view maintains her as his fantasy, not his reality.

Viewed through John's yearning gaze, Dorris's dancing body conjures the antebellum south's gendered and raced hierarchies of power inside the Howard Theater. Though she performs on an urban stage, she sings "of canebrake loves and mangroves feasting" and thus is a perfect illustration of the "south in the city." Even more striking is the fact that Toomer's depiction of Dorris, with lines such as "her limbs in silk purple stockings are lovely," may have inspired Sterling Brown's "Cabaret" (1927), which compares the sensual performance of a chorus line to a chain gang. In Brown's poem the chorus girls are "Creole Beauties from New Orleans" with

Creamy skin flushing rose warm, *O, le bal des belles quarterounes!*
Their shapely bodies naked save
For tattered pink silk bodices, short velvet tights
And shining silver-buckled boots
Red bandannas on their sleek and close-clipped hair.[79]

Like Dorris, Brown's barely clothed chorus girls are as inaccessible to black spectators as Dorris is to John, albeit for slightly different reasons. As Brown's characters perform for "Hebrew and Anglo" "overlords" in a "Black and Tan" club, the narrator compares them to antebellum fancy girls being auctioned to slave owners:

Proud high-stepping beauties
Show your paces to the gentlemen
A prime filly, seh. What am I offered, gentlemen, gentlemen.[80]

Just as Toomer uses the feminine in "Portrait" to create an analogy to lynching, Brown's chorus girls embody the ominous chain gang as an ever-present danger for black male would-be spectators on the margins. The feelings that John experiences while watching Dorris also illuminate Oscar Micheaux's strategic insertion of chorus line scenes in films such as *God's Step Children*. As John

watches "the glitter and color of stacked scenes, the gilt and brass and crimson of the house, converge towards a center of physical ecstasy," he "wills thought to rid his mind of passion."[81] As an exotic, inaccessible entertainer, Dorris is a temptress who can titillate, but any respectable union must be assiduously avoided.

Cane continues to explore the tension between resistance and conformity in urban spaces in "Box Seat." In this vignette, Muriel loves Dan but will not accept his love because his class background threatens her dreams of security and upward mobility; instead, she suppresses her passion for life and love. In "Box Seat," the domestic space of the home, with its traditionally feminine connotation, symbolizes the problems of integration and materialism that complicate Muriel and Dan's romance. Toomer personifies the house as female: "Houses are shy girls whose eyes shine reticently upon the dusk body of the street. Upon the gleaming limbs and asphalt torso of a dreaming nigger. Shake your curled wool-blossoms, nigger. Open your liver lips to the lean, white spring. Stir the root-life of a withered people. Call them from their houses, and teach them to dream." Both women and houses signify the empty masquerade that urban bourgeois mores require. Muriel suppresses her passion for life and for Dan; her aspirations for success transform her into a "house with girl-eyes," keeping out Dan's love and invading passion, an attraction that would dehumanize her: "her animalism, still unconquered by zoo-restrictions and keeper-taboos, stirs him."[82] As with the images in "Seventh Street," the passage reinforces the irony that movement to and within the city is more often horizontal than vertical: intraracial discrimination on the basis of skin color is often the mechanism that replicates the hierarchy of the plantation in the urban environment.

This Lincoln Theater scene likens Muriel to an expressionist painting:

> Muriel, leading Bernice who is a cross between a washerwoman and a blue-blood lady, a washer-blue, a washer-lady, wanders down the right aisle to the lower front box. Muriel has on an orange dress. Its color would clash with the crimson box-draperies, its color would contradict the sweet rose smile her face is bathed in, should she take her coat off. She'll keep it on. Pale purples shadows rest on the planes of her cheeks. Deep purple comes from her thick-shocked hair. Orange of the dress goes well with these. Muriel presses her coat down from around her shoulders. Teachers are not supposed to have bobbed hair.

Toomer conflates class, culture, and color in the first section of this passage, combining opposing descriptions, such as a blue-blooded laundress.[83] Unlike the pale heroines popularized by passing novels, Muriel's skin color does not allow her to pass; but the trappings of ladyhood, of middle-class propriety, interfere

with her desires. The central colors in this passage conflict with her wish to conform to bland, middle-class aesthetics.[84] Although she is cloaked with splashes of vivid orange and purple, she keeps her coat on to avoid conflict. She doesn't want to appear to be improper; and the narrator reminds us that, as a teacher, she is not "supposed to have bobbed hair," a style that signifies independence and the bohemian lifestyle of the flapper. This short poignant aside in "Box Seat" underlines Toomer's position that the south and the southern soul of the Negro cannot coexist productively in the city.

Reading Toomer's urban portraits in concert, we clearly see that, in contrast to the organic beauty of the southern women, the allure of urban femininity is contrived and destructively artificial. Dorris is lovely to look at but dangerous to embrace. Avey typifies the southern black woman out of her element; the materialism and bourgeois ideals of the city dislocate, repress, and finally render her unconscious. Like Muriel in "Box Seat," Avey is both misunderstood and dehumanized by her lover, who considers her to be "no better than a cow," while Muriel's "animalism, still unconquered by zoo-restrictions and keeper-taboos, stirs" Dan.[85] Despite its appeal, the nurturing potential associated with black southern womanhood fails to thrive in the city.

William H. Johnson's *The Café* (1939) is a unique final piece to discuss in conjunction with *Cane*'s urban landscapes because it represents both artists' interest in retaining black folk culture as a spiritual refuge in the modern urban center. *The Café* illustrates how Johnson managed to blend elements of African sculpture and expressionism to create a modern primitive (fig. 22). The medium is oil on paperboard, which gives the painting a rough texture that jars with its flat, geometric shapes. Because the work's two figures are positioned on opposite sides of the table with a bottle of wine before them, some have read this painting as a revision of Picasso's *The Frugal Repast*. But while Picasso's etching emphasizes the meagerness and despair of his couple, who are reversed in Johnson's painting, *The Café* portrays the vitality and leisure of urban life compared with the arduous labor of the south. The seated couple appears to be preparing for, or relaxing after, a night on the town. The mélange of bright purple, orange, and yellow evokes *Cane*'s description of Muriel's orange dress and purple-shadowed cheeks against the red curtains of the Lincoln Theater. It is not a realistic portrayal; the hands and limbs do not coordinate perfectly with the torso, nor do the table legs seem architecturally sound. The bending curves illustrate Johnson's earlier dedication to abstract art, which he has incorporated here. Ultimately, his celebratory images of black couples emphasize the importance of intimacy and love as the glue holding the black family together in a time of struggle. In contrast, Toomer's fraught portraits of black love in an urban setting oppose Johnson's joyful and unifying scenes.

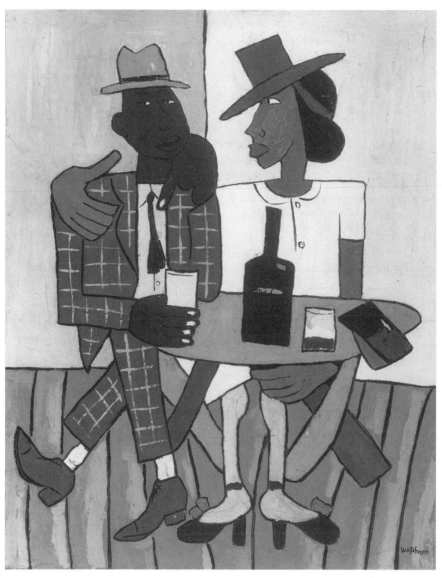

22. William H. Johnson, *Café*, 1939.

SMITHSONIAN AMERICAN ART MUSEUM, GIFT OF THE HARMON FOUNDATION.

The Son's Return

Cane concludes with "Kabnis," a semi-dramatic, poetic piece that marks the return of the southern-born, prodigal son who has been "northernized"; it is a story in which the north directly confronts the south in the south. Ralph Kabnis is a southern-born man who moves north and then returns south to work at a black school. He becomes increasingly overwhelmed by his fear of the south's unspeakably violent history of rape and lynching. Two broken semicircles reaching toward each other precede "Kabnis." Toomer refers to this section of *Cane* as "the plunge." Kabnis is plunged into the "heart of darkness." His worst fears of the south—lynching, rape, violence, and corruption—drive him dizzyingly close to self-destruction.

Lewis (a radical northern black visitor) names Kabnis's mulatto heritage: "Master; slave. Soil; and the overarching heaven. Dusk; dawn. They fight and bastardize you. The sun tint of your cheeks, flame of the great season's multicolored leaves, tarnished, burned. Split, shredded: easily burned. No use." After Lewis's articulation of Kabnis's mulatto heritage, Stella, a "beautifully proportioned, large-eyed, brown skin girl," rather than the mulatta Cora, is the first to respond: "Stella's face draws back, her breasts come towards him."[86] As Stella bodily "rememories" the sexual abuses of the slave master, her breasts come forward like an udder without her cognition. While other characters both admire and deplore Kabnis's slow descent into the bowels of history, only the women can save him by nurturing and facilitating his rebirth.

Because "Kabnis" is too dense to thoroughly interrogate here, I only touch on the portrayal of Carrie Kate, who in the final scene of *Cane* figuratively gives birth the future of the race. In fact, birth imagery dominates "Kabnis." Kabnis is "the unborn child whose calm throbbing in the belly of a Negress sets them somnolently singing." This Negress, the personification of night, appears to have trapped him in the perpetual darkness of the south: "Night, soft belly of a pregnant Negress throbs evenly against the torso of the South." The image of the madonna outlined in "charcoal on the courthouse wall" also has an encore in "Kabnis." Just as the Virgin Mary (often referred to as a "Second Eve") gave women a chance to redeem their misstep in the garden by giving birth to God's son, the fallen women of *Cane*—prostitutes, chorus girls, soulless social climbers—find redemption in Carrie Kate. Carrie Kate becomes the second incarnation of the madonna, after Fern. She is the only one who approaches the inner life Toomer believes is necessary for women to achieve the ideal feminine state, unlike Avey whose "emotions had overflowed into paths that dissipated them."[87]

Kabnis must be reborn through Carrie Kate in order to understand and

accept his southern heritage and all that it entails. With her "oval-olive face" and wistful expression, she is a "nascent woman," the only woman in *Cane* who has maintained her innocence beyond adolescence. In the final scene in "Kabnis,' she mends the half-circles into one, joining old and young, north and south, man and woman. Together, Carrie Kate, Father John, and Kabnis form a circle: "Light streaks through the iron-barred cellar window. Within its soft circle, the figures of Carrie Kate and Father John." Unlike the other women in *Cane*, who at the climax of their sections only sing like Louisa or moan like Fern, Carrie Kate murmurs, "Jesus, come." As she beckons to Kabnis, the "sun arises from its cradle in the tree-tops of the forest" as a "Gold-glowing child."[88] The sun/son is Kabnis, his coming foretold in section 1 in the "Song of the Son." It is fitting that *Cane* ends at dawn as so much of the novel takes place at dusk. Although Toomer maintains that *Cane* is a swan song, by concluding with "Kabnis," a mixed-genre story within a mixed-medium novel, Toomer leaves the reader with a sense of hope rather than the urban alienation that characterizes section 2 or the stagnation that dominates section 1.

In "The Negroes and Art," Louis Achille asks, "How much of you is still savage?"[89] Toomer's and Johnson's art responds to Achille's provocation by re-articulating a primitivism that underlines the spiritual components and folk elements of black culture as a method of preserving an ancestral heritage. Drawing on religious and primitivist iconography, *Cane* presents a varied, nuanced exploration of the mulatta figure and the circumscribed position of black women. Unfortunately, Toomer's effort to reconceptualize primitivism as a useful or authentic discourse of black representation fails because he makes little distinction between the primitive and black folk culture. While *Cane*'s vignettes illustrate the collective spirituality and the tragic history of the African in the United States, Toomer's philosophy of American identity—his prophecy for the future, as it were—amounts to an erasure of race that is ultimately untenable and contradicts the cultural legacies that resonate throughout the work. While cultural amalgamation may be inevitable, Toomer seems unaware of the cultural elisions of the melting-pot philosophy and how color (or its absence) comes to denote privilege. In redefining the Old Negro as a relic of the past and pushing the mulatto/a artist forward as the future, Toomer replaces one restrictive classification with another by transforming the primitive into the mulatto/a via the body of the black woman.

Certainly Toomer was not the only Harlem Renaissance writer to link primitivist or exotic imagery with the mulatta; Eric Walrond's *Tropic Death* (1926) features stories replete with exotic language and languid descriptions of a Caribbean landscape where the primitive and the modern fight for supremacy amid a mélange of culture, class, and color. Like Louisa in "Blood-Burning Moon,"

the black women in Walrond's stories often provoke acts of violent or sexualized encounters between the modern and the primitive. In "The Yellow One" a woman with "skin the ripe red gold of the Honduras half-breed" becomes an excuse for a brutal attack in which she is the unintended casualty: "Once catching a glimpse of her, they swooped down like a brood of starving hawks." Heritage in Walrond's world (Trinidadian, Jamaican, Honduran, Chinese, and Indian all mingle) is a complex matter that at first appears to have little in common with the stark racial binaries of the United States. Yet this sense of fluidity, of a multitude of hues, of the mysticism surrounding blood and belonging that echoes the landscape of *Cane* seems to have inspired the poetic depiction of characters like Maura in "The Wharf Rats," whose "skin was the reddish yellow of old gold and in her eyes there lurked the glint of mother-of-pearl. Her hair, long as a jungle elf's was jettish, untethered."[90] As in *Cane*, the narrator of *Tropic Death* plays the role of a sometimes distant, occasionally active, in-group spectator that allows Walrond to evokes the stench of capitalism and colonialism lurking beneath the veneer of paradise and *obeah* that threatens the maintenance of an already tentative harmony among the displaced island occupants who have a complex relationship to the term *native*.

Jean Toomer is often called a visionary. His many unpublished writings demonstrate that he was one of the twentieth century's most introspective thinkers and philosophers. His oracular tendencies recall Du Bois's prediction that the twentieth century would be dominated by "the problem of the color line." Indeed, color and vision are essential elements in *Cane*; they are the tools Toomer uses to depict African American culture in its diverse madness, its persistent beauty touched with tragedy and joy, and its obstinate refusal to disappear. His work anticipates Langston Hughes's argument that black folk culture is a crucial aspect of African American art.[91] But ironically, instead of heralding the start of what should have been a brilliant career, *Cane* marked the end of Toomer as a Harlem Renaissance writer. Yet just as the density of Ralph Ellison's *Invisible Man* propels us to reread it again and again, Toomer's work of art provides an unending source of discursive pleasure.

While Toomer and Johnson may or may not have brushed shoulders in the artistic arenas and social circles of the Harlem Renaissance, I have united them here to illustrate how fundamental the black female body, especially the mixed-raced body, was to their formal innovations and contributions to Afro-modernism. By placing the work of an abstract expressionist painter and experimental prose-poet in dialogue, I blur their boundaries; for each articulates a particular primitivism that is both possessively complicit and objectifyingly distant. Johnson identifies himself and his art explicitly with black culture. His revolutionary representations of the black subject in American art, most apparent

as *Nude* and *Girl in a Green Dress,* reflect multiple painting techniques and artistic traditions. Like Toomer, however, Johnson's articulation of the modern primitive in his art is limited because it does not sufficiently diverge from primitivist modernism to constitute a novel or reclaimed approach. More than merely a meditation on the relationship between the mulatta icon and Afro-modernist interrogations of primitivism, an analysis of their work interrogates the problem of origin and inspiration in black art and writing that draws from rural black folk culture and high modernism as both a vexing and revolutionary enterprise. A line from Toomer's *Essentials* best articulates the contradictory nature of this enterprise: "An artist is he who can balance strong contrasts, who can combine opposing forms and forces in significant unity."[92]

chapter five

Redressing the New Negro Woman

The beauty is how this strange trade works. The truth of it is, we are fabulous.

—ELIZABETH ALEXANDER, "The Josephine Baker Museum"

The strategy of taking elements of an established or imposed culture and throwing
them back with a different set of meanings is not only key to guerilla warfare;
the tactics of reversal, recycling, and subversive montage are aesthetics
that form the basis of many twentieth-century avant-gardes.

—COCO FUSCO, *English Is Broken Here*[1]

This concluding chapter looks at contemporary writers and visual artists who
brilliantly recast the mulatta iconography of the Harlem Renaissance and the
sociopolitical and aesthetic maelstrom that surrounded the New Negro woman.
My discussion centers on Faith Ringgold's *French Collection*—a series of story
quilts following the adventures of a black female artist in 1920s and 1930s
Paris—as a productive way of redressing the mulatta icon as the ideal New
Negro woman and the Harlem Renaissance as a collaborative, Afro-modernist
endeavor. Viewed in concert, the quilts take on primitivism, modernism, moth-
erhood, and miscegenation, offering a diasporic vision of the Harlem Renais-
sance through the eyes of Willia Marie Simone. An analysis of Ringgold's
visual-textual-tactile narrative allows me to address the limitations of the New
Negro movement and consider persistent questions concerning agency and
pleasure that arise in the work of the Harlem Renaissance authors and artists
central to this study. From Ringgold's work I proceed to Toni Morrison's *Jazz*,
a novel set in the New Negro era that satirizes the tragic mulatta/o trope and
offers a layered engagement of Jean Toomer's *Cane*. Morrison's novel is a tex-
tual photocollage that addresses the silent primitivism of Toomer's female prose
portraits and critiques his anointing of the mulatto son as the future of the
race. I close my discussion with a brief consideration of how contemporary
writers and artists revisit the interartistic representations of the mulatta icon
as the idealized New Negro woman; the exotic, alienated passing figure; and

the hybrid embodiment of cultural amalgamation. This final chapter applies the dialogical framework used throughout this book with a difference: Ringgold's and Morrison's work do not speak to each other; rather, both artist and writer talk back to the iconic images of the New Negro woman, providing contemporary commentary on the continued relevance of the Harlem Renaissance as a formative period in American literature and culture.

The story quilts of Ringgold's *French Collection*, with their astute synthesis of the visual and the textual, directly address the complex role of the New Negro woman as portrayed in the novels of Jessie Fauset and Nella Larsen. Ringgold's work illuminates the subtext submerged beneath her predecessors' narratives of passing and dislocation; that subtext, the New Negro woman's quest to find a space of artistic and sexual expression, is the thematic core of the *French Collection*. The undercurrent of dislocation encapsulated by the mulatta in the Harlem Renaissance reverberates in Ringgold's art, which seeks to reclaim the agency of the black female artist and her image.[2] When read in conjunction with Willia's journey, the complex longings of Larsen's and Fauset's heroines emerge as reflections of their authors' desire for an artistic, intellectual life that does not exclude domestic happiness. Because Ringgold's work is explicitly interartistic and mixes media (she combines both folk and modern art in the form of quilt making and textual narrative), the New Negro woman artist finds a voice through a confluence of written, visual, and sensual elements in the quilts' margin text. By problematizing primitivism and the function of the spectator's gaze, Ringgold's playful yet disturbingly beautiful images engage the Harlem Renaissance from the center of the modernist movement and the symbolic space of black artistic freedom: Paris. She incorporates and critiques modern art icons as she toys with the artist-subject binary, transferring the gaze back and forth between the viewer and the viewed. This magnificent collection not only reverses the hegemony of the white male gaze by placing the New Negro woman artist on the model's chaise longue but argues for a more diasporic vision of the Harlem Renaissance, first from the perspective of Willia and then through her mulatta daughter Marlena.

The *French Collection* chronicles the exploratory journey of Willia Marie Simone during the high modernist era. It is complemented by the *American Collection*, which follows the return of Willia Marie's biracial daughter, who "meditates on her African and European ancestors and questions certain family stories and values shared by both sides of her family as she ponders the questions: who am I and why am I here."[3] My discussion centers on the story quilts in the *French Collection* because, though Willia's daughter is biracial, the quilts in the *American Collection* by and large do not address her mixed-race status; the majority portray earlier periods in African American history, including

slavery and the Middle Passage. Few the of the quilts in the *American Collection* include more than a brief narrative; what text there is works as an endnote rather than being woven into the visual, tactile, literary experience. Most important, it is Willia, not Marlena, whose journey parallels that of the New Negro woman in Harlem Renaissance literature through her engagement of modernism, marital conflict, and women's art. Marlena's story as an artist begins in New York in the 1940s, after the era this book addresses. Finally, neither Marlena's self-portraits nor her compositions manifest the same iconic attributes or narrative strands that typify the other figures in this book.[4] It's almost as if her story begins, both chronologically and conceptually, where the New Negro woman artist's story concludes: a new chapter in the latter half of the century.

Through Ringgold's depiction of Willia as a successful artist, model, mother, and café owner in 1920s and 1930s France, Ringgold imagines and corrects history, bending time and space to her will. The collection's title quilt shows Willia, her friend Marcia, and the latter's three children on a trip to the Louvre. The quilt titled *Dancing at the Louvre* highlights Ringgold's main representative strategy: the insertion of black women into the echelons of western culture. In this case, the site of contestation is the museum. The women and children are not admiring the influential works of western art history but dancing in the midst of them, much to the amusement of the larger-than-life reproduction of the *Mona Lisa* in the background. They are appropriately expressing their own creativity inside "the master's house."

Coco Fusco's identification of reversal, recycling, and subversive montage as aesthetic tactics provides a useful and wonderfully relevant way of understanding the disconcerting promotion of mulatta iconography both during and after the Harlem Renaissance.[5] Although few would characterize their novels as guerilla warfare, Larsen's, Fauset's, and Toomer's depictions of the mulatta unveil inherent ideological contradictions about uplift and transformation. Fusco's articulation of resistant representative strategies combats the persistent misperception that Fauset's novels advocate bourgeois ideals or that Larsen's heroines' desires for artistic and sexual freedom are fundamentally tragic and unattainable. Fauset seeks to represent an authentic black female artist-protagonist who is deeply opposed to (in her opinion) Claude McKay's vulgar characterizations in *Home to Harlem* or the trite passing melodrama of T. S. Stribling's *Birthright*. Her narrative goals are clear: she seeks a space in which class, race, gender, and marital status do not hinder the black female artist.

Fauset's experience as an editor, journalist, and fosterer of literary culture enabled her to imagine an authentic, exclusive black community counterbalanced by the dangerous world of interracial mixing, passing and patronage. Yet while she criticized certain patriarchal elements of New Negro culture, it remained

her dominant vision of happiness and opportunity. Larsen's and Toomer's goals are more idealistic and elusive to identify. Their art suggests the possibility of a transcendent space in which all boundaries and restrictions fall away, but it wavers between being essentialist and anti-representational. For instance, while Toomer's agile manipulation of photography, painting, poetry, prose, and the blues is avant-garde and Afro-modernist, one cannot easily dismiss his appropriation of the primitive in service to his multiculturalist predictions. While arguing for a notion of identity and representation more expansive than black and white, Fusco offers a salient warning: multiculturalism should not conflate hybridity with parity.[6]

What I like best about Fusco's manifesto of cultural and artistic hybridity is that it allows me to expand the parameters of New Negro representation beyond explicit opposition to include playful interrogation and appropriation. Certainly, the visual realm remains a contentious issue within black cultural debates about the politics of representation. The discomfort with parody and abstraction in the works of MacArthur Award winner Kara Walker and her predecessor Robert Colescott illustrates African Americans' distrust of the visual realm and black bodies appearing in it, which is understandable considering that the visual has historically been a site of betrayal. Just as Colescott's exhibitions necessitated round-table and question-and-answer sessions to contextualize the "quality of sass" in paintings such as *Les Demoiselles d'Alabama* and *Eat dem Taters*, discussions of hybridity should further debates about cultural exchange and appropriation rather than function as catch-all solutions to the tension of the border between cultures.[7] In commenting on Ringgold's early images of the American flag as a national icon, Amiri Baraka wrote, "Faith's work is not the art of the drawing room. . . . She, when we can get close enough to check what she's about, is carrying news of the Field."[8] The antebellum metaphor of house and field that Baraka draws on to characterize her work echoes the dichotomy established by Audre Lorde's famous exhortation: "the master's tools will never dismantle the master's house."[9] Lorde highlights the irony inherent in African American art that developed in accordance with, or counter to, the hegemony of the Enlightenment and modernism. Each generation or movement of black artists has questioned, redefined, or resisted the place of so-called western art forms and discursive practices in their artistic tradition, asking if European language, ideas, forms, and philosophies can ever belong to them. This question is not relegated to artistic and cultural practices; it also informs issues of social and economic entitlement and national identity. When we attempt to distinguish between "house" and the "field," the bourgeoisie and the folk, the conformists and the nonconformists, we see that the

lines of aesthetic demarcation are still murky. If, in the black arts movement (and the Harlem Renaissance) the image was, as Alma Billingslea-Brown argues, the "workshop of meaning," Ringgold, like other contemporary black female artists, believes that by "transposing images into symbols" she can recast stereotypes and imbibe them with a new significance.[10] Conversely, the emphasis on image making in the nationalist discourse of the sixties carried with it the same restrictive ideological boundaries espoused by the New Negro movement: images must, in the words of Maulana Karenga, "expose the enemy, praise the people, and support the revolution." These aesthetic limitations create what Audre Lorde deemed "a new set of shackles."[11]

Faith Ringgold's early art appeared to conform to Karenga's aesthetics; however, her specific focus on the experience of the black female artist in the *French* and *American* collections distinguishes her work from the black arts movement's supposed avoidance of gender oppression. I focus on the *French Collection* because it is here that Ringgold confronts gender and intraracial politics by transposing iconic images from the New Negro era. Her revisioning of modernism, primitivism, and the Harlem Renaissance centralizes the black female artist and the black female body while delineating the limitations of the mulatta icon as the predominant figure in the literature and visual culture of the era.

Model, Muse, Artist:
The New Negro Woman Finds Her Brush

There are many moments of agency and self-reflection among black female artists and activists in Ringgold's work; she often imagines conversations between often-ignored black artists and the major figures of mainstream modernism. In her art, expression, joy, and freedom are sacred; silence and invisibility are enemies. In her story quilts, Picasso poses nude at a picnic of women artists and activists, and Gertrude Stein hosts soirees at which James Baldwin and Zora Neale Hurston sit beside Hemingway and Picasso. The images in the *French Collection* are drawn from James Van Der Zee's photographs as well as newspaper clippings and Ringgold's family history. Willia's original art converses with extracts from Picasso, Matisse, and Van Gogh.[12] Ringgold's compositions situate text as part of the visual landscape, including on the quilt's border a running narrative that reflects the experience of looking at, absorbing, and interpreting visual art. Quilt making is a feminine folk form that elicits a tactile response, requiring the viewer to engage several senses. Ringgold's story quilts are writerly art, the inverse of Larsen's and Toomer's painterly texts. The hand-printed narrative provides an experiential, almost stream-of-consciousness

commentary that does not fully explicate the visual images but provides an ephemeral context that gives clues to the sources in her art and situates Willia's experience as a black female artist within them.

Through a visual *kunstlerroman*, Ringgold shows that, before Willia can emerge as agent and artist, she must come to terms with her own subjectivity: what better place to start than on the chaise longue? Considering the history of black representation in modern (and postmodern) art and popular culture, it is a revolutionary stance to claim room for agency, even pleasure, in the self-exhibition of the black female nude. Given New Negro investments in the politics of respectability, Willia's assertion (or admission?) on the quilt border that all women at "one time or other have lain on a chaise longue" is radical precisely because of the black nude's long and frequently egregious history in western art.[13] In fact, with few exceptions, Harlem Renaissance artists, fearful of replicating the hypersexualized stereotypes of black women, shied away from this subject.[14] Their avoidance is similar to the reluctance of nineteenth-century African American writers to explicitly discuss black female sexuality.

Besides Johnson's *Nude*, discussed in Chapter 4, there are few serious studies of the black nude in Harlem Renaissance art. One is Motley's *Brown Girl After the Bath* (1931), an extraordinary work that embodies the problematics of the black nude in early African American art. At 122.5 inches by 91.4 inches, this larger-than-life painting is a beautiful, non-pornographic black nude (fig. 23). While the voyeuristic elements of the modern nude are still present, Motley has created a stylistically complex painting. The expression on the model's face is purposefully elusive, yet she indirectly perceives the spectator. The spatial dimensions in the painting are so tightly constructed that the audience seems to be sitting on the bed and meeting the woman's gaze in the mirror. The work is simultaneously invasive and exclusionary, incredibly sensual and meticulous, from the sexual organs to the unfastened strap on her shoe. The artist's attention to detail—draperies, knobs on the wooden vanity, perfume bottles, and a powder puff in the woman's hand—typical of his early realist pieces, draws our gaze away from his clever, signature use of artificial light. Yet his experiments with light animate the scene; the spotlight on the reflection contrasts with the dim light on the subject, making it impossible to determine whether or not the mirror reflects how the subject sees herself or how we and the artist imagine she looks from the front. The discernible tensions between subject and artist, viewer and viewed make this painting remarkable. But however lovely, Motley's portrait essentially replicates seventeenth-century Danish portraits of the harlot performing her toilet. The subject does not act within and upon the canvas in the way that Ringgold's does. Ringgold's placement of her nudes guides us through Willia's evolution from worshipped muse to conscious model to fully formed artist.

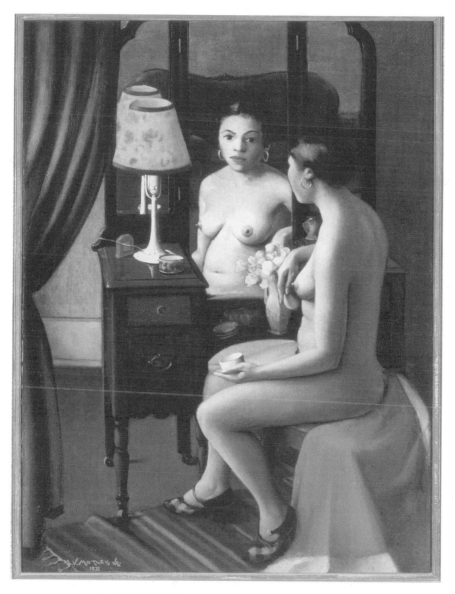

23. Archibald J. Motley, Jr., *Brown Girl After the Bath*, 1931.
CHICAGO HISTORY MUSEUM AND VALERIE GERRARD BROWNE.

Two quilts in the *French Collection, Matisse's Model* and *Picasso's Studio*, re-invent the black nude by articulating the experience of exhibition, eroticism, beauty, and aesthetic pleasure that encircles the black woman as an art subject. *Matisse's Model* figures our heroine as the reclining nude (fig. 24). The center of the piece reproduces Matisse's *La Danse*. Five mostly female figures (a few are possibly androgynous) dance in a circle with linked hands on a blue and green background. Directly beneath them lies Willia Simone. She poses for Matisse, whose gray form appears on the lower left. Her face is tranquil, and her dark eyes look slightly heavenward toward an unseen audience. Ringgold suggests that Willia's beauty inspires Matisse's masterpiece. Although we do not see his hands, they presumably hold a palette with several primary colors. His eyes focus intensely on the viewer. As spectators of modern art, we are immediately drawn to Willia, the naked model. But her complex relationship to the dancing figures framed directly above is the true subject of this piece.

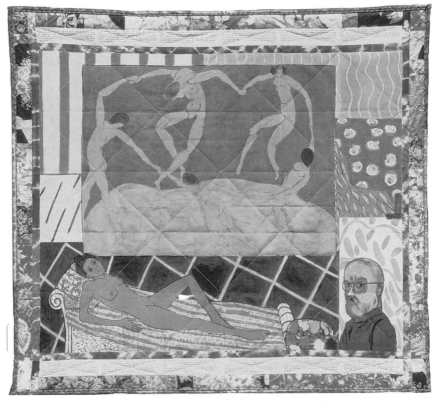

24. Faith Ringgold, *French Collection #5: Matisse's Model.*
FAITH RINGGOLD © 1991. COLLECTION OF THE BALTIMORE MUSEUM OF ART.

The long fluid lines, the sharp angles of her elbows and bent knee, and the orange tones in her skin all echo the ripples of the dancers' linked arms. A myriad of components, including fauvist patches of color, beckon for our attention.

Playing on the rivalry (and the inevitable similarities) between the two modern masters, Matisse and Picasso, Ringgold's heroine also poses nude in *Picasso's Studio* (fig. 25). In this quilt, a bare-chested Picasso poses with his brush against a blank page. Willia is centered in front of *Les Demoiselles d'Avignon.* Her hands are on top of her head, and she appears to be superimposed inside the painting. To the left are drawings of abstract female figures, ostensibly a reference

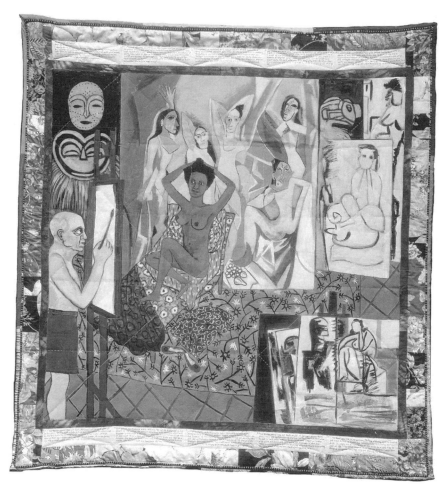

25. Faith Ringgold, *French Collection #7: Picasso's Studio.*
FAITH RINGGOLD © 1997. COLLECTION OF THE WOOSTER MUSEUM OF ART.

to the many sketches Picasso did of his subjects before committing them to oil and canvas. On the right are two African masks, the inspiration for the faces of the prostitutes in *Les Demoiselles*. The colors in this quilt are more subdued than in *Matisse's Model*, more in line with cubism rather than fauvism. In this piece, Willia strikes a mature and confident pose. And she is not the only figure *en dishabillé*: Picasso wears only short pants. Rather than vibrant splashes of patterned fabric, the predominant image in the margins of the quilt is the African image that was the impetus for Picasso's primitivist modernism.

Picasso's Studio and *Matisse's Model* recast the black female subject as central, a corrective to her role as a foil for the white female subject in works such as Ingres's *La Grande Odalisque* or Manet's *Olympia*. By juxtaposing Willia's body with famous works of art, Ringgold reminds us that black women have inspired many great masterpieces. Because these story quilts examine beauty (inner beauty, outer beauty, and beauty as an inspiration for art), literary and historical allusions to the black body as a spectacle overlay Willia's figure. Though there are no explicit references to Josephine Baker and Saartje Baartman (the famed Hottentot Venus) in the central images of either quilt, the two dance figuratively in the margins. We are reminded that La Baker, who makes a striking cameo appearance in *Jo Baker's Birthday*, inspired Paul Colin's colorful if highly caricatured lithography, several avant-garde photographs, and Le Corbusier's architectural genius. This juxtaposition of the black model with the painter diverges from the representation of the black-white binary exploited by most modern pieces. Most discussions of *Olympia*, for instance, neglect the black model in the painting as anything other than a foil for the central white figure. Yet Manet's own notes describe the model, "Laura," as "a very beautiful Negress" who posed for three of his paintings, including one in which she is the sole subject.[15] Through its interplay of visual referents and margin notes, Ringgold's work seeks to bare the untold stories of the margins; Willia, inhabiting the guise of the black nude, gives a maligned image an introspective consciousness when she says, "There is a certain power I keep in the translation of my image from me to the canvas."[16] In this way, the text is crucial to the interpretation of the visual image and the strategic reversal that Ringgold enacts through her story quilts.

What makes Ringgold's nudes avant-garde (or post–Afro-modernist) is that they preserve that beauty, sensuality, and pleasure without ignoring the complex history of black representation. Her compositions widen the lens; she problematizes primitivism and appropriation while privileging the individuality of the subject and self-determination. Her work demonstrates that, while the accoutrements of primitivism and exoticism can prompt black women to efface themselves, there is a possibility of pleasure and agency. Just as bell hooks

enjoys watching Fredi Washington's portrayal of Peola in *Imitation of Life*, Larsen's Helga Crane revels for a moment in the adoration of the Danish. Likewise, Josephine Baker relished and capitalized on her popularity as the toast of Paris; and Ringgold's quilts thematize the conflicting emotions of pleasure, identification, and exoticism that black women experience as subjects and spectators.[17] Her art illustrates that, while the black nude is no longer a shocking subject, it is still hard to admit a "pleasure in looking" when confronted with paintings like Motley's *Brown Girl After the Bath*.[18] From the exaggerated drawings of the Hottentot Venus to Paul Colin's caricatured lithographs in *La Revue Negre*, the history of exploitation and commodification still overshadows the black nude. It's precisely because of the maligned history of black womanhood in the public sphere that introspection is such an essential element; the visual may simply not be enough. Left unannotated, Ringgold's nudes risk falling into well-trodden categories of objectification.

Ringgold's carefully balanced negotiation of agency and exoticism prompts my backward glance at the tentative border between objectification and empowerment that Larsen explores in *Quicksand*. Before leaving for Denmark, Helga Crane "let herself drop into the blissful sensation of visualizing herself in different, strange places, among approving and admiring people, where she would be appreciated, and understood." In Denmark, she succumbs to the pleasure of exotic clothing, food, and attention, relatively unconscious of the consequences of her behavior; she never considers that the psychic costs of this adoration may lead to self-distortion and, quite possibly, madness. At Naxos and in Harlem, Helga's divergent attire is an affirmation of individuality and protest against the conformist impulse of the bourgeoisie and uplift culture. When she wears a "cobwebby black net touched with orange," her friend Anne disapproves: it is "too décolleté" and "outré" for talented-tenth parties. Worse, her outfit gives her "the air of something about to fly."[19] While Helga's clothes are empowering assertions of her own personal style (and betray Larsen's fascination with fashion), unfortunately her predilection for exotic garments alienates her in Harlem while accentuating her otherness abroad. Stuart Hall, paraphrased by Coco Fusco, writes, "Not all symbols and exchanges are interchangeable—there are still differences that make a difference."[20] As Josephine Baker did, Helga attempts to cash in on her "difference"; but Baker knew that, to maintain its mystery and appeal, the product must continue to be new, to shock, and to transform. Helga cannot keep up the pace. Her failure to maintain control, to establish a clear boundary between herself and her performance, ensures that her final transformation into a southern wife and mother is her last.

In the borders of the story quilts, we discover what allows Willia the possibility for self-empowerment that ultimately eludes Larsen's and Fauset's

protagonists. These border notes complicate and sometimes even oppose the visual image. A journal of sorts, the text that accompanies *Matisse's Model* re-counts Willia's memory of a young, dark-skinned black man who rejected her skin as "smokey." From this fragment, Willia ponders on the light-skin/dark-skin problem in the black community. Although both dark- and light-skinned women face color prejudice, Willia believes that "most boys favored peaches-and-cream over smoke" and that "dark skinned girls at school knew we were not the top priority."[21] As the written narrative moves us from Matisse's studio to a black elementary school classroom, the artist connects the idealization of a black primitive beauty in modern art and the colorist valorization of mixed-race or fair-skinned beauty as encapsulated by the mulatta icon in African American culture. Willia's critique of both standards of beauty and her wish to be loved and valued are tangible desires that cannot be suppressed or theo-rized away.

Willia wants to be "une belle peinture," an echo of the longing for beauty and adoration thematized in Fauset's *Plum Bun*.[22] In the scene in which Hetty Daniels poses for Angela, Hetty can "not conceive of being sketched because she was not, in the artist's jargon, 'interesting,' 'paintable,' or 'difficult.' Mod-els, as she understood it, were chosen for their beauty." A plain housekeeper, Hetty does not perceive herself as exotic or beautiful, yet she "loved to pose." Angela watches "her unslaked yearnings [gleam] suddenly out of her eyes, trans-forming her usually rather expressionless face into something wild and avid. The dark brown immobile mask of her skin made an excellent foil for the win-dows of an emotion which was so apparent, so palpable, that it seemed like something superimposed upon the background of her countenance."[23] Just as Willia's brown body is superimposed over the African-mask faces of *Les Demoi-selles* in *Picasso's Studio*, Hetty's emotion masks her brown skin. Tellingly, her name recalls the names of two very different cinematic icons: *Hetty* Lamarr and Hattie Mc*Daniels*. The portrait that Angela draws of Hetty Daniels mani-fests the contrast between the coveted beauty of the Hollywood starlet and the infamous mammy, because Hetty, like Miss Powell, is ultimately a foil for Fauset's central passing heroine. In contrast, Ringgold gives starring roles to the darker-skinned women in the background of Fauset's novel.

Unlike Hetty, Willia is conscious of her performance and its seductions. While posing in *Picasso's Studio*, she wonders, "What do you do with your mind, with your misplaced or mistaken identité?" Not until the masks and *les demoiselles* begin talking to her does she remember that she came to France to be an artist; while modeling may pay the rent, she has a duty to herself and her ancestors to take up the brush. The masks in *Picasso's Studio* tell Willia, "You was an artist's model years before you was ever born, thousands of miles from

here in Africa somewhere. Only you'all wasn't called artist and model. It was natural that your beauty would be reproduced on walls and plates and sculptures made of your beautiful black face and body." The twisted faces of Picasso's iconic brothel workers share a kinship with Willia; they tell her, "You go ahead, girl, and try this art thing." The psychological development that moves Willia from model to artist shows her progression from image provider to image maker. Picasso's denial of the African influence in cubism ("he has the power to deny what he doesn't want to acknowledge") becomes her inspiration.[24]

But before Willia can devote herself to her art, another crucial complication surfaces: an impending marriage that might stifle her artistic ambitions. In Ringgold's *Wedding on the Seine*, Willia, who has just married a French businessman, runs across a bridge away from Notre Dame. Resplendent in her white wedding dress, a diminutive Willia grandly flings her bouquet into the Seine. Because she is so tiny, she almost seems like a last-minute insert in what would otherwise be a lovely, romantic cityscape unbroken by human traffic. The text of this quilt jars violently with the architectural beauty of the Parisian skyline and the tranquility of the blue celestial canopy. In the margins, Willia relates an anxiety similar to the one that plagues Helga after her marriage to the southern preacher and Angela's Paris reunion with Anthony: how can a woman be both a successful artist and mother-wife? As Willia runs away from her wedding, the procession hot on her trail, she anxiously reminds herself, "I came to be une artiste, not a wife."[25] This is reminiscent of Angela's trip to Paris at the end of *Plum Bun*. Just a page or two after she affirms that "her aim, her one ambition, was to become an acknowledged, a significant painter of portraits," Anthony appears in her *pensionnaire*.[26]

Willia fears an interracial union. She wonders, as Helga does after Axel Olsen's proposal, if her husband loves her because she is an exotic foreigner and worries that his family and friends wonder, "Will [she] become civilized, or will [she] remain just a beautiful savage dressed in a Paris frock?"[27] The tensions around marriage and motherhood expressed in *Wedding on the Seine* recall the uneasy portrayals of motherhood in both of Larsen's novels. In *Quicksand*, children sap Helga's creative impulses (effectively trapping her in the south), while in *Passing*, Clare, echoing her friend Irene's sentiments, exclaims, "Being a mother must be the cruelest thing in the world," thus underlining her willingness to abandon her daughter in order to return to the black community and reclaim her racial identity.[28] Willia's husband's death partially resolves questions about her domestic role. After he leaves her "alone with [her] art and two babies," she determines that her children will not interfere with her art and returns them to the care of her Aunt Melissa in the United States.[29] Willia's daughter Marlena inherits her mother's artistic talent, but she does not have children.

In *Matisse's Model*, *Picasso's Studio*, and *Wedding on the Seine*, Ringgold inserts Willia into a scene or landscape from which she would normally have been barred, centering her where she would have been marginalized. These scenes are formative for Willia, and they address the early challenges to her artistic development. Outside of the ancestral voices that are always with her, she is the only black figure in the images. Later, in *Picnic at Giverny* and *Le Café des Artistes*, Willia comes into her own as an artist and community builder. In these two quilts, Ringgold makes full use of what Fusco calls "tactics of reversal, recycling, and subversive montage" by adding a community of black artists to support Willia.[30] In *Picnic at Giverny* (fig. 26), a group of eleven women decides to have a picnic in the middle of a Monet masterpiece. The quilt's background is a reproduction of Monet's *Blue Lilies*, one of the most popular of Monet's many paintings of his water lily pond. In Ringgold's unconventional garden party, eleven princesses flank the lily pond; the only male guest is Picasso (the frog?). He poses nude, wearing only a hat, on a small white blanket at the lower lefthand margin. Willia, wearing a white dress and pumps, is now the artist at the easel and is painting the scene before her. In Willia's picture, the women are clear, but Picasso's image is blurry; it is not clear that she will include him in her final composition. The women in the portrait include Michelle Wallace, Moira Roth, Thalia Gouma-Peterson, and Emma Amos. According to the quilt notes, they are "a group of American women artists and writers having a picnic and discussing the role of women in art."[31] Picasso's naked form seems out of place until we realize that Ringgold has combined her references: she has reproduced Monet's *Blue Lilies* and reversed Manet's 1863 *Dejeuner sur l'herbe*, the painting that shocked the Salon de Refusés and established modern art's oppositional stance toward censorship. The portrait was shocking because it portrayed bourgeois Parisian businessmen having lunch in a recognizable forest, possibly the Bois du Boulogne, with nude women (undoubtedly prostitutes).[32] In the border notes, Willia remarks, "Why not replace the traditional nude woman at the picnic with Picasso in the nude, and the 10 American women fully clothed?" Why not indeed? Though this reversal may shock some audiences, the women in *Picnic at Giverny* are not surprised to find Picasso disrobed and vulnerable. As Manet's businessmen were not distracted by the prostitutes, Picasso does not deter them from conversation.[33]

Picnic at Giverny brings the women's movement to France and explicitly questions the role of women as artists and image makers. The reference to the shock value of Manet's work and the pristine, though obsessively repetitive, beauty of Monet's water lilies provide the backdrop for a discussion of what Willia calls "WOMEN ART." She muses "that it must be wonderful, to have your work so approved and revered by people to have it hanging in a space specially made for

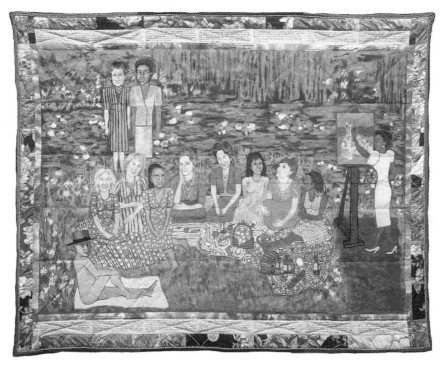

26. Faith Ringgold, *French Collection #3: Picnic at Giverny.*
FAITH RINGGOLD © 1991. PRIVATE COLLECTION.

it." The collective discusses what the aesthetics, form, and subjects of women's art should be and what sorts of spaces it should be exhibited in. Their discussion centers the question "Can women of color produce art in America?"[34] This conversation takes place in France because France has functioned, symbolically if not always factually, as a space of artistic freedom for black artists and writers. Notably, Willia has exchanged her bridal gown for a short white dress and heels that accentuate her brown skin and her femininity; she refuses to allow herself or her art to be invisible.

Ringgold's *French Collection* challenges without compromising. Fusco elucidates Ringgold's visual play with the scions and sacred images of modern art:

[Minority artists] look at Western history and art history not to excise its racism but to excavate and play with symptomatic absences and stereotypes, creating a counter history by bouncing off negative images and teasing out hidden stories. Rather than reject dominant culture for its exclusionary tendencies and retreating,

literally or figuratively, many artists of color who have matured in the last decade are forcefully engaged with it in ways that make it new.[35]

Ringgold herself has said, "After I decided to be an artist, the first thing I had to believe was that I, a black woman, could be on the art scene, without sacrificing one iota of my blackness or my femaleness, or my humanity."[36] Though she undergoes some hardship, Willia develops into an acclaimed artist and a loving (if absent) mother as well as the progenitor of a cross-Atlantic dialogue and interartistic culture in ways similar to literary editors and writers Paulette Nardal and Jessie Fauset. In *Dinner at Gertrude Stein's*, Willia observes Stein's inspiring circle of artistic and literary collaborators and, in response, opens *Le Café des Artistes*. Left to Willia by her husband, the café is located in Saint Germain de Pres, the same *quartier* as Café Deux Magots, where Baldwin wrote and which Hemingway immortalized in *A Moveable Feast*. In *Café* Ringgold portrays Willia as a "Bricktop" of the artistic and literary scene; she hosts Archibald Motley, Meta Vaux Warrick Fuller, Edmonia Lewis, Elizabeth Catlett, Sargent Johnson, Romare Bearden, Paul Gauguin, Vincent van Gogh, Augusta Savage, Henri de Toulouse-Lautrec, Maurice Utrillo, Aaron Douglas, Ed Clark, Raymon Saunders, Jacob Lawrence, Henry Tanner, and even Faith Ringgold herself, who shares a conspiratory glance with Willia across the table. More than any of the other pieces, this quilt levels the playing field on a broad scale. Though the women (with the exception of Willia) sit separately from the men, we sense that she is the one who has brought them together. With this quilt, Ringgold corrects the standard vision of modern art; she has re-imagined the Afromodernist tradition, which spans two centuries and at least three continents.

Ringgold centralizes the undercurrents of Fauset's and Larsen's novels in the *French Collection*; the mulatta overplot emerges briefly in her complementary *American Collection*, but not as a fraught icon of racial ambiguity. Instead, Ringgold situates Willia's half-French daughter as a hybrid figure who privileges her African American ancestry. Significantly, Marlena's mixed heritage does not make her a tragic figure; in fact, she becomes a more successful artist than her mother. While Willia's art is only seen in three of the quilts (*Jo Baker's Birthday*, *Picnic at Giverny*, and *Moroccan Holiday*), Marlena's images permeate the majority of the *American Collection*: she returns to the United States and creates her art from the folklore and history of her African American lineage rather that of her French father.

One of my arguments in this book is that, despite the transgressive, boundary-crossing potential of the mulatta icon, her reification frequently constrains black womanhood. To surmount those constraints, Ringgold's revisionary project portrays neither Willia nor Marlena as racially ambiguous.[37] In *Moroccan Holiday*,

when Marlena confronts her mother about the sacrifices she made to achieve her artistic success, Willia says, "Marlena, I want you to know there is a heavy price to pay for being a black woman." In the *American Collection, Picnic on the Grass . . . Alone* and *Listen to the Trees* both portray Marlena alone in nature. What little text we have suggests that she meditates on how her complicated relationship with her mother has influenced her ability to form lasting and fulfilling romantic relationships, rather than her biracial heritage.[38]

Through Willia's trials and Marlena's successes, Ringgold paints a complex portrait of the New Negro woman that also addresses the valorization of the mulatta icon. She reclaims the contradictions inherent to both roles without romanticizing, glorifying, or overdramatizing either ex-patriotism or miscegenation. By inserting a textual consciousness into the borders of her quilts, Ringgold fulfills the promise of a nascent women's art that Toomer's lyric portraits in *Cane* can only gesture at. Willia's courageous journey toward self-determination stands in sharp contrast to Toomer's nostalgic portraits of southern women as primitive subjects and urban women as spiritually disconnected. Ringgold's protagonists have the "inner life" that Toomer's narrator prophesies to Avey as she is sleeping: "I talked, beautifully I thought, about an art that would be born, an art that would open the way for women the likes of her."[39] Unlike the women in *Cane*, Ringgold's subjects are not asleep. They are not waiting for an art to be born. They already possess a complex inner life that they express through a multitude of genres.

Wild Lyric Womanhood: Toni Morrison's Response to *Cane*

If Ringgold's story quilts seem to answer "Avey's" unheard call for women's art, in Toni Morrison's *Jazz*, "the Harlem renaissance finds its most sophisticated voice and its critique."[40] Morrison has cited a James Van Der Zee photograph featured in a peculiarly macabre photodocumentary known as *The Harlem Book of the Dead* as the impetus for her novel's plot. The photograph shows a young black woman in a coffin. Although her sweetheart killed her, as she lay dying, she refused to name her killer, saying only, "I'll tell you tomorrow," a phrase that Morrison lifted from reports of her death.[41] *Jazz* builds upon this resonant image as Morrison re-creates Harlem in the twenties as seen through the extraordinary eyes of an ordinary man. Her decision to revisit the Harlem Renaissance–New Negro era through a character who is neither an artist nor an activist shows her interest in the uniqueness of the everyday. Along with addressing the issues of authenticity and representation that preoccupied the New Negro movement, *Jazz* critiques the era's ideological reification of the tragic mulatto/a and primitivism. Furthermore, portions of the novel directly

engage *Cane* through visual motifs and references to the iconic and memorializing function of photography and the still life.

In addition to referring to Van Der Zee's photographs of Harlem, which memorialize it as a place of optimism amid the harsh social, political, and economic realities of urban life in the twenties, Morrison uses photographic diction throughout *Jazz*. On the first page, the narrator provides a snapshot of the complex plot:

> Sth, I know that woman. She used to live with a flock of birds on Lenox Avenue. Know her husband, too. He fell for an eighteen-year-old girl with one of those deepdown, spooky loves that made him so sad and happy he shot her just to keep the feeling going. When the woman, her name is Violet, went to the funeral to see the girl and to cut her dead face they threw her to the floor and out of the church. She ran, then, through all that snow, and when she got back to her apartment she took the birds from their cages and set them out the window to freeze or fly, including the parrot that said, "I love you."[42]

This is the story in a nutshell, but these intimate, folksy sentences barely scratch the surface of the novel. Yet the poetic flash of phrases such as "deepdown spooky loves," "cut her dead face," and the improbably romantic parrot suggests the texture, irony, and madness that will propel the novel forward and backward.

As if immediately to call into question our desire to contain the past, the following passage warns of the dangers of nostalgic preservation; for the photograph of the very light-skinned Dorcas (the eighteen-year-old) continues to haunt Violet and Joe (the husband) Trace and their community long after she is dead:

> And the dead girl's face has become a necessary thing for their nights. They each take turns to throw off the bedcovers, rise up from the sagging mattress and tiptoe over cold linoleum into the parlor to gaze at what seems like the only living presence in the house: the photograph of a bold, unsmiling girl staring from the mantelpiece. If the tiptoer is Joe Trace, driven by loneliness from his wife's side, then the face stares at him without hope or regret and it is the absence of accusation that wakes him from his sleep hungry for her company. No finger points. Her lips don't turn down in judgment. Her face is calm, generous and sweet. But if the tiptoer is Violet the photograph is not that at all. The girl's face looks greedy, haughty and very lazy. The cream-at-the-top-of-the-milkpail face of someone who will never work for anything; someone who picks up things lying on other people's dressers and is not embarrassed when found out. It is the face of a sneak who

glides over to your sink to rinse the fork you have laid by her plate. An inward face—whatever it sees is its own self. You are there, it says, because I am looking at you.[43]

Words such as "haughty," "greedy," and "lazy," strung together with notions of deception, boldness, and a selfishness reminiscent of Clare Kendry's "having way" in *Passing*, attest to the threatening posture of the mulatta icon within the black community. Yet from Joe comes an opposing view of Dorcas: she is an icon of ideal womanhood, submissive, "sweet," nonjudgmental, and curiously empty—"without hope" or "regret." In addition its neat evocation of the familiar contradictory dimensions of mulatta iconography, the passage is a self-reflexive critique of how the relativity of the gaze, which shifts back and forth between the viewer and the viewed, the imagined and the real, complicates the function of the tragic mulatto/a as a mediator of race and class binaries. By situating Dorcas's photograph, an inanimate flat object, as an icon that embodies her living characters' fears and desires—making it "the only living presence in the house"—Morrison not only criticizes the romanticization of the Harlem Renaissance but the reification of the tragic mulatta within its literary and visual culture. In so doing, she refuses to aestheticize either Harlem or its inhabitants.

The snapshot summary cited previously roughly sketches the novel's major figures, but it is the seemingly tangential backstory of the fatal love triangle that takes on *Cane*. I follow only one of those strands: the story of Golden Gray. Golden Gray is the mulatto son of Miss Vera Louise and her black lover, Henry Lestroy (Hunter's Hunter), both figures from Violet and Joe's southern past. It's no coincidence that the only mulatto I discuss in any detail is an effeminate one, a dandy of sorts, who dresses in "dark brown cuffs," "ivory buttons," and a long "vanilla colored" coat.[44] Golden Gray's gender ambiguity is a function of the traditional feminization of the tragic mulatto/a; it recalls the famous scene in James Weldon Johnson's *Autobiography of an Ex-Colored Man* when the protagonist gazes at himself in the mirror, seeking evidence of his blackness as he singles out his features: the "ivory whiteness of [his] skin, the beauty of [his] mouth, the size and liquid darkness of [his] eyes," and "the softness and glossiness of [his] dark hair that fell in waves over [his] temples." Read with the narrator's preceding observation that people often remarked to his mother, "What a pretty boy you have!," this becomes a decidedly feminine self-portrait.[45] Yet while we might attribute the haziness of the ex-colored man's race and gender to his search for visual evidence of his maternal heritage, Golden Gray's feminization, underscored by "the yellow curls cover[ing] his coat collar" and his alliterative name, results as much from the visual archetype of the tragic mulatto/a as it does from his upbringing in a exclusively female setting.

On his way to confront his absentee father, Golden Gray meets a "Wild Woman" who lives "somewhere in the Cane field." This encounter has important repercussions for Joe, but I'm more interested in how the incident speaks to Toomer's prose portraits of black women as mulatta, primitive, or both. By pairing Wild and Golden Gray, *Jazz* critiques Toomer's prophetic anointing of the mulatto son at the end of "Kabnis": the "Gold-glowing child," whose birth song brings new life to the "gray" netherworld of *Cane*'s southern dreamscape.[46]

During the encounter in the woods, the intertextuality between *Cane* and *Jazz*, signaled by Morrison's depiction and location of Wild in the "Cane field" becomes startlingly complex as she juxtaposes the mulatto son's search for his black father with Wild's labor. At first, Golden Gray believes she is a vision, insubstantial and horrific. He perceives Wild as a "naked berry-black woman"; she is amorphous, a "black liquid female" who reminds him of his shiny dark horse. Yet while he takes pride in his horse's coloring, Wild's blackness provokes nausea. How Golden Gray looks is important because Morrison is sensitive to the visual contrast between him and Wild. Hunter's Hunter sees them as opposites: "to see the two of them together was a regular jolt: the young man's head of yellow hair long as a dog's tail next to her skein of black wool." Later, as her birth pains begin, she becomes a doe with "deer eyes that fixed on him." Golden Gray fears her eyes. This vision of blackness does not appeal to him the way it might to *Cane*'s spectatorial narrator, a viewer more invested in romantic notions of the primitive. Like Toomer's Karintha, Wild gives birth to a child (Joe) whom she refuses to raise: "too brain-blasted to do what the meanest sow managed: nurse what she birthed."[47] Despite the naturalistic imagery that drenches both Wild and Karintha, they reject their young and refuse motherhood, an action seemingly at odds with the animalistic depictions of their natures.

In *Cane*, the gray dusk, an in-between, neither-nor time, dramatizes the miscegenation motif; similarly, Wild's encounter with Golden Gray, whose name suggests something both precious and indeterminate, occurs in the purgatorial liminality of Hunter's cabin: "Woodsmen, white or black, all country people were free to enter a lean-to, a hunter's shooting cabin. Take what they needed, leave what they could. They were waystations and anybody, everybody, might have need of shelter."[48] The way station, like dusk, is a space for exchangeability that enables otherwise forbidden discourse. It is the place in *Cane* and *Jazz* where history interrupts the present with its urgent commentary. At dusk, the ugliness of a southern history of segregation and temptation can confront itself. *Jazz* envisions the spectator as hunter. Hunter's Hunter, the father of Golden Gray, is content to observe Wild in her element; he admires her ability to exist in the woods.

Not content merely to observe, Joe Trace, Wild's castoff son, hunts his mother, intent on murder. Later, the hunter-as-spectator motif migrates north as Joe seeks a new wild woman in Harlem, tracking the "hoofmarks" (acne) on Dorcas's light-skinned face.[49] Like Toomer's Esther, who is also neither beautiful nor ambiguously raced, Dorcas is the antithesis of the mulatta ideal. Morrison has stripped her of the icon's stereotypical features—extraordinary beauty and half-black, half-white heritage—leaving only the light skin.[50] Though several years his junior, Dorcas replaces Joe's mother: "I tracked my mother in Virginia and it led me right to her, and I tracked Dorcas from borough to borough."[51] In each instance, the man is both spectator and hunter. One might not characterize the poet-narrator in Cane as a hunter, for he pretends to be merely an observer. Nevertheless, he is a hunter in the sense that, like Joe, his bewilderment and inability to understand women and the complications of patriarchal privilege for black men leads him to exploit them. Neither Karintha nor Carma nor Louisa nor Becky speak. The narrative and the protagonists objectify them and render them silent or inarticulate. Even Dorcas, who is more analogous to Cane's urban prose portraits, is ultimately silenced. According to Deborah McDowell "because of the process of 'enlarging' herself, Morrison's narrator has reduced Dorcas to the dimensions of a snapshot—a motionless image, fixed, aestheticized, frozen."[52] That is the effect of the visual dimension in Cane: while writing, painting, photography, and music compose female portraits, the spectatorial narration maintains them at a distance. They are beautifully lyric meditations that seem to capture, to use Toomer's language, the essence of the feminine. Unfortunately, their lack of voice renders them not only mute but psychologically flat, an ironic twist given their multigenre depictions.

With Dorcas, Golden Gray illustrates Morrison's reading of the tragic mulatto/a in Harlem Renaissance fiction by directly questioning notions of authenticity and American identity brought forth in Cane. Morrison's critique culminates when Golden Gray asserts, "I don't want to be a free nigger; I want to be a free man," to which his father replies, "Don't we all. Look. Be what you want—white or black. Choose. But if you choose black, you got to act black, meaning draw your manhood up—quicklike, and don't bring me no white-boy sass." This is the choice Morrison gives to Toomer's desire to have it both ways, to claim himself as the "Son" of a black culture, while promoting a new Americanness that is neither black nor white: "Not notice the hurt that was not linked to the color of his skin, or the blood that beat beneath it. But to some other thing that longed for authenticity, for a right to be in this place, effortlessly without need to acquire a false face, a laughing grin, a talking posture." Such passages as well the narrator's repeated comments on Gray (for example, "I don't hate him much anymore") express compassion for his stereotyped

position as a tragic mulatto that complicates the author's otherwise castigating portrait of him. Moreover, in these reflective moments, the novel gestures outward at its meta-commentary on the writers and visual artists of the Harlem Renaissance who courted authenticity. Their art often told a different story, one in which survival meant acquiring a "false face, a laughing grin, a talking posture" that dissembled and thus reinforced the divided souls of black folk. In this way *Jazz* elucidates "Kabnis," the often avoided and misunderstood conclusion of *Cane*. One might say that Negress in "Kabnis" actually prefigures Wild in *Jazz:* Wild gives birth to Joe who in turn attempts to articulate throughout the novel what it means to be a New Negro. His statement, "I've been a new Negro all my life," directly precedes the tale of Golden Gray, Wild, and his birth.[53]

Despite its pastoral mood in the section on Golden Gray, *Jazz* incorporates photographic diction, creating a tension between technology and nature that is also prevalent in *Cane*. In the following passage, the camera's eye adds a visually inflected perspective to the narration, which is revealed through a series of "clicks" that recall the mechanical nature of the modern city: "When I see them now they are not sepia, still losing their edges to the light of a future afternoon. . . . For me they are real. Sharply in focus and *clicking*. . . . The *click* of the dark and snapping fingers drives them to Roselands, to Bunny's; boardwalks by the sea. . . . Into places their fathers have warned them about and their mothers shudder to think of. Both the warning and shudder come from the snapping fingers, the *clicking*."[54] With her repetition of "clicking" and her play on the action of the camera's shutter, Morrison uses photographic diction in much the same way that Toomer does in his description of Karintha. In *Cane*'s first vignette, the narrator describes her in a series of photographic images as "a wild flash" whose "sudden darting past you was a bit of vivid color, like a black bird that flashes in life" and whose "running" simulates the "whir" of the camera's shutter.[55] Toomer's photographic images possess immediacy. They are fleeting glimpses of a nearly extinct culture that he memorializes in a swan song. In contrast, Morrison uses the camera to look back at the era and its visual memorabilia. As the narrator says, "When I see them now they are not sepia," reminding us that New Negro men and women were "more than a state of mind" and not fixed or singular identities.[56]

Like Ringgold, who draws her references and art materials from the ephemera of the Harlem Renaissance, Morrison makes good use of the visual arts—in particular, the lingering impression of the still life, which is the last image Dorcas sees before she dies: "Now it's clear. Through the doorway I see the table. On it is a brown wooden bowl, flat, low like a tray, full to spilling with oranges. I want to sleep, but it is clear now. So clear the dark bowl the pile of

oranges. Just oranges. Bright. Listen I don't know who is that woman singing but I know the words by heart."[57] The passage links the visual and the visceral; color, texture, and sound are engaged simultaneously. Still-life painting features the ordinary as its subject and in so doing renders the ordinary extraordinary. The passage also portrays Dorcas in a rare introspective moment: here, she has a voice rather than existing only as a photographed, iconic facade or a preserved body. Given Morrison's investment in imagining the Harlem Renaissance era through the eyes of an ordinary person, her use of the still life works as a poignant meditation on Dorcas's death—the tragic result of romantic love gone awry.

Toni Morrison's *Jazz* and Faith Ringgold's quilts prove that the "peculiar vision" of the Harlem Renaissance has had a lasting effect on African American literary and artistic culture and traditions.[58] Ringgold's art, in particular, speaks to the ever-present necessity for black artists to challenge dominant ideology while maintaining an internal critique of in-group aesthetics, values, and norms. Indebted to the Afro-modernist artists who are themselves beholden to their nineteenth-century precursors, both *Jazz* and the *French Collection* illustrate the continued relevance of decoding the visual grammar of racial representation.

A Mulatto/a Nation?

New criticism interrogating the resurgence of interest in the mulatto/a as a literary trope and a cultural figure finds its counterpart in even more recent creative interpretations and transformations. A prescient example of how the iconography of the mulatta lives on in visual (and virtual) culture is Lezley Saar's mixed-media installation *Mulatto Nation*. Organized into five sections—"Birth of a Nation," "The Founding Mothers and Fathers of the Mulatto Nation," "Half-Breeds in Crisis," "Alienation," and "Materialism and the Mulatto"— the installation creates a museum that chronicles an alternative history of miscegenation. In Saar's revisionist universe, historical figures such as Elizabeth Keckley, author of *Behind the Scenes: Thirty Years a Slave, and Four Years in the White House,* and Alexandre Dumas coexist with imaginary characters such as Sister Mule Lady. Ostensibly, the installation begins with "Birth of a Nation," a scene in which pink baby dolls that look like they have been half-dipped in chocolate chronicle "how the great mulatto nation came to be; its intermingled roots, its tarred struggles and its high yellow escapades on the open seas."[59] Irreverent and eclectic, the installation uses myth and stereotype to underline the absurdity of the terminology of racial admixture. The installation is not concerned with accuracy or offensiveness but challenges us to confront society's continued obsession with racial categorization.

In a more subdued tone, contemporary poet Natasha Trethewey also reflects on the mutability of biracial identity as a category that cannot be fixed but is constantly. In "Flounder" she writes:

> A flounder, she said, and you can tell
> 'cause one of its sides is black
> The other side is white, she said
> It landed with a thump
> I stood there watching that fish flip-flop
> Switch sides with every jump.[60]

What it meant to be mulatto/a in the nineteenth century (in both legal and literary spaces) repeatedly changed throughout the twentieth. The rigidity of the color line that W.E.B. Du Bois identified nearly one hundred years ago as the defining problem of the twentieth century has been ruptured, though not broken, in the twenty-first. No longer does the mulatto/a designation connote merely a half-and-half split that tears the subject apart. With multiculturalism, a new language has arisen to contend with the old binaries of black and white. In Trethewey's "Saturday Matinee," the speaker signals her familiarity with the literary and visual grammar of the tragic mulatta and her identity conflicts. She writes, "I already know the story"; she has studied the plot trajectory and its tragic, predestined ending. Reflecting on *Imitation of Life* (1959), she wonders if the mixed girl is "a character I can shape my life to" and if she will inherit a "sparkling world" (a reference to the diamonds in the film's opening montage) along with a host of nineteenth- and early twentieth-century baggage.[61]

Trethewey's poetry frames my final comment on how the mulatta has been reshaped and revived in contemporary black women's writing at the turn of the twenty-first century. Works such as Danzy Senna's novel *Caucasia* and Toi Derricotte's memoir *The Black Notebooks* challenge critical assumptions that post Harlem Renaissance, the mulatta became an untenable and outdated figure, especially in light of what constituted authentic black culture. Writer Trey Ellis labels himself and his generation "cultural mulattoes," making it clear that the American literary landscape has shifted.[62] Invigorated concepts of hybridity and literal and figurative border crossings are now applied to old literary tropes.

As multicultural debates raise issues concerning acculturation, assimilation, and biraciality, artists and writers will continue to revive the mulatta figure and the passing subject. In Senna's *Caucasia*, the biracial protagonist's father theorizes that the mulatto/a is analogous to a miner's canary, a litmus test for the racial climate of the country. In a scene in which the very light-skinned Birdie confronts her black father, who has rejected her in favor of her darker

sister, she notices a chart with the words "Canaries in the Coal Mine" in her father's study:

> It depicted a row of pictures of mulattos throughout history—some of whom I remembered from the walls of the Nkrumah School, others from my father's old study at Boston University. I recognized Alexander Pushkin, Phillipa Schuyler, Nella Larsen, Jean Toomer—Xeroxed photographs of their sallow faces above the dates of their lives, and beneath that their "fates," brief descriptions of their desolate or violent deaths: Pushkin, shot in a duel; Nella Larsen, obscure and poverty stricken, with no records of her birth or obituary to mark her death; Phillipa Schuyler, the child genius of the Harlem Renaissance, passing as white, in a firefight in Vietnam.

Her father displays Birdie's and her sister's photographs with their fates left unknown. He then explains, "The fate of the mulatto in history and in literature . . . will manifest the symptoms that will eventually infect the rest of the nation."[63]

While visual depictions and narratives of the mulatta figure do indicate national anxieties about miscegenation and racial boundaries, Trethewey, Senna, Morrison, and Ringgold question her tragic legacy as an inherent condition. Yet their work also illustrates the dangers of situating the mulatta as an icon of multicultural harmony or an experiment in pseudo-scientific research on racial intermixing. As bell hooks warns, "when the specificities of particular, cultural histories are generalized, the result is not a progressive vision of cultural diversity, but a superficial fantasy."[64]

As the representative of American anxieties of miscegenation, patriarchy, citizenship, and legal racial classification, the mulatta is a hidden national icon at whose shrine we both worship and scorn. We fear her allure yet are inevitably drawn to her, as Irene is to Clare in *Passing*. An integral part of African American literary history and visual culture, she appears in a variety of media and artistic productions; and her desirability disturbs us, even if her beauty, like Dorcas's light-skinned but "hoofmark[ed]" face, is flawed. The mulatta of the twenty-first century still has the potential to be tragic. Contemporary writers and scholars are attempting to mine the figure and her accompanying iconography for her transgressive potential, focusing on her capacity to traverse rigid class and race hierarchies. Avant-garde works such as Adrienne Kennedy's *Funny house of a Negro* and singer Laura Love's Afro-Celt folksong "Octoroon" take the icon in new global directions. Nevertheless, even those who excise tragedy from the trope must contend with the historical and cultural context of her legacy. She remains a tricky figure to classify, partly because the issues that she mediates are slippery. While the mulatta was a marketable fixture in Harlem

Renaissance literature, visual art, and popular culture, she is ultimately a limited figure through which to examine race relations, class stratification, or gender roles. Iconized as a the black feminine ideal on the one hand, demonized as an identity-conflicted Jezebel on the other, her transgressive potential has been frequently undercut by her reification within the black community as the ideal New Negro woman. Despite her exotic representations, she, like the "brown madonna," was seen as a positive image of black femininity. Though both Larsen and Fauset critique her role in the Harlem Renaissance, they still privilege the mulatta as their ideal heroine or protagonist. And while Toomer's representations of the mulatta icon are more varied, his anointing of the mulatto son as the new American expands the figure to encompass American culture as a whole.

With all her limitations, the mulatta is an appropriate figure through which to trace the corrosive underside of New Negro uplift ideology. Mulatta iconography and its accompanying plot trajectory illustrate a history of miscegenation and sexual exploitation that adheres even to narratives that do not end tragically. The mulatta in literature, visual art, and film forces us to gaze upon an unspeakable part of American history. My examination of the iconography of the mulatta reveals a visual and narrative manifesto that condemns women to a subordinate position in the struggle for political, social, and economic freedom in the guise of positive imagery. Fortunately, as soon as the "new" mulatta of the Harlem Renaissance rose to popularity, writers and artists struggled to understand the inherent problems of representative tactics within the New Negro movement as they labored to create, or respond to, the aesthetics of transformation that so defined the ideology of the era.

In rethinking the mulatta icon as collaborative visual and literary endeavor, I have primarily sought to illuminate how she complicated the already complex role of the New Negro woman as artist and activist. Placing the writers and artists of the Harlem Renaissance era in conversation expands our understanding of the movement beyond its traditional chronological, aesthetic, and geographic boundaries. The counter-representational strategies of any movement have advantages and disadvantages, as artists and writers prove in their continued reinvention of the mulatta in visual and literary culture as a figure to celebrate, satirize, or identify with. Rather than continuing to belabor her as a haunting, tragic trope with an unspeakable interracial history, interrogation of the mulatta icon as an *intraracial* figure productively addresses how the visibility of black subjects troubles constructions of national and international identity in the black diaspora while enhancing discussions of race, gender, class, and sexuality central to American cultural identity.

Notes

Notes to Preface

1. Exhibition catalog, 1, in Archibald J. Motley, Jr., Papers, Chicago History Museum, hereafter cited as "Motley Papers, Chicago."

2. Motley, "How I Solve My Painting Problems," in Motley Papers, Chicago.

3. "The Art Galleries," *New Yorker,* March 10, 1928, p. 79.

4. Exhibition catalog, 1, in Motley Papers, Chicago.

5. Ibid., 4.

6. *Iconography* refers to the collected representations that illustrate a subject, while *iconology* refers to the description, analysis, and interpretations of icons or iconic representation.

7. The term *Harlem Renaissance* continues to be a popular and convenient label for the period between 1917–1935 (as identified by David Levering Lewis). Nevertheless, several critics have identified its limitations in regard to region and concept. Though I use the term loosely in this book, I am conscious of its besieged position, particularly in the sense articulated by Gloria Hull, who points out that the periodization of artistic movements tends to exclude women's contributions. See Hull, *Color, Sex, and Poetry,* 2.

8. Nella Larsen, letter to Gertrude Stein, February 1, 1928, in Gertrude Stein and Alice B. Toklas Papers.

9. For an interesting reading of Larsen's *Quicksand* as a revision of Stein's *Melanctha,* see Brickhouse, "Nella Larsen."

10. Carby, *Reconstructing Womanhood,* 89.

11. My perspective on the intrinsic femaleness of the figure has been informed by the work of Sánchez-Eppler, *Touching Liberty;* Sollors, *Neither Black nor White yet Both;* Kutzinski, *Sugar's Secret;* Carby, *Reconstructing Womanhood;* and Berzon, *Neither White nor Black.*

12. Brody, *Impossible Purities,* 16; Spillers, *Black, White, and in Color,* 28.

13. "Exalting Negro Womanhood," 22.

Notes to the Introduction

1. Brown, *Clotelle,* 56.

2. I have borrowed the concept of visual grammar partially from Hortense Spillers's landmark essay "Mama's Baby, Papa's Maybe." In her discussion of what she terms the "American

grammar" of subjugation she asserts that "we might concede, at the very least, that sticks and bricks *might* break our bones, but words will most certainly *kill* us" (see Spillers, *Black, White, and in Color*, 68.

3. Though Brown draws heavily on Lydia Maria Child's "The Quadroons" (1842), the story most often credited with ushering the tragic mulatta into literary culture, he makes some significant alterations in chapters 4 ("The Quadroons Home") and 15 ("Today a Mistress, Tomorrow a Slave") of *Clotel*. See Raimon, *The "Tragic Mulatta" Revisited*, 64–67; and Sherrard-Johnson, "Delicate Boundaries," 206.

4. Brown, *Clotel*, 9. Also see Brown, *Narrative of William W. Brown*.

5. Ibid., 48, 51.

6. Brown, *Clotelle*, 56.

7. Grimké, *Appeal to the Christian Women of the South*, 32.

8. The circulation of images of white slaves anticipates the panic around the supposed epidemic of forced prostitution during the Progressive era. According to Margit Stange, "white slavery literature" as a "neo-abolitionist call to reform occludes race and class behind an outraged vision of the 'white woman' exploited by the forces of commercialism" (see Stange, *Personal Property*, 5).

9. Wiegman, *American Anatomies*, 30.

10. Hopkins, *Contending Forces*, 107.

11. Hopkins, *One Blood*, in *The Magazine Novels of Pauline Hopkins*, 445.

12. Harper, *Iola Leroy*, 115.

13. Hopkins, *Contending Forces*, 152. With a name that connotes the African origins of Greek culture as well as the famous female poet of Lesbos, it's not surprising that Sappho's "beauty appealed strongly to Dora's artistic nature" (114).

14. See Willis and Williams, *The Black Female Body*, 140.

15. According to David Levering Lewis, the Harlem Renaissance began in 1917 (see Lewis, *The Harlem Renaissance Reader*, xliv). Others posit that it began during a period of racial violence after World War I known as the Red Summer of 1919. Despite, or perhaps in appreciation of, current debates about accuracy and chronology, I still find the term *Harlem Renaissance* useful for the purposes of this book. While certainly we should recognize the geographic specificity of Harlem, the idea that the local can become global, both coterminus with and inspirational to national and international black artistic movements from the Chicago Renaissance to pre-Negritude, speaks to the power of what the label, however inadequate, represents.

16. The *Oxford English Dictionary* defines *mulatta/o* as the first-generation offspring of a black and a white parent; the word is possibly derived from *mule*, a sterile hybrid of a horse and a donkey. The term purportedly denotes an exact half-and-half proportion of black and white blood, as opposed to *quadroon*, for example, which denotes one-quarter black and three-quarters white.

17. According to the U.S. Census, the reduction was due to the agency's use of black census takers, who more accurately reported mulatto/a identity.

18. Carby, *Reconstructing Womanhood*, 89–90.

19. Hughes, *The Big Sea*, 263. "Cross" serves an epigraph to Nella Larsen's *Quicksand*.

20. This is not to say that the negrophilia of affluent whites such as Carl Van Vechten had no precedent or counterpart in the white working class. Eric Lott's *Love and Theft* teases out an earlier, alternate history of white America's love affair with black culture through the performance of what he terms "blackface blackness" (18).

21. Daphne Duval Harrison's *Black Pearls* and Angela Davis's *Blues Legacies and Black*

Feminism explore a different type of New Negro woman, one whose aggressive sexuality articulates gender and class politics within the black culture of the twenties and thirties.

22. Ellison, *Invisible Man,* 201, 202, 205.

23. In addition to works already mentioned in this book, we might include Charles Chesnutt's *House Behind the Cedars* (1900) and *The Marrow of Tradition* (1901); Pauline Hopkins's "Talma Gordon" (1900), *Winona* (1902, reprinted in *The Magazine Novels*), and *Hagar's Daughter* (1901–2, ibid.); Eric Walrond's "The Yellow One" (in the collection *Tropic Death*); Ottie B. Graham's "Holiday" (1923); Zora Neale Hurston's play *Color Struck!* (1925); and Marita Bonner's "On the Altar" (circa 1938; reprinted in *Frye Street and Environs*), to name just a few. Moreover, several works parody, critique, or satirize preoccupations with lightness and miscegenation, including Wallace Thurman's *The Blacker the Berry* (1929) and Claude McKay's *Home to Harlem* (1928).

24. Cheryl Wall goes further and asserts that "no tragic mulattoes people [Hurston's] fiction" (see Wall, *Women of the Harlem Renaissance,* 140).

25. Though Janie does not distinguish among other blacks based on color, she is punished by Tea Cake, who "whups" her to distinguish her from the "color struck" Mrs. Turner, who seeks out Janie because of her "coffee-and-cream complexion" and "luxurious" hair. Perversely, the workers in the Everglades value her lightness not just because of its respectability but because her skin allows "uh person [to] see every place you hit her." Far from arousing indignation, her bruises engender "a sort of envy in both men and women" (Hurston, *Their Eyes Were Watching God,* 140).

26. Brown, *Negro Poetry and Drama,* 133.

27. Hurston's *Mules and Men* includes illustrations by Miguel Covurrabias that directly refer to and enrich the folktales retold in the text. See Nadell, *Enter the New Negro,* 110–12, for an insightful discussion of Hurston's and Covurrabias's collaborative project.

28. Hurston, *Their Eyes Were Watching God,* 17. Bertram Ashe remarks that Janie's hair is referred to so often throughout that text that it can actually be treated as its own character (see Ashe, "'Why Don't He Like My Hair?'").

29. Hurston, *Their Eyes Were Watching God,* 55. Significantly, this scene precedes the discussion of the "yellow mule." Like Janie, the mule is yellow; but also like Janie, the mule stands in for all the poorly treated black women in the book.

30. Ibid., 87, 103.

31. Taylor, *The Veiled Garvey,* 60. It's also worth noting that Jacques's editorials—some two hundred pieces—were penned during Garvey's imprisonment.

32. Ibid., 31, 30.

33. Larsen to Carl Van Vechten, New York, April 11, 1932, James Weldon Johnson Collection.

34. Favor, *Authentic Blackness,* 80.

35. Raimon, *The Tragic Mulatta Revisited,* 12.

36. Zackodnik, *The Mulatta and the Politics of Race,* xvii.

37. Critical of the black-white binary established by Huggins and Lewis, which situates New Negro aesthetics as an oppositional philosophy or counter-movement, George Hutchinson argues for a more complex analysis of the dialogic relationship between black and white American writers, stressing the influence of American modernism and pragmatism. He offers a compelling discussion of the American pragmatism of William James, John Dewey, Waldo Frank, and Sherwood Anderson as opposed to the high modernism of Stein, Pound, and Eliot (see Hutchinson, *The Harlem Renaissance in Black and White*).

Notes to Chapter One

1. In Motley Papers, Chicago, quoted in Greenhouse and Robinson, *The Art of Archibald J. Motley, Jr.*, 15.

2. Motley's one-man show at the New Gallery in March 1928 established his success as a modernist painter. Although he continued to work as an artist in Chicago for more than fifty years, his portraits and urban scenes of the 1920s evoke some of the most vivid recollections of the period. While they have not received the same attention as work by Harlem Renaissance painters such as Aaron Douglas, Palmer Hayden, and Hale Woodruff, Motley's paintings encapsulate the glamor of the era in the same way that James Van Der Zee's photographs provide a pictorial guide to both extraordinary and commonplace people in 1920s Harlem.

3. *The Octoroon Girl* appears, for example, on the cover of Fauset, *Plum Bun;* and Larsen, *Passing. Blues* appears on the cover of Lewis, ed., *The Portable Harlem Renaissance Reader;* and Bailey and Powell, *Rhapsodies in Black Art.*

4. Motley, "How I Solve My Painting Problems," 4, in Motley Papers, Chicago.

5. Presuming a dialogic relationship between Larsen's work and modernism, I consider her writing within the contested space of a Harlem Renaissance defined by artistic diversity as much as uniformity. Building on the foundational work of Cheryl Wall and David Levering Lewis, several critics have explored the artistic exchange—and consequent anxiety of influence—among Harlem Renaissance and high-modernist writers. Contemporary considerations of Garveyism, leftist politics, blues, mongrelization, primitivism, feminism, and Afro-modernism have fractured and expanded the once-perceived cohesion of the Harlem Renaissance, questioning its chronological and geographic boundaries and its reduction to an elitist phenomenon (see Wall, *Women of the Harlem Renaissance;* and Lewis, *When Harlem Was in Vogue*). The many recent comparative studies revisiting the Harlem Renaissance include Douglas, *Terrible Honesty;* Hutchinson, *The Harlem Renaissance in Black and White;* Maxwell, *New Negro, Old Left;* and Lemke, *Primitivist Modernism.* Houston A. Baker, Jr., briefly deals with a brand of modernism he calls "mulatto modernism," defined by a "gospel" of uplift and racial ambivalence in *Turning South Again,* 33.

6. Davis, *Nella Larsen,* 274.

7. Helga detests the severe color aesthetics that require students at Naxos to wear uniform, unadorned clothing in dismal colors that downplay both their dark skin and their individual style. She secretly loves brilliant colors and wants to see African Americans celebrate their complexions with complementary colors that accentuate their difference (see Larsen, *"Quicksand" and "Passing,"* 18).

8. Ibid., 66.

9. See Sollors, *Neither Black nor White yet Both.*

10. Larsen, *"Quicksand" and "Passing,"* 21, 45.

11. The first edition contains Reiss's color portraits of Jean Toomer, Alain Locke, Countee Cullen, Paul Robeson, Charles Johnson, and W E.B. Du Bois in addition to drawings by Miguel Covarrubias and Aaron Douglas. In later editions, Reiss's work is omitted, reducing the incredible interdisciplinary nature of this groundbreaking anthology and eclipsing the efforts of the few white modernist painters who sought to portray African Americans as dignified and sophisticated.

12. Locke, *The New Negro,* 419.

13. Larsen, *"Quicksand" and "Passing,"* 45; Locke, *The New Negro,* 8.

14. "The New Negro woman," writes McDougald, "realizes that the ideals of beauty, built up in the fine arts, have excluded her almost entirely. Instead, the grotesque Aunt Jemimas of the streetcar advertisements proclaim only an ability to serve, without grace of loveliness [*sic*]" ("The Task of Negro Womanhood," in Locke, *The New Negro*, 369–70). McDougald refers to the advertising industry's popularization of the mammy figure as a promotional icon. (Less than ten years later, of course, the image of the mammy reached epic proportions in John Stahl's film *Imitation of Life* [1934], which features an enormous neon "Aunt Jemima" flipping pancakes atop a skyscraper.)

15. Locke, *The New Negro*, 370.

16. Larsen, *"Quicksand" and "Passing,"* 45.

17. Locke, "1928," 9.

18. Larsen, *"Quicksand" and "Passing,"* 59.

19. Ibid., 2.

20. Motley, "How I Solve My Painting Problems," 5, in Motley Papers, Chicago.

21. See "The New Gallery Exhibition Fact Sheet with Artist's Comments," in Motley Folder (1928), Art and Artifacts Division, Schomberg Center for Research in Black Culture, hereafter cited as "Motley Folder, Schomberg Center."

22. Quoted in McGrath, "White Brides," 104.

23. Quoted in ibid., 699–70.

24. Delacroix's *Aline, the Mulatress* is also listed intermittently in various catalogs as *Woman in a Blue Turban*. For further analysis of Delacroix's Orientalist predilections and use of black models, who were frequently his mistresses, see Honour, *The Image of the Black in Western Art*

25. In contrast to the rendering of sedate *Aline*, Delacroix paints the "la mulatrêsse" Aspasie (who is sometimes confused with Aline) in *Portrait of Aspasie* (1824) with her dark hair loose, wearing a beaded choker and a full, off-the-shoulder blouse that reveals her breasts.

26. Larsen, *"Quicksand" and "Passing,"* 1.

27. Ibid., 55.

28. See Said, *Orientalism;* and Lee, *Orientals*. Primitivism has a long history in the western psyche as a rationalization for slavery, as does colonialism and the wholesale transport of so-called primitive art from the developing to the industrial world (see Torgovnick, *Gone Primitive*).

29. Larsen, *"Quicksand" and "Passing,"* 74. This is the second time that Larsen associates Helga and African Americans with gypsies, a significant allusion given the European-Scandanavian context. Gypsies have been Europe's racialized other since their arrival in England at the beginning of the sixteenth century. The migratory connotations of the word *gypsy* identify a life-style that reiterates the alienation and dislocation Helga experiences.

30. Ibid., 57.

31. Ibid., 88, 68, 87.

32. Rebecca Schneider suggests that, "for Walter Benjamin, theorizing modernism, the prostitute presented a prime dialectical image because of the ambivalence inherent in her status as both a 'commodity and seller in one'" (see Schneider, *The Explicit Body in Performance*, 24).

33. Larsen, *"Quicksand" and "Passing,"* 77.

34. Ibid., 91, 83.

35. Ibid., 70.

36. Smith, *Bricktop,* 107–110.

37. Larsen, *"Quicksand" and "Passing,"* 70.

38. Jean-Auguste-Dominique Ingres's *Odalisque with a Slave* (1842) epitomizes the proliferation of the mid-nineteenth-century genre of harem paintings in which the white, central figure is served or framed by African or Asiatic figures. It is also no coincidence that this proliferation coincides with the rise of colonialism as a system of economic oppression to replace slavery.

39. John Berger defines the category of the nude as distinct from nakedness: nakedness is natural, but nudeness is display (see Berger, *Ways of Seeing*). That is why, with few exceptions, the eyes of the nude subject are averted so that her gaze does not disturb the spectator's pleasure.

40. Larsen, *"Quicksand" and "Passing,"* 89.

41. Ibid., 88.

42. Motley, "The Negro in Art," in Motley Papers, Chicago, quoted in Greenhouse and Robinson, *The Art of Archibald J. Motley, Jr.,* 15.

43. Larsen, *"Quicksand" and "Passing,"* 89.

44. Ibid., 95.

45. Ibid., 62, 144, 161, 194.

46. Jennifer Brody reads Irene's relentless examination of Clare as a kind of disciplining, a policing of class boundaries in which Irene plays "Nick" to Clare's "Gatsby" (see Brody, "Clare Kendry's 'True' Colors").

47. Laura Mulvey discusses Freud's concept of scopophilia as pleasure in looking, isolating it as an instinct of sexuality that functions independent of the erotogenic zones. According to Mulvey, the scopophilic gaze involves "taking other people as objects, subjecting them to a controlling and curious gaze" (see Mulvey, *Visual and Other Pleasures*, 16).

48. In her introduction to *"Quicksand" and "Passing,"* Deborah McDowell contends that the passing narrative conceals the more dangerous exploration of female-to-female attraction. While Barbara Johnson supports McDowell's reading of the eroticism in *Passing*, she maintains that the lesbian structure is revealed in "intense eye contact and involuntary re-encounters" (see Johnson, *The Feminist Difference*, 160). Skeptical of such a reading, Thadious Davis argues that Irene's fear of Clare and Brian together demonstrates Larsen's investment in heterosexual notions of desire (see Davis, *Nella Larsen*). While there is a strong, erotic attraction between the two women, I am not convinced that *Passing* can be called a lesbian text.

49. Du Bois, "The Browsing Reader," 248.

50. Als, introduction, in Brown, *Clotel,* xiv.

51. Du Bois, "Two Novels," 202.

52. Larsen, *"Quicksand" and "Passing,"* 186, 178, 157, 218, 157.

53. Ibid., 150, 206.

54. See Lewis and Ardizzone, *Love on Trial.*

55. Larsen, *"Quicksand" and "Passing,"* 150.

56. Ibid., 161.

57. In an analysis of the properties of whiteness and the structures that reinforce its superiority, Richard Dyer claims that "whites must be seen to be white, yet whiteness as a race resides in invisible properties and whiteness as power is maintained by being unseen" (see Dyer, *White,* 45).

58. Larsen, *"Quicksand" and "Passing,"* 161.

59. In Vera Kutzinski's compelling study of the erotics of the mulatto figure in Cuban national and literary culture, the mulatta's beauty is always flawed by a barely discernible

trait that reveals her tainted ancestry and adds to her forbidden allure. Analyzing the novel *Cecilia Valdés*, Kutzinski argues that the title character "can be taken as representative of a racialized and sexualized cultural iconography that offers an alternate mythic foundation: the Cuban cult of the mulata [*sic*]" as exemplified by this novel, which established the mulatta as the ideal of nineteenth-century feminine beauty (see Kutzinski, *Sugar's Secret,* 21).

60. In works such as Harriet Beecher Stowe's *Uncle Tom's Cabin,* among others, the tragic mulatta functions as a sexual surrogate for white male and female desire. The mulatta stands in as a false body for white women; she operates as an emotional donor, revealing the interdependency implicit in the master-slave relationship and the marketability of such narratives to a white and black readership.

61. "Misadventure" appears in a sentence that was dropped, for an unknown reason, from the McDowell edition of *Passing* and placed in a footnote to the text. The deleted sentence originally appeared directly after the present last line ("then everything was dark"): "Centuries after, she heard the strange man saying: 'Death by misadventure I'm inclined to believe. Let's go up and have another look at that window'" (Larsen, *"Quicksand" and "Passing,"* 246). For further analysis of the omission, see Madigan, "'Then Everything Was Dark'?"

62. Larsen, *"Quicksand" and "Passing,"* 203, 220, passim.

63. Davis, *Nella Larsen,* 287.

64. Motley, interview with Denis Barrie, 26, in Archibald J. Motley, Jr., Papers (1925–77), Archives of American Art, Smithsonian Institution, hereafter cited as "Motley Papers, Smithsonian."

65. From an audiotaped interview with Elaine Woodall, July 1972, archived in the Rare Books Room, Pennsylvania State University Library, and quoted in Woodall, "Archibald J. Motley, Jr.," 127.

66. Ibid.

67. Ibid., 74. Even more significant is the elongated structure of the face and hands, a technique repeated in *The Octoroon* and *The Octoroon Girl,* which lends a regal quality to Motley's representation of his grandmother, a former slave. Furthermore, her status in the family as a matriarch is solidified by her wedding ring, the jewel affixed to her collar, and the nimbus of light that crowns her head. Far more than experimentation with a range of colors, Motley's clever use of background color in the composition of his grandmother's portrait underscores miscegenation as commonplace, an integral part of African American history and American culture.

68. Larsen, *"Quicksand" and "Passing,"* 210.

69. Motley, "How I Solve My Painting Problems," 5, in Motley Papers, Chicago.

70. Motley's delineation of the artistic and the scientific reflects the legal discourse of slavery's one-drop rule, revealing the lingering influence of the atavism that attributes behavior to blood quantum and perpetuates the use of pseudoscience to uphold racist ideology in American culture.

71. Patton, *African American Art,* 123.

72. Larsen, *"Quicksand" and "Passing,"* 102, 221, 229, 152, 149, 155, 225, 249.

73. Ibid., 60.

74. The relationship between Laura, the narrator in Le Fanu's novella, and Carmilla, the vampire, bears an eerie resemblance to Clare and Irene's friendship, particularly in the latter's inability to sever their alliance. Laura's description of her union with Carmilla resembles Irene's reactions to Clare, evinced in the "brilliant red patches" that flamed in her cheeks as she reads Clare's letters (ibid., 145).

75. Larsen, *"Quicksand" and "Passing,"* 60, 62.

76. Lewis, *When Harlem Was in Vogue,* 244. Lewis describes Dunn as "tall, slender, ambiguously beige, with the cool, sculptured, haughty beauty of an Andalusian courtesan" (ibid.).

77. Larsen, *"Quicksand" and "Passing,"* 62, 205, 239, 64.

78. Ibid., 129, 135.

79. Ibid., 239, 238, 221, 178.

80. Jennifer Brody notes that the only time we see Clare literally "ascend in the novel" is when she walks up to the Freelands' apartment just before her final freefall (see Brody, "Clare Kendry's 'True' Colors," 1056).

81. Larsen, letter to Dorothy Petersen, July 19, 1927, in the James Weldon Johnson Collection.

82. Du Bois, "The Browsing Reader," 248; Seabrook, "Touch of the Tar-Brush," 1017.

83. Chesnutt, *The House Behind the Cedars,* 324.

Notes to Chapter Two

1. McKay, *A Long Way from Home,* quoted in Lewis, *A Harlem Renaissance Reader,* 159; Bishop, December 17, 1982, quoted in Todd, *New Woman Revised,* 273.

2. Carby, *Reconstructing Womanhood,* 170.

3. Fauset's other novels are *Plum Bun* (1929), *The Chinaberry Tree* (1931), and *Comedy American Style* (1933).

4. Hughes, "The Negro Artist and the Racial Mountain," 694. In *The Big Sea*, Hughes wrote: "At the novelist, Jessie Fauset's, parties there was always quite a different atmosphere from that at most other Harlem good-time gatherings. At Miss Fauset's, a good time was shared by talking literature and reading poetry aloud and perhaps enjoying some conversation in French. White people were seldom present there unless they were very distinguished white people, because Jessie Fauset did not feel like opening her home to mere sightseers, or faddists momentarily in love with Negro life. At her house one would usually meet editors and students, writers and social workers, and serious people who liked books and the British Museum and had perhaps been to Florence (Italy, not Alabama)" (247).

5. Fauset, letter to Langston Hughes, dated "Tuesday," no. 66 in a folder dated "1920–26," James Weldon Johnson Manuscript Collection.

6. McKay, *A Long Way from Home,* 159.

7. Douglas, *Terrible Honesty,* 86. Also see North, *The Dialect of Modernism.*

8. Fauset, *Comedy American Style,* xxxii.

9. H.L.M., "Tragedy: Fauset Style," 6.

10. Fauset's interests in female repression and the complex interplay of gender, race, and class are especially well illustrated by Olivia, heroine of her most cynical novel, *Comedy American Style*, whose internalization of racist and sexist ideologies leads to the destructive consequences of self-hatred and cultural exile.

11. Baker, *Workings of the Spirit.* Also see Baker, *Turning South Again.*

12. Although White's heroine, Mimi Daquin, flouts convention by engaging in premarital sex and then refusing to marry her child's father after he suggests an abortion, White stops short of exploring female desire. The sex scene in *Flight* is no more than a romantic kiss: the reader does not suspect that intercourse actually took place until pages later, when Mimi's doctor informs her she is pregnant. By obscuring the female experience of sexual desire, White misses an opportunity to create a fully developed modern black heroine.

13. Lewis, *The Harlem Renaissance Reader*, xxxiv. The Gibson girl was the idealized American woman of the 1890s, dressed in high-necked shirtwaists, puffed sleeves, and corsets. Lewis chooses this analogy to indicate that Angela represents Harlem Renaissance chic. Unfortunately, making an 1890s icon analogous to the purposefully modern protagonist of *Plum Bun* indicates that he has misinterpreted Fauset's work, slotting it into the category of sentimental nineteenth-century novels.

14. Todd, *The New Woman Revised*, 8.

15. Fauset, *Plum Bun*, 144.

16. See Barker, *Aesthetics and Gender and American Literature*.

17. Fauset, *Plum Bun*, 164, 171, 155, 304.

18. W.E.B. Du Bois has erroneously received much of the credit for the success of the *Crisis* that should really be given to Fauset. David Levering Lewis, in particular, overcredits him with ushering black literature into the forefront of the New Negro discourse and plays down Fauset's contributions. See Lewis, *When Harlem Was in Vogue;* and Lewis, *W.E.B. Du Bois*.

19. Advertisement, *Crisis* (April 1929): 139.

20. Fauset, "Double Trouble," 155. The title paraphrases a line from Shakespeare's *Macbeth*: "Double, double, toil and trouble" (157).

21. Ibid., 158.

22. Waring's second illustration accompanies part 2 of "Double Trouble" and features Angelique's repudiation by her beau, who turns out to be her half-brother (ibid., 208).

23. Fauset similarly uses the passing motif in *Comedy American Style* to criticize intraracial hatred and classism. Employing the structure of a play, the tragicomedy tells the story of Olivia Blanchard, a young fair-skinned black woman whose ultimate desire is to pass forever into white society. When she is unable to achieve the class standing she desires in the white community, she settles on marriage with an equally light-skinned black doctor and manipulates her children, whose lives are destroyed by her self-absorbed yearning to be white. Considered by Thadious Davis to be Fauset's most mature novel, *Comedy American Style* is also the only novel in which, once married, at least two of the women continue to pursue their vocations. Marise Davies, a Josephine Baker–inspired character, continues her career while supporting her husband; and Phebe Grant, a talented seamstress, builds up a strong clientele and, with her husband, Christopher Cary, reconstitutes the Cary family as African American. See Davis's introduction to Fauset, *Comedy American Style*.

24. Ammons, *Conflicting Stories*, 8. She continues: "This assertion of the moral purity of black womanhood, at a time when many white women of much the same educational and sociological background were trying to throw off sexual restrictions, defined one of the fundamental differences between the black women's movement at the turn of the century and the white women's."

25. Wells, *The Memphis Diary of Ida B. Wells*, 78.

26. Hull, *Give Us Each Day*, 23.

27. Letter from Jessie Fauset to Arthur Spingarn, 26 January 1926, Moorland-Spingarn Research Center, Howard University.

28. Fauset, *Plum Bun*, 122.

29. Ibid., 87.

30. Todd, *The "New Woman" Revised*, 198.

31. Fauset, *Plum Bun*, 87.

32. Ibid., 97.

33. Kassanoff, "Extinction, Taxidermy, Tableaux Vivants," 67.

34. Fauset, *Plum Bun,* 97, 87, 111.

35. Ibid., 88.

36. Todd, *The "New Woman" Revised,* 138.

37. Ibid., 18, 14.

38. Ibid., 234, 122, 112, 268.

39. Johnson, *Autobiography of an Ex-Colored Man,* 154. After viewing the brutal lynching of a black man, the narrator rationalizes his decision: "I argued that to forsake one's race to better one's condition was no less worthy an action than to forsake one's country for the same purpose" (139).

40. Fauset, *Plum Bun,* 94, 342, italics mine.

41. Ibid., 17.

42. See Glickman, ed., *Consumer Society in American History,* 199.

43. Dimock, "Debasing Exchange," 783.

44. Quoted in Todd, *The "New Woman" Revised,* 147.

45. Fauset, *Plum Bun,* 88–89.

46. McDowell, introduction, in ibid., xxvii.

47. Kassanoff, "Extinction, Taxidermy, Tableaux Vivants," 68.

48. Wharton, *The House of Mirth,* 3.

49. Fauset, *Plum Bun,* 14.

50. Wharton, *The House of Mirth,* 34; Fauset, *Plum Bun,* 15.

51. Cohen, "Encountering Mass Culture at the Grassroots," 158, 160; Greenberg, "Don't Buy Where You Can't Work," 250.

52. Fauset, *Plum Bun,* 73.

53. Ibid., 149.

54. Dimock, "Debasing Exchange," 66.

55. Fauset, *Plum Bun,* 88–89, 149.

56. Ibid., 105.

57. See Chapter 3 for further discussion of the Rhinelander case.

58. Fauset, *Plum Bun,* 199, 206, 207.

59. Lewis to Fauset, November 17, 1925, quoted in Sylvander, *Jessie Redmon Fauset,* 63.

60. Achille, preface, *La Revue du Monde Noir,* viii. Unlike Alain Locke's treatise on the New Negro, Paulette Nardal's "Eveil de la conscience de Race" addresses the position of black women: "colored women living alone in the metropolis, until the colored exhibition, have certainly been less favored than colored men who are content with a certain easy success." She was not so critical of Du Bois's notion of uplift by means of the talented tenth and encouraged the Antillean black elite to lend a hand to their "retarded brothers" (see Achille, "The Negroes and Art," 29; translations here are mine).

61. Fabre, *From Harlem to Paris,* 118. In *Comedy American Style,* there is a dramatic shift in France's status as an idyllic space for black art and experience; the novel concludes with the passing heroine stranded in the small-minded provinces.

62. Fauset, *Plum Bun,* 375.

63. "Fauset, "Yarrow Revisited, 109. Also see Leininger-Miller, *New Negro Artists in Paris.*

64. Hughes, "The Negro Artist and the Racial Mountain," 92.

65. Bearden and Henderson, *History of African American Artists,* 170.

66. Savage, May 20, 1923, quoted in Bearden and Henderson, *A History of African American Artists,* 170.

67. Du Bois, "Postscript: May Howard Jackson," 351.

68. Quoted in Leininger-Miller, *New Negro Artists in Paris,* 171.

69. Savage did manage to study in France with funds from the Julius Rosenwald Fellowship. There she met Paulette Nardal, who visited her atelier and later wrote: "[Savage] easily succeeds in the modern genre that is so imbued with Negro art" (quoted in ibid., 195).

70. Fauset, *Plum Bun,* 344, 348, 354.

71. Ibid., 373.

Notes to Chapter Three

1. Kracauer, "Little Shopgirls Go to the Movies," 292; Jackson, "Fredi Washington Strikes a New Note," 8; Hughes, "Movies," in *The Collected Poems of Langston Hughes,* 295.

2. McKay, *The Harlem Renaissance Intelligentsia,* 159. McKay continues condescendingly: "Miss Fauset is prim and dainty as a primrose, and her novels are quite as fastidious and precious."

3. See Stewart, "Negroes Laughing at Themselves?," especially her treatment of Bigger's movie watching in Richard Wright's *Native Son.*

4. hooks, "The Oppositional Gaze: Black Female Spectators," 204.

5. The section head is from an intertitle in Micheaux's film *Symbol of the Unconquered* (1920).

6. Diawara, *Black American Cinema,* 3.

7. Ibid.

8. In Larsen's *Quicksand,* Audrey Denny's skin is a "creamy alabaster" that produces a "deathlike pallor" (60). In Hopkins's *Contending Forces,* Grace Montfort's skin has "too much cream color" for a "genooine white 'ooman" (41).

9. See also Frank Peregini's *Scar of Shame* and Micheaux's *Within Our Gates.*

10. See Larsen, *Passing,* 206; Henderson defines saturation as "the communication of 'Blackness,' and fidelity to the observed or intuited truth of Black Experience in the United States," 10. According to Amy Robinson, "there is no word to describe what exactly the in-group recognizes in the passing subject" (see Robinson, "It Takes One to Know One," 725).

11. Bowser et al., *Oscar Micheaux and His Circle,* 255. Among the select circles of the New Negro movement, Micheaux was considered to be an outcast because he dared to criticize the sacrosanct black church when he cast Paul Robeson as a corrupt minister in *Body and Soul.*

12. Gaines, *Fire and Desire,* 5.

13. Unlike Angela, who resolves to pass permanently into the white world after she and her dark-skinned date are barred from entering a "little gem of a theatre" together, *Comedy American Style*'s Phebe, who is described by a white suitor as "the whitest white girl I ever saw," sees passing at the movies as a private in-joke: "It happened that we were all going to the same place on Market street, to a movie. You know how nasty those theaters are down there? They watched me like hawks to find out where I was going to sit. I had been meaning to sit in the balcony, for I didn't have much money that day, but just to spite them I bought a seat in the orchestra. . . . It's a good thing there isn't anything in the idea of the Evil Eye. . . . If looks could kill, your girl-friend wouldn't be here today" (see Fauset, *Plum Bun,* 74; and Fauset, *Comedy American Style,* 286, 238).

14. Gaines, *Fire and Desire,* 128.

15. Bowser et al., *Oscar Micheaux and His Circle,* 255.

16. Bowser and Spence, "Oscar Micheaux's *Symbol of the Unconquered*," 95. Pearl Bowser addresses accusations that Micheaux often cast by color (ibid.).

17. Greenhouse and Robinson, *The Art of Archibald J. Motley, Jr.*, 9.

18. In a note to Chesnutt, Micheaux suggests that Frank should be more intelligent and well-spoken; thus worthy of Rena's affection: "I would make the man Frank more intelligent at least towards the end of the story permitting him to study and improve himself, for using the language as he does in the story, he would not in anyway be obvious as a lover or that the girl could have more than passing respect for him." (*Oscar Micheaux and his Circle*, 91).

19. Chesnutt, *The House Behind the Cedars*, 57.

20. See Lupack, *Literary Adaptations in Black American Cinema*; and Creekmur, "Telling White Lies."

21. Hopkins, *Contending Forces*, 15, 261, 258.

22. Ibid., 150, 261.

23. Brody, *Impossible Purities*, 55.

24. Gaines, *Fire and Desire*, 187, 188.

25. See Brody, *Impossible Purities*. Although later works, such as Ralph Ellison's *Invisible Man*, Toni Morrison's *The Bluest Eye*, Gayl Jones's *Corregidora*, and Alice Walker's *The Color Purple* address inter- or intraracial incest, African American literary criticism on the incest motif is rare.

26. Chesnutt, *The House Behind the Cedars*, 6, 5, 6.

27. Dijkstra, *Idols of Perversity*, 384.

28. Douglas Sirk's adaptation of *Imitation of Life* features Sarah Jane performing in a chorus line on a conveyer belt.

29. See *isabelwpowell.org/book/index.html*.

30. Ibid. Evidently, though he left the church for her, she did not accompany him to Washington after he went into politics. They divorced in 1945; and he later married another performer, the renowned pianist Hazel Scott.

31. A screenplay of *God's Step Children* includes a scene in which Naomi's white, presumably second husband, Andrew, confronts her: "You aren't the first to try this, Naomi. No, it has been tried since the days of slavery and even before that; but they can't get away with it, so you see you can't get away with it, for sooner or later, somewhere, some time after a life of fear and exemption you will be found out, and when you are they'll turn on you, loathe you, despise you, even spit in your face and call you by your right name—Naomi, Negress" (see Bowser and Spence, "Oscar Micheaux's *The Symbol of the Unconquered*," 94). The scene does not appear in the print of the film currently in circulation. It is possible that it was cut because it portrays an interracial relationship, but there is no existing record of the Motion Picture Commission of the State of New York's decision. The script's preface, however, states that "all the characters appearing herein, regardless how bright in color they may seem, are members of the Negro Race," an important point to stress in a film that thematizes incest and miscegenation (quoted in Bowser et al., *Oscar Micheaux and His Circle*, 300). Film historian J. Ronald Green maintains that Micheaux *did* film this passing scene between Naomi and her husband (see Green, *With a Crooked Stick*, 221).

32. Advertisement for *House Behind the Cedars*, *Baltimore Afro-American*, 14 March 1925, p. 5, quoted in Creekmur, "Telling White Lies," 149.

33. In the racially volatile climate of the 1920s, Micheaux subtitled *Symbol of the Unconquered* as "A Story of the Ku Klux" and advertised the film thusly: "see the Ku Klux in action

and their annihilation," although the night riders in the film were in fact an interracial group of criminals and deceivers (Bowser and Spence, "Oscar Micheaux's *The Symbol of the Unconquered*," 86.

34. Fauset, *Plum Bun,* 228, 127, 128.

35. Lewis and Ardizzone, *Love on Trial,* 167.

36. Using a photograph of the model's naked back (she wore only a slip lowered to the waist), the paper created a composite by cutting and splicing photographs of the judges and lawyers and other courtroom personnel to give the appearance of realism. Issues of the paper flew off the newsstands. For more on the case, see ibid., 172–73.

37. Du Bois, "Rhinelander," 112.

38. Letter from Fauset to Hughes, October 2, 1950, James Weldon Johnson Manuscript Collection. Despite the availability of well-known light skinned black actresses, such as Dorothy Dandridge and Nina Mae McKinney, the regressive racial climate of the 1950's dictated that white actors portray the passing characters in these films. The casting of white actors in these roles maintained the films overall theme: that the mulatto characters' suffering was a result of their black blood.

39. I borrow the phrase "Peola discourse" from Anna Everett, who provides empirical evidence of a critical black viewership of *Imitation of Life* (see Everett, *Returning the Gaze,* 221).

40. Robinson, "It Takes One to Know One," 724.

41. The narrator in Johnson's *Autobiography of an Ex-Colored Man* (24) uses "freemasonry of the race" to address those aspects of race and culture known only to the in-group. Also see Larsen, *"Quicksand" and "Passing,"* 206.

42. Zora Neale Hurston once worked for Hurst as a maid. Hurst's name also appeared in the *Crisis* in an anti-lynching protest with other prominent artists.

43. The first Aunt Jemima, Nancy Green, was born a slave in 1834. Significantly, though she did not create the recipe for ready-made pancake flour, her image boosted the product's sales tremendously. The name "Aunt Jemima" is based on the mammy figure, a staple of the American minstrel tradition.

44. See Glickman, ed., *Consumer Society in American History.*

45. Artifacts on display at the Coca-Cola Museum, Atlanta.

46. See Kern-Foxworth, *Aunt Jemima, Uncle Ben and Rastus.*

47. The technique of shot reverse shot allows for equal status within the frame.

48. In her study of Sirk's *Imitation of Life,* Judith Butler alludes to his racialization of gender but focuses primarily on Lana Turner "as a site for the convergence and contradictions of identification and desire, effectively refuting the claim that the two notions are mutually exclusive" (see Butler, "Lana's Imitation," 16).

49. In Sirk's film, the white actress Susan Kohner plays the daughter who is renamed Sarah Jane (Bogle, 192).

50. Bogle, *Brown Sugar,* 79.

51. Through *Pecola,* a character named for Peola, Toni Morrison's *The Bluest Eye* explores the trauma resulting from this lack of self-esteem. Movies and spectatorship play a large part in her novel and have created a space for cultural critics such as bell hooks to examine the painful effects that images privileging Anglo beauty (from dolls to candy to film) have on a young woman's development.

52. hooks, *Reel to Real,* 204. She also argues that Peola was fascinating because she represented black women's "unrealized desiring selves"; her tragedy is that she represents the absence of African American women in cinema (ibid.).

53. According to Anna Everett, "the cartoon illustration of a black woman enjoying the aroma of hair pomade was strategically placed under the McKinney story and the photograph bears a striking resemblance to the young star" (see Everett, *Returning the Gaze,* 166).

54. Bowser et al., *Oscar Micheaux and His Circle,* 187.

55. My thanks to Deborah McDowell for suggesting that I look at this film, in which Ellington performs with his Cotton Club orchestra for the first time onscreen.

56. Smith "Reading the Intersection of Race and Gender in Narratives of Passing"; hooks, *Reel to Real,* 197–213. Both writers also respond to the marked absence of any interrogation of black womanhood in Judith Butler's use of psychoanalytic discourse and her critique of identity performance (see Butler, "Lana's Imitation").

57. Stewart, "Negroes Laughing at Themselves," 653.

58. Cook, Mercer P., "Imitation of Life in Paris," 182.

59. It is unlikely that passing was an unfamiliar occurrence in France. Light-skinned African Americans who immigrated there sometimes passed as Italian, like Terisa does in *Comedy American Style.* The idea that the French could not translate passing also idealized France as a place free of racial discrimination; this characterization is at odds with the nation's colonial history, the Algerian wars, and France's treatment of North African immigrants.

60. Byrd, letter to the editor, 91–92.

61. Locke, *The New Negro,* 4–5.

62. Jackson, "Fredi Washington Strikes a New Note," 8.

63. At the beginning of the film, Bea is on the phone discussing business while baby Jessie is left alone and falls in the bathtub. Later in the film, when she is again away searching for Peola with Delilah, her college-aged daughter falls in love with her fiancé.

64. Bogle, *Toms, Coons, Mulattoes, Mammies, and Bucks,* 60.

65. Jackson, "Fredi Washington Strikes a New Note," 8.

66. Mulvey, *Visual and Other Pleasures,* 13.

67. Fauset, *Plum Bun,* 38, 43–44, 72.

68. This scene either occurs offscreen or has been lost.

69. Fauset, *Plum Bun,* 348.

70. Ibid., 19.

71. Ibid., 17.

72. Brown, *Babylon Girls,* 24.

73. Fauset, *Plum Bun,* 28, 29, 32.

74. Ibid., 83, 79.

Notes to Chapter Four

1. Toomer, letter to Alain Locke, quoted in McHenry, *Forgotten Readers,* 258; Frank, foreword to *Cane,* typescript draft, n.d., in Toomer Papers.

2. Quoted in Powell, *Homecoming,* 123.

3. Current Toomer criticism blames Gurdjieff for Toomer's inability to publish any further work. Jon Woodson's *To Make a New Race* overstates Gurdjieff's influence on Toomer and the Harlem Renaissance, while Nellie McKay's *Jean Toomer, Artist* stops short of investigating his encounter with Gurdjieff. Rudolph Byrd's *Jean Toomer's Years with Gurdjieff* is the most thoughtful analysis of the writer's attempt to thematize his "ideal of man" philosophy. Byrd sees Toomer's interests in man's possibilities and development as part of a disguised chapter of *Cane,* which was written before he encountered the guru.

4. Toomer, "The Negro Emergent," 92; Toomer, "Race Problems and Modern Society," 63.

5. Toomer, *Cane*, xiii.

6. Toomer, Paris notebook, September, journals folder 1929–30, in Toomer Papers. Identifying Toomer as either a black writer of the Harlem Renaissance or an American modernist is complicated by his often contradictory views of racial and cultural heritage. His publication history demonstrates the two distinct yet interdependent literary groups to which he belonged. Boni and Liveright published *Cane* in 1923, but "Karintha" and "Song of the Son" had been previously published in *Broom* and the *Crisis*.

7. McKay, *Jean Toomer, Artist*, 45.

8. Powell, *Homecoming*, 111.

9. In 1930, Johnson married Holcha Krake, an independent Danish textile artist who was sixteen years older than he was. They collaborated on their art and lived in the Netherlands in a fishing village where Johnson painted startlingly beautiful landscapes. He traveled throughout France and Scandinavia and finally went to North Africa with his wife, who died in 1943. After her death, Johnson experienced a gradual mental breakdown as a result of a luetic infection. After he was admitted to a mental institution and the Harmon Foundation was dissolved, his artwork was in danger of being discarded until the Smithsonian agreed to accept it. According to Steve Turner, the common belief that Johnson's work was "destined for destruction" actually simplifies the complex and somewhat pernicious distribution of his work among his Danish relatives, black colleges, and Harmon Foundation administrator Mary Brady. For more on Turner's alarming findings, see Turner and Dailey, *William H. Johnson;* and Bearden and Henderson, *A History of African American Artists from 1792 to the Present*, 197.

10. Johnson's 1928–29 painting *Cagnes-sur-Mer* illustrates Chaim Soutine's influence on Johnson's quarrels with modernist abstraction.

11. Powell, *Homecoming*, 69.

12. Unlike Johnson, whose acclaim was fleeting and whose paintings were rarely financially lucrative during his lifetime, Aaron Douglas managed to successfully incorporate African and Egyptian elements into his work, thus answering Langston Hughes's call for an authentic black aesthetic free from the demands of white patrons or the collective approval of black community. Douglas's murals and book illustrations—for the periodicals *Survey Graphic* and *Fire!!* and Locke's *The New Negro*—are some of the most celebrated artifacts of the era. See Amy Kirsche's excellent *Aaron Douglas*.

13. Powell, *Homecoming*, 123.

14. Powell et al., *Rhapsodies in Black*, 25.

15. Powell, *Homecoming*, 14.

16. Romare Bearden harshly critiques Johnson's "folk" art: he believes that Johnson's initial desire to please his teachers never translated into original art. He credits him with ushering ordinary black life into Expressionism, but compares his lack of depth to Horace Pippin, whose work expresses "a superb intelligence" in spite of his lack of formal training (see Bearden and Henderson, *A History of African American Artists from 1792 to the Present*, 199).

17. I'm thinking of works such as John Edgar Wideman's *Damballah*, which follows the multigenerational history of a specific community through a series of interconnected vignettes. In *The Negro Novel in America*, Robert Bone also reads *Cane* as an experimental novel, an assumption vehemently disputed by Darwin Turner's *In a Minor Chord* (27).

18. Toomer's aesthetics also reflect the American pragmatism of William James and John

Dewey, especially their emphasis on truth, experience, and consequence. Waldo Frank's dramatized social commentary, popularized in works such as *Holiday* and *Our America,* also influenced Toomer's detached, spectatorial narrator and its prophetic and ethnographic dimensions.

19. Sanders, *Afro-Modernist Aesthetics and the Poetry of Sterling A. Brown,* 28.

20. *Impressionism* as a term was originally applied in 1874 to a coterie known as the Anonymous Society of Artists; the core group included Monet, Renoir, Sisley, Caillebotte, Cezanne, and Gauguin. While some art historians maintain that impressionism's wide use has rendered the term useless, I take it to be loosely defined as "an offshoot of Realism interested principally in the transcription of visual reality as it affects the retina of the painter within a discrete, and short period of time" (Brettell, *Modern Art,* 16).

Several essays in Frank Durham's *Merrill Studies in "Cane"* comment on the visuality in *Cane*: they consistently characterize Toomer's writing as visually sensitive, all the while engaging in the continuing debate among Toomer scholars on whether to consider *Cane* to be a novel or a collection. Straddling the fence, Rudolph Byrd reads *Cane* as "unified series of stories, sketches, poems and a semi-dramatic piece that individually addresses a whole range of issues but that collectively gives voice to Toomer's most important theme—human development, or man's lack of and search for wholeness" (see Byrd, *Jean Toomer's Years with Gurdjieff,* 15).

21. Toomer, letter to Alfred Steiglitz, January 10, 1924, in Toomer Papers, box 49, 1173–74.

22. Originally, there were also arcs on the blank pages preceding the first section of *Cane*; for unknown reasons these arcs have been omitted from all subsequent printings. See the galley print in the Jean Toomer Papers, Yale University, hereafter cited as "Toomer Papers."

23. Quoted in Toomer, *A Jean Toomer Reader,* 25.

24. Ibid., 280. Here, Toomer's understanding of *see* is similar to the Impressionist desire to get away from a narrative reading and rely solely on the visual.

25. Toomer, letter to Georgia O'Keeffe, January 13, 1924, in Toomer Papers. The "clouds" Toomer refers to this letter are the photographs of clouds in Stieglitz's series *Equivalents.* Characterized by Graham Clarke as "mood poems," the natural images approximate feelings and emotions; Stieglitz portrays the heavens to evoke a transcendent mood (see Clarke, *The Photograph,* 170). Toomer later compares this series to Herman Melville's white whale in *Moby Dick.*

26. Holmes, "Apostle of Beauty," 50. For more on the relationship between O'Keeffe and Toomer, see Nadell, "Race and the Visual Arts in the Works of Jean Toomer and Georgia O'Keeffe, 142–61.

27. The influence of imagistic poets, especially Ezra Pound, is evident in several of the short poems in *Cane.* One of the major objectives of imagism was to render precisely, without comment, the poet's responses to a visual object or scene.

28. Toomer, *Cane,* 8. Despite the imagism in "Face," poems such as "Reapers" (3) depart from imagistic principles. See North, *The Dialect of Modernism,* 172

29. Toomer, *Cane,* 27.

30. Ibid., 29, 31.

31. Melville published "Benito Cereno" in 1856 as part of a collection titled *Piazza Tales.* It is the dramatic retelling of an 1805 slave-ship mutiny related through the eyes of the detached yet supposedly detail-oriented Captain Delano.

32. Toomer, letter to Alfred Stieglitz, October 20, 1925, in Toomer Papers.

33. Meville, "Benito Cereno," 37.

34. Toomer, *Cane,* 38, 34; Melville, "Benito Cereno," 34.

35. Toomer, *Cane*, 31, 28, 34, 35. In "Kabnis," the specter of lynching and Kabnis's fear of this southern "pastime" precipitates his psychological decline.

36. James Latimer's photograph *Madonna and Child* (1930) is one of the most famous of such images.

37. Toomer, *Essentials*, part 24.

38. Du Bois, "The Younger Literary Movement," 41.

39. According to David Levering Lewis, Du Bois's teaching experience in Wilson County, Tennessee, provided the rich material from which he drew his analyses of the character and struggles of the south in *The Souls of Black Folk* (see Lewis, *W.E.B. Du Bois*, 68).

40. Didier, review of *Cane*, n.d., p. 3, in Toomer Papers; Bone, *The Negro Novel in America*, 82.

41. See McKay, *Jean Toomer, Artist*, 96.

42. The figure of the nude filled an iconographic place in modernist art rivaled only by its importance in baroque art. See Brettell, *Modern Art, 1851–1929*.

43. Powell, *Homecoming*, 121.

44. See Willis and Williams, *The Black Female Body*, which documents representations of black women on paper, film, and canvas.

45. Powell, *Homecoming*, 127.

46. Though the origin or reasoning behind this pseudonym is unknown, Powell suggests that Johnson chose it for its "folksy cadence" (see ibid.).

47. McKay, *Jean Toomer, Artist*, 96, 95.

48. Toomer, *Cane*, 1. What appealed to Toomer about Stieglitz's photographs was their ability to capture "the subject itself, in its own substance and personality." Stieglitz took those elements basic to fine art photography such as "straight," "pure," and "tone" seriously in his quest to portray the "ideal form and purity of vision" (see Clarke, *The Photograph*, 169, 168, 169).

49. Toomer, *Cane*, 2.

50. Ibid., 4, 1. Many critics have explored Toomer's use of the blues idiom in *Cane*, but I only touch upon it here, giving primacy to the relatively unexplored terrain of the visual.

51. Ibid., 14.

52. Powell, *Homecoming*, 44.

53. Toomer, *Cane*, 17.

54. Ibid., 15.

55. Ibid., 1.

56. Ibid., 14, 20.

57. Ibid., 20.

58. Larsen, *"Quicksand" and "Passing,"* 118.

59. Toomer, *Cane*, 22, 23.

60. Ibid., 25.

61. "Declaration and Confession of Esther Rodgers," 405.

62. Ibid.

63. Baker, *Turning South*, 25.

64. I borrow this term from Farah Griffin's *"Who set you flowin'?"* and Brett Williams's "The South in the City." Williams expresses the cultural adaptation of migrants to a new locale: "Migrants bring to cities an expressive culture deeply rooted in another place. Because expressive culture is crucial in defining place, they must revise the often-inappropriate aesthetics of home and join them to the more embracing commercial and popular media" (30).

65. For a thorough analysis of Toomer's participation in Georgia Johnson's literary circle, see McHenry, *Forgotten Readers*.

66. Toomer, *Cane*, 47.

67. Ibid., 46.

68. Stieglitz, quoted in Clarke, *The Photograph*, 169.

69. Toomer, *Cane*, 46, 45.

70. Scruggs and Van Demarr, *Jean Toomer and the Terrors of American History*, 77.

71. Quoted in Clarke, *The Photograph*, 79.

72. Toomer, *Cane*, 47.

73. Quoted in Scruggs, "The Photographic Print, the Literary Negative," 70.

74. Ibid., 44; Larsen, *"Quicksand" and "Passing,"* 18.

75. Toomer, Journals (1923), in Toomer Papers, folder 1412.

76. Toomer, *Cane*, 39.

77. Ibid., 51.

78. Scruggs and Van Demarr, *Jean Toomer and the Terrors of American History*, 30.

79. Ibid., 53, 51; Brown, *The Collected Poems of Sterling A. Brown*, 101.

80. Brown, *The Collected Poems of Sterling A. Brown*, 102.

81. Toomer, *Cane*, 51.

82. Ibid., 57, 59.

83. Ibid., 61. Anne Spencer uses a similar conceit in her poem "Lady, Lady," which challenges society's definition of ladyhood in its depiction of a black laundress performing backbreaking labor (quoted in Locke, *The New Negro*, 148).

84. In *Quicksand*, Naxos College determines that "black, gray, brown and navy blue are the most becoming colors for colored people"; and when a "sooty blackgirl" appears "decked out in a flaming orange dress," a strict matron consigns her dress to the dyer (see Larsen, *"Quicksand" and "Passing,"* 8).

85. Toomer, *Cane*, 44, 59.

86. Ibid., 107, 105, 107.

87. Ibid., 103, 46.

88. Ibid., 116.

89. Quoted in Powell, *Rhapsodies in Black*, 25.

90. Walrond, *Tropic Death*, 50, 70.

91. Hughes, "The Negro Artist and the Racial Mountain."

92. Toomer, *Essentials*, part 45.

Notes to Chapter Five

1. In Alexander, *Body of Life*, 15; Fusco, *English Is Broken Here*, 34.

2. Artists Augusta Savage, Edmonia Lewis, and Elizabeth Catlett are all precursors of contemporary black female artists who studied in Paris during the Harlem Renaissance They also appear in Ringgold's quilts as important characters, ancestral voices, and role models for her artist-protagonist.

3. Cameron, ed., *Dancing at the Louvre*, 59.

4. Several of Marlena's quilts, such as *Jo Baker's Bananas* and *Picnic in the Grass*, appear to respond to her mother's images (*Jo Baker's Birthday* and *Picnic at Giverny*, respectively). Since it does not appear Cameron's *Dancing in the Louvre*, I include the text to *Picnic on the Grass* here: "The last of the American Collection is a love Story. Since Marlena has success,

money, beauty and fame, but neither a husband or children, she finds herself searching for a real relationship. In *Picnic on the Grass (#12)* Marlena prepares a sumptuous picnic lunch for an enchanting afternoon date in the park only to be stood up at the last minute. She goes anyway alone and alas discovers her lover there with another woman" (courtesy of Grace Matthews, assistant to Faith Ringgold. *Picnic on the Grass Alone, 1997,* The American Collection #12. 79 x 77.25 inches. Acrylic on canvas with painted borders, quilted. © Faith Ringgold 1997. ACA Gallery). Thanks to Lisa Farrington for suggestions on how to obtain a copy of this text.

5. Fusco, *English Is Broken Here.*

6. "The postcolonial celebration of hybridity has been interpreted as the sign that no further concern about the politics of representation and cultural exchange is needed" (ibid., 76).

7. See Sharon Patton's discussion in *African American Art,* 239. Robert Colescott draws on a variety of sources, including advertisements, cartoons, and African art, to create "subversive appropriations" of nineteenth- and twentieth-century art that comment on social and racial hierarchies (ibid., 236). Like him, Kara Walker finds parody and satire crucial to her art. She is best known for her larger-than-life cutouts and silhouette installations that portray scenes from the antebellum south (see Walker, *Narrative of a Negress*).

8. Cameron, ed., , *Dancing at the Louvre,* 26.

9. Lorde, *Sister Outsider,* 100.

10. Billingslea-Brown, *Crossing Borders through Folklore,* 31.

11. Ibid., 23; Lorde, *Sister Outsider,* 29.

12. The later work of Afro-modernist expressionist William H. Johnson (specifically, *Lamentation (Descent from the Cross)* and *Mount Calvary*) inspired the quilt *Born in a Cotton Field* in the *American Collection.*

13. Cameron, ed., *Dancing at the Louvre,* 134. Also see Honour, *The Image of the Black in Western Art,* vol. 4; and Carla Williams, "Naked, Neutered or Noble," in Wallace-Sanders, ed., *Skin Deep, Spirit Strong,* 183–200.

14. Judith Wilson's essay addresses the absence of the black female nude in African American art before the early twentieth century. She applauds artists for making the black nude a subject but critiques them for avoiding "the volatile conjunction of gender and race or the inflammatory myths of black sexuality that the black nude also inscribes" (see Wilson, "Getting Down to Get Over," in Dent and Wallace, ed., *Black Popular Culture,* 116).

15. Reff, *Manet,* 53.

16. Cameron, ed., *Dancing at the Louvre,* 135.

17. bell hooks writes that it was not the "Big Mama" but *Peola* who "captured our gaze; we were fascinated by [her]" (hooks, *Reel to Real,* 294).

18. There are two other paintings of black nudes from the later period of the Harlem Renaissance: Eldzier Cortor's *Room No. 5* and Charles Sallee's *Bed Time,* both painted in 1940. See Wallace-Sanders, ed., *Skin Deep, Spirit Strong,* and Willis and Williams, eds., *The Black Female Body,* for a thorough history of the black nude.

19. Larsen, *"Quicksand" and "Passing,"* 57, 56.

20. Fusco, *English Is Broken Here,* 32.

21. Cameron, ed., *Dancing at the Louvre,* 134.

22. Ibid., 134. I translate the phrase as "a beautiful portrait."

23. Fauset, *Plum Bun,* 65, 63.

24. Cameron, ed., *Dancing at the Louvre,* 135, 136.

25. Ibid., 130.

26. Fauset, *Plum Bun,* 375.

27. Cameron, ed., *Dancing at the Louvre,* 130.

28. Larsen, *"Quicksand" and "Passing,"* 197.

29. Cameron, ed., *Dancing at the Louvre,* 130.

30. Fusco, *English Is Broken Here,* 34.

31. Cameron, ed., *Dancing at the Louvre,* 131.

32. Along with the improper content in Manet's painting, its formal oddities drew critical attention. Picasso's position in Ringgold's *Picnic* mimics the formal situation of the nude woman in *Dejeuner* (see Brettell, *Modern Art,* 6).

33. Cameron, ed., *Dancing at the Louvre,* 131. Richard Brettell identifies Monet's suppression of the "space-suggesting illusionism of the models' left leg by draping it, and hence flattening the foot into the plane of the body" (Brettell, *Modern Art,*132).

34. Cameron, ed., *Dancing at the Louvre,* 132.

35. Fusco, *English Is Broken Here,* 33.

36. Turner, *Faith Ringgold,* 10.

37. In the quilt *A Family Portrait,* we discover that Pierrot, Willia's son, is racially ambiguous. Two quilts from the *American Collection* (*Moroccan Holiday* and *A Family Portrait*) discuss some aspect of the tension between mother and daughter and interracial marriage.

38. Cameron, ed., *Dancing at the Louvre,* 144. *In Listen to the Trees,* Marlena, wearing a white and green dress, holds a bouquet of flowers, paintbrushes and a painting.

39. Toomer, *Cane,* 46.

40. Gates, "Review of Toni Morrison's *Jazz,*" 52.

41. A poem by Owen Dodson accompanies the portrait of the dead young woman in Van Der Zee et al., *The Harlem Book of the Dead* (52):

> They lean over me and say:
> "Who deathbed you who,
> who, who, who, who. . . . "
> I whisper: "Tell you presently . . .
> Shortly . . . this evening. . . .
> Tomorrow . . . "
> Tomorrow is here
> And you out there safe.
> I'm safe in here, Tootsie.

42. Morrison, *Jazz,* 1.

43. Ibid., 12.

44. Ibid., 143.

45. Johnson, *Autobiography of an Ex-Colored Man,* 11.

46. Toomer, *Cane,* 116.

47. Morrison, *Jazz,* 167, 179.

48. Ibid., 170.

49. Ibid., 128.

50. Like Angela in *Plum Bun* and Irene in *Passing,* Dorcas is the orphaned daughter of African American parents. Dorcas's parents were killed during the East St. Louis race riots.

51. Ibid., 130.

52. McDowell, "Harlem Nocturne," 4. McDowell stresses in her review that *Jazz* is a "photocollage" that "straddles several artistic media all at once. Photography is just one."

53. Morrison, *Jazz*, 173, 161, 151, 135.
54. Ibid., 226–27.
55. Toomer, *Cane*, 1.
56. Morrison, *Jazz*, 226, 135.
57. Ibid., 193.
58. Larsen, quoted in Davis, *Nella Larsen*, 456.
59. See *http://www.mulattonation.com/birthofanation.ht*.
60. Trethewey, "Flounder," in *Domestic Work*, 35.
61. Ibid., 40
62. Ellis, "The New Black Aesthetic," 235.
63. Senna, *Caucasia*, 335.
64. hooks, "A Revolution of Values," 295.

Bibliography

Archives

Archives of American Art, Smithsonian Institution, Washington, D.C.
 Archibald J. Motley, Jr., Papers, 1925–77
Chicago History Museum
 Archibald J. Motley, Jr., Archives and Manuscript Collection
James Weldon Johnson Collection, Beinecke Rare Book and Manuscript Library, Yale University, New Haven, Conn.
 Gertrude Stein and Alice B. Toklas Papers
 Jean Toomer Papers
 Carl Van Vechten Papers

Published Works

Achille, Louis, preface, and "The Negroes and Art," *La Revue du Monde Noir* 1 (1931): 1, 23–31.
Alexander, Elizabeth. *Body of Life*. Chicago: Tia Chucha, 1996.
Ammons, Elizabeth. *Conflicting Stories: American Women Writers at the Turn into the Twentieth Century*. London: Oxford University Press, 1992.
"The Art Galleries: Art Reaches a Peak—A New Color on the Palette—Notes." *New Yorker*, March 10, 1928, p. 79.
Ashe, Bertram. "'Why Don't He Like My Hair?' Constructing African-American Standards of Beauty in Toni Morrison's *Song of Solomon* and Zora Neale Hurston's *Their Eyes Were Watching God.*" *African American Review* 29 (winter 1995): 579–92.
Baker, Houston, Jr. *Modernism and the Harlem Renaissance*. Chicago: University of Chicago, 1987.
———. *Turning South Again: Rethinking Modernism/Re-Reading Booker T.* Durham, N.C.: Duke University Press, 2001.
———. *Workings of the Spirit: The Poetics of Afro-American Women's Writing*. Chicago: University of Chicago Press, 1993.
Barker, Deborah. *Aesthetics and Gender and American Literature*. Lewisburg, Pa.: Bucknell University Press, 2000.

Barksdale, Richard, and Kenneth Kinnamon, eds. *Black Writers of America: A Comprehensive Anthology.* New York: Macmillan, 1972.

Barlow, William, and Janette Dates. *Split Image: African Americans in the Mass Media.* Washington, D.C.: Howard University Press, 1990.

Bearden, Romare, and Harry Henderson. *A History of African American Artists, from 1792 to the Present.* New York: Pantheon, 1993.

Berger, John. *Ways of Seeing.* London: British Broadcasting Corporation and Penguin, 1972.

Berlant, Lauren. "National Brands/National Bodies." In *Comparative Identities: Race, Sex, and Nationality in the Modern Text,* edited by Hortense Spillers, 110–40. New York: Routledge, 1991.

Berzon, Judith. *Neither White nor Black: The Mulatto Character in American Fiction.* New York: New York University Press, 1978.

Billingslea-Brown, Alma. *Crossing Borders through Folklore: African American Women's Fiction and Art.* Columbia: University of Missouri Press, 1999.

Bogle, Donald. *Brown Sugar.* New York: Da Capo, 1980.

———. *Toms, Coons, Mulattoes, Mammies, and Bucks: An Interpretive History of Blacks in American Film.* New York: Continuum, 1991.

Bone, Robert. *The Negro Novel in America.* New Haven: Yale University Press, 1965.

Bonner, Marita. *Frye Street and Environs: The Collected Works of Marita Bonner,* edited by Joyce Flynn and Joyce Stricklen. Boston: Beacon, 1987.

Bowser, Pearl, and Louis Spence. *Writing Himself into History: Oscar Micheaux, His Silent Films, and His Audiences.* New Brunswick, N.J.: Rutgers University Press, 2001.

———. "Oscar Micheaux's *Symbol of the Unconquered: Text and Context,*" edited by Bowser, Pearl, Louis Spence, Jane Gaines, and Charles Musser. Bloomington: Indiana University Press, 2001.

Bowser, Pearl, Louis Spence, Jane Gaines, and Charles Musser, eds. *Oscar Micheaux and His Circle: African American Filmmaking and the Race Cinema of the Silent Era.* Bloomington: Indiana University Press, 2001.

Brettell, Richard. *Modern Art, 1851–1929: Capitalism and Representation.* Oxford: Oxford University Press, 1999.

Brickhouse, Anna. "Nella Larsen and the Intertextual Geography of *Quicksand.*" *African American Review* 35 (winter 2001): 543–44.

Brody, Jennifer DeVere. "Clare Kendry's 'True' Colors: Race and Class Conflict in Nella Larsen." *Callaloo* 15 (autumn 1992): 1053–65.

———. *Impossible Purities: Blackness, Femininity, and Victorian Culture.* Durham, N.C.: Duke University Press, 1998.

Brown, Jayna. *Babylon Girls: African American Women Performers and the Modern Body.* Durham, N.C.: Duke University Press, 2007.

Brown, Sterling A. *The Collected Poems of Sterling A. Brown,* edited by Michael S. Harper. New York: Harper and Row, 1980.

———. *The Negro in American Fiction.* Washington, D.C.: Associates in Negro Folk Education, 1937.

———. *Negro Poetry and Drama.* 1937. Reprinted in *The Negro in American Poetry.* New York: Atheneum, 1969.

Brown, William Wells. *Clotel, or, the President's Daughter,* introduced by Hilton Als. Hilton. New York: Modern Library, 2000.

———. *Clotelle: or, the Colored Heroine.* 1867. Reprint, Miami: Mnemosyne, 1969.

———. *Narrative of William W. Brown, a Fugitive Slave, Written by Himself.* Boston: Anti-Slavery Office, 1848.

Bryson, Norman. *Looking at the Overlooked: Four Essays on Still Life Painting.* Cambridge, Mass.: Harvard University Press, 1990.

Butler, Judith. "'Lana's Imitation': Melodramatic Repetition and the Gender Performative." *Genders* 9 (fall 1990): 1–18.

Byrd, Pauline Flora. Letter to the editor. *Crisis* (March 1935): 42.

Byrd, Rudolph. *Jean Toomer's Years with Gurdjieff: Portrait of an Artist, 1923–1936.* Athens: University of Georgia Press, 1990.

Cameron, Dan, ed. *Dancing at the Louvre: Faith Ringgold's "French Collection" and Other Story Quilts.* Berkeley: University of California Press, 1998.

Carby, Hazel. *Race Men: W.E.B. Du Bois Lectures.* London: Oxford University Press, 1998.

Chesnutt, Charles. *The House Behind the Cedars.* 1900. Reprint, New York: Library of America, 2002.

———. *The Marrow of Tradition.* Boston: Houghton Mifflin, 1901.

Child, Lydia Maria. "The Quadroons." 1842. Reprinted in *Fact and Fiction.* New York: Francis, 1847.

Clarke, Graham. *The Photograph.* Oxford: Oxford University Press, 1997.

Cobb, Martha. *Harlem, Haiti, and Havana: A Comparative Critical Study of Langston Hughes, Jacques Roumain, and Nicolas Guillen.* Washington, D.C.: Three Continents, 1970.

Cohen, Lizabeth. "Encountering Mass Culture at the Grassroots: The Experience of Chicago Workers in the 1920s." In *Consumer Society in American History: A Reader,* edited by Lawrence Glickman, 147–69. Ithaca, N.Y.: Cornell University Press, 1999.

Cohen, Rachel. *A Chance Meeting: Intertwined Lives of American Writers and Artists, 1854–1967.* New York: Random House, 2005.

Cook, Mercer. "Imitation of Life in Paris." *Crisis* (June 1935): 182, 188.

Craft, William, and Ellen Craft. *Running a Thousand Miles for Freedom, or, The Escape of William and Ellen Craft from Slavery.* London: Tweedie, 1860.

Creekmur, Corey K. "Telling White Lies: Oscar Micheaux and Charles W. Chesnutt." In *Oscar Micheaux and His Circle: African American Filmmaking and the Race Cinema of the Silent Era,* edited by Pearl Bowser, Pearl, Louis Spence, Jane Gaines, and Charles Musser, 147–60. Bloomington: Indiana University Press, 2001.

Cripps, Thomas. *Slow Fade to Black: The Negro in American Film, 1900–1942.* New York: Oxford University, Press, 1977.

Cunard, Nancy. *Negro: An Anthology.* New York: Ungar, 1970.

Davis, Angela. *Blues Legacies and Black Feminism: Gertrude "Ma" Rainey, Bessie Smith, and Billie Holiday.* New York: Pantheon, 1998.

Davis, Thadious. *Nella Larsen: Novelist of the Harlem Renaissance: A Woman's Life Unveiled.* Baton Rouge: Louisiana State University Press, 1994.

"The Declaration and Confession of Esther Rodgers." In *English Literatures of America, 1500–1800,* edited by Myra Jehlen and Michael Warner, 404–7. New York: Routledge, 1997.

De Jongh, James. *Vicious Modernism: Black Harlem and the Literary Imagination.* Cambridge, England: Cambridge University Press, 1990.

Denning, Michael. *The Cultural Front: The Laboring of American Culture in Twentieth Century.* New York: Verso, 1996.

Derricotte, Toi. *The Black Notebooks.* New York: Norton, 1997.

Diawara, Manthia. *Black American Cinema.* New York: Routledge, 1993.

Dijkstra, Bram. *Idols of Peversity: Fantasies of Feminine Evil in Fin-de Siècle Culture.* New York: Oxford University Press, 1988.

Dimock, Wai Chee. "Debasing Exchange: Edith Wharton's *The House of Mirth.*" *PMLA* 100 (October 1985): 783–92.

Douglas, Ann. *Terrible Honesty: Mongrel Manhattan in the 1920s.* New York: Farrar, Straus, and Giroux, 1995.

Du Bois, W.E.B. "The Browsing Reader." *Crisis* 36 (July 1929): 248.

———. "Postscript: May Howard Jackson." *Crisis* 38 (October 1931): 351.

———. *The Souls of Black Folk.* 1903. New York: Knopf, 1993.

———. "Two Novels." *Crisis* 35 (June 1928): 202.

———. "Rhinelander." *Crisis* (January 1926): 112–13.

Dunbar, Paul Laurence. *The Collected Poetry of Paul Laurence Dunbar,* edited by Joanne Braxton. Charlottesville: University of Virginia Press, 1993.

Durham, Frank, ed. *Merrill Studies in "Cane."* Columbus, Ohio: Merrill, 1971.

Duval Harrison, Daphne. *Black Pearls: Blues Queens of the 1920's.* New Brunswick, N.J.: Rutgers University Press, 1988.

Ellison, Ralph. *Invisible Man.* New York: Vintage, 1989.

Everett, Anna. *Returning the Gaze: A Genealogy of Black Film Criticism, 1909–1949.* Durham: Duke University Press, 2001.

Fabre, Geneviève, and Michel Feith. *Jean Toomer and the Harlem Renaissance.* New Brunswick, N.J.: Rutgers University Press, 2001.

Fabre, Michel. *From Harlem to Paris: Black American Writers in France, 1840–1980.* Chicago: University of Illinois Press, 1991.

Fanon, Frantz. *Black Skin, White Masks.* New York: Grove, 1967.

Farrington, Lisa. *Creating Their Own Image: The History of African-American Women Artists.* New York: Oxford University Press, 2005.

———. *Faith Ringgold.* San Francisco: Pomegranate, 2004.

Fauset, Jessie Redmon. *The Chinaberry Tree.* 1931. Reprint, introduced by Thadious Davis. New York: Simon and Schuster, 1997.

———. *Comedy American Style.* 1933. New York: Negro Universities Press, 1969.

———. "Double Trouble." *Crisis* 26 (August–September 1923): 155–59, 205–309.

———. *Plum Bun: A Novel without a Moral.* 1928. Reprint, introduced by Deborah McDowell. Boston: Beacon, 1990.

———. *There Is Confusion.* New York: Boni and Liveright, 1924.

———. "Yarrow Revisited." *Crisis* 29 (January 1925): 107–9.

Favor, J. Martin. *Authentic Blackness: The Folk in the New Negro Renaissance.* Durham, N.C.: Duke University Press, 1999.

Fusco, Coco. *English Is Broken Here: Notes on Cultural Fusion in the Americas.* New York: New Press, 1995.

Gaines, Jane. *Fire and Desire: Mixed-Race Movies in the Silent Film Era.* Chicago: University of Chicago Press, 2001.

Gates, Henry Louis, Jr. "Review of Toni Morrison's *Jazz.*" In *Toni Morrison: Critical Perspectives Past and Present,* edited by Henry Louis Gates, Jr., and Kwame Anthony Appiah. New York: Amistad, 1993.

———. "The Trope of a New Negro and the Reconstruction of the Image of the Black." *Representations* 24 (fall 1988): 129–55.

Gates, Henry Louis, Jr., and Karen Dalton. *Josephine Baker and "La Revue Negre": Paul Colin's Lithographs of Le Tumulte Noir in Paris, 1927*. New York: Abrams, 1998.

Glickman, Lawrence B., ed. *Consumer Society in American History: A Reader*. New York: Cornell University Press, 1999.

Green, J. Ronald. *With a Crooked Stick—The Films of Oscar Micheaux*. Bloomington: Indiana University Press, 2004.

Graham, Ottie B. "Holiday." *Crisis* 26 (May 1923): 12.

Greenberg, Cheryl. "Don't Buy Where You Can't Work." In *Consumer Society in American History: A Reader*, edited by Lawrence Glickman, 241–76. Ithaca, N.Y.: Cornell University Press, 1999.

Griffin, Farah. *"Who set you flowin?": The African American Migration Narrative*. New York: Oxford University Press, 1995.

Grimké, Angelina Weld. *Appeal to the Christian Women of the South*. 1836. Reprint, New York: Arno, 1969.

Harper, Frances Watkins. *Iola Leroy, or Shadows Uplifted*. 1892. Boston: Beacon, 1987.

Hartsock, Nancy. *Money, Sex, and Power: Toward a Feminist Historical Materialism*. Boston: Northeastern University Press, 1983.

Henderson, Stephen. *Understanding the New Black Poetry: Black Speech and Black Music as Poetic References*. New York: William Morrow and Company, 1973.

H.L.M. "Tragedy: Fauset Style." *Amsterdam News*, December 6, 1933, p. 6.

Holmes, Eugene. "Jean Toomer—Apostle of Beauty." In *Merrill Studies in "Cane,"* edited by Frank Durham, 45–50. Columbus, Ohio: Merrill, 1971.

Honey, Maureen, and Venetria Patton, eds. *Double-Take: A Revisionist Harlem Renaissance Anthology*. New Brunswick, N.J.: Rutgers University Press, 2001.

Honour, Hugh. *The Image of the Black in Western Art*. Volume 4, *From the American Revolution to WWI*. Cambridge, Mass.: Harvard University Press, 1976.

hooks, bell. *Reel to Real: Race, Sex, and Class at the Movies*. New York: Routledge, 1996.

———. "A Revolution of Values: The Promise of Multicultural Change." In *The Cultural Studies Reader*, 2d ed., edited by Simon During 233–40. New York: Routledge, 1999.

Hopkins, Pauline. *Contending Forces: A Romance Illustrative of Negro Life North and South*. 1900. Reprint, New York: Oxford University Press, 1988.

———. *The Magazine Novels of Pauline Hopkins*. New York: Oxford, 1988.

———. "Talma Gordon." In *Spooks, Spies, and Private Eyes: Black Mystery, Crime, and Suspense Fiction*, edited by Paula L. Woods. New York: Doubleday, 1995.

Hughes, Langston. *The Big Sea: An Autobiography*. New York: Hill and Wang, 1940.

———. *The Collected Poems of Langston Hughes*, edited by Arnold Rampersad and David Roessel. New York: Knopf, 1994.

———. "The Negro Artist and the Racial Mountain." *Nation*, June 28, 1926, pp. 692–94.

Huggins, Nathan. *Harlem Renaissance*. New York: Oxford University, 1971.

Hull, Gloria T. *Color, Sex, and Poetry: Three Women Writers of the Harlem Renaissance*. Bloomington: Indiana University Press, 1987.

———. *Give Us Each Day: The Diary of Alice Dunbar Nelson*. New York: Norton, 1984.

Hurst, Fannie. *Imitation of Life*. New York: Harper Brothers, 1933.

Hurston, Zora Neale. *Color Struck!* 1925. Reprinted in *Fire!* (1926): 7–14.

———. *Mules and Men*, introduced by Franz Boas, illustrated by Miguel Covarrubias. Philadelphia: Lippincott, 1935.

———. *Their Eyes Were Watching God.* 1937. Reprint, New York: Harper and Row, 1990.

Hutchinson, George. *The Harlem Renaissance in Black and White.* London: Belknap, 1995.

Jackson, Fay. "Fredi Washington Strikes a New Note." *Pittsburgh Courier*, December 15, 1934, p. 8.

James, C.L.R. *Mariners, Renegades, and Castaways: The Story of Herman Melville and the World We Live In.* New York: C.L.R. James, 1953.

Johnson, Barbara. *The Feminist Difference: Literature, Psychoanalysis, Race, and Gender.* Cambridge, Mass.: Harvard University Press, 1998.

Johnson, James Weldon. *The Autobiography of an Ex-Colored Man.* 1912. Reprint, introduced by William Andrews. New York: Penguin, 1990.

———. *Black Manhattan.* New York: Arno, 1968.

Jones, Gayl. *Corregidora.* Boston: Beacon, 1986.

Kassanoff, Jennie. "Extinction, Taxidermy, Tableaux Vivants: Staging Race and Class in *The House of Mirth.*" *PMLA* 115 (January 2000): 60–74.

Kennedy, Adrienne. *Funnyhouse of a Negro: A Play in One Act.* New York: French, 1969.

Kerman, Cynthia, and Richard Elridge. *The Lives of Jean Toomer: A Hunger for Wholeness.* Baton Rouge: Louisiana State University Press, 1987.

Kern-Foxworth, Marilyn. *Aunt Jemima, Uncle Ben, and Rastus: Black in Advertising, Yesterday, Today and Tomorrow*, foreword by Alex Haley. Westport, Conn: Greenwood, 1994.

Kirsche, Amy Helene. *Aaron Douglas: Art, Race, and the Harlem Renaissance.* Jackson: University Press of Mississippi, 1995.

Kracauer, Siegfried. "The Little Shopgirls Go to the Movies." In *The Mass Ornament: Weimar Essays,* translated, edited, and introduced by Thomas Y. Levin, 291–304. Cambridge, Mass.: Harvard University Press, 1995.

Kramer, Victor, and Robert A. Russ. *The Harlem Renaissance Re-Examined: A Revised and Expanded Edition.* Troy, N.Y.: Whitson, 1996.

Kutzinksi, Vera. *Sugar's Secrets: Race and the Erotics of Cuban Nationalism.* Charlottesville: University of Virginia Press, 1993.

Larsen, Nella. *"Quicksand" and "Passing."* 1929. Reprint, introduced by Deborah McDowell. New Brunswick, N.J.: Rutgers University Press, 1996.

Larson, Charles. *Invisible Darkness: Jean Toomer and Nella Larsen.* Iowa City: University of Iowa Press, 1993.

Lee, Robert. *Orientals: Asian Americans in Popular Culture.* Philadelphia: Temple University Press, 1999.

Le Fanu, J. Sheridan. "Carmilla." 1872. In *The Penguin Book of Vampire Stories,* edited by Alan Ryan, 71–137. New York: Penguin, 1987.

Leininger-Miller, Theresa. *New Negro Artists in Paris: African American Painters and Sculptors in the City of Light, 1922–1934.* New Brunswick, N.J.: Rutgers University Press, 2001.

Lempke, Siglinde. *Primitivist Modernism.* New York: Oxford University Press, 1998.

Lewis, David Levering. *The Portable Harlem Renaissance Reader.* New York: Penguin, 1994.

———. *When Harlem Was in Vogue.* New York: Penguin, 1997.

———. *W.E.B. Du Bois—Biography of a Race, 1868–1919.* New York: Holt, 1993.

———. *W.E.B. Du Bois—The Fight for Equality and the American Century, 1919–1963.* New York: Holt, 2001.

Lewis, Earl, and Heidi Ardizzone. *Love on Trial: An American Scandal in Black and White.* New York: Norton, 2001.

Locke, Alain. *The Negro in Art: A Pictorial Record of the Negro Artist and of the Negro Theme in Art.* 1940. Reprint, New York: Hacker, 1979.

———. *The New Negro: An Interpretation.* New York: Albert and Boni, 1925.

———. "1928: A Retrospective Review." *Opportunity* 7 (January 1929): 9.

Lorde, Audre. *Sister Outsider: Essays and Speeches.* Trumansberg, N.Y.: Crossing Press, 1984.

Lott, Eric. *Love and Theft: Blackface Minstrelsy and the American Working Class.* New York: Oxford University Press, 1993.

Lupack, Barbara Tepa. *Literary Adaptations in Black American Cinema: From Micheaux to Morrison.* New York: University of Rochester Press, 2002.

Madigan, Mark. "'Then Everything Was Dark?' The Two Endings of Nella Larsen's *Passing.*" *Papers of the Bibliographical Society of America* 83, no. 4: 521–23.

Maxwell, William J. *New Negro, Old Left: African-American Writing and Communism between the Wars.* New York: Columbia University Press, 1999.

McHenry, Elizabeth. *Forgotten Readers: Recovering the Lost History of African American Literary Societies.* Durham, N.C.: Duke University Press, 2002.

McDowell, Deborah. *"The Changing Same": Black Women's Literature, Criticism, and Theory.* Bloomington: Indiana University Press, 1995.

———"Harlem Nocturne." *Women's Review of Books* 9 (June 1992): 1–5.

McGrath, Ann. "White Brides: Images of Marriage across Colonizing Boundaries." *Frontiers* 23, no. 3 (2002): 76–108.

McKay, Claude. *Home to Harlem.* New York: Harper, 1928.

———. *A Long Way from Home.* New York: Furman, 1937.

McKay, Nellie. *Jean Toomer, Artist: A Study of His Literary Life and Work, 1894–1936.* Chapel Hill: University of North Carolina Press, 1984.

Melville, Herman. *"Bartleby" and "Benito Cereno."* 1856. Reprint, New York: Dover Publications, 1990.

———. *The Shorter Novels of Herman Melville,* edited by Raymond Weaver. New York: Fawcett, 1928.

Miller, Nina. *Making Love Modern: The Intimate Public Worlds of New York's Literary Women.* New York: Oxford University Press, 1999.

Morrison, Toni. *The Bluest Eye.* 1970. Reprint, New York: Plume, 1994.

———. *Jazz.* New York: Knopf, 1992.

Mulvey, Laura. *Visual and Other Pleasures.* Bloomington: Indiana University Press, 1989.

Nadell, Martha Jane. *Enter the New Negroes: Images of Race in American Culture.* Cambridge, Mass.: Harvard University Press, 2004.

———. "Race and the Visual Arts in the Works of Jean Toomer and Georgia O'Keeffe." In *Jean Toomer and the Harlem Renaissance,* edited by Geneviève Fabre and Michel Feith, 142–61. New Brunswick, N.J.: Rutgers University Press, 2001.

Naylor, Gloria. *Linden Hills.* New York: Penguin, 1986.

"The Negro in Art: How Shall He Be Portrayed? A Symposium." *Crisis* (February–November 1926).

Nelson, Cary. *Repression and Recovery: Modern American Poetry and the Politics of Cultural Memory, 1910–1945.* Madison: University of Wisconsin Press, 1989.

Nelson, Dana. *"The Word in Black and White: Reading "Race" in American Literature, 1638–1867.* New York: Oxford University Press, 1992.

North, Michael. *The Dialect of Modernism: Race, Language and Twentieth-Century Literature.* New York: Oxford University Press, 1994.

Patton, Sharon. *African American Art*. Oxford History of Art Series. London: Oxford University Press, 1998.

Porter, James. *Modern Negro Art*. Washington, D.C.: Howard University Press, 1992.

Powell, Richard. *Homecoming: The Art and Life of William H. Johnson*, introduced by Martin Puryear. New York: Rizzoli, 1991.

———. "Re/Birth of a Nation." In *Rhapsodies in Black: Art of the Harlem Renaissance*, edited by Richard Powell and David Bailey, 14–33. Berkeley: University of California Press, 1997.

Raimon, Eva Allegra. *The "Tragic Mulatta" Revisited: Race and Nationalism in Nineteenth-Century Antislavery Fiction*. New Brunswick, N.J.: Rutgers University Press, 2004.

Reff, Theodore. *Manet: Olympia*. New York: Viking, 1973.

Reynolds, Gary, and Beryl Wright. *Against the Odds: African American Artists and the Harmon Foundation*. Newark, N.J.: Newark Museum, 1989.

Robinson, Amy. "It Takes One to Know One: Passing and Communities of Common Interest." *Critical Inquiry* 20 (summer 1994): 715–36.

Robinson, Jontyle, and Wendy Greenhouse. *The Art of Archibald Motley, Jr*. Chicago: Chicago Historical Society, 1991.

Roses, Lorraine, and Elizabeth Randolph. *Harlem Renaissance and Beyond: Literary Biographies of 100 Black Women Writers. 1900–1945*. Boston: Hall, 1990.

Rusch, Frederik, ed. *A Jean Toomer Reader: Selected Unpublished Writings*. New York: Oxford University Press, 1993.

Said, Edward. *Orientalism*. New York: Vintage, 1979.

Sánchez-Eppler, Karen. *Touching Liberty: Abolition, Feminism, and the Politics of the Body*. Berkeley: University of California Press, 1997.

Sanders, Mark. *Afro-Modernist Aesthetics and the Poetry of Sterling A. Brown*. Athens: University of Georgia Press, 1999.

Schneider, Rebecca. *The Explicit Body in Performance*. London: Routledge, 1997.

Schuyler, George. *Black No More: Being an Account of the Strange and Wonderful Workings of Science in the Land of the Free, A.D. 1933–1940*. 1931. Reprint, College Park, Md.: McGrath, 1969.

———. "Negro Art Hokum." *Nation*, June 16, 1926, pp. 662–63.

Scruggs, Charles. "The Photographic Print, the Literary Negative: Alfred Stieglitz and Jean Toomer." *Arizona Quarterly* 53 (spring 1997): 61–89.

Scruggs, Charles, and Lee Van Demarr. *Jean Toomer and the Terrors of American History*. Philadelphia: University of Pennsylvania Press, 1998.

Seabrook, W. B. "Touch of the Tar-Brush." *Saturday Review of Literature*, 18 May 1929, p. 1017.

Senna, Danzy. *Caucasia*. New York: Riverhead, 1998.

Sherrard-Johnson, Cherene. "Delicate Boundaries: Passing and Other Crossing in Fictionalized Slave Narratives." In *A Companion to American Fiction, 1780–1865*, edited by Shirley Samuels, 204–15. Oxford: Blackwell, 2004.

Sollors, Werner. *Neither Black Nor White Yet Both: Thematic Explorations of Interracial Literature*. New York: New York University Press, 1997.

Somerville, Siobhan. "Passing through the Closet in *Contending Forces*." *American Literature* 69 (March 1997): 139–66.

Smith, Adah, with James Haskins. *Bricktop*. New York: Atheneum, 1983.

Smith, Valerie. "Reading the Intersection of Race and Gender in Narratives of Passing." In *Not Just Race, Not Just Gender: Black Feminist Readings*. New York: Routledge, 1998.

Spillers, Hortense. *Black, White, and In Color: Essays on American Literature and Culture.* Chicago: University of Chicago Press, 2003.

Sprinker, Michael. *Imaginary Relations: Aesthetics and Ideology in the Theory of Historical Materialism.* London: Verso, 1987.

Stange, Margit. *Personal Property: Wives, White Slaves, and the Market in Women.* Baltimore: John Hopkins University Press, 1998.

Stavney, Anne. "'Mothers of Tomorrow': The New Negro Renaissance and the Politics of Maternal Representation." *African American* Review 32, no. 4 (1998): 533–61.

Stein, Gertrude. *The Autobiography of Alice B. Toklas.* New York: Vintage, 1990.

———. *Melanctha.* New York: Grafton, 1909.

Stewart, Jacqueline. "Negroes Laughing at Themselves? Black Spectatorship and the Performance of Urban Modernity." *Critical Inquiry* 29 (summer 2003): 650–77.

Stovall, Tyler. *Paris Noir: African Americans in the City of Light.* New York: Houghton Mifflin, 1996.

Stowe, Harriet Beecher. *Uncle Tom's Cabin, or, Life among the Lowly.* Boston: Jewett, 1852.

Stribling, T. S. *Mulatto: A Tragedy of the Deep South.* 1932.

Sylvander, Carolyn Wedin. *Jessie Redmon Fauset, Black American Writer.* New York: Whitson, 1981.

Taylor, Ula Yvette. *The Veiled Garvey: The Life and Times of Amy Jacques Garvey.* Chapel Hill: University of North Carolina Press, 2002.

Thurman, Wallace. *The Blacker the Berry . . . A Novel of Negro Life.* 1929. Reprint, New York: Collier, 1970.

Todd, Ellen Wiley. *The "New Woman" Revised: Painting and Gender Politics on Fourteenth Street.* Berkeley: University of California Press, 1993.

Tomlinson, Susan. "Vision to Visionary: The New Negro Woman As Cultural Worker in Jessie Redmon Fauset's *Plum Bun.*" *Legacy* 19, no. 1 (2002): 90–97.

Toomer, Jean. *Cane.* New York: Boni and Liveright, 1923.

———. *Essentials,* edited by Rudolph Byrd. Athens, Ga.: Hill Street Press, 1999.

———. "Karintha." *Broom* 4 (January 1922).

———. "The Negro Emergent." In *A Jean Toomer Reader: Selected Unpublished Writings,* edited by Frederick L. Rusch, 86–93. New York: Oxford University Press, 1993.

———. "Race Problems and Modern Society." 1929. In *The Uncollected Works of American Author Jean Toomer, 1894–1967,* edited by John Chandler Griffin, 148–170. New York: Mellen, 2003.

———. "Song of the Son." *Crisis* 23 (April 1922): 261.

———. *The Wayward and the Seeking: A Collection of Writings by Jean Toomer,* edited by Darwin Turner. Washington, D.C.: Howard University Press, 1980.

Torgovnick, Marianna. *Gone Primitive: Savage Intellects, Modern Lives.* Chicago: University of Chicago Press, 1990.

Trethewey, Natasha. *Domestic Work.* St. Paul, Minn.: Graywolf, 2000.

Turner, Darwin. *In a Minor Chord: Three Afro-American Writers and Their Search for Identity.* Carbondale: Southern Illinois University Press, 1971.

Turner, Robin. *Faith Ringgold.* Boston: Little, Brown, 1993.

Turner, Steve, and Victoria Dailey. *William H. Johnson: Truth Be Told.* Los Angeles: Seven Arts, 1998.

Van Der Zee, James, Owen Dodson, and Camille Billops. *The Harlem Book of the Dead,* foreword by Toni Morrison. New York: Morgan and Morgan, 1978.

Veblen, Thorstein. *The Theory of the Leisure Class.* New York: Huebsch, 1924.

Walker, Alice. *The Color Purple.* New York: Pocket Books, 1985.

Walker, Kara. *Kara Walker: Narratives of a Negress,* edited by Ian Berry et al. Cambridge, Mass.: MIT Press, 2003.

Wall, Cheryl. *Women of the Harlem Renaissance.* Bloomington: Indiana University Press, 1995.

Wallace-Sanders, Kimberly, ed. *Skin Deep and Spirit Strong: The Black Female Body in American Culture.* Ann Arbor: University of Michigan Press, 2002.

Walrond, Eric. *Tropic Death.* New York: Boni and Liveright, 1926.

Washington, Mary Helen. *Invented Lives: Narrative of Black Women, 1860–1960.* New York: Anchor, 1987.

Wells, Ida B. *The Memphis Diary of Ida B. Wells,* edited by Miriam DeCosta-Willis. Boston: Beacon, 1995.

Wharton, Edith. *The House of Mirth.* 1905. Reprint, New York: Signet, 2000.

White, Walter. *Flight.* New York: Negro Universities Press, 1926.

Wideman, John Edgar. *Damballah.* Boston: Houghton Mifflin, 1998.

Wiegman, Robyn. *American Anatomies: Theorizing Race and Gender.* Durham, N.C.: Duke University Press, 1992.

Williams, Brett. "The South in the City." *Journal of Popular Culture* 16 (winter 1982): 30–41.

Williams, Raymond. *The Politics of Modernism: Against the New Conformists,* introduced by Tony Pinkney. New York: Verso, 1989.

Willis, Deborah. *Reflections in Black: A History of Black Photographers, 1840 to the Present.* New York: Norton, 2000.

Willis, Deborah, and Carla Williams. *The Black Female Body: A Photographic History.* Philadelphia: Temple University Press, 2002

Wilson, Judith. "Getting Down to Get Over: Romare Bearden's Use of Pornography and the Problem of the Black Female Body in Afro-U.S. Art." In *Black Popular Culture: A Project by Michele Wallace,* edited by Gina Dent and Michele Wallace, 112–22. Seattle: Bay Press, 1992.

Woodall, Elaine. " Archibald J. Motley, Jr.: American Artist of the Afro-American People, 1891–1928" Master's thesis. Pennsylvania State University, 1977.

Woodson, Jon. *To Make a New Race: Gurdjieff, Toomer, and the Harlem Renaissance.* Jackson: University of Mississippi Press, 1999.

Zackodnik, Teresa. *The Mulatta and the Politics of Race.* Jackson: University of Mississippi Press, 2004.

Index

Abyssinian Baptist Church, 87
acculturation, 166
activism, 51, 76
Adams, John Henry, 26
Adam's Belle (Powell), 88
African American art/artists, 74, 132, 141
African American colleges, 28
African American community, 102. *See also under* black
African American modernism, 52
African American novel traditions, 116–117
Afro-modernism, xviii, xx, 52, 108–109, 111, 121, 132, 141–142. *See also* modernism
Alexander, Elizabeth, 143
Aline, an Octoroon (Motley), 29, 31, 41, 42
Aline, the Mulatress (Delacroix), 28, 30, 31
Als, Hilton, 37
American Collection (Ringgold), 144–145, 158, 159
American identity, 121, 140
Ammons, Elizabeth, 60
Amsterdam News (newspaper), 52
Anderson, Sherwood, 111
antebellum culture, 5, 18
Art Institute of Chicago, xiii
artists, 50, 73–75, 76, 132, 141, 156. *See also specific artists*
assimilation, 132, 166
audience, 97, 105. *See also* gaze
Austen, Jane, 72

The Autobiography of an Ex-Colored Man (Johnson), 10, 66, 161–162, 178n39
"Avey" (Toomer), 133, 134

Baartman, Saartje, 152
Baker, Houston, Jr., 52, 132
Baker, Josephine, 33, 96, 152, 153
Baldwin, James, 147
Ball, J. P., 6
Barrie, Dennis, 40
beauty, 48, 79, 94, 135, 154
Beavers, Louise, 97, 98
Behind the Scenes: Thirty Years a Slave, and Four Years in the White House (Keckley), 165
"Benito Cereno" (Melville), 119, 133
Berlant, Lauren, 99
Billingslea-Brown, Alma, 147
biracial identity, 7, 17, 19, 144, 146. *See also* mixed-race icons; mulatta
birth, 130–131, 139, 162
Birth of a Nation (film), 78, 80, 81
Birthright (Stribling), 145
Bishop, Isabel, 49
Black, White and in Color (Spillers), xx
Black American Cinema (Diawara), 80
"Black and Tan Fantasy" (Ellington), 96
black artistic community, 132
black audiences, 97
black bourgeois, 68. *See also* elite
black community, 72, 84, 102, 134

Black Cross, 15
black culture, 110, 117, 132, 141–142, 146, 163
black family, 137
black feminist studies, 17
black folk culture, 132, 140, 141, 142
black manhood, 78
black modernist tradition, 52, 78, 133
The Black Notebooks (Derricotte), 166
black publications, 53, 81, 96, 118. See also
 Crisis; Messenger; Opportunity
Black Salome (Walker), 87
black women, 54, 72, 84–85, 96, 97, 118–119,
 123, 141, 162; feminine ideal and, 24, 28,
 32, 79, 91, 93, 103, 168; mulatta icon
 and, 158; sexualization and, 122, 148
"Blood Burning Moon" (Toomer),
 119–120, 128, 131, 140
Blue Lilies (Monet), 156
Blues (Motley), 21
Boas, Frank, 74
Bogle, Donald, 94
Bone, Robert, 122, 125
bourgeois, 68, 132, 137
boycotts, 70
Broom (periodical), 132
Brown, Jayna, 103, 104, 170n3
Brown, Sterling, 14, 135
Brown, William Wells, 3–4, 7, 37
Brown Girl After the Bath (Motley), 148,
 149, 153
Brown Madonna (Reiss), 25, 37, 122
Byrd, Pauline Flora, 98

"Cabaret" (Brown), 135
Cabin in the Sky (film), 91
Les Café des Artistes (Ringgold), 156, 158
The Café (Johnson), 137, 138
Cane (Toomer), xviii, 19–20, 97, 107–110,
 116, 124, 132, 139, 141–143, 160–162;
 division in, 136, 164; economy and, 117,
 134; Johnson and, 112; miscegenation
 in, 130; misrecognition in, 119; sexual
 language in, 122; urban landscape and,
 137; visuality in, 125, 159, 184n20;
 women in, 120, 128, 129, 131, 140
capitalism, 70, 71, 130–131, 132, 141
Carby, Hazel, xix, 10, 18, 49

"Carmilla" (Le Fanu), 42
Caucasia (Senna), 166
A Chance Meeting: Intertwined Lives of
 American Writers and Artists (Cohen),
 xvii
Chesnutt, Charles, 6, 48, 80, 84, 85, 86,
 105, 171n23; Micheaux and, 180n18
The Chinaberry Tree (Fauset), 10, 57, 90
cinema, 80, 82, 93, 96, 100
citizenship, 167
class, 12, 13, 47, 48, 60, 61, 140, xvi;
 aesthetics and, 105, 137; divisions of,
 13, 81, 134, 135; identity and, 53, 168;
 position in, 71, 131, 136, 161. See also
 status
Clotel, or, the President's Daughter (Brown),
 3–5, 37
Clotelle: or, the Colored Heroine (Brown),
 4–5
Cohen, Lizabeth, 70
Cohen, Rachel, xvii
Colescott, Robert, 146
Colin, Paul, 152, 153
colonialism, 141
Color, Sex, and Poetry (Hull), 17
Colored Players Production Company, 96
colorism, 48, 131, 134
color line, 132, 141
Comedy American Style (Fauset), 10, 52, 73,
 82, 90, 177n23, 179n13, 182n59
community, 47, 72, 84, 102, 134
complexion, 54, 64
The Conjure Woman (Chesnutt), 84
consumerism, 68, 70, 78
Contending Forces (Hopkins), 5, 6, 85,
 170n13
Cook, Mercer, 97, 98
Cooper Union, 63
Copenhagen, 27
Crane, Helga (Quicksand), 12, 22, 24–25,
 27–28, 31–32, 44, 47, 61, 129, 153; color
 and, 134; future and, 35; Naxos and,
 172n7; painting of, 33; productivity
 and, 45; sexualization of, 34, 35, 39, 155.
 See also Larsen, Quicksand
Crisis (periodical), xiii, xix, 25, 36, 54–55,
 57, 60, 73, 97–98, 123; Du Bois, and,

177n18; images in, 16; literary editor of, 51; passing narratives in, 10
Cuban nationalism, 39
culture, 18, 50, 130, 136, 140, 141, 166, 167, 183n6

Dancing at the Louvre (Ringgold), 145, 188n33
La Danse (Matisse), 150
Danse Savage (Baker), 87, 96
Davis, Thadious, 17, 24
Dejeuner sue l'herbe (Manet), 156
Delacroix, Eugène, xvii, 28, 30
Les Demoiselles d'Alabama (Colescott), 146
Les Demoiselles d'Avignon (Picasso), 151, 152, 154
Denmark, 32
Derricotte, Toi, 166
Dial (periodical), 132
Diawara, Manthia, 80
Didier, Roger, 122
Dijsktra, Bram, 87
Dimock, Wai Chee, 68, 71
Dinner at Gertrude Stein's (Ringgold), 158
discrimination, 19, 71, 98, 100, 102, 119–120, 136, 140–141, 165–167
"Don't buy" campaign, 70
"Double Trouble" (Fauset), 55, 57
Douglas, Ann, 51
Du Bois, W.E.B., 36–37, 47, 75, 82, 90, 121–122, 141, 166, 177n18
Dumas, Alexandre, 165
Dunbar, Paul Laurence, 124
Dunbar-Nelson, Alice, 17, 60
Dunn, Blanche, 44, 46

Easterly, Thomas, 7, 8
Eat dem Taters (Colescott), 146
economy, 52, 68, 70–71, 72, 75, 78, 130–132, 141
education. *See specific schools*
Eliot, T. S., 117
Ellington, Duke, 87, 96
Ellis, Trey, 166
Ellison, Ralph, 12, 141
English Is Broken Here (Fusco), 143
Enlightenment, 146

Enter the New Negroes (Nadell), 19
eroticism, 50, 71, 76, 92–93, 130, 144. *See also* fetishism
Essentials (Toomer), 142
Ethical Cultural Society, 74
European American modernism, 108
Evening Graphic (newspaper), 90
exoticism, 152. *See also* primitivism
expressionism, 137

Fabre, Michel, 73
Le Fanu, J. Sheridan, 42, 44
Fauset, Jessie, xviii, 10, 14, 17–20, 50, 52, 79, 82, 89, 98; advertisement for *Plum Bun*, 56; articles in *Crisis*, 73; on colonialism, 73; *Comedy American Style* and, 177n23; comparison with Larsen, 108; correspondence of, 158, 181n38; critics of, 51, 52, 77, 78; differences in, 91; film and, 90; Fourteenth Street and, 63; misinterpretation of, 177n13; misperceptions on bourgeois ideals and, 145; New Negro movement and, 75; private life of, 60, 176n4; protagonists and, 153–154; race and, 49, 92, 144; Ringgold and, 158; women and, 57, 72, 105, 176n10
Favor, J. Martin, 17
femininity, 55, 137, 161–162
feminism, 15, 17, 105
fetishism, 15, 37, 79, 87, 111. *See also* eroticism; mulatta/o iconography
films, 78–79, 80, 90–91, 93, 96, 98, 100–101, 104. *See also specific films*
Fisk College, 28
Fitzgerald, F. Scott, 68
flapper, 137
Flatiron Building, 133
Flight (White), 10
"Flounder" (Trethewey), 166
Folies-Bergère (film), 33
folk culture, 110, 111, 122, 131, 141. *See also* black folk culture
Fontainebleau School, 74, 75, 101
Forsyne, Ida, 104
Fourteenth Street, 54, 61, 105
Fourteenth Street School, 49, 53, 63, 68

France, 98
Frank, Waldo, 107, 117
"Fredi Washington Strikes a New Note"
 (Jackson), 77, 98
free love, 50, 71, 76
Freeman, Daniel, 6
French Collection (Ringgold), xviii, 20,
 143–144, 147, 150, 157–158, 165
Freud, Sigmund, 36
The Frugal Repast (Picasso), 137
Fuller, Meta Vaux Warwick, 73
Funnyhouse of a Negro (Kennedy), 167
Fusco, Coco, 143, 145–146, 153, 156

Gaines, Jane, 81, 82
Garvey, Marcus, 15
Gauguin, Paul, 32
gaze, 39, 48, 63, 76, 87, 97, 161; gendered
 aspects of, 13, 128, 133, 135, 148; spectators
 and, 13, 36, 100, 144
gender, xv, 47, 61, 69, 71, 77, 105, 135–136;
 boundaries of, 12, 13; gaze and, 13, 36,
 128, 133, 135, 148; identity and, 22, 53,
 132, 140, 168
The Girl from Chicago (film), 84
Girl in a Green Dress, Portrait Study, No. 16
 (Johnson), 123, 125, 126–127, 128,
 141–142
God's Step Children (film), 84, 86, 87, 88,
 101, 135–136, 180n31
Gold Diggers of 1933 (film), 88
Goodridge, Glenalvin J., 7
gothic genre, 44
La Grande Odalisque (Ingres), 152
Great Migration, 132
Greenwich Village, 50, 53, 54
Grigsby, Darcy Grimaldo, 28
Gurdjieff, George, 109

Hals, Frans, 28
Harlem, 7, 53
The Harlem Book of the Dead (Van Der
 Zee), 159
Harlem community, 96
Harlem elite, 44, 81
"Harlem on My Mind" (Van Der Zee), 16
Harlem Renaissance aesthetics, 75, 107, 118

Harlem Renaissance community, 112
Harlem Renaissance (Huggins), 17
The Harlem Renaissance Reader (Lewis),
 170n15
Harlem Renaissance society, 38
Harmon Foundation, 57, 110
Harper, Frances, xix, 37, 55
Hawthorne, Charles, 111, 112
Hemingway, Ernest, 117, 147, 158
Henderson, Stephen, 81
heritage, 4, 38, 50, 110, 111, 116, 126, 130,
 139, 142
heroines. *See specific characters and works*
The Hidden Self (Hopkins), 6
Holmes, Eugene, 118
Home to Harlem (McKay), 145
hooks, bell, 79, 94, 152–153, 167, 181n52,
 182n56
Hooper, M., 60
Hopkins, Pauline, 5–7, 37, 55, 80, 85,
 170n13
Horne, Lena, 124
Hottentot Venus, 152, 153
The House Behind the Cedars (Chesnutt),
 84, 89, 105, 171n23
The House of Mirth (Wharton), 68, 71
Howard, Louise, 83
Howard Theater, 134
Huggins, Nathan, 17
Hughes, Henry, 86
Hughes, Langston, 10, 16–17, 50, 51, 74,
 77, 90, 181n38
Hull, Gloria, 17
Hurst, Fannie, 10, 77, 92, 94, 99
Hurston, Zora Neale, 13–15, 17, 147

iconography, 22, 24, 42, 53, 78, 83, 125,
 140, 162, 169n6. *See also* mulatta
 iconography
identity, xv, 49, 53, 121, 132, 140, 168; biracial,
 7, 17, 19, 144, 166; gender and, 22, 53, 132,
 140, 168; racial, 53, 92, 109–110, 111, 168
ideological assumptions, 61
Imitation of Life (Hurst novel and film),
 10, 77–81, 88, 91, 94, 96–99, 101, 102,
 104, 153, 166, 173n14; race and gender
 in, 181n48

"Imitation of Life in Paris" (Cook), 97
immorality, 85–86, 104, 119, 128–131,
 135–136, 139
incest, 86, 89
infanticide, 130–131
In Fourteenth Street (Marsh), 61–62
Ingres, Jean Auguste Dominique, 123, 152
In Passing (Miller), 64
integration, 136. *See also* race
interracial desire, 119. *See also* miscegenation
interracial discrimination, 136
interracial division, 135
interracial sex, 130. *See also* miscegenation
intersectional politics, 91
Intruder in the Dust (film), 90
Invisible Man (Ellison), 12, 141
Iola Leroy (Harper), 37
Irene (*Passing*), 39–42, 44, 47. *See also*
 Larsen; *Passing*

Jackman, Harold, 44
Jackson, Fay, 77, 98–99, 100
Jackson, May Howard, 75
Jacques, Amy, 15
Jazz (Morrison), 20, 143, 159–160, 162,
 164–165, 165
Jean Toomer, Artist (McKay), 110
Jezebel, 25, 27, 35, 42, 89, 168. *See also*
 iconography
Jim Crow laws, 10, 80
Jo Baker's Birthday (Ringgold), 152
Johnson, Charles, 55, 108, 109
Johnson, Georgia Douglas, xviii, 17, 132
Johnson, James Weldon, 10, 66, 161–162,
 178n39, 183nn9, 16. *See also specific
 works*
Johnson, Sargent, 110
Johnson, William H., xvii, 20, 107,
 110–111, 113–115, 122–127, 131, 137–138,
 141; Toomer and, 132, 142. *See also
 specific works*
Jones, Lois Mailou, 110
"The Josephine Baker Museum" (Alexan-
 der), 143

Karenga, Maulana, 147
Kassanoff, Jennie, 63, 69

Keckley, Elizabeth, 165
Kemp, Arthur, 70
Kendry, Clare (*Quicksand*), 36–38, 40, 42,
 44, 47, 129, 167; death of, 39, 45, 47;
 description of, 39, 161; womanhood
 and, 38, 155. *See also* Larsen; *Quicksand*
Kennedy, Adrienne, 167
Kracauer, Siegfried, 77

Larsen, Nella, xviii, 10, 14, 16–17, 19–22,
 24–25, 27–28, 31, 38–41, 45, 80; class
 status of, 60; Colin and, 33; Fauset and,
 108; gaze and, 48; Guggenheim fellow-
 ship and, xvii; heroines and, 32, 145;
 modernism and, 172n5; motherhood
 and, 155; objectification and empower-
 ment, 153; Orientalism and, 24, 31, 44;
 race and, 35, 49, 92, 144; Ringgold and,
 147, 158; writing and, 36, 47, 146. *See
 also Passing*; *Quicksand*
League of Women Shoppers, 92
Lewis, David Levering, 17, 53, 170n15
Lewis, Sinclair, 72
Listen to the Trees (Ringgold), 159
"Little Shop Girls Go to the Movies"
 (Kracauer), 77
Locke, Alain, 16, 25, 27, 51, 82, 98, 107, 122
A Long Way Home (McKay), 49
Lorde, Audre, 146
Lost Boundaries (film), 90
Louisiana, 6
love, 50, 71, 72, 76
Love, Laura, 167
lynching, 85, 118, 119, 120, 128, 135, 139

MacArthur Award, 146
McDaniels, Hattie, 154
McDougald, Elise, 25, 27, 122, 173n14
McKay, Claude, 49, 51, 77, 78, 110, 145
McKay, Nellie, 125, 128
McKinney, Nina Mae, 94, 96
madonna, xvi, 35, 121, 123. *See also*
 iconography
mammy, 42, 98, 99, 104–105. *See also*
 iconography
Manet, Edouard, 123, 152
marginalization, 13

marriage, 37–38, 66, 69, 71, 72
Marrow of Tradition (Chesnutt), 84–85
Marsh, Reginald, 61, 62, 63
Martin, Alfred, 74
materialism, 129, 136, 137
Matisse, Henri, 147, 150, 151
Matisse's Model (Ringgold), 150, 152,
 153–154, 156
Melville, Herman, 119, 120, 133
Messenger (periodical), xix, 16, 54, 123
Micheaux, Oscar, 41, 78–80, 82–84, 86,
 88–89, 91, 101, 105, 135, 180n18. *See also*
 cinema; films
Miller, Kenneth Hayes, 64, 65, 66
miscegenation, 41, 108, 119, 130, 131, 132,
 143, 167
mixed-race icons, 19, 28, 84, 105, 107, 144.
 See also biracial identity; mulatta/o
modernism, 44, 50–52, 68, 105, 108,
 116–117, 133, 137, 142–143, 145–147;
 abstraction in, 110; influences in, 111;
 Larsen and, 172n5; racial icons and, 79;
 redefining, 16. *See also* Afro-modernism
Modernism in the Harlem Renaissance
 (Baker), 132
Modigliani, Amedeo, 125–126
Monet, Claude, 156
"Mood Indigo" (Ellington), 87
morality, Victorian era, 52
moral transgression, 104, 105
Moroccan Holiday (Ringgold), 158
Morrison, Toni, 20, 143–144, 159, 160, 161,
 162–164, 165, 167. *See also Jazz*
Mory, Angèle, 66
Moses, Lucia Lynn, 96
Mosley, John, 123
motherhood, 45, 97, 130–131, 139, 143, 155,
 162. *See also* madonna; mammy
Motley, Archibald J., Jr., xiii, xv, 20–24,
 28, 29, 30, 39, 83, 126, 149, 153; race
 and, 40–43, 79
A Moveable Feast (Hemingway), 158
"Movies" (Hughes), 77
"La Mulatrêsse" (Delacroix), 28
The Mulatta and the Politics of Race
 (Zackodnik), 18
Mulatta Nation (Saar), 165

mulatta/o, 13, 21, 39, 55, 134, 167, 170n16;
 characters within novels and, xix, 4, 6,
 10, 42, 81; classification of, 10, 12, 139;
 fetishization of, 37, xvi; figure, 22, 89,
 140; film and, 78, 85; idealization of, 11,
 163; as tragic figure, 12, 18, 35, 47, 49,
 105, 161, 164. *See also Imitation of Life*
mulatta/o iconography, 41, 48–49, 55, 69,
 79, 105, 143, 145, 159; black womanhood
 and, xvii, 3, 19, 158; in *Cane*, 120–122,
 129; Larsen's use of, 24, 28, 31, 39;
 miscegenation and, 37, 168; primitivism
 and, 16, 90–93, 108–109, 140, 142, 162
Mulatto (Hughes), 10
Mulatto Mother and Child (Jackson), 75
A Mulattress (Motley), xiii–xvi, 41
multiculturalism, 17, 166. *See also* com-
 munity; culture
multi-ethnic, 19. *See also* race; culture
multiracial iconography, xx
multiracial movements, 17
Mulvey, Laura, 100
Murray, Angela *(Plum Bun)*, 62, 64,
 67–71, 89, 101, 103; gaze and, 63, 76;
 marriage and, 72, 155; passing and, 74,
 84, 100–101, 104. *See also* Fauset; *Plum
 Bun*

Nadell, Martha, 19
Nardal, Jane, 73
Nardal, Paulette, xviii, 73, 158
"National Brands/National Bodies"
 (Berlant), 99
Naxos School, 28, 31, 45
"Negro Art Hokum" (Schuyler), 17
"The Negro Artist and the Racial
 Mountain" (Hughes), 17, 51, 74
"The Negro Emergent" (Toomer), 109
"The Negro in Art" (Motley), 21
"The Negro in Art: How Shall He Be
 Portrayed? A Symposium" (Fauset), 73
Negro World (periodical), 15
Neither Black nor White yet Both (Sollors), 18
Nella Larsen (Davis)
The New Negro (Locke), 16, 25, 98, 122
New Negro movement, xix, 10, 12, 16, 50,
 110, 118, 143, 146, 147, 159; community, 74,

108; culture of, 36, 72, 145; discourse of, 55, 111; identity, xv, 49; ideology of, 17, 53, 123, 168; periodicals of, xvi, 7, 76, 83

New Negro women, xvi, 49, 68, 80–81, 84, 118, 121, 170–171n21, 173n14; fictional portrayal of, 13, 53–57, 164; as ideal, 89, 107–108, 123, 143–145, 168; sexualization of, 121

New York City, 133

New Yorker (periodical), xiii, xv

New York World (newspaper), 74

Nig (Larsen), 40

Nigger Heaven (Van Vechten), 16

North, Michael, 51

"November Cotton Flower" (Toomer), 125

Nude Girl on the Oriental Carpet (Van Der Zee), 123

Nude (Johnson), 123, 124, 131, 141–142, 148

objectification, 32, 48

octoroon, xv

The Octoroon (Adams), 26

"Octoroon" (Love), 167

The Octoroon (Motley), 41, 42, 43, 175n67

The Octoroon Girl (Motley), 21, 22, 23, 39, 41, 42, 175n67

An Octoroon Girl (Motley), 42

Odalisque with a Slave (Ingres), 123

Of One Blood (Hopkins), 6

O'Keefe, Georgia, xviii, 24, 111, 118, 184n25

Old Negro, 140

Olsen, Axel, 32, 33, 34, 35, 155

Olympia (Manet), 34, 123, 152

Ophelia, 6. *See also* iconography

Opportunity (periodical), xix, 10, 16, 25, 54, 55, 97, 123

Orientalism, 28, 31, 44

othering, 32, 84, 105

"Our Women and What They Think" (Garvey), 15

painters. *See specific artists*

paintings. *See specific works*

Pannetier, Odette, 98

passing, 13, 38, 66, 68, 72, 91, 96, 98, 101–102, 143; anti-passing ideology and, 84, 105; deception and, 90, 100, 104;

Fauset and, 50, 78; language and, 88, 98; narratives of, 10, 40, 79, 90, 91, 99, 100, 144; novels of, xix, 49, 136; transgression of, 71, 105, 107; women and, 12, 89

Passing (Larsen), 10, 22, 35–38, 40–45, 80, 92, 97–101, 155, 161, 167; same-sex attraction and, 174n47

patriarchy, 120, 128, 167

Peola *(Imitation of Life)*, 92, 93, 98, 100, 102, 103; Washington playing role of, 96, 99, 153

Periscope (periodical), 122

Perugini, Frank, 83

Peterson, Dorothy, 16, 47

Picasso, Pablo, xviii, 32, 117, 137, 147, 151, 152, 154

Picasso's Studio (Ringgold), 150, 151, 152, 154, 156

Picktall, Marmaduke, 31

Picnic at Giverny (Ringgold), 156, 157, 188nn32

Picnic in the Grass . . . Alone (Ringgold), 159

The Picture of Dorian Gray (Wilde), 32

Pinky (film), 90, 96

Pittsburgh Courier (newspaper), 96, 98

Plum Bun (Fauset), 10, 19–20, 50, 52, 54–55, 57, 78–79, 84, 89, 92, 97, 100–105; advertisement for, 56; capitalism and, 70; gender conflict in, 71; marriage and, 155; misinterpretation of, 177n13; New Negro woman artists and, 49; references to cinema in, 82. *See also* Fauset

Le Populaire (Beavers), 97

Portrait of an Octoroon (Motley), 42

Portrait of Mattie McGhee (Shepherd), 9

Portrait of My Grandmother (Motley), 41

Powell, Adam Clayton, Jr., 87

Powell, Isabel W., 88

Powell, Richard, 123

prejudice, 88, 90, 98

primitive iconography, 140, 162

primitive imagery, 111, 122, 125

primitivism, 24, 32, 35, 93, 107, 110, 137, 140–143, 147, 152; art and, 116; in

primitivism *(continued)*
　Europe, 110; mulatta icon and, 108;
　problems of, 144; redefining, 16
prostitution, 34, 123, 139, 152
publications, 41, 55, 118. *See also* black
　publications; New Negro movement:
　periodicals of; *specific publications*

Quicksand (Larsen), 10, 12, 19, 22–24, 27,
　42–45, 61, 97, 124, 134; comparison to
　Olympia, 34–36; critiques of, 37; Naxos
　College and, 186n84; same-sex attraction
　and, 174n47. *See also* Larsen
quilts, 144, 147. *See also* Ringgold

race, xv, 33, 35, 37, 41, 47, 61, 99, 161;
　boundaries of, 12, 13; categorization
　and, 19, 44, 48, 71, 102, 119, 141, 165;
　discourse and, 4, 10; future of, 139, 143;
　heritage and, 38, 50, 110, 130; hierarchy
　and, 100, 120, 140, 167; icons and, 69;
　identity and, 53, 63, 92, 98, 108, 109,
　111, 168; indeterminacy and, 108; mixed-
　race and, 19, 28, 84, 105, 107, 144; per-
　formance of, 69, 77, 82, 102, 104; racial
　barriers and, 44, 71; representation and,
　51, 165; status and, 25, 105, 135; visibility
　and, 67. *See also* mixed-race icons;
　mulatta iconography
race films, 41, 78, 79, 80, 91, 101
"Race Problems in Modern Society"
　(Toomer), 109
racial violence, 85, 118–120, 128, 135–136,
　139. *See also* violence
racism, 52, 75, 103. *See also* lynching
racist iconology, 108
radicals, 51, 76
Raimon, Eva Allegra, 18
rape, 85, 86, 119, 139. *See also* violence
Reconstructing Womanhood (Carby), 49
Reel to Real (hooks), 181n52, 182n56
Reid, Ira, 70
Reiss, Winold, 25, 27, 37, 51, 112, 122
religion. *See* spirituality
religious icons, 120, 130
Renoir, Pierre-Auguste, 64
representation, 146

repression, 176n10
Revue du Monde Noir (periodical), 73
La Revue Nègre (film), 33, 153
Rhinelander, Alice, 71
Rhinelander case, 38, 71, 89, 91
Ringgold, Faith, xviii, 20, 143–145, 147, 151,
　157, 158, 159, 167; Morrison and, 165;
　quilts subject matter, 186n2, 188n32,
　188n33; symbolism and, 147; Toomer
　and, 147. *See also American Collection;
　French Collection; specific works*
Robinson, Amy, 91
Running a Thousand Miles for Freedom
　(Craft), 5

Saar, Lezley, 165
Said the Fisherman (Picktall), 31
"Salon Clamart" (Nardal), 73
Sanders, Mark, 117
Saturday Evening Post (periodical), 70
"Saturday Matinee" (Trethewey), 166
"Saturday Nighters" (Johnson), 132
Savage, Augusta, 73, 74, 75, 110, 179n69,
　186n2
The Scar of Shame (film), 81, 83, 96
Schuyler, George, 17, 55
Scruggs, Charles, 133
Scurlock, Robert S., 95
Seabrook, W. B., 47
segregation, 74–75, 98, 105
Self-Portrait (Johnson), 112, 113, 114
Self-Portrait 1923–1926 (Johnson), 112
Self-Portrait with Pipe (Johnson), 112, 115
Senna, Danzy, 166, 167
"Seventh Street" (Toomer), 133, 134, 136
sex appeal, 100
sexuality, 52, 53, 57, 89, 90, 104, 126, 148,
　168; encounters and, 71, 141; exploita-
　tion of, 5, 6, 120; expression of, 50, 144;
　free love and, 50, 71, 76; gratification
　and, 92, 130; incest and, 86, 89; rape
　and, 85, 86, 119, 139. *See also* violence
Shepherd, Harry, 6–7, 9
Shop Girls (Soyer), 64
The Shoppers (Miller), 64, 65
Sirk, Douglas, 93, 99, 105
skin color, 103, 136; beauty and, 135

slavery, xviii, 4–5, 7, 28, 119, 133, 139, 145
social emancipation, 50
social equality, 75
socialization, 103
social position, 61, 66. *See also* class; status
social realism, 54
Sollors, Werner, 18
Sorbonne, 60
The Souls of Black Folk (Du Bois), 122
Soutine, Chaim, 110, 111, 125–126
Soyer, Raphael, 64, 66
Sparks, Ned, 92
Spillers, Hortense, xx
Spingarn, Arthur, 60
spirituality, 87, 116, 126, 130–133, 140
Stahl, John, 77, 92, 94, 99, 105, 173n14
Starr, Martha, 75
status, 25, 47, 60, 79, 105, 135. *See also*
 class; social position
Stein, Gertrude, xvii, xviii, 117, 147
stereotypes, 18, 60, 78, 97, 163, 165
Stewart, Jacqueline, 97
Stieglitz, Alfred, 24, 111, 117, 118, 133,
 185n48
Stowe, Harriet Beecher, 37
Stribling, T. S., 78
supremacy, 109, 140
Symbol of the Unconquered (film), 80

Tanner, Henry Ossawa, 110
"The Task of Negro Womanhood"
 (McDougald), 25
"Theater" (Toomer), 133, 134
Their Eyes Were Watching God (Hurston),
 13, 14–15
There Is Confusion (Fauset), 10, 51, 73
Todd, Ellen Wiley, 53, 64
Toomer, Jean, xviii, 14, 17, 19–20, 24, 146;
 birth and, 162–163; compared to Ring-
 gold, 147; correspondence of, 107,
 184n25; Du Bois and, 122; Fauset and,
 51; illustrations of, 112; Johnson and,
 109, 132, 142; literary groups and,
 183n6; Melville and, 120; O'Keeffe and,
 118; philosophy of, 140; race and,
 109–110, 145; Stieglitz and, 185n48; as
 visionary, 141. *See also Cane*

tragic mulatta, 12, 18, 35, 47, 49, 105, 161,
 164. *See also* mulatta/o
The Tragic Mulatta Revisited (Raimon), 18
Trethewey, Natasha, 166, 167
Tropic Death (Walrond), 140, 141
Tucker, Lorenzo, 83
Tucker, Sophie, 104
Tuskegee University, 28
"Type Sketches of Negro Woman" (Reiss),
 27

*Unidentified Young African-American
 Woman* (Easterly), 8
United Negro Improvement Association
 (UNIA), 15
University of Wisconsin, 109
upward mobility, 136
urban culture, 62, 93

vampire, 42, 44
Van Der Zee, James, 16, 79, 123, 147, 159,
 160, 172n2
Van Gogh, Vincent, 147
"The Vanishing Mulatto" (*Opportunity*
 editorial), 10
Van Vechten, Carl, 16, 44, 46, 47, 51, 78
Veiled Aristocrats (film), 84, 86
Victorianism, 42, 52, 57, 60, 63
violence, 85, 86, 89, 130–131, 141; racial, 85,
 118–120, 128, 135–136, 139. *See also*
 lynching; rape
virgin, 126
Virginia, 54
Virgin Mary, 121, 128, 139
visual art, 32. *See also specific artists*
voyeurism, 87

Walker, Kara, 146
Wall, Cheryl, 17
Wallace, Michelle, 156
Walrond, Eric, 110, 140
Washington, Booker T., 52, 82, 83, 132
Washington, Fredi, 20, 79, 88, 91, 94–96,
 99–100, 104–105, 153
Washington, Isabel, 88
Washington, D.C., 132
Washington elite, 135

Wedding on the Seine (Ringgold), 155, 156
Wells Barnett, Ida B., xix, 60
Wharton, Edith, 68–69, 72
Wheeler, Laura, 57; illustration, 58–59
When Harlem Was in Vogue (Lewis), 17
"When Malindy Sings" (Dunbar), 124
White, Walter, 10
white consciousness, 119
white culture, 117
white female body, idealization of, 124. *See also* passing
"White Slaves" (*Youth's Companion* illustration), 5
white starlet, black maids and, 103–104

Wiegman, Robyn, 5
Wilde, Oscar, 32
Williams, Moses, 7
Within Our Gates (film), 81, 82, 85, 86
womanhood, 79, 96, 161
Women, and the Harlem Renaissance (Wall), 17
Woodall, Elaine, 41
Woodruff, Hale, 73

Youth's Companion (periodical), 5

Zackodnik, Teresa, 18

About the Author

Cherene Sherrard-Johnson is assistant professor of English at the University of Wisconsin–Madison. Among her publications are articles on Nella Larsen, Dorothy West, and the slave narrative. She is presently co-authoring a collection of essays addressing racial identity, indeterminacy, and identification in the nineteenth century. Also a creative writer, her poetry and short stories have appeared in numerous journals and anthologies. She lives in Madison with her husband, poet Amaud Johnson, and her son, Hayden.